WALKING
WILDWOOD
TRAIL

Poems and Photographs

Amelia L. Williams

Wild Ink
128 Wildwood Trail
Afton, VA 22920

This is a work of poetry. Any resemblance to actual persons, living or dead, or actual events is purely coincidental.

Cover photograph by Max Johnson
Interior photographs by Max Johnson, Melissa Luce, and Amelia L. Williams
Trail map illustration by Ryan Wender
Book and cover design by Stillpoint Press Design Studio

Printed in the United States of America
 Library of Congress Cataloging-in-Publication data
 Williams, Amelia L., 1961
 Walking Wildwood Trail: Poems and Photographs / Amelia L. Williams
 ISBN 978-0-692-60498-4
 Library of Congress Control Number 2016900382

INTRODUCTION

When I walk the Wildwood Trail with Amelia in early May of 2014, it is an ideal spring morning, cool enough to need a sweater that will be shed in a few hours. Recent rain has brightened the fresh greens of ferns, may apples, leafing trees. Our path through her LandEscapes installation starts with poems that conjure intimacy with these woods: "Early Spring, With Scissors" tucked in a tree hollow surrounded by running cedar; "Rivulets: A Soundscape" in earshot of a mossy creek gurgling under webs of thick tree roots; "Spring Familiars."

We climb the hill in the watery green light of sun through beech leaves, admire sculptural masses of sooty mold (non-parasitic fungi) unique to American beech and the rich lichen communities that produce the characteristic mottling of the beeches' smooth trunks. At the top of the hill, Amelia locates a system of ropes and lowers the poem "Beech Grove" from canopy branches. A geometer moth, likely a common tan wave, has flattened itself along the outside of the home-harvested bamboo culm that holds the poem. On the inside of that same node wall, like a mirror image, is a twin geometer moth.

The poem itself is printed, as Amelia describes on her LandEscapes copyright application (an application that has since been approved), on "the back of a map of the proposed path of the Atlantic Coast

pipeline." That path — that pipeline — would cut through the very ridge on which we are standing, destroying the spectacular beech grove that surrounds us. Beeches are slow growing trees, so the grove and its complex community has been decades, if not centuries, in the making.

With each location and assemblage of each poem, the life of the woods and fields has entered into Amelia's work, as Amelia's work has entered into it — soil, residue, webs, insects, droppings. Woven through the poems as naturally as the hills, lichened trees, and creek beds that inform the trail is human narrative — son, spouse, meals around the table, a friendship neglected, cancer advancing, ashes scattered, love lost, love found, hesitant, shy as spring green unfurling. That narrative is not dominant melody but harmony. The human in proportion to the lives of plants and animals, rocks and soil. One narrative among many, all together weaving textures rich and profuse as the surrounding ecologies, as the poet's containers and artifacts.

Poetry — poiesis — means making. A poet is a maker. Ecology is the study (-logy) of the household (oikos "house, abode, dwelling"). Economy literally means household thrift, management, housekeeping. And so ecopoetry is the making of the household, making with the household, making a stand with the household. It is studying how to make and keep the household safe. How to keep faith.

In our introduction to *The Ecopoetry Anthology*, my co-editor, Ann Fisher-Wirth, and I describe ecopoetry in terms of three subcategories: nature poetry, the traditional praise and awe of the natural world that comes

out of the Romantic tradition; environmental activist poetry, which engages directly with environmental issues in the social and political spheres; and ecological poetry, poetry that is often experimental in the way it explores aspects of ecology in both content and form. Amelia's poems express wonder; they take action; they enact ecology; *LandEscapes* is an ecopoetic engagement in every possible sense.

With the publication of *Walking Wildwood Trail*, others will now have — through these pages and perhaps some in person — an opportunity to see the land that Amelia and so many in Nelson County love and to gain some understanding of the depth of loss they — and anyone living along the pipeline path — would feel at the destruction of such beyond-human-efforts beauty. Yes, there is a different impact, seeing the poems in place, in the form of artifacts, versus reading them on the page. But either way, Amelia has planted seeds of herself into the ground, into tree trunks, into the creek bed. She is letting the seeds bloom, letting the work change and decay with the seasons, the weather, the animals of all kinds (human and other than).

By allowing her poems and assemblages to follow the flow of place, Amelia is working to preserve this collective home, rather than standing by as the area and its riches are dug up by distant agendas for feeding economic growth and making money. While poets don't object to making money, it is generally not a poetic project, nor is poetry known to be a money-making venture. But poetry can remake our understandings, our sense of priority and purpose. It can refashion our relationship between the resources we use carelessly and the land

that provides those resources for us. Poetry like Amelia's helps to preserve a connection between the where of those resources and the what and who. It helps us understand the meaning of resources on a much broader scale.

At the end of our walk through the Wildwood Trail and Amelia's *LandEscapes* installation, we encounter a female wolf spider crossing the road with her egg sac. This is what a maternal wolf spider does: She spins a silk ball, in which she lays her eggs. She attaches the egg sac to her spinnerets at the end of her abdomen and carries it with her wherever she goes. When the young hatch, they climb up her legs and cluster on her back and abdomen until they are strong enough to go off on their own. Even so encumbered, the wolf spider is a fierce hunter and protector. Without diminishing the wolf spider on that road in Nelson County, a creature with a unique life separate from ours and our purposes on that May morning, I can't think of a better emblem, a more appropriate totem or guide for Amelia and her work in *Walking Wildwood Trail*.

Amelia is an inspired maker and a fierce protector. And she has been incredibly resourceful, with the kind of imagination and initiative, we are told over and over, this country was built on. Her work reminds us that we the people are also resourceful. Let us continue to make and build on that rather than an invasive pipeline. Let us, like Amelia, keep house by keeping faith.

Laura-Gray Street

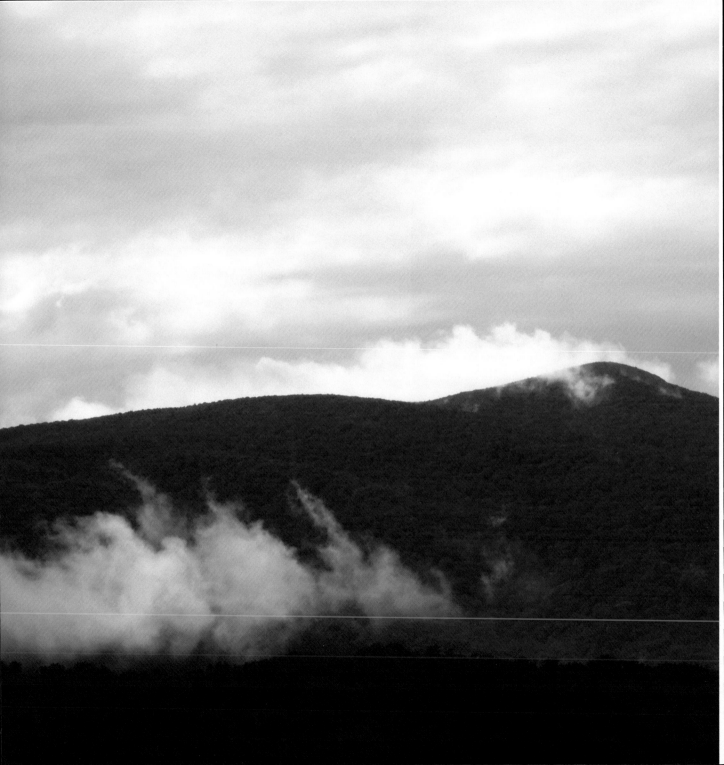

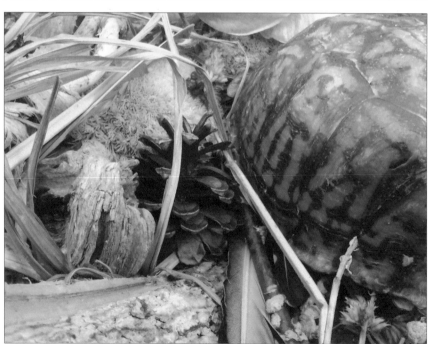

Gathering

We walk through the story at night
 whenever deer eyes cipher
 like fallen wind.
"Ky-ah?" my child asks, his command
 to sing the word for a thing,
 wrinkling his nose,
fierce fire to name his world, become
 my stone circle. Strange gap
 after river trickled ashes.
Eyes, fireflies, apples, naming—
 orchard gathering letters, glowing road
 in red darkness, amid the fruit.

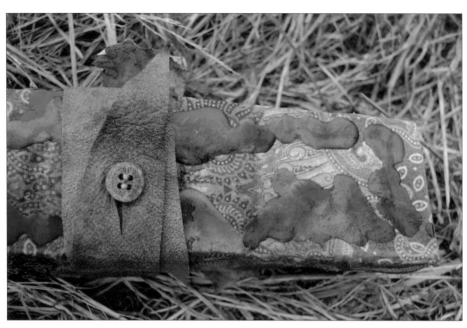

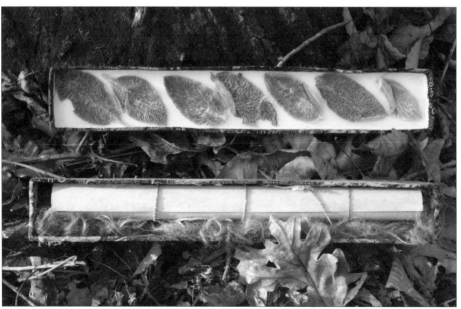

Blue Ridge Visions

Thalo, recumbent goddess,
giant hips and thighs edged blue,
wraps my offered moods about her
each morning as I emerge
from the woods to where the ridgeline
beckons, wrapped in a ribboned
sarong of hourly hues.

Come evenings, Indigo opens
to my darkest memories; stone coal,
luster of jet, clinks cold in the bucket.
I step back from that familiar pit—
the stars are out and the air is noisy
with crickets; katydids mask all sound
of weeping. Indigo says, "How you use
night's blue-black coverlet is up to you."

Sometimes Azure filters down
to prepare me for a journey—braids
a lapis luck charm into my hair,
tells me to rest. At dawn, she says,
"Drink sweet water, eat bitter fruit—
now start walking. Adjust your stride.
Carry your words with you, a field
of flax, one blue and then another."

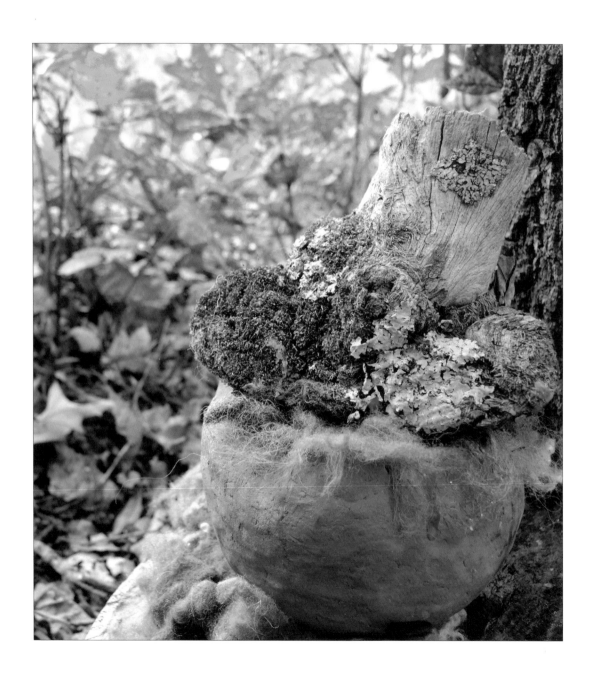

Equinox

Let us be less busy, wind down
to quiet when leaves tumble loose;
let us resist bustle, thicken
our coats against jingle and jitter,
the commerce of compulsion.

Autumn now gathers more dusky wool each evening.
Goldenrod and purple ironweed flare.
On the mountain, trees display whatever
daub of russet and ochre
this year's rainfall and frost allow.

Threads of morning mist
trace creek to marsh;
disheveled cattails, losing tufts
of seed, and milkweed pods
twisted into strange paisley,
foretell the palette
of coming winter.

As we go down into the softening
browns, beech leaves whispering,
as grey bark blooms with pale green
lichens, and creatures slip into crevice
and hollow, let us rest,
set aside our burnished hurry.

. . .

Let us turn toward deepening
night, bank the fires of spirit.
Soon enough, slowly stretching,
we'll unravel the sweet dark cloak
from off our shoulders, evening by evening,
coaxing to life again the spark of spring.

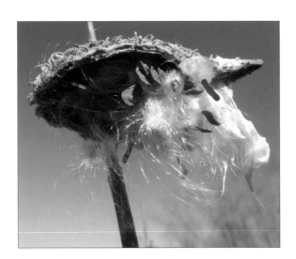

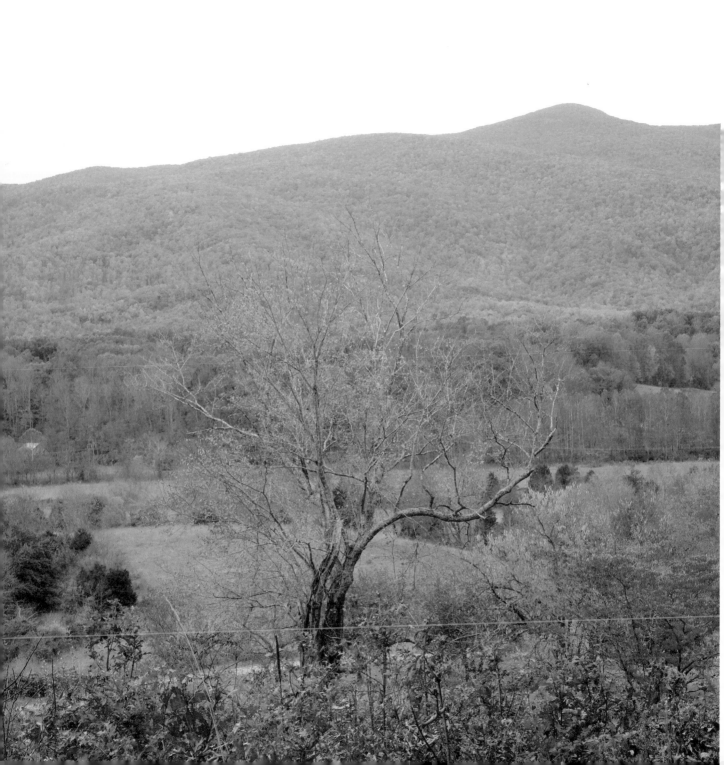

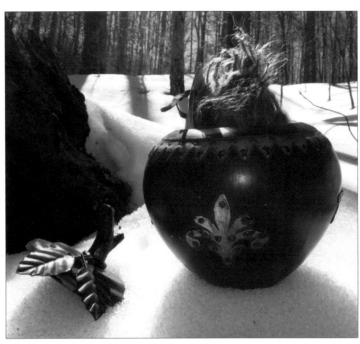

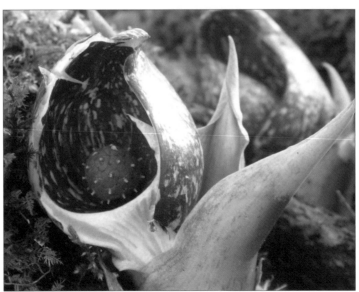

Early Spring, With Scissors

I am sorry I let slip our friendship,
 neglected to call, make plans.

 I have been folding and creasing my marriage
into tiny origami animals.

 When my skill faltered
 I took up scissors cutting away

 negative spaces to make paper doll garlands.
 They look only half human as if I sewed together

 bones of a small mammal
 we found at the river's edge—

 star-shaped vertebrae, a hip bone, a rib,
when the skunk cabbage was
 peeking green,
 a marbled sleeve concealing

 its secret spadix, flower-spiked ball,
 like a medieval weapon, tucked inside.

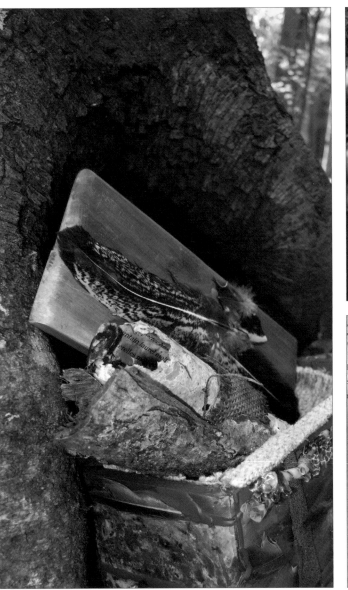

thunder...
...ounce pitiless
...r lightning
...eam cups splashy surrender
...sifts snow to muddy track
...l traverses
...ets taking and giving
...r path

Rivulets: A Soundscape

Mantra: taking in and giving away – these two shall ride the breath.

rain ripping rain

rattles rue anemone rue ruin

disintegrates delicate showy orchis

orchestral thunder rolls

torrents obliterate

primitive pounce pitiless

drench down petals pour lightning

tap rap patter hiss

cream cups splash surrender

mountain laurel molts sifts snow to muddy track

chanterelles melt trail traverses

la rue regret

rivulets taking

and giving away

rain on the deer path

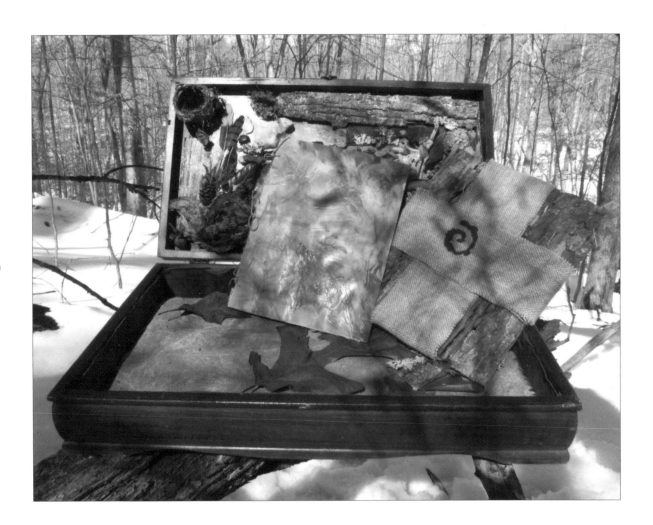

Spring Familiars

i

Just tell me if anything comes into your mind,
he says. I expect nothing, focused
on not wincing, breathing into the ache
of deep-tissue massage. And in my head I'm running,
frightened, in a red dress. A blond child I don't recognize,
startled from quiescence. Crow cries alarm
to all who will listen. Now I'm on the dock
with other fishermen, boats rocking, nets unspooled
for repair, laughing in the sun. I'm sure
I've been fishing all of my days.

ii

I conjure gratitude to husband
for cooking dinner, son for fetching mail,
when earlier each was an irritation.
What is familiar and what is strange?
I walk the trail near my home so often
I sometimes don't see it. On this path the Gray Fox once
looked me straight in the eye and turned into the woods.
Over the years the stream has been sinking
under tree roots in the shade of mossy boulders.

. . .

iii
They emerge from winter's leafmeal
on slopes above the cliff trail; I have enticed
to memory their names: Cut-leaved Toothwort,
Spring Beauty, Rue Anemone,
Pennywort. Some are yet unfurling
green: May Apple, Twin-leaf,
Cinnamon Fern, Lyre-leaved Sage. The vireo
asks and answers—an incessant, liquid call.

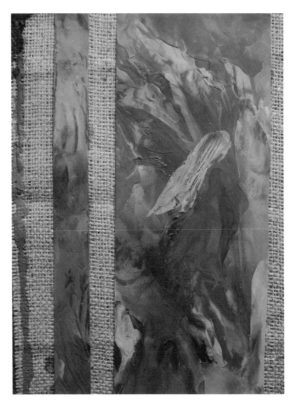

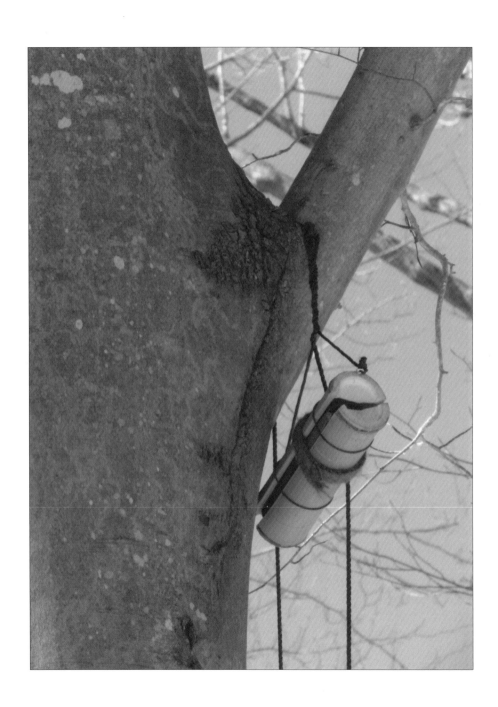

Beech Grove

Márgarét, are you grieving
Over Goldengrove unleaving?
> G. M. Hopkins

i

Circle of gold beeches,

lit for fall, not unleaving.

Whisper-scoff raspy stammer,
poplar, hickory, maple gone brown,

wind-plucked,

detached; we crush them underfoot. All winter
beech leaves grip.

Soon Spring's coiled greening

will insist, flick them, launched, crackling,

to swoop low one by one.

ii

We had eyes for one another. I took you among a group of visitors, on a hike
to the beech grove. We two walked back down the trail in a late August swelter,
turned onto the road toward the gardens. My friend was in her yard and wondered,
were we seeing one another. Not answering her question, you said "I like Aurora."

. . .

iii

Stranger still, you took my hand.
Something bloomed like a tingsha bell;
who tipped its edges together to sing in summer air?
I believed — took unfurling sound as a sign.

iv

Beech leaves cling once upon another lover walked me here
to this circle of memories
marrow of trust took six years to fill hollow branches

father of my sons died leaving me
clutching
lest I drift down frostbitten air.

v.

I notice our syncope gapped, canted.
Tender angers billow
with August storms. Your ironwood arms
trellis vines, pick corn and squash. Is this
my nested hollow my leafy rest?

There's summer sweat,
there's a circle of gold;
now green days come and compel me to let go.

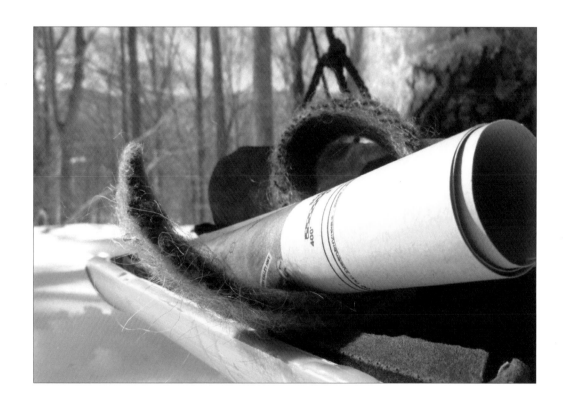

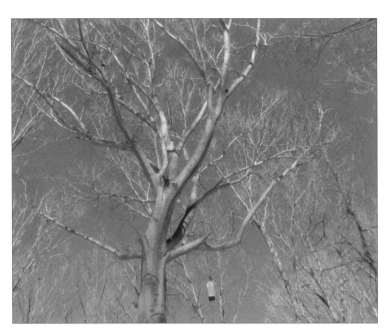

In the Meditation Room

I hold like a limpet to its rock, sessile. Edges
curl up with umbilicaria lichen, leathery, crisp.

I solidify over eons, with greenstone, mafic,
no longer molten.

Hanging Rock—outcropping flat enough for the sleeping bag—
stay well back, in case you roll in your sleep.

Over the low reverb of cicada, slopes of trillium & wood betony
trickle warbler, vireo, pewee.

The seventeen year cicada, red-eyed, emerges
from the ground.

Soon I will have mouthparts, and a husk.
Soon I will sing and split open.

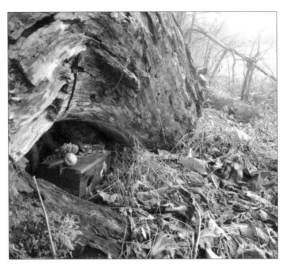

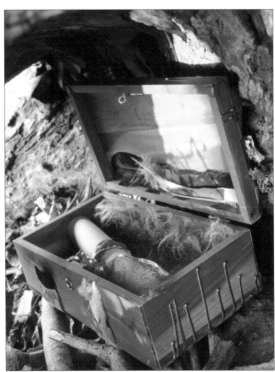

I Wanted to Write You a Valentine

In the riverbottoms, mangy-looking cattails
are dropping their seeds in clumps,
 while along the ridges, the trees,
 like worn-out whisk brooms,
 scratch at gray winter sky.
 A misty rain begins — so chill and drear,
 it's hard to recall that underground
 the roots and rhizomes are biding their time.

Ladybeetles clump in window corners seeping cold;
a crushed flake and milk trail dribbles from table to floor —
 dust-devil swirls of mess and chaos —
 each jam-smeared face my best bouquet.
 Surely the spark of our love is not tucked away
 like a crocus-jewel inside a velvet-lined box,
 a dormant ballerina waiting for the lid to lift
 to dance to "Oh What a Beautiful Morning."

Instead, like glitter the kids spilled on our table
that over the course of weeks stuck to hands, dishes,
 faces, carpets, it's dispersed in glimmerings —
 milkweed seeds, lifted by wind into silken parachutes,
 cattail fluff blown in spidery bloom to stipple the river,
 or that wintery day when the maples bud
 and the ragged tree-line
 puts on its shawl of fringed red lace.

Ginseng Diaries

How'd I meet your Mom? You want to hear it again?
Annie and Herb took me ginseng hunting in the Virginia hills.
Back then, any legal way to earn a dime, I went along.
You've never met Annie? Suburban Jersey girl
gone earth-momma, all tofu and feathers,
and I don't eat dairy. Wanted to hook me up,
tried to sell me on the idea while we scrambled uphill,
looking for red berries and five-leaved stems of "sang."

Her real name's Louise, but she's going by Hester now.
I think it's a phase. She's a real peach, you'll love her.
I looked over at Herb, who winked,
Two pretty peaches, Jim, and a mean rhubarb pie.
I told Annie the last peach turned out to be devil's spawn.

I know you'll like her. Nature girl and artsy chic
rolled into one. She's building a spiral
herb garden maze – plays harpsichord, of all things.
An inheritance from her Mom.
She says it's 'still in probate,' whatever that means.

Is she a carnivore hater? I asked.
I've got to fry up some bacon now and again.
I don't mind a vegetarian chick, if I can eat what I want.
She doesn't throw blood or adopt every stray cat. You'll see.
Spiral maze and harpsichord. I mulled it over,
and the peaches. Alright, I said. I'll meet her.

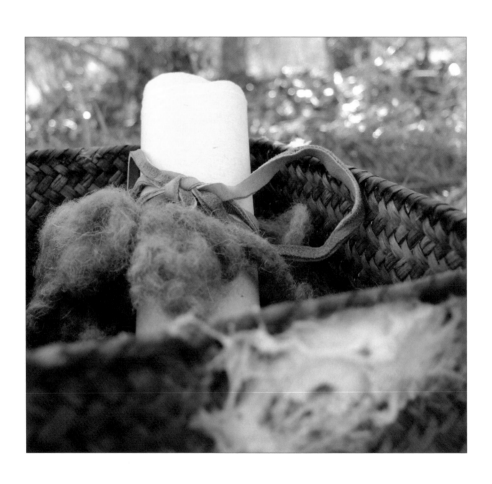

Gowned in green tangle

I trail cherry tomato vines' explosive growth
to sprawl out of garden bed ramble across the lawn climb
the deer fence persist into late October with globed red clusters of six
so sweet to mash against roofs of mouths.

Years ago your cancer receding briefly I wound watchful waiting
around me a pashmina scarf like meditators use warm ritual
hopeful as this black tortoiseshell kitten is now hovering near
shy fosterling not purring not cleaning its cobwebby whiskers.

After the cells mounted a new assault I assembled other outfits
dressed in piling detritus springing static-clinging skirting me
magnetically a not-quite-crinoline of dust
bunnies torn calendar pages unopened mail crusty dishes.

Dressed for duty opioid patches gauze remote control bulging
my pocketed vest controlling remote sensations I bustled
competent movements covering a caged dressmaker's dummy
in crisp tailored Oxford cloth prêt-à-porter.

In my closet is one I tried to give away doesn't fit me anymore
but no one is falling for it felted dress of desolation over leggings
leather-laced the way the conquered clans wore them mud flat brown.

I travel now red-hooded hiking-booted green corselet falling away
past hemlock creek's stony riffle to ridge of beech trees I can't encircle
away from or is it toward the fangs of the wolf that was my love.

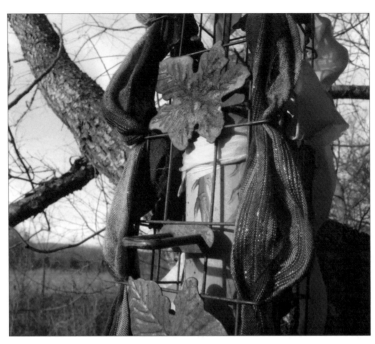

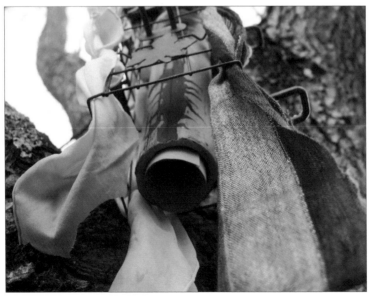

A Question of Passage

I return to the bridge of moth breath,

 chances of crossing uncertain. Its outlines flicker, like starry campion nodding.

 My chemise, silks — tokens of fortitude & defiance,

still flutter on branches of river birch, oak willow, spicebush, edging

 stream's throat. A Hermit Thrush spills liquid trills.

 Into this adumbration, hazy intimation,

my lover comes, smelling of maple sugar, wearing hide-strung snowshoes

 saying the bridge is repaired:

 its filaments shine like spun tungsten,

call like summer puddles to swallowtail & crescent throngs.

 Quick now — its wind-tangled mesh sifts repercussions, spins worry

 like cotton candy, lifts certitude with milkweed fluff to river's edge.

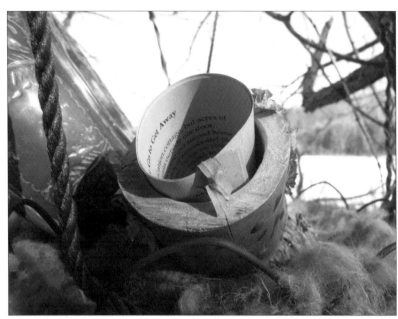

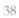

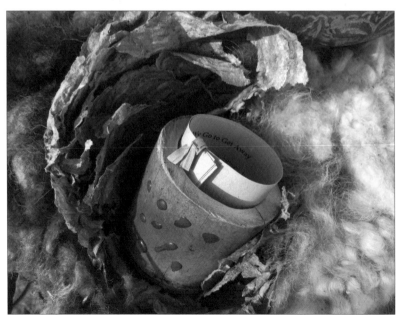

No distant vacation cottage

but acres of bushwhack terrain outside our door,
a maze of trails become our second home
as we prowl in search of animals and plants —
an argument-free zone. Today we seek leaves
of puttyroot and cranefly orchid, to mark
each spot for stalks of tiny blooms that come
in late summer, long after the leaf is gone.

We descend through cut-leaf toothwort, its white
whorls just emerging on the hill that flanks
the river field. Hazy yellow ribbon under peeling
sycamores — the river's outlined in leafless spicebush —
willowy branches bearing delicate flowers.
A deer path threads through to the water.

Past the pebble beach of greenstone and blue quartz,
otter and weasel tracks run beside splayed
heron prints in near-dry sand. A hefted sound
trailing legs, then rattle and blue flash;
green heron and kingfisher revealed in leaving.

All over this land, another imprint, fading:
at the sandbar where I scattered his ashes,
in gardens where he grew hot peppers.
But the spotted sandpiper at the river,
veined leaves of rattlesnake plantain, flare
of showy orchis, are ours to share — our spring
getaway of bloodroot and rue anemone.

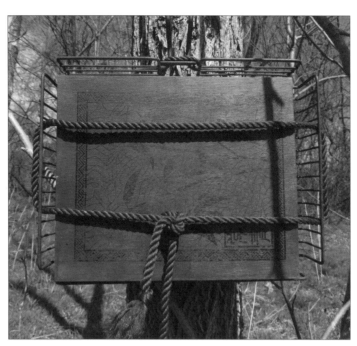

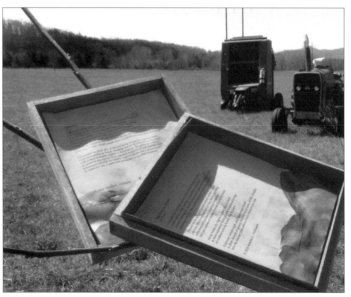

The Farm in Winter
For Karl

Horses in rough and mud-caked
winter coats eat into the sweet
center of hay bales, leaving
odd-shaped hollows, eyes
that witness the last glint
of frost in the river field.

The sentinel spine of the Blue
Ridge bristles with winter trees.
Indigo, slate-blue, oyster-shell gray —
these hills cast off their homespun only
for the extravagance of certain sunsets.

Away from city lights I gape
like a child; stars spatter, pulse,
eddy and snag in the topmost twigs
of these restless woods
lonely for leaves.

February winds whisk;
tree-tops creak in their dream
of green. Thoughts of you nibble
steadily into the tender pith
where love renews its sap.

Surrender to the orchard

like bare feet give
 in a red dirt road—
 let stinging rain travel

pore to pore. You'll have to ball up the sheet music,
 kindle a fire; don't cry
 as spark and ash sing up the sky.

She's gone. I cradle her voice in my ear.
 Indentured—fleeing lash and worse, we waded for hours,
 smeared in bear fat to cover the scent.

Hang on a few more nights, sister, to the sheaf of foolscap,
 because you never know. Cold this hungry night passes slow
 under clouds that hide the moon.

I wake to apple blossom snow
 at dawn's clear sky, linger by logs
 that took waltz and polka to heart.

Nesting tree swallows dive at my head
 with a blue metallic chitter—keep away. No grits, no cook kit,
 no wren in the eaves. Only spotted knapweed

and checker-bark persimmon to call me lonely. Can't bide
 for the curious or a Minnie ball to come for me.
 I pack and consent to a cobalt horizon.

44

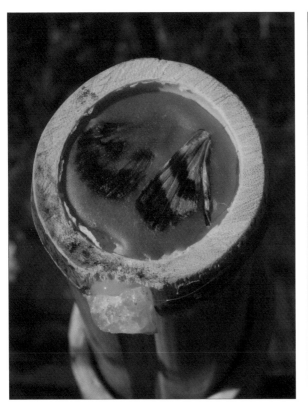

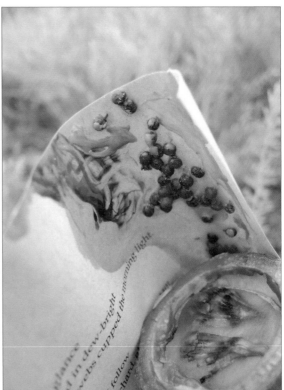

Concatenation

It flickered as I woke dream-blurred to glance
 outside where field grasses flecked in dew-bright
 bowl-&-doily spider webs cupped the morning light.

Later, at dusk, I travel to witness something,
 a splendor, maybe. Carried or drawn, I follow
 a familiar path, past the orchard, above Horse Hill.

As fringed ironweed and red sumac berries move
 in a cool wind warning of winter, I stroll the ridge-pulse,
 overtaking wise women, my elders,

at the orchard's edge gathered to see, bated by gentle constraints—
 ditch, fence, stile. They are content, they tell me, to wait here
 where dusk gathers to dark. I wonder

at their stillness. No impulse to stop and visit, a pull
 to keep going, to arrive unencumbered—seems
 simple. Just out of sight, there above river-bottom cattails,

milkweed going to fluff, there in the sky it will happen—
 lightning finger paint, ineffable, fell, obdurate,
 feral, nebular—poised to flex.

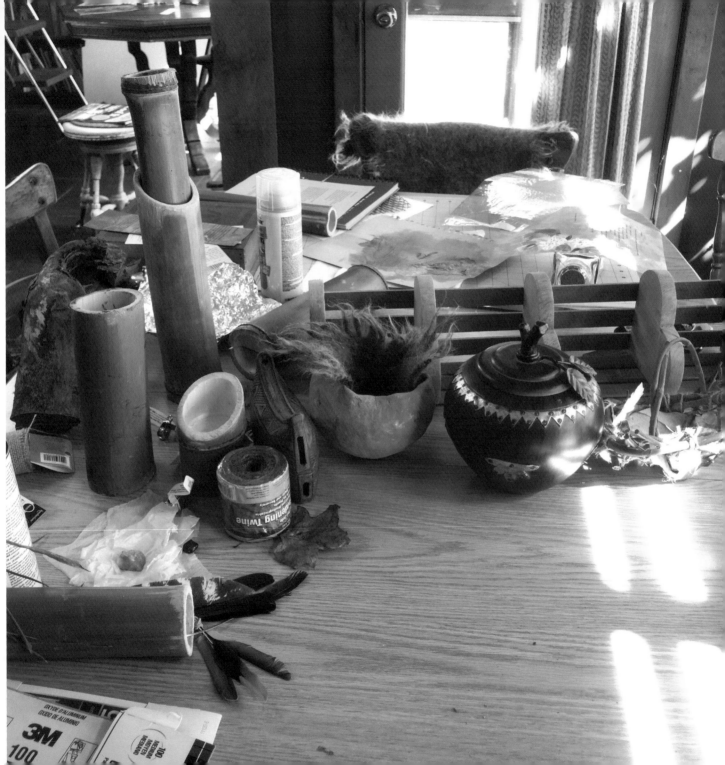

AUTHOR PROFILE

Amelia L. Williams has long been interested in the synergies among artistic creativity, mindfulness practice, and the spirit of place—a nexus made more urgent by her activism against the Atlantic Coast Pipeline. Amelia received her doctorate in English Literature at the University of Virginia. Her work has appeared in *Hospital Drive: A Journal of Word & Image, The Right Eyed Deer, Centrifugal Eye, The Blue Ridge Anthology, Sow's Ear Poetry Review, The Piedmont Virginian,* and on the website of the Poetry Society of Virginia. She is a fellow of the Hambidge Center for the Creative Arts & Sciences.

ACKNOWLEDGMENTS

Thank you and kudos to project photographers Melissa Luce and Max Johnson for devoting countless hours in all seasons, to document the project for federal copyright registration and to capture its spirit, textures and colors. Thanks to poetry editor S. H. Lohmann for her perceptive questions and attunement to the project. Much metta to Susan Oliveri, photography editor, for helping to winnow the best of the best. In tramping around the trail with Laura-Gray Street I was in the presence of a keen observer of context, who took in each detail of the art and its surroundings, noted the song of the white-throated sparrow and the delicate moth lodged in a bamboo box — all distilled in her lyrical introduction. I want to acknowledge the *Orion Magazine Tumblr* blog (May 15, 2014), in which earlier versions of "Concatenation," and "Early Spring, With Scissors" appeared as part of a poetry exchange about the growing season.

I'm grateful for encouragement from the Rapunzel's poetry critique group, from Cathryn Hankla and the Nimrod Hall writers, the SFA Pipeline Ad Hoc Committee and Rollie Lawless, Helen Kimble, Karen Backburn, Judith Williams, and Shannon Farm Community. Thanks also to book designer and Nelson County resident Kristin Adolfson for her "no pipeline" discount, and to illustrator Ryan Wender for his contribution of the beautiful trail map.

CONTRIBUTORS

Laura-Gray Street is the author of *Pigment and Fume* and co-editor, with Ann Fisher-Wirth, of *The Ecopoetry Anthology*. Her work has appeared in *The Colorado Review, Poecology, Poet Lore, Shenandoah, Blackbird*, and elsewhere. Her honors include a poetry fellowship from the Virginia Commission for the Arts and editor's prizes from Terrain.org, *Isotope*, and *The Greensboro Review*. Street is an associate professor of English and directs the Creative Writing Program at Randolph College.

Melissa Luce has a BA in Psychology and a love of the brilliance of nature which she has been attempting to illuminate through photography for over 30 years. She was a member of Shannon Farm Community for 10 years.

Max Johnson grew up at Shannon Farm and is intimately familiar with its ridges and hollows. He is a Communications major at the University of Mary Washington, but his passion is photography.

Susan Oliveri loved teaching art and photography in Albemarle County Schools, and University of Virginia and Tandem summer enrichment programs. She received Virginia Commission for the Arts grants and was a fellow in the Japan Fulbright Memorial Fund Teacher Program. Susan has an MEd from the University of Virginia and a BS from Central Michigan University.

Ryan Wender graduated from Fairfield University with a BA in Fine Arts, and was a member of Shannon Farm Community for 16 years. He is a musician, performer, and occasional cartoonist, and this is his first foray into cartography.

WILDWOOD TRAIL - POSTSCRIPT

Walking outdoors is a meditative practice for me—it feeds my creativity, and the things I notice have a way of showing up in my poetry. I've long been intrigued by outdoor sculpture and works that are intended to dissolve, weather or fade back into the landscape, like the works of Andrew Goldsworthy. There is a discipline of letting go involved in making such art, like the practice of Tibetan monks who make elaborate sand mandalas that will be blown away. I learned about a public library that teamed up with a park to place poems along one of the hiking trails. This laid the groundwork for a plan to put poems out in the woods and meadows where I live—to be a surprise discovery for someone walking a trail or rambling cross-country. But I have a busy life with full-time work and two sons and I didn't get around to doing anything about this idea.

Then in 2014, something I didn't know was even possible happened. The place I call home, a place so rural that the county still has just one traffic light, was suddenly going to be the site for a 42 inch, high-pressure fracked gas pipeline. The energy company told us we should let them survey our land, that we should just accept that they could raze the climax beech forest, destroy our communal organic garden and threaten our wells and streams. As we learned more about the threat, my neighbors and I decided to fight this proposed pipeline. It's a bad idea for dozens of reasons I won't go into here.

Someone told me that a Canadian sculptor who makes large outdoors installations had copyrighted his land to ward off an oil pipeline. I decided to show my opposition by incorporating a series of my poems

into a visual art installation that would be rooted in the landscape in a very literal way and to register the installation with the U.S. Copyright Office. This book documents that project. Proceeds from book sales will go to organizations trying to stop the Atlantic Coast pipeline.

When I ramble through the woods, fields and along the river where I live, they strike me as works of art. I didn't want to impose something; I wanted my pieces to be tucked away in, to just peek out of, the landscape. I thought of tree hollows, fallen logs, high branches, tangled vines, and tall grasses as likely places for the works I would create. The place I live is an intentional community—a land trust in which the land and buildings are all owned in common by about 80 people. My fellow community members appreciated that my proposed art work wasn't going to stand out like a Christo, but was intentionally crafted so that the pieces would eventually dissolve back into the landscape.

I call the work "LandEscapes," because we escape into nature, but also nature sometimes escapes us. We walk through without really seeing —notice wildflowers, but fail to hear birds call, or chat with a friend and don't notice the terrain at all. The multi-media works that form the basis for this book suggest how life-forms rely on camouflage and mimicry for survival, and convey the solace many of us find in the beauty and particularity of the land—escaping into it for renewal, drawing upon its forms, textures, and colors to bring meaning to our lives and relationships.

My poems and their enclosing/enfolding vessels are concerned with inner and outer wilderness, the "wild wood" of relationship, the

geology and natural history of human attachments — with husbands and lovers, children, parents, community.

The installation pieces are technically assemblages — works assembled from found or handmade objects — like a three-dimensional collage. I made a poplar bark basket, a wood-fired clay pot, several fire-hardened bamboo boxes, and encaustic (wax) paintings. Neighbors in my intentional community donated materials. The raw wool came from a community member who raised sheep. Each piece has a story. I felted my mother's Irish wool shawl that moths had attacked, and used a copper jelly mold from when my family lived in Istanbul. There's bark cordage my son made, and my next-door neighbor gave me beeswax candles that came from her relative's candle factory. Another neighbor knew how to use a fishing rod to cast a line up into beech tree branches 20 feet off the ground so that two pieces could be hauled up into the trees they are intended to protect and celebrate. My sweetheart trekked through the woods with me, helping me to install the pieces.

Following the Wildwood Trail is an experience of uncovering and discovering the poems — finding what is hidden, noticing what might be lost (through natural processes or the effects of climate change) and the act of opening or unfolding.

The pieces have now weathered a year. I have done a few repairs myself and solicited help to stabilize some works. The progress of seasons has affected even the weather-resistant materials I used most (beeswax, fire-hardened bamboo, wool, leather, and wood). Some of

the containers are now shelter for jumping spiders, ants, seedlings. Now that the poems, which have also been changing a little over the course of a year, are done, I will install the final poem in each piece (once again using acid-free recycled paper), make a few minor repairs, and then leave them alone to fade and fall apart, attracting insects and fostering colorful displays of fungus.

The order of the poems in this book follows the order of the trail but begins in the middle—On Orchard Hill—a site that is at the heart of the community and hosts many of our gatherings. But the literal trail, as the map suggests, begins at the fire icon with the poems *The Farm in Winter* and *Surrender to the orchard* (both in the same container). Two other possible ways to read the poems would be chronologically, and by the season represented in the imagery. I offer those two orders on the following page.

CHRONOLOGICAL ORDER

The Farm in Winter

I Wanted to Write You a Valentine

Blue Ridge Visions

Gathering

Gowned in green tangle

Ginseng Diaries

Equinox

Spring Familiars

Rivulets: A Soundscape

No distant vacation cottage

Early Spring, With Scissors

In the Meditation Room

A Question of Passage

A Hole in the Fabric of Sound

Concatenation

Beech Grove

Surrender to the orchard

SEASONAL ORDER

Spring

Spring Familiars
Rivulets: A Soundscape
Early Spring, With Scissors
No distant vacation cottage

Summer

Blue Ridge Visions
Surrender to the orchard
Ginseng Diaries
A Hole in the Fabric of Sound
In the Meditation Room

Fall

Gathering
Gowned in green tangle
Concatenation
Equinox
Beech Grove

Winter

The Farm in Winter
I Wanted to Write You a Valentine
A Question of Passage

MAP ICONS KEY

ICON	POEM
Apple	Gathering
Katydid	Blue Ridge Visions
Cattails	Equinox
Skunk	Early Spring, With Scissors
Chanterelle	Rivulets: A Soundscape
May Apple	Spring Familiars
Beech leaf	Beech Grove
Pewee	In the Meditation Room
Butterfly	A Hole in the Fabric of Sound
Rain cloud	I Wanted to Write You a Valentine
Ginseng	Ginseng Diaries
Hiking boot	Gowned in green tangle
Spicebush berries	A Question of Passage
Hot pepper	No distant vacation cottage
Fire	The Farm in Winter and Surrender to the orchard
Spider web	Concatenation

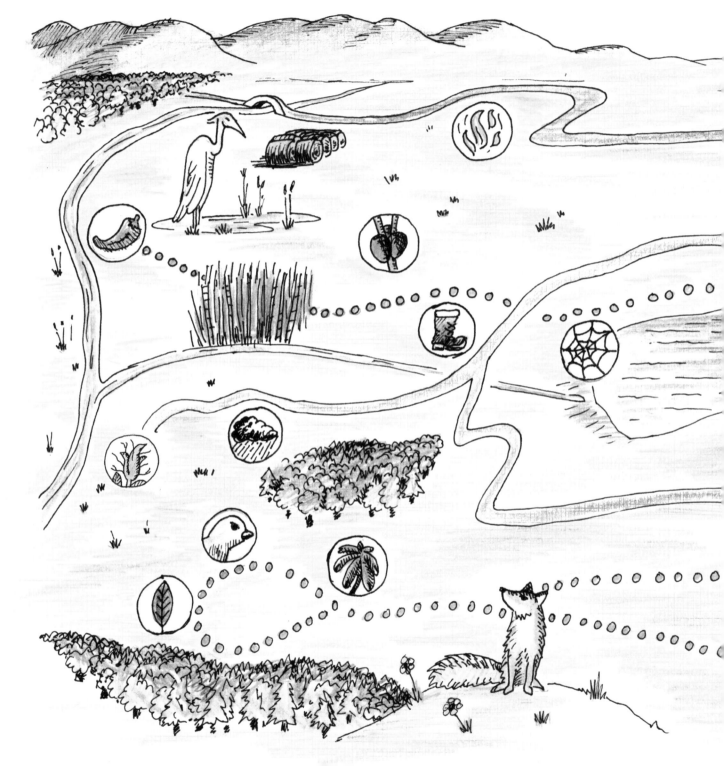

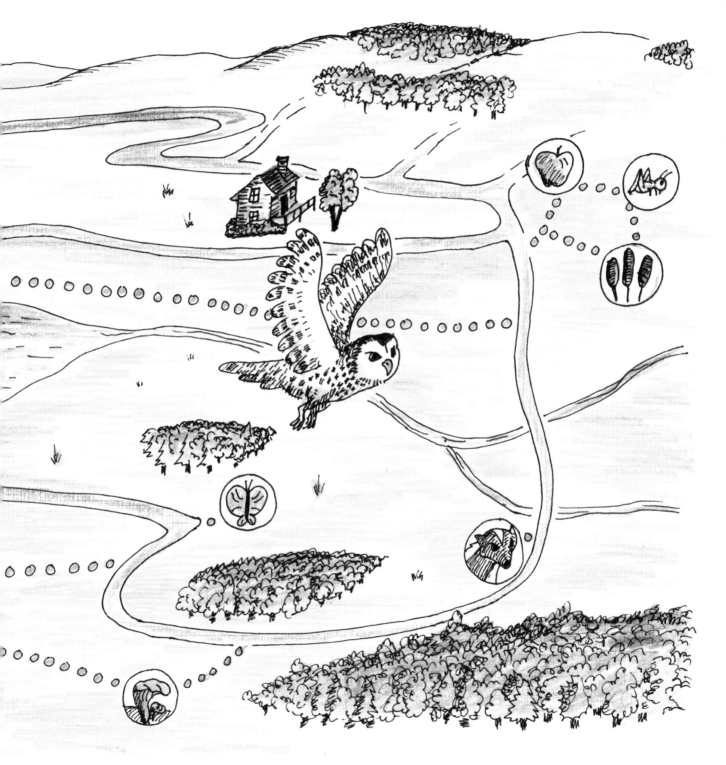

A Hole in the Fabric of Sound

1. Print and cut out the fortune teller/cootie catcher. Cut along the outermost square.

2. Fold in half and in half again. The folds will intersect the center.

3. Open out, turn over so the top is blank. Take one outer corner and pull its tip into the center, folding along the diagonal line to form a triangular flap. Repeat with the other 3 corners. Now you have a smaller square. Turn this smaller square over and repeat folding in the corners.

4. Turn over so you can see the numbered flaps. Fold the cootie catcher in half.

5. Slide thumb and index finger of right hand behind the 2 flaps on the right. Do the same on the left.

6. Push your fingers toward one another so the top point of each flap touches the others. You are ready to use your cootie catcher!

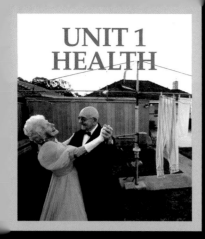

**UNIT 1
HEALTH**

**UNIT 2
COMPETITIONS**

**UNIT 4
ADVENTURE**

**UNIT 5
THE ENVIRONMENT**

**UNIT 6
STAGES IN LIFE**

**UNIT 7
WORK**

**UNIT 8
TECHNOLOGY**

**UNIT 9
LANGUAGE AND
LEARNING**

**UNIT 10
TRAVEL AND
VACATIONS**

**UNIT 11
HISTORY**

**UNIT 12
NATURE**

Contents

4

LISTENING	READING	CRITICAL THINKING	SPEAKING	WRITING
a health expert analyzes sleep a radio interview about long life	a quiz about how well you sleep an article about centenarians an article about measuring health and happiness	the main argument	a quiz your current life measuring happiness	text type: online advice writing skill: conjunctions (*and*, *or*, *so*, *because*, *but*)
three people talking about sports a reporter describing the rules of a competition	quotes by famous sports people an article about crazy competitions an article about female wrestlers in Bolivia	reading between the lines	guess the ambition explaining the rules of a competition your opinions about sports	text type: an ad writing skill: checking your writing
two people discussing the pros and cons of electric cars two documentaries about animals	an article about transportation in the future an article about dog sledding an article about the fate of the rickshaw in Kolkata	reading between the lines	transportation you use attitudes toward using animals to carry things/goods arguing for and against keeping rickshaws in Kolkata	a report about how people travel around town text type: notes and messages writing skill: writing in note form
an interview with a survival expert	an article about adventurers an article about a climbing accident	identifying opinion	asking about your past qualities needed for an expedition events you remember retelling a story	text type: a true story writing skill: using *-ly* adverbs in stories
a radio call-in show about recycling	an article about e-trash an article about the Greendex an article about the *Plastiki*, a boat made of plastic bottles an online order	close reading	opinions on recycling presenting a report an interview with an environmentalist	a report of a survey text type: emails writing skill: formal language
three people talking about their plans and intentions a news item about Mardis Gras	an article about how a couple changed their life an article about how Mardi Gras is celebrated around the world an article about a Masai rite of passage	identifying key information	life-changing decisions your favorite festival describing annual events	text type: a description writing skill: descriptive adjectives

	UNIT	GRAMMAR	VOCABULARY	REAL LIFE (FUNCTIONS)	PRONUNCIATION
UNIT 7	Work pages 81–92	prepositions of place and movement present perfect	jobs wordbuilding: suffixes office equipment *for* or *since* job satisfaction word focus: *make* or *do* job listings	a job interview	irregular past participles
	VIDEO: Butler school **page 90** ▶ REVIEW **page 92**				
UNIT 8	Technology pages 93–104	defining relative clauses zero and first conditional	the Internet wordbuilding: verb prefixes expedition equipment word focus: *have* technology verbs	asking how something works	intonation in conditional sentences linking
	VIDEO: Wind power **page 102** ▶ REVIEW **page 104**				
UNIT 9	Language and learning pages 105–116	present passive voice: *by* + agent past passive voice	education phrasal verbs wordbuilding: phrasal verbs	describing a process	stress in two-syllable words
	VIDEO: Disappearing voices **page 114** ▶ REVIEW **page 116**				
UNIT 10	Travel and vacations pages 117–128	past perfect subject and object questions *-ed / -ing* adjectives	vacation words (types of vacation accommodation, activities, travel items) vacation adjectives wordbuilding: dependent prepositions places in a city	direct and indirect questions	number of syllables /dʒə/
	VIDEO: Living in Venice **page 126** ▶ REVIEW **page 128**				
UNIT 11	History pages 129–140	*used to* reported speech	archeology wordbuilding: word roots *say* or *tell* word focus: *set*	giving a short presentation	/s/ or /z/ pausing
	VIDEO: The lost city of Machu Picchu **page 138** ▶ REVIEW **page 140**				
UNIT 12	Nature pages 141–152	*any-, every-, no-, some-* and *-thing, -where, -one, -body* second conditional *will / might*	classification of animals extreme weather society and economics wordbuilding: adjective + noun collocations	finding a solution	word stress
	VIDEO: Cambodia Animal Rescue **page 150** ▶ REVIEW **page 152**				

COMMUNICATION ACTIVITIES **page 153** ▶ GRAMMAR SUMMARY **page 156** ▶ AUDIOSCRIPTS **page 169**

LISTENING	READING	CRITICAL THINKING	SPEAKING	WRITING
a documentary about working as a photographer an interview with an engineer	workplace messages with instructions an article about the cost of new jobs to an area an article about modern-day cowboys	the author's opinion	giving directions describing past experiences your opinion of a job	text type: a resume writing skill: action verbs for resumes
a science program about a new invention	an explorer's blog an article about biomimetics	supporting the main argument	problems that inventions solved inventing a new robot planning an expedition using nature to improve designs	text type: a paragraph writing skills: connecting words; topic and supporting sentences
a radio documentary about learning Kung Fu in China	an article about the history of writing an article about saving languages	fact or opinion	adult education a general-knowledge quiz the author's opinion	a general-knowledge quiz text type: forms writing skill: providing the correct information
two conversations about problems while on vacation an interview with a National Geographic tour guide	an article about tipping in other countries an article about the tunnels in Paris	reading between the lines	a vacation or trip you remember planning the vacation of a lifetime a tourist website	a tourist website text type: a formal letter writing skill: formal expressions
an interview with an archaeologist	an article about moments in space history a biography of Jane Goodall	relevance	items for a time capsule how we used to live moments in history reporting an interview an interview for a biography	text type: a biography writing skill: punctuation in direct speech
a documentary about a photographer	an article about storm chasers a profile on Greenland	close reading	promoting your region planning for every possibility predicting your country's future	text type: a press release writing skill: using bullet points

Life around the world

Unit 4 Alaskan ice climbing

How to climb a wall of ice.

Unit 2 Cheese rolling

The ancient tradition of cheese rolling in an English town.

Unit 7 Butler school

Find out how to become a butler.

Unit 9 Disappearing voices

A project to record the last speakers of disappearing languages.

Unit 3 Indian railroads

Learn more about the Indian railroad system.

Alaska

UK

USA

West Coast

Italy

India

Cambodia

Trinidad & Tobago

Peru

Australia

Unit 5 Coastal cleanup

A global effort to clean up the world's beaches.

Unit 8 Wind power

How the wind turbines of Spirit Lake save the schools energy and money.

Unit 6 Steel drums

Steel band music is an important part of this Caribbean island's culture.

Unit 1 Slow food

A city that is enjoying itself—taking life slowly.

Unit 11 The lost city of Machu Picchu

The impact of tourism on the Inca city of Machu Picchu.

Unit 10 Living in Venice

Learn what it's like to live in Venice.

Unit 12 Cambodia Animal Rescue

Rescuing victims of illegal animal poaching in Cambodia.

Unit 1 Health

Dance practice, Australia
Photo by Brendan McCarthy

FEATURES

1 Look at the two people in the photo and answer the questions.

1 Why do you think they are happy?
2 Do you think they are married? Why?
3 What are they doing?
4 Do you think dancing is good for just their physical health or their mental health too? Why?

2 Work in pairs. Look at these activities. Tell your partner which activities you often do. Why do you do them?

> bike through the countryside do crossword puzzles
> go for a long walk work long hours read a book
> play computer games run marathons watch TV

> I often bike through the countryside because it's good for my health.

3 Think about other activities you do in your free time that are good for your physical or mental health. Tell your partner.

1a How well do you sleep?

Reading and speaking

1 Do you feel tired today? Why? / Why not?

2 Take the quiz below about sleep and make a note of your answers.

Listening

3 🔊 **1** Listen to a health expert talking about the quiz. Mark the characteristics that are true for each answer.

People with mostly A answers:
1 You have regular routines.
2 You are hardly ever tired.

People with mostly B answers:
3 You wake up once or twice a night.
4 You need more sleep than other people.

People with mostly C answers:
5 You regularly work in the evening.
6 You don't like sports.

4 Work in pairs. Compare your answers in the quiz. Which type of person are you? Do you need to change your lifestyle?

Grammar simple present and adverbs of frequency

5 Match the sentences from the quiz (1–2) with the uses of the simple present tense (a–b).

1 Before bedtime, I often do some work.
2 I'm never tired at work.

a to talk about things that are always true
b to talk about habits and routines

> ► **SIMPLE PRESENT**
>
> I/you/we/they sleep
> he/she/it sleeps
>
> I/you/we/they don't sleep
> he/she/it doesn't sleep
>
> Do you sleep ...?
> Does he sleep ...?
>
> For more information and practice, see page 156.

How well do you sleep?

Question: **1** 2 3 4 5 6

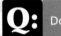
Q: Do you often feel tired?

A No, I don't often feel tired.
B I sometimes feel tired after a long day at work.
C All the time! I'm always ready for bed.

Question: 1 **2** 3 4 5 6

Q: How many hours a night do you sleep?

A between seven and eight
B more than nine
C fewer than six

Question: 1 2 **3** 4 5 6

Q: Before bedtime, I often ...

A watch TV or read a book.
B do some exercise.
C do some work.

Question: 1 2 3 **4** 5 6

Q: On weekends, I ...

A usually sleep the same amount as any other day.
B sometimes sleep for an hour or two extra.
C always sleep until noon! I never get up early.

Question: 1 2 3 4 **5** 6

Q: How often do you wake up in the middle of the night?

A I never wake up before morning.
B I rarely wake up more than once, and I usually fall asleep again quite quickly.
C Two or three times a night.

Question: 1 2 3 4 5 **6**

Q: Are you often sleepy during the day?

A No, I'm never tired at work.
B Sometimes, so I take a nap after lunch.
C Always, because I work long hours.

fall asleep /ˈfɔl əˈslip/ start sleeping
take a nap /ˈteɪk ə ˈnæp/ sleep for a short time during the day

6 Complete the article about sleep with the simple present form of the verbs.

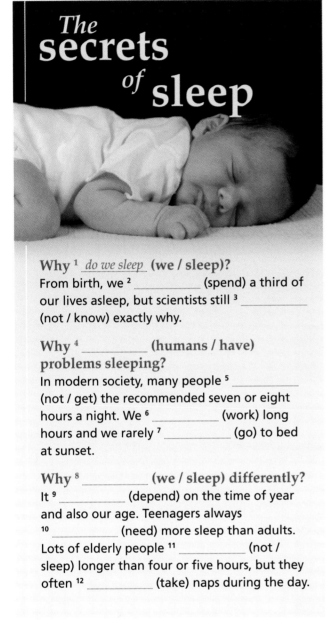

The secrets of sleep

Why [1] *do we sleep* (we / sleep)?
From birth, we [2] _____ (spend) a third of
our lives asleep, but scientists still [3] _____
(not / know) exactly why.

Why [4] _____ (humans / have)
problems sleeping?
In modern society, many people [5] _____
(not / get) the recommended seven or eight
hours a night. We [6] _____ (work) long
hours and we rarely [7] _____ (go) to bed
at sunset.

Why [8] _____ (we / sleep) differently?
It [9] _____ (depend) on the time of year
and also our age. Teenagers always
[10] _____ (need) more sleep than adults.
Lots of elderly people [11] _____ (not /
sleep) longer than four or five hours, but they
often [12] _____ (take) naps during the day.

7 **Pronunciation** /s/, /z/, or /ɪz/

🎧 **2** Listen to the ending of these verbs and write
/s/, /z/ or /ɪz/ for the endings. Check your answers
with your teacher.

1	feels */z/*	3	watches	5	goes
2	needs	4	sleeps	6	dances

8 Discuss the questions.

1 What time do people normally get up in your
country? How late do they stay up? Do they
ever take a nap in the afternoon?
2 How does this change during summer and
winter?

9 Complete this table with adverbs of frequency
from the quiz in Exercise 2.

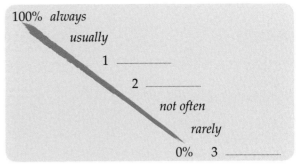

100% *always*
usually
1 _____
2 _____
not often
rarely
0% 3 _____

10 Look at the position of the adverbs and expressions
of frequency in the example sentences below.
Choose the correct options to complete the rules
(1–2).

▶ **ADVERBS and EXPRESSIONS OF FREQUENCY**

She's **usually** late for work.
I **often** wake up at seven.
How **often** do you wake up at night?
She wakes up **two or three times a night**.
In the winter, we sleep longer.

For more information and practice, see page 156.

1 An adverb of frequency goes *after / before* the
verb *to be* but *after / before* the main verb.
2 An expression of frequency usually goes
at the beginning / in the middle or at the end of
a sentence.

11 Work in pairs. Use adverbs or expressions of
frequency to ask or answer questions about these
activities.

exercise	read a book
eat out in restaurants	be in a bad mood
do gardening	go on vacation
play board games	be busy on the weekend
check your email	be stressed at work

How often do you exercise?

Two or three times a week.

Speaking and writing

12 Work in groups. Prepare a *How healthy are you?*
quiz for another group. Start each question with
How often…? Are you often…? or *Do you ever…?*
and offer three choices of answer (A, B, or C).

13 When you are ready, join another group and give
and take your quizzes. Compare your answers. Do
you think the other group is very healthy?

1b The secrets of long life

Reading

1 How old is the oldest person you know? How healthy is his or her lifestyle?

2 Read the article and answer the questions.

 1 Why are the people of Okinawa famous?

 2 What are the reasons for their good health?

3 Which of the reasons for good health in the article are true for your life? Tell your partner.

Vocabulary *do, go, or play*

4 Complete the table with activities from the article in Exercise 2.

do	go	play
	fishing	

5 Add these activities to the table in Exercise 4. Use your dictionary to help you, if necessary. Then think of one more activity for each verb.

cards	hiking	homework	nothing	running	shopping
tennis	the piano	yoga	soccer	karate	surfing

▶ **WORDBUILDING verb + noun collocations**

We can only use certain nouns with certain verbs. These are called collocations. For example, *go fishing* but not *do fishing* or *play fishing*.

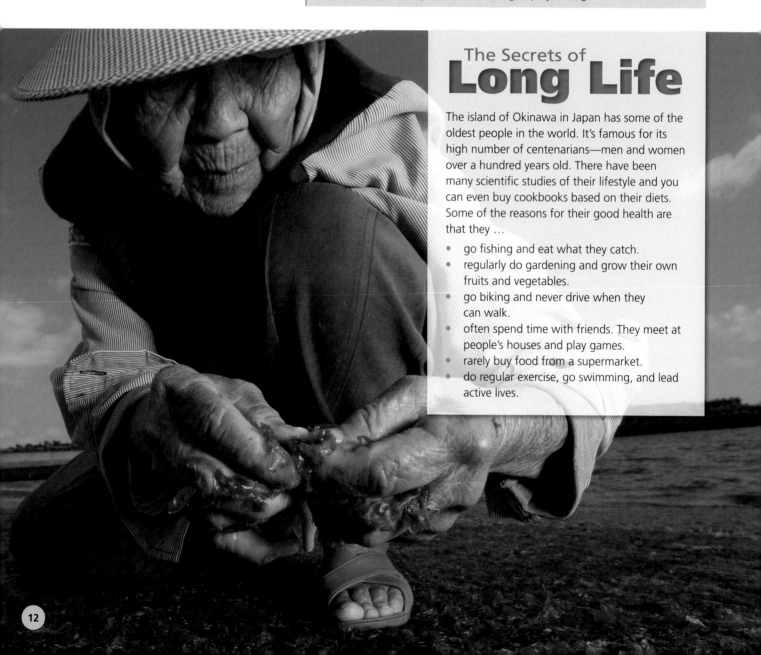

The Secrets of
Long Life

The island of Okinawa in Japan has some of the oldest people in the world. It's famous for its high number of centenarians—men and women over a hundred years old. There have been many scientific studies of their lifestyle and you can even buy cookbooks based on their diets. Some of the reasons for their good health are that they …

- go fishing and eat what they catch.
- regularly do gardening and grow their own fruits and vegetables.
- go biking and never drive when they can walk.
- often spend time with friends. They meet at people's houses and play games.
- rarely buy food from a supermarket.
- do regular exercise, go swimming, and lead active lives.

Listening

6 🔊 **3** Listen to a radio interview and answer the questions.

1 What does David McLain want to know?
2 Why is he in Sardinia?

7 🔊 **3** Listen again and mark the sentences true (T) or false (F).

1 David McLain is traveling to different countries.
2 He's in a studio.
3 Men don't live as long as women on Sardinia.
4 Sardinian families often eat together.
5 David thinks Sardinia is less stressful than other countries.
6 Younger people are eating more unhealthy food and they aren't getting much exercise.

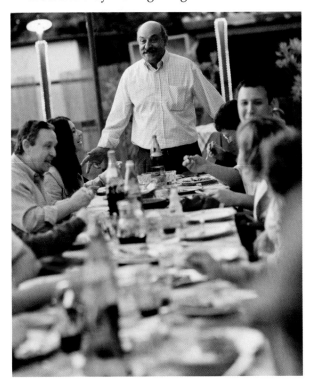

Grammar simple present and present continuous

8 Look at the five sentences below. Which two use the simple present tense? Why?

1 He's currently traveling to places and regions.
2 He's speaking to us right now on the phone.
3 Men live as long as women.
4 Every Sunday the whole family meets and they eat a huge meal together.
5 Young people are moving to the city so they are doing less exercise because of their lifestyle.

9 The three other sentences in Exercise 8 use the present continuous tense. How do you form that tense? Match the three sentences to the uses (a–c).

a to talk about things happening at the moment of speaking
b to talk about things happening around now but not necessarily at the moment of speaking
c to talk about current trends and changing situations

> ▶ **PRESENT CONTINUOUS**
>
> I am speaking
> you/we/they are speaking
> he/she/it is speaking
>
> I'm not traveling
> you/we/they aren't traveling
> he/she/it isn't traveling
>
> Am I moving?
> Are you/we/they moving?
> Is he/she/it moving?
>
> For more information and practice, see page 156.

10 Complete the sentences with the simple present or present continuous form of these verbs.

check	not / do	not / eat	go
~~learn~~	play	read	spend

1 We *'re learning* a new language now.
2 We often _____ time together.
3 Give me a minute! I _____ my email.
4 How often _____ you _____ to the gym?
5 Right now I _____ a really interesting book.
6 Currently, a friend of mine _____ any candy and he says he feels healthier.
7 I'm nearly eighty but I _____ any exercise!
8 Which video game _____ you _____? It looks like fun.

Speaking

11 Work in pairs. Take turns asking and answering the questions. Use the simple present and present continuous tense in your answers.

1 What's your typical working day like? Are you working on anything new right now?
2 How do you spend your free time? Are you getting much exercise?
3 Do you often read novels? Are you reading anything interesting at the moment?
4 Where do you normally go on vacation? Are you planning any vacations this year?
5 Do you speak any other languages? Are you learning any new languages?

1c Health and happiness

Speaking

1 Which of these things make you feel happy? Order them from 1 to 5 (1 = most happy). Compare with your partner.

- Sleeping for a long time
- Having money
- Relaxing on vacation
- Going out with friends
- Getting exercise

Critical thinking **the main argument**

2 Read the article on page 15. Which of the sentences (1–3) is the best summary of the main argument?

1 Happiness improves our health.
2 Denmark is the happiest country in the world.
3 There are different ways to measure happiness.

Reading

3 Choose the correct answer (a–c).

1 The King of Bhutan measured his country's development by...
 a money b health c happiness

2 Which is easier to measure?
 a happiness b health
 c sickness and bad health

3 In one survey, Iceland was number one for its...
 a money b health c happiness

4 How did researchers measure happiness in 155 countries?
 a with answers to questions
 b by looking at people's faces
 c by measuring the number of sick people

5 What do visitors to Krikortz's website click on?
 a questions b faces c numbers

6 How many categories does Krikortz have for measuring happiness?
 a three b five c seven

7 What color are the lights on the building when Stockholm is happy?
 a red b green c purple

Word focus *feel*

4 Look at the sentences (1–4) from the article. Match the word *feel* in each sentence with one of its uses (a–d).

1 It's also easy to measure how many people feel ill or unhealthy in a country.
2 Denmark feels happier than other countries.
3 Krikortz feels that there are other ways of measuring happiness.
4 The colored lights are also useful if you feel like visiting the city.

a to give an opinion
b to talk about an emotion
c to talk about physical illness
d to talk about wanting something or wanting to do something

5 Match the questions (1–3) to the responses (a–c).

1 How do you feel today?
2 What do you feel about Krikortz's project?
3 Do you feel like going for coffee?

a Fine, thanks. How about you?
b Yes, I'd like to.
c I'm not sure. It's interesting, I suppose.

6 Work in pairs. Take turns asking the questions in Exercise 5. Answer with your own words.

Speaking

7 Work in groups. Discuss the questions.

1 How happy do you think your country is? Give reasons for your answer.
2 How much do you agree with the opinion that "happy people don't get sick"?
3 What do you think are useful categories for measuring happiness? Which are not very useful?

8 Work in the same group. Make a list of five categories for measuring happiness (e.g., money, sleep). Then have everyone in the group give a score for each category (1 = very happy, 2 = happy, 3 = OK, 4 = not very happy). How happy is your group? Present your categories and result to the class.

measuring
HEALTH
AND
HAPPINESS

The small country of Bhutan in the Himalayan mountains is over 1,000 years old. In the past, it was a poor country and not many people visited it. But nowadays, it is becoming more and more popular with tourists. Medicine and health are improving and the economy is growing. King Jigme Singye Wangchuck, the king of Bhutan until 2006, talked about his country's "Gross National Happiness" because he thought happiness was the way to measure his country's development.

But how do you measure happiness? Perhaps health is the best way because, as a famous doctor once said, "Happy people generally don't get sick." It's also easy to measure how many people feel ill or unhealthy in a country. For example, one survey says that Iceland is the healthiest country in the world because men and women live a long time there, the air is very clean, and there are more doctors available per person than anywhere else in the world.

However, in a survey of the happiest countries in the world, Iceland was not near the top. The questions in this survey included: How much do you earn? How healthy are you? How safe do you feel? After visiting 155 different countries, the researchers decided that Denmark feels happier than other countries.

So does happiness equal money and good health? Not according to the artist Erik Krikortz. He feels that there are other ways of measuring happiness. Krikortz has a website where visitors click on different happy or sad faces to comment on how well they sleep, their family and friends, their level of stress, their inspiration, and their physical activity. When you finish, his website adds the results for each area and gives you a final result for your happiness.

In his home city of Stockholm, Krikortz also shows the results of his survey as colored lights on the side of a large building in the city. For example, red means the people of Stockholm are very happy, green is OK, and purple means many people are sad. "A lot of people look at the building every day and see how 'we' are," Krikortz says. The colored lights are also useful if you feel like visiting the city. If the lights are red, you know the locals are feeling happy!

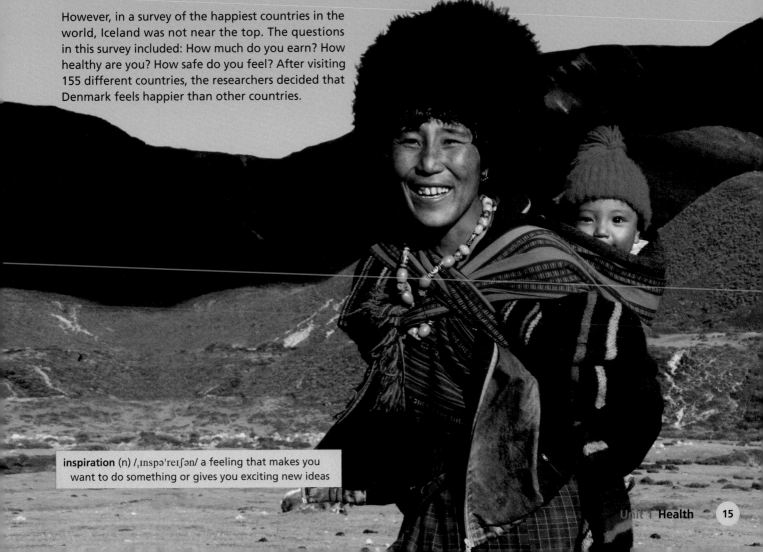

inspiration (n) /ˌɪnspəˈreɪʃən/ a feeling that makes you want to do something or gives you exciting new ideas

1d At the doctor's

Vocabulary medical problems

1 Match the people (1–8) with their medical problems (a–h).

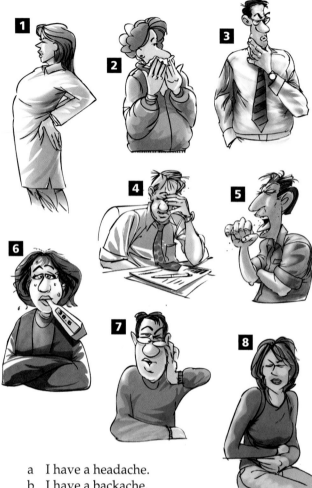

a I have a headache.
b I have a backache.
c I have a runny nose.
d I have an earache.
e I have a stomachache.
f I have a fever.
g I have a sore throat.
h I have a bad cough.

Pronunciation sound and spelling

2 🔊 4 Many English words have the same vowel sounds but different spellings. Match the words with the same vowel sounds. Then listen and check.

1	head	wake
2	throat	off
3	cough	note
4	ache	here
5	ear	bed

3 What do you do when you have the medical problems in Exercise 1? Choose an answer and compare with your partner.

1 I go to bed.
2 I take medicine.
3 I go to the doctor.

Real life talking about sickness

4 🔊 5 Listen to a conversation at a drugstore (1) and a doctor's office (2). Match the person's medical problems and the medical advice they receive with each conversation. One item in each list is not mentioned.

Medical problem	Medical advice
sore throat *1*	take this medicine twice a day *1*
bad cough	go to bed
runny nose	drink hot water with honey
earache	and lemon
feel sick	take one pill twice a day
fever	buy a box of tissues
	drink lots of water

5 🔊 5 Listen again and complete the sentences. Then match them with the correct section in the box.

1 I _____ a sore throat.
2 You _____ take this medicine.
3 It's _____ _____ a sore throat.
4 You _____ a box of tissues.
5 If you still feel sick in a few days, see a _____.
6 Let me have a _____.
7 Do you _____ sick?
8 Let me check your _____.

> ▶ **TALKING ABOUT SICKNESS**
>
> **Asking and talking about sickness**
> I don't feel very well. / I feel sick/ill.
> Do you have a fever?
> How do you feel?
>
> **Giving advice**
> Try drinking hot water with lemon.
> You need to take one of these.
> Drink lots of water.

6 Work in pairs to practice this conversation. Then change roles and repeat it.

Student A: You have a medical problem. (Choose one from Exercise 1.)

Student B: You are a pharmacist. Ask how Student A feels and give advice.

1e Online medical advice

Writing online advice

1 Many people look for medical advice on the Internet before they visit their doctor. Do you think this is a good idea? Why?

2 Look at the advice forum on a website. Answer the questions.

 1 What medical problem does each person have?
 2 Do you think the doctor gives them good advice?
 3 Can you think of any more advice for each person?

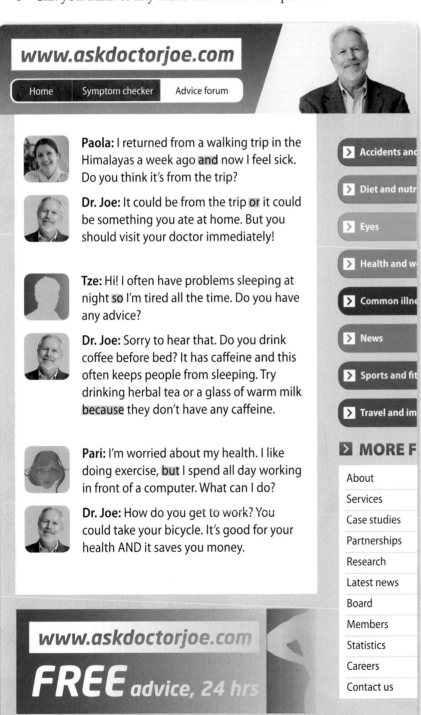

www.askdoctorjoe.com

Home Symptom checker Advice forum

Paola: I returned from a walking trip in the Himalayas a week ago and now I feel sick. Do you think it's from the trip?

Dr. Joe: It could be from the trip or it could be something you ate at home. But you should visit your doctor immediately!

Tze: Hi! I often have problems sleeping at night so I'm tired all the time. Do you have any advice?

Dr. Joe: Sorry to hear that. Do you drink coffee before bed? It has caffeine and this often keeps people from sleeping. Try drinking herbal tea or a glass of warm milk because they don't have any caffeine.

Pari: I'm worried about my health. I like doing exercise, but I spend all day working in front of a computer. What can I do?

Dr. Joe: How do you get to work? You could take your bicycle. It's good for your health AND it saves you money.

> Accidents and
> Diet and nutr
> Eyes
> Health and w
> Common illne
> News
> Sports and fit
> Travel and im

> **MORE F**

About
Services
Case studies
Partnerships
Research
Latest news
Board
Members
Statistics
Careers
Contact us

www.askdoctorjoe.com
FREE advice, 24 hrs

3 Writing skill conjunctions (*and, or, so, because, but*)

a Look at the highlighted conjunctions in Exercise 2 and complete the rules with them.

 1 We use *and* to connect two words or parts of a sentence.
 2 We use _____ to introduce an idea that is different.
 3 We use _____ to say "with the result that."
 4 We use _____ to explain the reason.
 5 We use _____ to connect an alternative word or idea.

b Complete the sentences with the conjunctions in Exercise 3a.

 1 You need to do more exercise _____ eat healthy food.
 2 Jogging is healthy, _____ eating chocolate is nicer!
 3 You could try biking _____ walk if you don't have a bike.
 4 Fruits and vegetables are good for you _____ they are full of vitamins.
 5 Fruit and vegetables are full of vitamins, _____ they are good for you.

4 Imagine you want advice from the forum. Choose a medical problem. Then write a message to Dr. Joe and ask for advice.

5 Exchange your message with your partner. Imagine you are Dr. Joe. Write a reply with two or three pieces of good advice. Remember to use conjunctions.

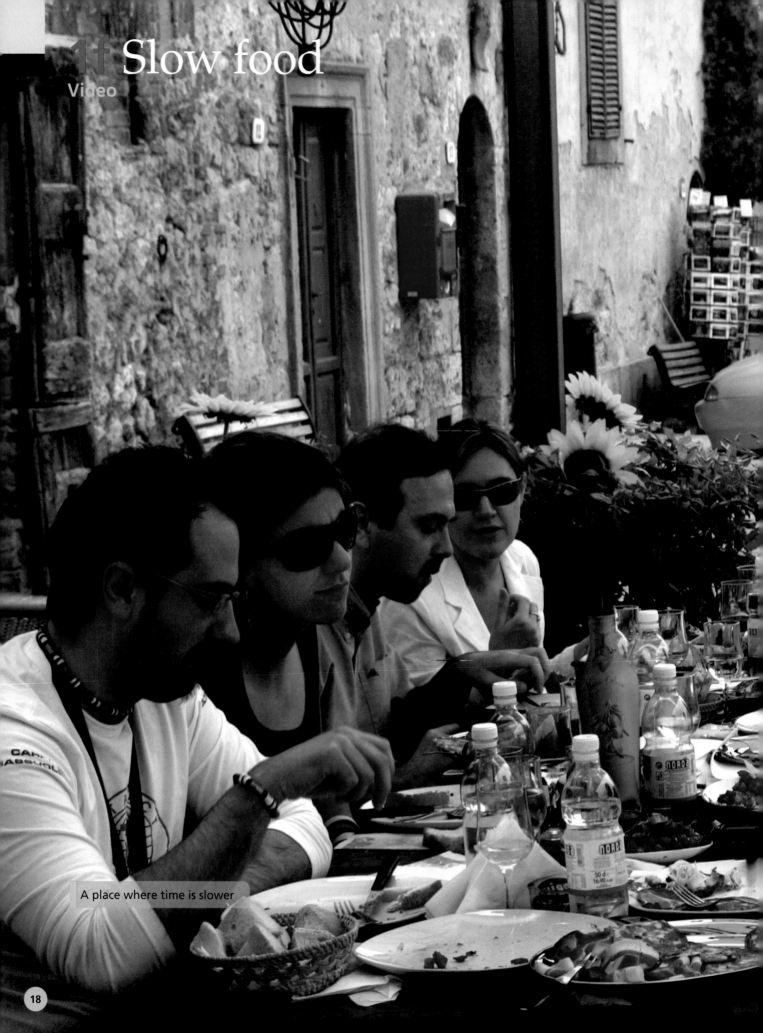

Slow food

A place where time is slower

Before you watch

1 Work in groups. Look at the title of the video and the photo. Discuss the questions.

1. What do you think "slow food" is?
2. How do you think the people in the photo feel?
3. What do you think the photo caption means?
4. What do you think the video is about?

2 Mark the things you think will be in this video.

> countryside
> farmers and people making food
> fast food restaurants
> lots of cars
> a modern city
> relaxed people enjoying food

While you watch

3 Watch the video and check your ideas from Exercise 2.

4 Mark the sentences true (T) or false (F).

1. Chianti is a region in Spain.
2. Four thousand people live in Greve.
3. Greve is part of the Slow Cities League.
4. Salvatore Toscano runs an American-style restaurant.
5. His restaurant is in Greve.
6. Farmers make pecorino cheese from cows' milk.
7. Pecorino cheese is not very popular nowadays.
8. Greve wants to escape from the modern world.

5 Watch the video again. Answer these questions.

1. What is Greve famous for?

2. How many cities are in the Slow Cities League?

3. What is the purpose of the Slow Cities League?

4. What does the Slow Food movement encourage?

5. Why is pecorino cheese popular again?

6. What can you find everywhere in the world?

die out (v) /ˈdaɪ ˈaʊt/ disappear
mayor (n) /ˈmeɪər/ the head of the administration of a town
vineyard (n) /ˈvɪnjərd/ a place where grapes grow
worldwide (adv) /ˈwɜːldˈwaɪd/ all over the world

After you watch

6 Match the people (1–4) with what they say (a–d).

1. the narrator
2. Salvatore Toscano
3. Greve's mayor
4. the cheesemaker

a. Our aim is to keep Greve the same. We want to keep Greve and all the other slow cities special.
b. It's about taking more time so you are more calm and relaxed.
c. In the mountains of Pistoia, in northern Tuscany, farmers produce pecorino cheese.
d. Not everyone knows about our product. But now the Slow Food movement means people know about us.

7 **Roleplay a conversation with Salvatore Toscano**

Work in pairs.

Student A: You are Salvatore Toscano. Read the questions below and make notes about yourself. Then ask your customer about his life.

- Why do you like Greve?
- What is it like living in Greve?
- Do you enjoy your job?

Student B: You are a customer in Salvatore Toscano's restaurant. You come from a large, busy city. Read the questions below and make notes about yourself. Then ask Salvatore about his life in Greve.

- What's your name?
- What's your job?
- Do you like visiting Greve? Why?
- Do you want to live somewhere like Greve?

Act out the conversation. Compare your lives. Then change roles and repeat the conversation.

8 Read what the man says at the end of the video and answer the questions.

From Singapore to Macao, in New York, in Rome, you always find the same pizza, the same hamburgers. Slow food doesn't want this.

1. Do you agree?
2. Do you think slow food is a good idea?

9 Work in pairs. Discuss these questions.

1. Would you like to live in Greve? Why?

2. Do you live a quiet life or do you live in the fast lane? In what ways?

UNIT 1 REVIEW

Grammar

1 Work in pairs. Look at the photo. Where are the man and the elephant? What are they doing?

2 Choose the correct forms to complete the text about the man in Exercise 1.

Every day, Nazroo ¹ *drives / is driving* elephants for a living, but, as you can see here, ² *he takes / he's taking* his favorite elephant, Rajan, for a swim. Sometimes they ³ *like / are liking* to relax this way after a hard day. I was surprised because Rajan ⁴ *doesn't seem / isn't seeming* worried about being in the water. I guess it feels good after a long, hot day at work.

3 Work in pairs. How often do you go swimming? How do you like to relax?

I CAN	
talk about regular actions and events using the simple present	☐
describe actions in progress (now or around now) using the present continuous	☐
ask and answer questions with *How often...?*	☐

Vocabulary

4 Which words can follow the verb in CAPITAL letters? Delete the incorrect word.

1 FEEL tired, happy, ~~ache~~, sick
2 DO exercise, housework, relaxing, yoga
3 PLAY golf, swimming, games, tennis
4 GO marathon, racing, hiking, driving

5 Work in pairs. How do you feel about your new English course? Do you feel worried about anything? (Tell your teacher if you do.)

I CAN	
talk about leisure activities	☐
say how I feel	☐

Real life

6 Choose the correct words to complete the conversation between two friends.

A: ¹ *How do / Do* you feel?
B: Not very ² *well / sick*. I've got a ³ *pain / sore* throat.
A: ⁴ *Do you feel / Do you have* a fever?
B: I don't know. I feel a little hot.
A: ⁵ *Try / You need* drinking some honey and lemon in hot water.
B: Good idea.
A: But ⁶ *you should / it's a good idea* also see your doctor.

7 Work in pairs. Practice two similar conversations.

Conversation 1:
Student A has a headache. Student B gives advice.

Conversation 2:
Student B has a stomachache. Student A gives advice.

I CAN	
talk about feeling sick	☐
give advice	☐

Speaking

8 Complete these questions to ask someone about their everyday habits and interests.

1 Do you often play...?
2 How often do you go...?
3 Do you ever...?
4 What are you *-ing*...?
5 Why do you...?

9 Work in pairs. Ask and answer your questions from Exercise 8.

Unit 2 Competitions

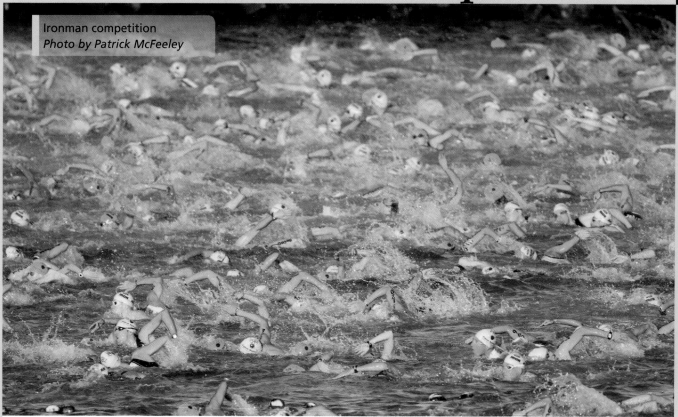

Ironman competition
Photo by Patrick McFeeley

FEATURES

1 Look at the photo.

1 What kind of competition is it? Do you like this kind of sport?
2 What other sports do you think the Ironman competition includes?
3 Why do you think both competitors and spectators like these types of competition?

2 Work in groups. Discuss the questions.

1 Do you prefer to be a competitor or a spectator?

2 Are you competitive? What kinds of competition do you compete in?

> ▶ **WORDBUILDING word forms**
>
> When you learn a new word, try to learn its other forms.
> For example:
> *compete (verb) – competitive (adjective) – competition (noun) – competitor (noun/person)*

2a Competitive sports

Reading and speaking

1 Read the quotes by famous athletes (1–6) and discuss the questions.

1 How are the six quotes similar?
2 Are all these sports popular in your country? What other sports are popular?

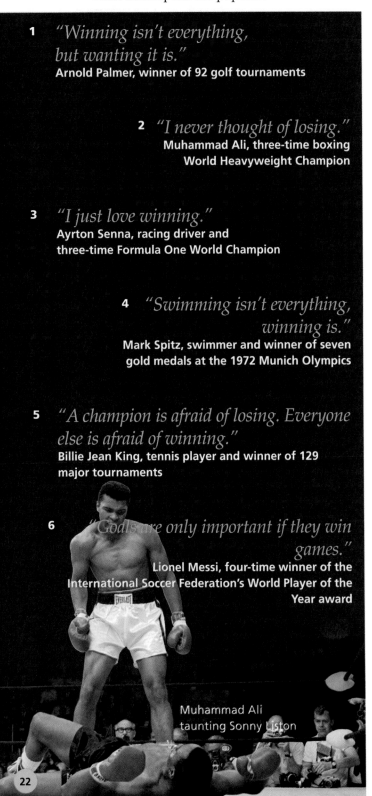

1 *"Winning isn't everything, but wanting it is."*
Arnold Palmer, winner of 92 golf tournaments

2 *"I never thought of losing."*
Muhammad Ali, three-time boxing World Heavyweight Champion

3 *"I just love winning."*
Ayrton Senna, racing driver and three-time Formula One World Champion

4 *"Swimming isn't everything, winning is."*
Mark Spitz, swimmer and winner of seven gold medals at the 1972 Munich Olympics

5 *"A champion is afraid of losing. Everyone else is afraid of winning."*
Billie Jean King, tennis player and winner of 129 major tournaments

6 *"Goals are only important if they win games."*
Lionel Messi, four-time winner of the International Soccer Federation's World Player of the Year award

Muhammad Ali taunting Sonny Liston

Grammar verb + -*ing* forms

2 Underline the verb + -*ing* forms in the quotes in Exercise 1. Which of the underlined forms:

1 are the subject of the sentence?
2 come after verbs (e.g., *like, dislike*) as an object?
3 come after a preposition?

> **▶ VERB + -*ING* FORMS**
> • Subject of the sentence: ***Swimming*** *is good for you.*
> • After verbs (often *like, love, enjoy, prefer, don't like, hate, can't stand*) as an object: *I like **playing** tennis.*
> • After a preposition: *I'm good at **learning** languages.*
>
> For more information and practice, see page 156.

3 Look at the grammar box. Then correct the conversation between two friends. Change eight verbs into the -*ing* form.

A: The *Tour de France* is on TV tonight! I love ~~watch~~ it. *watching*

B: Oh no! Cycle is so boring.

A: I really enjoy see the cyclists on the mountains.

B: But it lasts for days! I hate wait for the end.

A: Today is the final day. It's exciting.

B: Sit in front of the TV is not exciting. I prefer do something. Hey! Are you good at play tennis? We could play this afternoon.

A: But I want to watch this.

B: Are you afraid of lose against me or something?

4 Pronunciation /ŋ/

a 🔊 6 Listen to the words and underline the part of the word with the /ŋ/ sound. What is the most common spelling with the /ŋ/ sound? Check your answers with your teacher.

1 watching 6 losing
2 language 7 winning
3 waiting 8 English
4 thinks 9 competing
5 cycling 10 thanks

b Read the conversation in Exercise 3 aloud. Pay attention to the /ŋ/ sound in the verb + -*ing* forms.

5 Work in pairs. Ask questions to complete the sentences for both of you with the names of any sports or leisure activities.

1 I love watching but my partner doesn't.
2 My partner likes but I prefer
3 I think is boring but my partner loves it!
4 We both enjoy but we can't stand
5 I'm good at but my partner isn't.

> Do you like -ing?

> What do you like -ing?

> Are you good at …?

Vocabulary and listening
talking about sports

6 Write about the six sports in Exercise 1. Use these words to say where you play each sport and what you need. Then think of two other sports you like and describe them in a similar way.

where you play	what you need
court course field pool ring track	ball bat car club gloves goggles net racquet

Example:
You play golf on a golf course. You need a golf club and a ball.

7 Work in pairs. Take turns describing a sport for your partner to guess.

> The two teams play on a field. They use a bat and a ball.

> Baseball

8 🔊 **7** Listen to three people talking about sports. Make notes in the table.

	Which sport are they discussing?	Do they like or dislike it?	Why do they do it?
Maria			
Paulo			
Kali			

coach (n) /kəʊtʃ/ a person who trains sports people

Grammar *like + -ing / 'd like to*

9 Read sentences a and b. Answer the questions (1–2).

a I like playing tennis so much that I'm working with a tennis coach.
b One day I would like to become a professional player.

1 Which sentence describes a future ambition?
2 Which sentence is true now and talks about a general feeling?

> ▶ **'D LIKE TO**
>
> **would ('d) like + to + infinitive**
> *She'd like to play tennis later.*
> *He'd love to become a boxer one day.*
> *They wouldn't like to judge the competition.*
>
> For more information and practice, see page 157.

10 Make sentences about each pair of pictures using these words. Use *like + -ing* and *'d like to*.

1 love / drive / formula one cars

2 like / play golf

3 not like / lose

Speaking

11 Write down three ambitions for the future, one true and two false. Read them to each other and guess which are false.

> I'd like to become a rock star.

> No, you wouldn't.

> I'd like to jump from an airplane with a parachute.

> Yes, you would.

2b Crazy competitions!

Reading

1 Look at the photos of competitions (A–C) in the article. Which do you think is a fight, a game, and a race?

2 Read about the competitions and check your predictions in Exercise 1.

3 Match the sentences (1–7) with the competitions (A–C).

1 Competitors run from one place to another.
2 You can win money.
3 The competition is once a year.,
4 You use some kind of vehicle.,
5 The rules are the same as for a real sport.
6 It's for teams.,
7 There is a time limit.

4 Which of these sports would you like to play or watch? Do you have crazy competitions in your country?

Crazy competitions!

Ross McDermott and Andrew Owen travel around the United States going to different festivals. They blog about their experiences on *The American Festivals Project*. Many of the festivals are also competitions.

A The Idiotarod -

The Idiotarod is an annual race in New York City. Each team must have five people and a shopping cart. They can decorate their carts but they can't change the wheels. All the teams have to start and finish at the same place but they don't have to run on the same roads. The teams can choose their route but the members of each team must reach the finish line together. And they can't finish without the cart!

B Mud Bowl Championship - - - - - - -

Mud Bowl football is similar to normal American football. The game is shorter but there are two teams and a referee. The winner is the team with the most points at the end of sixty minutes. The only real difference is that the players have to play in a foot and a half of mud!

C Combine Harvester Fight - - - - - - -

Combine harvesters are normally found on farms, but for one day every summer in the small town of Hillsdale, Michigan, farmers compete against each other for a prize of $1,500. For three hours, the giant machines have to fight until only one combine harvester is still moving.

Grammar modal verbs for rules

5 Look at the sentence from the article about the Idiotarod. What does the highlighted modal verb mean? Choose the correct answer (1–4).

Each team must have five people and a shopping cart.

1 It is necessary and an obligation.
2 It is allowed according to the rules.
3 It is not necessary (but allowed).
4 It is not allowed.

6 Find five more modal verbs in the article about the Idiotarod. Match them to the meanings (1–4) in Exercise 5.

> ▶ **MODAL VERBS FOR RULES**
>
> • Necessary and an obligation: *must, have to*
> • Allowed: *can*
> • Not necessary (but allowed): *don't have to*
> • Not allowed: *mustn't, can't*
>
> For more information and practice, see page 157.

7 Choose the correct options to complete the sentences.

1 You *have to / don't have to* practice to become a good competitor.
2 Athletes *don't have to / can't* argue with the judge's decision.
3 Competitors *can't / must* know all the rules.
4 The members of a team *have to / don't have to* work well together.
5 Teams *have to / can* compete against each other.
6 Teams *can / don't have to* score every point to win the game.

Listening

8 🔊 **8** Listen to the description of the Woolly Worm Race and answer the questions.

1 What does the speaker describe?
2 How often is the competition?
3 How old do you have to be to enter?
4 Do you have to bring your own woolly worm?
5 Can you touch your worm during the race?
6 What is the prize for the winner?

Vocabulary competitions

9 Complete the pairs of sentences with the correct words. Use a dictionary to help you.

1 (win / beat)
My woolly worm _____ yours! I _____!
2 (score / win)
How many games did you _____?
How many goals did you _____?
3 (fans / spectators)
We're your biggest _____! We come to every game.
There were about 50,000 _____ at the game.
4 (referee / judge)
The _____ sent the player off the court.
One _____ gave the ice skater a perfect score.
5 (trophy / prize)
The President gave the winning team the silver _____.
The _____ for the winner is $500.

Speaking

10 Work in groups. Imagine that you want to have a new annual competition for your town. Follow these steps.

1 Decide on a crazy competition.
2 List the rules and discuss the details.
3 Present your new competition to the class and explain the rules.

2c Bolivian wrestlers

Reading

1 Look at the photos on pages 26 and 27. Before you read, do you think the statements (1–3) will be true (T) or false (F)? Read the article and check your predictions.

1 Wrestling is popular in Bolivia.
2 Only men can wrestle in public.
3 People earn a lot of money doing it.

2 Read the article again. Which paragraph (1–6) describes:

a the two wrestlers before the fight? 2
b the popularity of male and female wrestling in Bolivia?
c the moments before the wrestlers enter?
d Yolanda's family life?
e the reason why a fan watches it?
f the fight between the two women wrestlers?

3 Find words in the first three paragraphs of the article to match these definitions.

1 three words meaning a large group of people at a performance or sporting event:
 a_____, s_____, c_____
2 two verbs meaning to speak loudly and make a lot of noise:
 s_____, s_____
3 to clap your hands together:
 a_____
4 people who support someone famous:
 f_____
5 to get away from someone or something:
 e_____
6 three verbs to describe fast movements:
 j_____, s_____, t_____

Critical thinking *reading between the lines*

4 An article doesn't always tell us everything about how the people feel, but we can often guess. Match these people from the article (1–3) with the sentences (a–c).

1 Yolanda
2 One of Yolanda's daughters
3 Esperanza

a I don't like the days when there's wrestling.
b I get a wonderful feeling every time I go out there.
c Life can be hard for people like me.

Word focus *like*

5 Look at the sentences from the article. Match *like* in each sentence (1–4) with its meaning (a–d).

1 Would they **like** to become wrestlers one day?
2 Yolanda and Claudina walk through the crowds **like** pop stars.
3 Esperanza explains why she **likes** watching wrestling.
4 She also has two daughters who both look **like** her.

a enjoy in general
b want to do in the future
c behave in a similar way
d have a similar appearance

Speaking

6 Discuss the questions.

1 Do you like watching women's sports in your country? Would you watch women's wrestling?
2 How important are sports and athletes in your country? Do any of them act like stars?
3 Why do you think most people like watching sports?

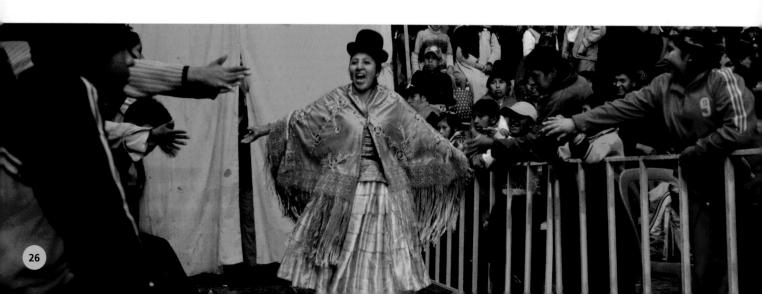

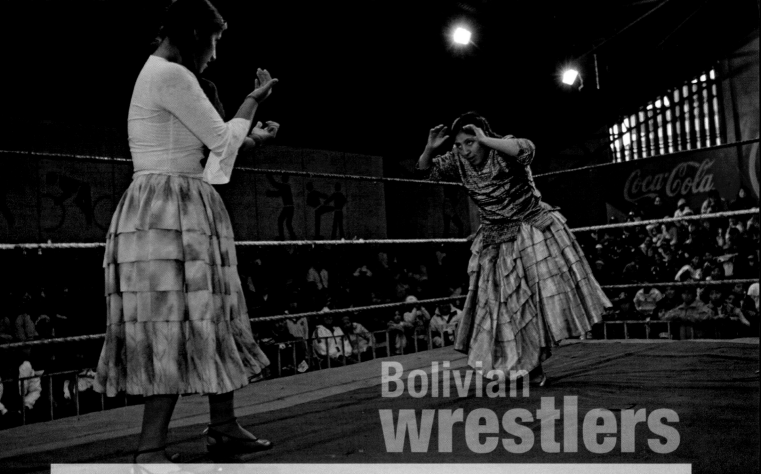

Bolivian
wrestlers

I n El Alto in Bolivia, an audience is sitting around a huge wrestling ring. The spectators are getting impatient and so they start to scream, "Bring them on! Bring them on!" Suddenly, an announcer speaks into the microphone: "Ladies and gentlemen. It's time for Yolanda and Claudina!" The crowd shouts and applauds with excitement.

Two women enter. Yolanda and Claudina walk through the crowd like pop stars. They smile and greet their fans until suddenly the music stops. Both women jump into the wrestling ring and within seconds, Claudina hits Yolanda. Yolanda grabs Claudina. Claudina tries to escape, but Yolanda doesn't let her go. She spins Claudina around and throws her down on the floor. The audience goes crazy!

The women wrestlers fight here and we laugh and forget our problems for three or four hours.

As Claudina lies on the floor, Yolanda is smiling and waving to the crowd. She doesn't see Claudina get up behind her. Then Claudina pushes Yolanda onto the ropes. The crowd shouts at her. Yolanda throws Claudina out of the ring, and the crowd cheers with happiness. One minute Yolanda is winning. The next minute, Claudina is winning.

Wrestling in Bolivia is incredibly popular, and after a hard day's work many people love watching this mixture of sport, drama, and entertainment. Usually, the wrestling matches are between men wearing masks and special costumes. But in El Alto, where it's especially popular, you can also see women wrestling.

Yolanda is one of the top women wrestlers. Her father was also a wrestler so it's a family tradition. During the day she makes clothes. She also has two daughters who both look like her. Would they like to become wrestlers one day? Yolanda doesn't think so. "My daughters ask me why I do this. It's dangerous and they complain that wrestling doesn't bring any money into the house." But Yolanda loves wrestling because of her fans, and she has lots of them!

One fan called Esperanza Cancina pays $1.50 (a large part of her salary) to sit near the ring. She explains why she likes wrestling: "It's a distraction. The women wrestlers fight here and we laugh and forget our problems for three or four hours."

Unit 2 **Competitions** 27

2d Joining a club

Speaking

1 Who is a member of a club or local group in your class? Ask them these questions.

1 Does the club have regular meetings? How often?
2 Do you pay a membership fee? How much is it?
3 What are the benefits of being a member?
4 Does it ever hold competitions?

Look at the ads (A–C). In groups, ask each other which of these questions they each answer.

A Would you like to **get fit** and **make new friends?**

Our running club meets at 7 p.m. every Wednesday.

We run in two groups:
• Beginners (for anyone)
• Experienced (for runners who can do 12 miles or more)

It's noncompetitive and a fun way to get fit!

Call Esteban Lopez at 617-555-3697.

B *Join us and* **WIN** *a new camera!*

The Barton Photography Club welcomes new members. We are a busy club with regular speakers at our club meetings. Join before March 1, and you can also enter our summer photography competition to win a new camera! The $15 entry fee includes club membership for a year. Visit www.bartonphotoclub.com to sign up.

C *Community Theater*

A local theater group is looking for actors to be in a musical this summer. You must be available twice a week starting April 2. Enthusiasm is more important than talent!

Contact Mandy Giles at mandy76@dmail.com

Real life talking about interests

2 Read this conversation where two friends discuss the ads. Number the ads in the order they are discussed.

A: Hey! Have you seen this ad?
B: Yes, but I have so much work at the moment, I don't have time.
A: Taking photos is a good way to relax.
B: I can take a good one of friends and family but I'm not very creative with it.
A: Alright. Well, what about joining something else? Are you interested in acting?
B: You're joking. I hate standing up in front of people. And it's a musical. I'm not very good at singing.
A: But it says here enthusiasm is more important than talent. Try it. I think you'd enjoy it.
B: Emm, well maybe but I think I'd prefer to join this on Wednesday evenings. It looks fun. Why don't you come too?
A: Me? But I can't even walk twelve miles, never mind run it.
B: No, but that's the point. Look, there's even a beginner's group. You should do it with me.

3 In pairs, practice the conversation. Then find examples that meet each category in the box.

> ▶ **TALKING ABOUT INTERESTS**
>
> **Asking about interests**
> Do you like taking photographs?
>
> **Talking about interests (and likes/dislikes)**
> I'd like/prefer to join a running club.
> I'm good at acting.
> I wouldn't like it.
> I'm (not) interested in photography.
>
> **Recommending and encouraging**
> It looks interesting.
> I think you'd enjoy it.
> You should do it with me.

4 Pronunciation **silent letters**

🔊 **9** Some letters are not pronounced in English words. Listen to these words and cross out the silent letters.

1 peøple 2 should 3 friends
4 evenings 5 something 6 what

5 Work in pairs. Imagine you are interested in joining a club. Talk about each ad in Exercise 1 and each other's interests. Then choose a club to join.

2e Looking for members

Writing an ad

1 Read the advice on how to write effective ads. Then look back at the three ads on page 28 and answer the questions.

1 Which ad follows most of the advice?
2 How could you improve the other ads?

> ### *How to* WRITE EFFECTIVE ADS
>
> - Start with a good headline. You could ask a question or solve a problem.
> - Explain the benefits.
> - If possible, offer something for free or a prize.
> - Include important information like dates, times, and location.
> - Add photos, pictures, or images if possible.

2 Work in pairs to plan a new club.

1 What type of club is it (e.g., a chess club, a tennis club, a walking group)?
2 Who is the club for?
3 Are there any rules for members?
4 Is there a membership fee? How much is it?
5 How often will you meet?

3 Plan and write an ad for your new club.

4 Writing skill checking your writing

a It's always important to check your writing for mistakes, especially when a lot of people will read it. Find the mistake in each ad sentence below. Then match the sentences with the types of mistake (a–h) and correct the mistakes.

1 Would you like to learn a musical instrument ? *c*
2 *Enter our exciteing competition!*
3 **Are you good at play tennis?**
4 *We meet at Tuesdays and Thursdays.*
5 **It's fun way to get in shape.**
6 **Join this club new!**
7 Get healthy and play yoga.
8 Call lin at 954-555-2563.

a	spelling	e	grammar
b	missing word	f	word order
c	punctuation	g	capital letter
d	preposition	h	wrong word

b Read your ad in Exercise 3 again and correct any mistakes.

5 Display your ads around the classroom. While you read each other's ads, consider:

- which clubs you would like to join.
- which ads are effective and why.

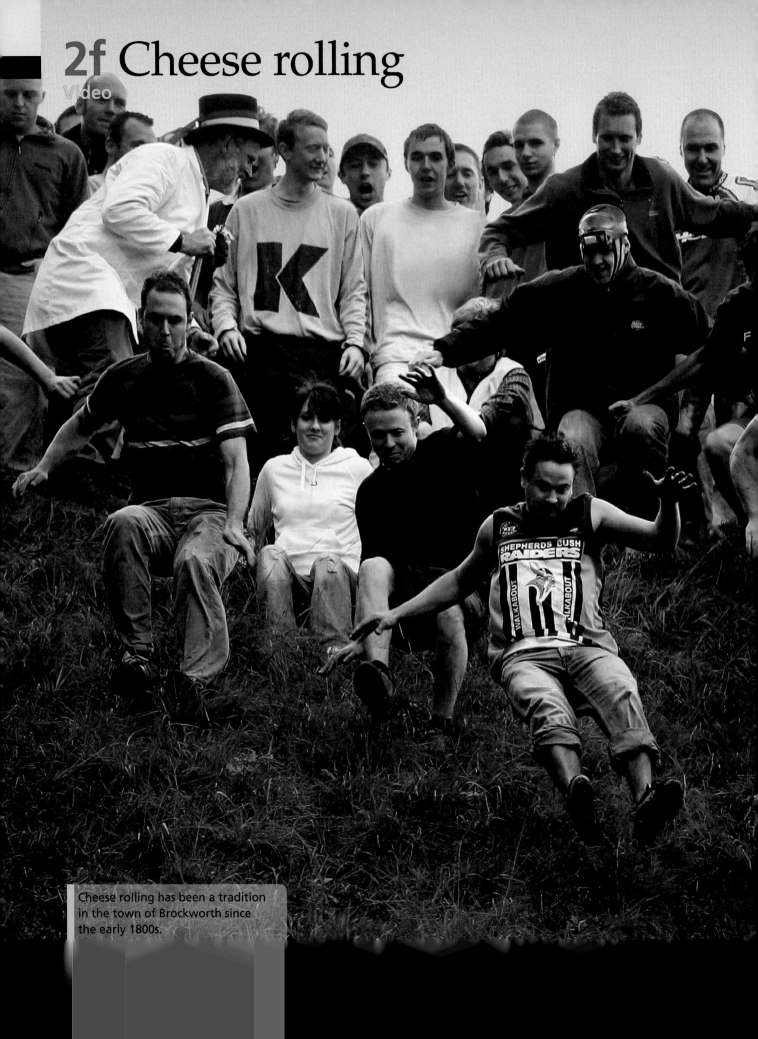

Cheese rolling has been a tradition in the town of Brockworth since the early 1800s.

Before you watch

1 Work in groups. Look at the photo and discuss the questions. Use the words in the glossary to help you.

1 What are the people doing?
2 Why do you think they are doing this?
3 Do you think they enjoy doing this?

2 Complete the summary with words from the list. Use the glossary to help.

bottom	crash barriers	competitors	injured		
prize	race	spectators	steep	top	traditions

Most towns have their own ¹t_____ . However, one town in England has a very unusual one: the annual cheese-rolling ²r_____ . At the start, the ³c_____ wait at the ⁴t_____ of Cooper's Hill. Then someone pushes a wheel of cheese down the ⁵s_____ slope. The competitors run after the cheese. The winner is the first person who gets to the ⁶b_____ of the hill. The ⁷p_____ is the wheel of cheese. The race can be dangerous, for the competitors and the ⁸s_____ . One year a wheel of cheese went into the crowd and thirty people were ⁹i_____ . Nowadays there are ¹⁰c_____ to protect the crowd.

While you watch

3 Watch the video and check your answers from Exercise 2.

4 Put these people and events in the order in which you see them.

a Doctors helping an injured person.
b People clapping to encourage the competitors.
c Someone carrying a British flag.
d An Asian man with blond hair talking.
e Craig Brown holding up the cheese.
f The view from the top of Cooper's Hill.

5 Mark the sentences true (T) or false (F).

1 The race is more than 200 years old.
2 The cheese travels at more than forty miles an hour.
3 Competitors have to catch the cheese before it reaches the bottom of the hill.
4 There is no protection for spectators.
5 The race is dangerous for competitors when the weather is cold.
6 You can only compete once a day.

After you watch

6 **Roleplay** an interview with Craig Brown

Work in pairs.

Student A: You are a reporter for National Geographic. Use the ideas below to prepare questions to ask Craig Brown.

Student B: You are Craig Brown. Look at the ideas below. Think about what you are going to say to the reporter.

- age
- interests
- why you take part in the race
- how many times you have taken part
- if you have ever been injured

Act out the interview and then change roles.

7 At the end of the video, the narrator says, "It's more than just cheese that makes people want to win." What does she mean?

8 Work in pairs to discuss these questions.

1 What kind of people do you think take part in the race?
2 Would you like to take part in the race? Why or why not?
3 Would you go to watch the race? Why or why not?
4 Do you have any unusual traditional races in your country? What are they and why are they popular?

accident (n) /ˈæksɪdənt/ an event where a person is hurt unintentionally
balance (n) /ˈbæləns/ a position in which your body stays upright
bottom (n) /ˈbɑtəm/ the lowest part of a thing or place
crash barrier (n) /ˈkræʃ ˌbæriər/ an obstacle that keeps competitors from running into spectators
fail (v) /feɪl/ be unsuccessful
ground (n) /graʊnd/ what is under your feet when you are outside
injured (adj) /ˈɪndʒərd/ hurt
protect (v) /prəˈtɛkt/ keep someone or something safe
slope (n) /sloʊp/ the side of a mountain or hill
steep (adj) /stip/ going up or down at a sharp angle
top (n) /tɑp/ the highest part of a thing or place
wheel (of cheese) (n) /wil/ a round object

UNIT 2 REVIEW

Grammar

1 Put the words in order to make sentences and questions.

1 than / losing / winning / is / fun / more
2 I'm / new / good / learning / at / games
3 learning / languages? / you / do / like
4 like / a race? / win / would / to / you
5 you / like / who / look / do / in your family?

2 Complete the text with these verbs.

can	don't have to	must	can't

There's a competition in Alaska where you ¹ _____ compete without facial hair! That's because it's the World Beard and Moustache Championship. The judges ² _____ choose the winners from the beards and moustaches of over 300 contestants from all over the world. But you ³ _____ have the longest moustache or the biggest beard because there are many different categories. For example, you ⁴ _____ win the prize for "Best English Moustache" or "Best Natural Moustache."

3 Work in pairs to discuss the sports on TV that you like to watch. Explain the rules to your partner.

I CAN	
talk about likes, dislikes, and ambitions	☐
describe the rules of a competition or sport using modal verbs	☐

Vocabulary

4 Choose the correct options.

1 My favorite soccer team *scored / beat* another goal!
2 In ice skating, the *judges / spectators* give points to the competitors.
3 My grandmother won a $1,000 *trophy / prize* in a competition.
4 My team never *wins / beats*!
5 Hit the tennis ball with your *racquet / net*!
6 During the fight, the two boxers must not leave the *court / ring*.
7 Wear these *gloves / goggles* over your eyes when you ski.
8 The *track / court* is 100 meters long. The fastest runners can complete it in seconds.

5 Work in pairs to talk about an athlete you'd like to meet one day, and why.

I CAN	
talk about different kinds of sports	☐
talk about future ambitions	☐

Real life

6 Complete the conversation.

A: Are you interested ¹ _____ painting? There's a new evening course at my college.
B: I'm afraid I'm not very good ² _____ art.
A: I'm not either but I'd like ³ _____ learn. Come ⁴ _____. You should do it with me.
B: Sorry.
A: ⁵ _____ you like taking photos? There's also a course for that.
B: Actually, that sounds interesting.

7 Complete these sentences with your own interests.

1 I'm good at…
2 I wouldn't like to…
3 I'm also interested in…
4 I think I'd enjoy learning…

I CAN	
talk about interests	☐
recommend and encourage people to do things	☐

Speaking

8 Work in pairs. Take turns telling each other about your interests. Then recommend one of your interests to your partner and encourage him or her to do it in the future.

Unit 3 Transportation

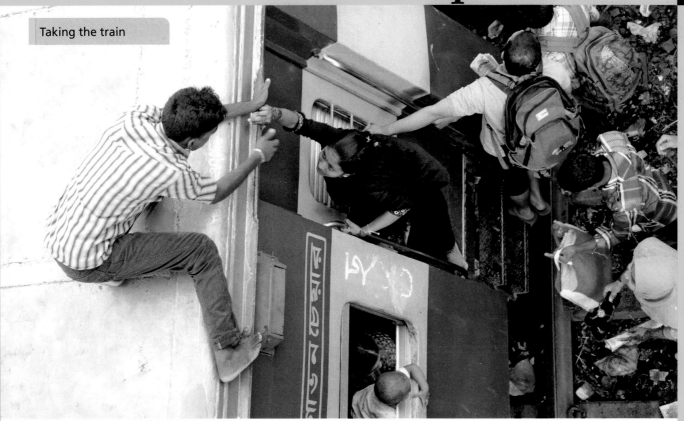

Taking the train

FEATURES

1 Look at the photo. Where are these people? Why do you think some of them are not inside the train?

2 Work in pairs. Which mode of transportation would you use for each activity (1–10)? Explain why.

bicycle	bus	car	ferry	motorcycle	plane
ship	taxi	train	truck	walking	

1 visit relatives
2 move house and furniture
3 get to the airport
4 see the countryside for pleasure
5 cross a river
6 get to the train station
7 go out in the evening to a party or restaurant
8 take children to school
9 cross the ocean
10 go shopping

3 What is your favorite way to travel? Tell your partner why.

3a Transportation in the future

Reading

1 Do you use transportation every day? How do you commute to work? Is your morning commute difficult?

2 Read the text below about transportation in the future. How is it different from transportation today?

3 Read the text again. Answer the questions.

Who…
1 commutes to work every morning?
2 knows in advance when there is a problem on the road?
3 can't drive a long distance without recharging?
4 always needs to plug in the car before bedtime?
5 has a car that stops him from driving too fast?
6 doesn't commute to work?
7 works in an office?

Vocabulary transportation nouns

4 Find the words in the article for these definitions.

1 machines with engines for transporting people v........
2 people who travel to work every day c........
3 period in a day when lots of people travel to and from work r........ h........
4 long line of vehicles on the road t........ j........
5 road construction or maintenance r........ w........
6 place to fill your car with gas g........ s........
7 the maximum speed you can drive legally s........ l........
8 people walking in a town or city p........

> ▶ **WORDBUILDING** compound nouns
> You can join two nouns to make a new noun:
> *rush + hour = rush hour, traffic + jam = traffic jam,*
> *speed + limit = speed limit*

5 Do you think the predictions in the article are true? Are any of them true now? Would you prefer an electric or a gas car? Why?

T R A N S P O R T A T I O N I N T H E F U T U R E

Meet the Watts. They are a three-car family in the near future that uses electric vehicles.

Bob is like most commuters. He charges his car at home overnight so it's ready for the morning rush hour. If he needs more electricity, there's a charging station in the office parking lot.

Sonia's car travels about 19 miles on a full battery so it's good for short trips like going shopping or visiting friends nearby. The car also has its own computer which tells her if there are traffic jams or road work ahead.

Justin works from home but enjoys going on long drives in his sports car on the weekend. Instead of going to a gas station, he can charge his battery on the highway or plug into a high-voltage charger. A device in the car's engine keeps him from going over the speed limit.

Their neighbors still use a car with a gas engine but most cars have electric engines. The roads are quieter and there is less pollution, so life is also better for pedestrians and bike riders!

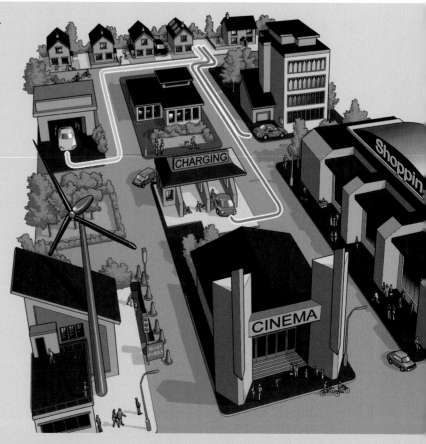

Listening

6 🎵 **10** Listen to two people discussing electric cars. What reasons do they give for and against this kind of transportation?

7 🎵 **10** Listen again and choose the correct options.

1 Electric cars are much *cleaner / louder* than gas cars.
2 Electric cars have the *more efficient / most efficient* type of engine.
3 Electric cars are much *cheaper / more expensive* than gas cars.
4 Eight o'clock in the morning is the *best / worst* time of the day for commuting.
5 The town needs *better / faster* public transportation.

Grammar comparatives and superlatives

8 Look at the comparative and superlative adjectives in Exercise 7. Answer the questions.

1 What letters do you add to regular short adjectives to form comparative and superlative adjectives? How do you form the comparative and superlative forms with longer adjectives?
2 Which are examples of irregular comparative and superlative adjectives?
3 Which word usually comes after a comparative adjective? Which word usually comes before a superlative adjective?
4 What word adds emphasis to a comparative adjective?

▶ COMPARATIVES and SUPERLATIVES		
Regular adjectives		
clean	clean**er**	clean**est**
big	big**ger**	big**gest**
happy	happ**ier**	happ**iest**
expensive	**more** expensive	**most** expensive
Irregular adjectives		
good	better	best
bad	worse	worst
For more information and practice, see page 158.		

9 Pronunciation *than*

🎵 **11** Listen to the pronunciation of *than* in sentences 1 and 3 in Exercise 7. Notice how we say /ðən/ not /ðæn/. Practice saying the two sentences.

10 A local town council asked residents for their views on transportation. Look at the grammar box in Exercise 8. Complete the paragraph with the comparative or superlative form of the adjectives.

◀ ◀ ◀ **REPORT BACK**

Your views on transportation

For commuting and daytime travel, the ¹_____ (popular) form of public transport is the bus. ²_____ (large) number of people in the survey use buses every day to get to work or school. However, taking the bus isn't ³_____ (fast) form of transportation. Everyone said that parking downtown is still the ⁴_____ (big) problem so they don't often drive their car. The situation is much ⁵_____ (good) in the evenings than during the day. As a result, taxis are ⁶_____ (popular) than private cars but they are the ⁷_____ (expensive) form of transportation. So many people want buses to run ⁸_____ (late) in the evenings.

Speaking and writing

11 Look at the questionnaire for the survey in Exercise 10. Use it to interview other students about transportation where they live. Make a note of their answers.

QUESTIONNAIRE ▶ ▶ ▶

Resident views on transportation

• How do you usually commute to and from work/college? Why?
• How often do you use public transportation?
• What types of public transportation do you use?
• How do you rate parking downtown?
 Excellent ____ Good ____ Poor ____
• How often do you take taxis?
• Do you have any suggestions for improving travel and transportation in town?

12 Working in pairs, use your notes to write a short report like the one in Exercise 10.

3b Animal transportation

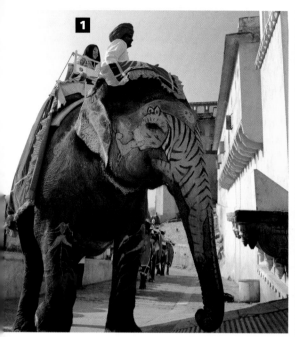

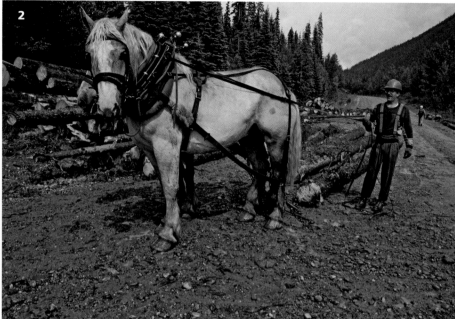

Listening

1 Look at the photos. What is each animal transporting? Do people use animals for transportation in your country?

2 🔊 **12** Listen to excerpts from two documentaries. What kind of modern transportation does the speaker compare each animal to?

3 🔊 **12** Listen again. Answer the questions.

Documentary 1
1 What special event is happening?
2 What jobs did the Asian elephant do in the past?
3 What kind of people do they transport now?

Documentary 2
4 Lester Courtney is a "logger." What do loggers do?
5 Why does Lester prefer to use horses?

Grammar *as ... as*

4 Look at the sentence and answer the questions (1–2).

Elephants are as heavy as *cars but they* aren't as fast.

1 Are elephants and cars the same weight?
2 Do they travel at the same speed?

> ▶ AS ... AS
>
> Use *as* + adjective + *as* to compare something and say they are the same or equal.
> Use *not as* + adjective + *as* to compare two things and say they are different or not equal.
>
> For more information and practice, see page 158.

5 Complete each second sentence so that it has the same meaning as the first sentence.

1 Most people think cars are more comfortable than elephants.
 Most people think elephants aren't as

2 Elephants have the same importance now as they did in the past.
 Elephants are as ever.
3 Lester believes horses are better than modern machines.
 Lester doesn't believe modern machines are as horses.
4 Trucks are stronger than horses.
 Horses as as trucks.
5 Trucks are noisier than horses.
 Horses as trucks.

6 Pronunciation **sentence stress**

🔊 **13** Listen to these sentences and notice the stressed words. Then listen again and repeat.

1 **Trucks** are **heavier** than **horses**.
2 **Elephants** are as **heavy** as **trucks**.
3 They **aren't** as **fast** as **cars**.
4 **Horses** are the **fastest**.

7 Working in pairs, make sentences using each adjective to compare these animals. Use comparative and superlative adjectives and (*not*) as + adjective + *as*.

1 strong: lion, mouse, horse
2 fast: snail, cheetah, elephant
3 comfortable: car, camel, plane
4 heavy: hippopotamus, blue whale, elephant
5 dangerous: shark, alligator, snake

8 Read your sentences from Exercise 7 out loud, stressing the most important words.

Reading

9 Complete the article on the right with these words.

> as best fast longest more much
> than the

10 Read the article again and discuss the questions.

1 What are the advantages and disadvantages of dog sleds in Alaska?
2 Why do you think some people say the Iditarod is cruel to the dogs?
3 What animal sports do you have in your country? Do people think they are cruel to animals?

Speaking

11 Working in groups, read and discuss these comments about using animals for transportation and sport. What's your opinion? Do you agree or disagree?

> It's more natural and cleaner to use animals for work and transportation than engines. We should use them more.

> It's wrong to use animals like horses and dogs in sports.

> Modern transportation is much better. There's no reason to use animals.

> We still need animals for certain kinds of work.

> I think it's better because …

> I don't think it's as bad as …

> In my opinion, it's worse because …

> I agree …

THE BEST WAY TO TRAVEL

In the most northern state of the US, you'll see every type of modern transportation. But during the winter months, the state of Alaska becomes one of ¹ _____ coldest parts of the world. Temperatures fall as low ² _____ –58°F (–50°C). Car engines can freeze, and even if a car starts, the snow and ice on the road can make travel impossible. When the weather is like this, the ³ _____ way to travel is with a team of huskies pulling you. That's according to people like Geoff Roland who prefer traveling by dog sled. "Huskies might not be as ⁴ _____ as a modern snowmobile but they are better for the environment. The journey is also much quieter ⁵ _____ by snowmobile. It's what makes travel through the wilderness so enjoyable."

When Geoff was younger, he took part in the Iditarod. The word *Iditarod* comes from an old Native American word meaning "a faraway place," but nowadays it's the name of the world's ⁶ _____ dog sled race, which takes place in Alaska each spring. The 1,049-mile (1,600km) route follows the old roads that the original Native Americans once used. As years passed, airplanes and snowmobiles became ⁷ _____ common and people started to forget about the old trails. But in 1973, a group of people started the race to maintain Alaska's history and its traditional form of transportation. Some people criticize the Iditarod because they think it's cruel to the dogs, but Geoff disagrees: "Huskies are natural racers. I think they're ⁸ _____ happier when they're in front of the sled."

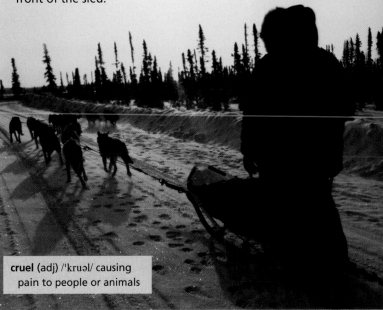

cruel (adj) /ˈkruəl/ causing pain to people or animals

3c Last days of the rickshaw

Reading

1 Look at the photo of the rickshaw in the article on page 39. Why do you think people choose this kind of transportation? What are the advantages?

2 Read the first paragraph of the article. Which of these words and expressions describe Kolkata?

> busy highly-populated noisy polluted quiet
> safe for pedestrians

3 Read the second and third paragraphs of the article. Which arguments in favor of rickshaws does it mention?

Rickshaws are useful because…

1 they are better in traffic jams.
2 they can travel down small streets.
3 they don't produce pollution.
4 they are good for shopping.
5 they are cheaper than other public transportation.
6 they always travel during the monsoons.

4 Read the last paragraph. Choose the reason (1–3) that local officials and politicians don't ban rickshaws.

1 There isn't much other employment for the drivers.
2 The tourists want them.
3 The drivers don't want to go back to the countryside.

Vocabulary **transportation verbs**

5 Find these verbs in the article and underline them and the noun that follows.

> catch take (x2) pick up miss drop off
> get on / off

Example:
catch a train

6 Replace the verbs in bold in the sentences with a verb of similar meaning from Exercise 5.

1 Do you want me to **get** the children from school?
 pick up
2 We need to **leave** the train at the next station.
3 I was late and I nearly didn't **get on** my flight.
4 Go! You don't want to **not catch** your flight.
5 I should **travel by** a taxi. It's much quicker.
6 Ask the driver to **leave** the children at school.

Critical thinking **reading between the lines**

7 Based on the article, which of these statements do you think people in Kolkata often say about rickshaws?

1 "Rickshaw drivers always blow their horns so loudly."
2 "They represent our city!"
3 "They shouldn't be on the roads!"
4 "They're very useful."
5 "You can never find a rickshaw when you need one."
6 "Rickshaws are cruel."

Speaking

8 Work in groups. Make a list of the reasons for and against keeping rickshaws in Kolkata. Use the information in the article and add your own ideas.

Example:
Rickshaws don't have engines so they are quiet and don't pollute the air.

9 You are going to have a debate to decide if Kolkata should ban rickshaws. Each person in the group has a role. Choose one of the roles below and decide if your person wants to ban rickshaws or not. Choose arguments for or against from your list in Exercise 8 and plan your arguments for the debate. When you are all ready, discuss the topic and try to find a solution.

- a rickshaw driver in Kolkata
- a local politician who wants to modernize Kolkata
- a foreign tourist visiting the city
- a local person who uses rickshaws for shopping and sending the children to school
- a taxi driver in the city

> *In my opinion we should ban rickshaws because …*

> *I think rickshaws are good for the city because …*

Last days of the rickshaw

Rickshaw: *a two-wheeled wooden cart, pulled by a person on foot*

Kolkata (previously known as Calcutta) is the famous capital of West Bengal in India and home to nearly 15 million people. The traffic jams and engine fumes begin early in the morning with long lines of cars, buses, taxis, scooters, and pedicabs. There aren't many alternatives. You can catch a train through the city or take the subway but sooner or later you have to go on foot, and walking in Kolkata is dangerous. Drivers race towards pedestrians, blowing their horns. The sound never stops from morning to night.

So when I crossed a small road on my first day in the city, I was surprised because I heard a bell—not a horn. It was a tiny man pulling a rickshaw. He stopped and picked up two children from their house and then, with great strength, pulled them to school. For many people, the rickshaw is a symbol of Kolkata and they have many advantages. When the traffic is bad, rickshaws find a way through it. If you miss your bus and can't find a taxi, you can always find a rickshaw. Rickshaws are also very popular with local shoppers. The driver takes you from your house to the market and waits for you. Then he loads all your purchases, drops you off outside your home, and helps you unload. No other type of public transportation offers this kind of service.

You also see lots more people getting on and off rickshaws during the monsoon season. That's the period from June to September when Kolkata gets heavy rainfall. Sometimes it rains for 48 hours without a break. In the older parts of the city, the roads flood. The water can rise as high as people's waists. When it's that bad, anything with an engine is useless. But the rickshaw drivers never stop working, even with water all around them.

Not everyone thinks rickshaws are a good thing, though. Some local officials and politicians want to ban rickshaws on humanitarian grounds. They believe it is wrong for one man to pull another person when there is modern transportation available. The problem is that many of the rickshaw drivers come from the countryside with no job and no qualifications. The only job they can find in Kolkata is pulling a rickshaw. If the city bans rickshaws, these men won't have a job or an income. So for the moment, the people of Kolkata can still take a rickshaw.

fumes (n) /fjumz/ smoke and gases from an engine
scooter (n) /ˈskutər/ a small motorbike
pedicab (n) /ˈpedɪˌkæb/ a type of taxi with no engine. The driver bikes.
flood (v) /flʌd/ when water covers an area (e.g., a floor, road, city)
ban (v) /bæn/ to stop or make illegal

3d Getting around town

Vocabulary and listening
taking transportation

1 Match each word in a pair with its correct definition (a or b).

1 stop / stand
 a where you can get a taxi
 b where you can get a bus
2 fare / price
 a the money you pay for a journey by bus, train, or taxi
 b what/how much something costs
3 change / receipt
 a the money you get back when you don't have the correct amount
 b the piece of paper you receive to show you paid for something
4 gate / platform
 a where you get on a train
 b where you get on a plane
5 book / check in
 a when you buy a ticket in advance
 b when you arrive at the airport and leave your bags

2 🎧 **14** Suri and Javier are going to the airport. Listen to their conversations and answer the questions.

1 At the taxi stand: Where does Javier want to go?
2 In the taxi: How much is the fare? Does Javier want a receipt?
3 At the bus stop: Where does Suri want to go? What type of ticket does she buy?
4 At the train station: How much is the ticket? Which platform does the train leave from?
5 At the airport: Where did Suri book her plane ticket? Does she check any bags?

Real life going on a journey

3 🎧 **14** Listen again and mark the expressions below that you hear.

> ▶ **GOING ON A JOURNEY**
>
> **In a taxi**
> I'd like to go to the station, please.
> You can drop me off here.
> How much is it?
> Do you have change?
> Do you want a receipt?
>
> **On a bus**
> Do you stop at the airport?
> One-way or round-trip?
> Please stop at the next one.
> That's two dollars.
>
> **At the train station**
> A round-trip ticket to the airport, please.
> First or second class?
> Can I pay by credit card?
> Which platform is it?
>
> **At the airport**
> May I see your passport?
> How many bags are you checking?
> I only have this carry-on.
> Window or aisle?
> Can I have a seat next to my friend?

4 Pronunciation **intonation**

🎧 **15** People often ask questions with incomplete sentences, like *One-way or round-trip?* instead of *Do you want a one-way or a round-trip ticket?* Listen to these questions and mark the intonation of the words ⤴ up or ⤵ down. Then listen again and repeat.

1 One-way or round-trip?
2 Window or aisle?
3 Cash or credit?
4 Bus or train?
5 North or south?
6 First or second?

5 Work in pairs. Student A is going to the airport and Student B is the driver or the person at the ticket office or check-in desk. Practice the conversations using the expressions for going on a journey.

In the taxi. A has a $50 bill. The fare is $23.50.

On the bus.

At the train station.

At the airport. You have two bags.

6 Change roles and repeat the four conversations in Exercise 5.

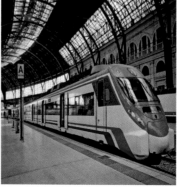

3e Quick communication

Writing notes and messages

1 Read the notes and messages (1–8) and match them with the reasons for writing (a–e).

 a thanking
 b apologizing
 c giving travel information
 d suggesting a time and place
 e giving a message from someone else

2 Writing skill writing in note form

a People often leave out words in notes and messages. This is called *elision*. Find examples of these kinds of missing words in the notes and messages in Exercise 1.

 • articles
 • pronouns (*I, me*)
 • auxiliary verbs (*have, will*)
 • polite forms (*Would you like to…? Can we…?*)

Example:
(Can we) Meet outside (the) airport at 2? (Is that) OK?

b Rewrite these transcripts from a telephone voicemail as shorter messages.

 1 "I'm sorry but I'm stuck in a traffic jam. I'll see you in half an hour."
 Sorry. Stuck in traffic. See you in 30 mins.
 2 "Thank you for booking the train tickets. I'll pay you when we meet at the station."
 3 "Take the subway to Palermo Street and the Luna café is at the end of platform one."
 4 "Peter wants to come with us in the taxi. Can you call him and tell him where to meet us?"
 5 "My flight is an hour late. Meet me in the arrivals terminal at five o'clock."

3 Write a message for each situation.

 1 You have to work late. Text your friend to say you will arrive at the bus station an hour later.
 2 You are meeting a friend downtown tonight. Suggest that he catches a taxi from the stand outside the train station.
 3 You cannot travel with your friend on the subway to the airport. Explain that you will travel by bus and meet her at the check-in desk.

4 In pairs, write each other messages and see if you can understand them. Write a reply if necessary!

1

Meet outside airport at 2? OK?

2

Sorry. Bus late. Will be 15 minutes late.

3

Javier called. Call him back. 305-555-7272.

4

Train leaves platform 6.

5

Thanks for getting tickets. Here's the money.

6

Plane at gate 6. Boarding now.

7

In taxi. See you outside museum in 5?

8

Afraid I missed meeting. Sorry!

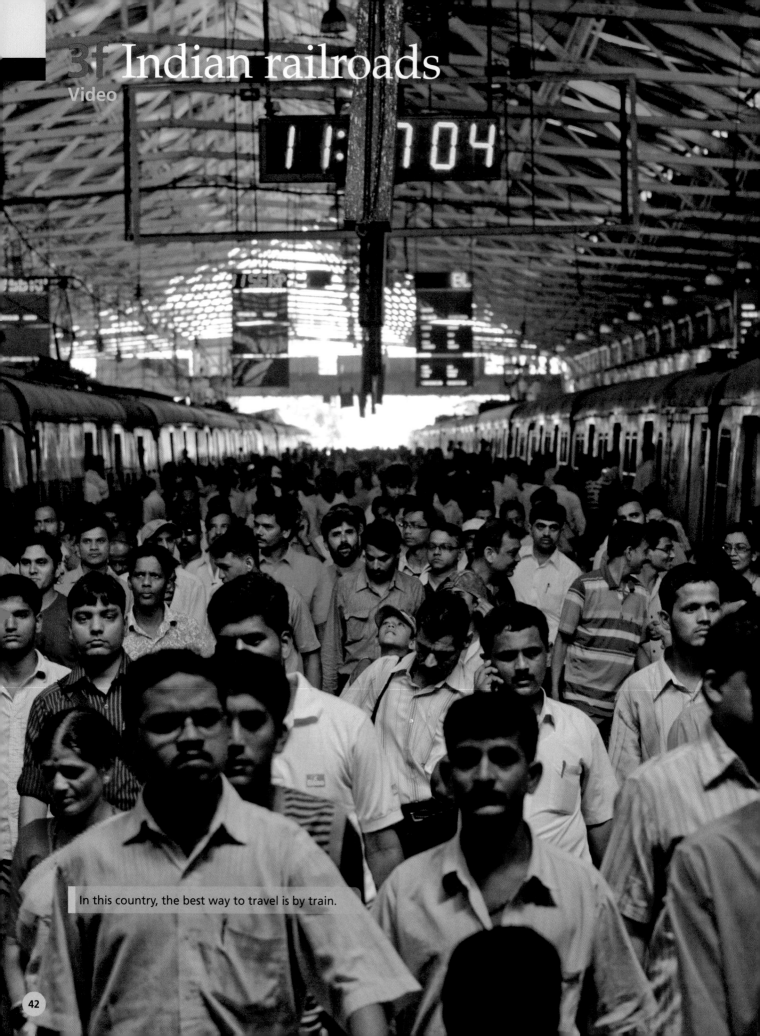

Indian railroads

In this country, the best way to travel is by train.

Before you watch

1 Working in groups, look at the photo and the caption and discuss the questions.

1 How important are trains in your country?
2 Do many people travel by train? Why?

2 Working in pairs, think about Indian railroads and choose the option you think is correct.

1 Every day approximately *two hundred thousand / two million* passengers pass through Mumbai train station.
2 There are over *two billion / one billion* people in India.
3 The British built the railroads in India in the *eighteenth / nineteenth* century.
4 There are over *38,000 / 3,800* miles of railroad tracks in India.
5 The Grand Trunk Express has traveled through India since *1939 / 1929*.
6 India's railroads carry *four billion / four million* passengers every year.
7 The railroad employs *one hundred thousand / one and a half million* staff.

While you watch

3 Check your answers from Exercise 2.

4 Answer the questions.

1 When did the first steam train run in India?

2 Is it easy for everybody in India to get to a railroad station?

3 What is the key man's job?

4 Who tries to get travelers' attention and money at Indian railroad stations?

5 What do passengers do on the train?

5 Complete the sentences with words from the glossary.

1 At the Victoria Terminus, Mumbai, it always seems to be _____ .
2 Many of the trains have _____ names.
3 India's railroads are the world's largest _____ .
4 A huge _____ keeps this enormous system running.

After you watch

6 Roleplay **a conversation between passengers**

Work in pairs.

Student A: You are from the city. Use the questions below to make notes about yourself and your trip.

Student B: You are from a small town, a day's walk from the station. Use the questions below to make notes about yourself and your trip.

- What's your name?
- How old are you?
- Who do you live with?
- What's your job?
- What's your daily routine like?
- What's the best moment of your day? And what's the worst?

Act out the conversation. Describe your trip to the station today and your life at home. Say why you're traveling.

7 At the end of the video, the narrator says, "The Indian railroads are their own adventure." What does that mean?

8 Working in pairs, discuss these questions.

1 In what way are trains in your country similar to, or different from, trains in India?
2 Is traveling by train a good way to see a country? Why?

employer (n) /ɪmˈplɔɪər/ a person or organization that gives work to other people
impressive (adj) /ɪmˈpresɪv/ something that causes admiration
rural (adj) /ˈrʊrəl/ having to do with the countryside
rush hour (n) the busiest time to commute
track (n) /træk/ metal rails that a train runs on
villager (n) /ˈvɪlɪdʒər/ a person who lives in a very small town, often in the countryside
workforce (n) /ˈwɜrkˌfɔrs/ people who work for an organization

UNIT 3 REVIEW

Grammar

1 Complete the article with the correct form of the adjectives.

The city of **Guangzhou wins** transportation prize

China has the ¹ _____ (large) population in the world, and its capital city, Beijing, has some of ² _____ (bad) traffic problems. A few decades ago, China's streets weren't as ³ _____ (polluted) as they are now because most people rode bicycles. But in modern China, cars are selling ⁴ _____ (fast) than in the U.S.

However, one city in China recently received a prize for its transportation system from the Institute for Transportation and Development Policy (ITDP), which works with cities to make city life ⁵ _____ (good). This year it gave the city of Guangzhou a prize because it has one of the ⁶ _____ (good) public transportation systems, not only in China, but worldwide. And bicycles are still as ⁷ _____ (popular) as ever because of the extensive network of bicycle paths. It all means the air in Guangzhou is much ⁸ _____ (clean) than in other cities.

2 Work in pairs to compare your countries to their nearest neighbors. Make five sentences using comparatives, superlatives, or *as ... as* about these things:

- size (larger / smaller / as big as)
- population
- age
- other?

I CAN	
compare differences between things	☐
talk about the similarities between things	☐

Vocabulary

3 Complete the sentences with transportation nouns and verbs.

1 I work from home so I don't have to c_____ to and from work every day.
2 You can avoid r_____ hour if you leave home earlier in the morning.
3 There's always a bad traffic j_____ downtown.
4 The speed l_____ on a highway in China is 50 miles per hour.
5 Look out! There's a p_____ crossing the road.
6 You can cross the river by f_____ .

4 Complete the sentences with a preposition.

1 Can you pick _____ my shopping on the way home?
2 Please drop me _____ at the café on the corner.
3 We both fell asleep on the train so we didn't get _____ at our station!
4 I think I'll go _____ foot today and save some money.
5 Did you come _____ your car or _____ your motorcycle?

I CAN	
talk about transportation and travel in the city	☐

Real life

5 Put the conversation in the correct order (1–8).

1 Hi. I'd like a ticket to Mumbai, please.
☐ At ten thirty. Here's your ticket.
☐ One-way or round-trip?
☐ OK. A one-way ticket is 61 dollars. Is that OK?
☐ Thanks. Which platform does it leave from?
☐ Yes, that's fine. What time is the next one?
8 Platform eight.
☐ One-way, please.

6 Working in pairs, roleplay this situation:

Student A: You are a tourist in Kolkata. Ask a rickshaw driver to take you to your hotel.

Student B: You are rickshaw driver. Talk to the tourist and discuss your price.

I CAN	
ask for and buy a ticket	☐
go on a trip using different types of transportation	☐

Speaking

7 Work in pairs. What is your favorite way to travel (by plane, train, or bus)? What is your least favorite way to travel? Why?

Unit 4 Adventure

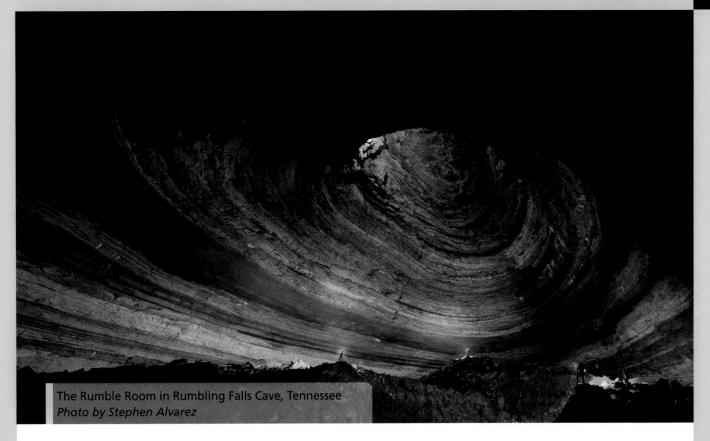

The Rumble Room in Rumbling Falls Cave, Tennessee
Photo by Stephen Alvarez

FEATURES

1 Look at the photo and answer the questions.

1 Do you think what the people in the cave are doing is exciting or dangerous? Why?
2 Why do you think cavers need to be physically fit?
3 What do you think the Rumble Room is like?

2 Complete each sentence (1–3) with one of the words (a–c).

a risk b challenge c achievement

1 You take a _____ when you go caving.
2 Discovering a new cave is a great _____ .
3 Adventurers like a tough _____ .

3 Work in groups. Discuss the questions.

1 Are you a person who takes risks or are you usually careful?
2 What is your biggest achievement in life so far?
3 What is your biggest challenge in the future?
4 Is there any kind of adventurous or risky activity you would like to try?

4a Adventurers of the year

Reading

1 Read the article and complete the diagram with the phrases (1–6).

Both

Edurne
Pasaban

1

Steven
Shoppman

1 born in the US	4 is famous
2 traveled around the world	5 finished the adventure
3 qualified in engineering	6 loves adventure

2 Answer the questions.

1 What was Edurne's biggest challenge?
2 Why is she famous?
3 What was the men's ambition?
4 What was the men's biggest risk?

Grammar **simple past**

3 Underline all the verbs in the past tense in *The Mountaineer* section of the article. Answer the questions.

1 What do you add to regular verbs in the simple past?
2 What auxiliary verb do you use to make the verb negative?

ADVENTURERS
of the YEAR

EVERY YEAR, READERS OF **NATIONAL GEOGRAPHIC MAGAZINE** VOTE FOR ADVENTURERS OF THE YEAR. HERE ARE TWO OF THEM.

THE MOUNTAINEER

As a child, Edurne Pasaban lived in the mountainous Basque region of Spain. She climbed her first mountain when she was fourteen. In college, she studied engineering but she didn't want a nine-to-five job. In May 2010, she finished her biggest challenge: climbing the world's fourteen tallest mountains. Edurne is famous for her many climbing achievements, but she didn't climb in order to become famous. "For me," she says, "adventure is a way of life."

THE ROAD TRIPPERS

Steven Shoppman and Stephen Bouey were old friends who grew up together in Denver, but they knew each other a lot better after their adventure. They both had an ambition to go on a road trip around the world. From 2007 to 2010, they drove through 69 different countries and covered 76,000 miles (122,000 km). They took a big risk when they went across a minefield (see photo). They also got help from lots of people and they found that the world wasn't as dangerous as they thought!

road trip (n) /'roʊd ˌtrɪp/
a long journey by road

4 Pronunciation /d/, /t/, or /ɪd/

🔊 **16** Listen to the -ed ending of these regular verbs. Write /d/, /t/ or /ɪd/, then listen again and repeat.

1 lived /d/ 4 studied 7 decided
2 finished /t/ 5 waited 8 climbed
3 wanted /ɪd/ 6 looked

▶ **SIMPLE PAST**

He climbed the mountain.
He didn't climb a mountain.
Did he climb a mountain?

For more information and practice, see page 159.

5 Find the past tense form of these irregular verbs in *The Road Trippers* section of the article in Exercise 1.

1 be *was / were* 6 grow up
2 drive 7 have
3 find 8 know
4 get 9 take
5 go 10 think

6 Complete the text about another adventurer with the simple past form of the verbs.

THE PHOTOGRAPHER

Reza ¹ *was born* (be born) in Tabriz, Iran, in 1952. He
² (study) architecture at the university in Tehran
but he ³ (not / become) an architect. When he was
a teenager, Reza ⁴ (love) photography and, after
college, he ⁵ (get) a job with a local newspaper as a
photographer. But he ⁶ (not / want) to take photos
of local news and in 1978 he ⁷ (go) abroad and he
⁸ (take) photos of wars. These days he works for
National Geographic magazine.

7 Read the text in Exercise 6. Answer the questions.

1 When was Reza born?
2 Where did he study architecture?
3 What did he do after college?
4 Did he want to take photos of local news?
5 When did he go abroad?

▶ **SIMPLE PAST QUESTIONS**

When were you born? In 1989.
What did you study in college? Economics.
Did you go abroad when you were young?
Yes, I did. / No, I didn't.

For more information and practice,
see page 159.

8 Working in pairs, read the article in Exercise 1 again and write questions for these answers (1–6). Check your answers with your teacher.

1 In the mountainous Basque region of Spain.
2 When she was fourteen.
3 Engineering.
4 From 2007 to 2010.
5 A minefield.
6 That the world wasn't as dangerous as they thought.

Speaking

9 Write eight to ten questions to ask your partner about his or her past. Use some of these prompts to help you.

where / born? where / live?
what subjects / like / at school?
go / college? what job / want?
what / do after that?

10 Take turns interviewing each other. Make notes about your partner's answers.

11 Swap partners and describe your first partner's life.

Chan was born in Hong Kong in 1982 ...

4b The survivors

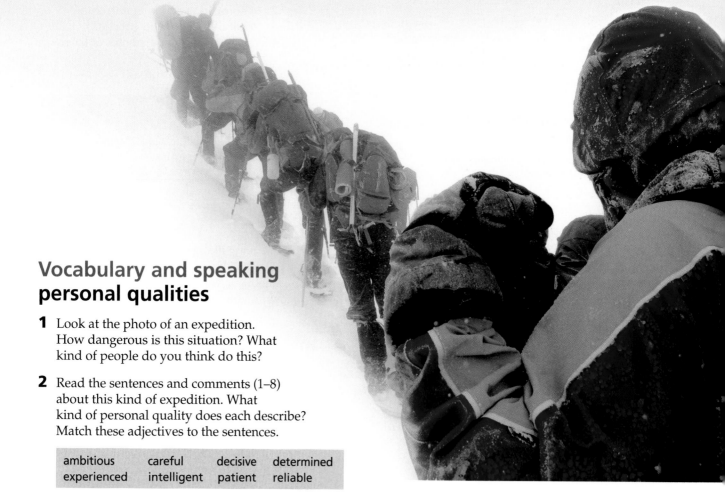

Vocabulary and speaking
personal qualities

1 Look at the photo of an expedition. How dangerous is this situation? What kind of people do you think do this?

2 Read the sentences and comments (1–8) about this kind of expedition. What kind of personal quality does each describe? Match these adjectives to the sentences.

ambitious	careful	decisive	determined
experienced	intelligent	patient	reliable

1 "The leader of our team has worked for thirty years as a mountaineer."
2 "Whatever the risk, we always achieved our goal. Nothing stopped us."
3 "Even as a child, I wanted to be the best."
4 "It's important to plan before any expedition."
5 "When the weather is really bad, you have to wait. There's no point in taking stupid risks."
6 "We all have to be there for each other. We won't survive without each other's help and support."
7 "He has a quick brain and you need that for this kind of expedition."
8 "The leader is the person who makes the final decision and everyone has to agree."

> ▶ **WORDBUILDING** negative prefixes
>
> You can make some adjectives for personal qualities negative by adding a prefix: *unambitious*, *indecisive*, *impatient*.

3 What personal qualities do these people need? Make sentences with the adjectives in Exercise 2 and explain your reasons.

a teacher	a close friend	a language learner
a news photographer		a president
an athlete		a TV presenter

Example:
A teacher is patient because the students need time to learn.

Listening

4 🔊 **17** Listen to part of a radio interview with a survival expert. Match the survivors (1–3) to their stories (a–c).

1 Maria Garza
2 Bethany Hamilton
3 Mr. and Mrs. Carlson

a lost at sea for thirty-one days
b escaped from a burning airplane
c surfing when attacked by a shark

5 🔊 **17** Listen again and choose the correct option (a–c) to complete the sentences.

1 The aim of the program is to talk about _____.
 a recent survival stories
 b the best survival stories
 c the personal qualities of survivors

2 Dr. Weisz says all survivors _____.
 a are decisive
 b need determination
 c are decisive and need determination

3 Unlike Bethany, the Carlsons _____.
 a were at sea for a long time
 b were in the water
 c didn't have experience

4 Most survivors _____.
 a don't take risks
 b often take risks
 c aren't very careful

6 Do you ever need the personal qualities of a survivor? For example, are there other situations when you need to be decisive or careful?

Grammar past continuous

7 Look at the highlighted verbs and answer the questions.

She was sitting on an airplane in Denver airport with her one-year-old child when she saw a fire from the window. While the other passengers were running to the exits, Maria climbed out of the window.

1 Do all the highlighted verbs talk about the past?
2 Which verbs describe a completed action?
3 Which verbs describe actions in progress at a particular time?
4 How do you form the past continuous tense? What is the auxiliary verb? What is the form of the main verbs?

▶ **PAST CONTINUOUS**

I/he/she/it was sitting	you/we/they were sitting
I/he/she/it wasn't sitting	you/we/they weren't sitting
Was I/he/she/it sitting?	Were you/we/they sitting?

We often join the past continuous tense with the simple past using the words *when* or *while* to talk about one action happening at the same time as another.
Maria was sitting on an airplane in Denver airport when she saw a fire from the window.
While the other passengers were running to the exits, she climbed out of the window.

For more information and practice, see page 159.

8 Choose the correct options to complete the stories.

TRUE*life*
SURVIVAL STORIES!

The sun [1] *shone / was shining* when Bethany Hamilton arrived at the beach on a beautiful morning in Hawaii. But hours later, the young teenager [2] *surfed / was surfing* when a shark attacked her and she lost her left arm. Amazingly, Bethany [3] *swam / was swimming* back to the beach with one arm and, as she was swimming, she told other surfers to get out of the water.

While Steven and Rachel Carlson [4] *sailed / were sailing* around the Canary Islands, their boat sank. They [5] *didn't have / weren't having* much food and water but after 31 days at sea they still survived.

It was a normal afternoon at Denver airport but as Flight 455 was taking off, passengers [6] *saw / were seeing* a fire from the window. Immediately, the plane's captain realized that the engines [7] *didn't work / weren't working* and radioed for help. While passengers [8] *ran / were running* towards the front exits, Maria Garza pulled her daughter through the window exit next to the wing.

9 Which survival story do you think is the most amazing? Why?

Speaking

10 Work in pairs. Tell your partner which of these events happened to you in the past. Explain:

1 when they happened
2 what you were doing at the time

broke a bone	got your first job
felt scared	fell off your bicycle

I was climbing on a wall when I was eight. I fell and broke my arm.

11 Think of three more real or special events in your life. Tell your partner.

Examples:
While I was working in …, I met …
I was living abroad when I …

4c The right decision?

Reading

1 Working in pairs, talk about the best and worst decisions you have ever made. Tell each other what happened.

2 Read the true story on page 51. What decision did Yates make? What decision did Simpson make?

3 Mark the sentences true (T) or false (F).

Joe Simpson

Simon Yates

1 The accident happened while Simpson and Yates were climbing up the mountain.
2 They didn't reach the top of Siula Grande.
3 Yates cut the rope because he wanted to survive.
4 Yates didn't look for Simpson afterwards.
5 Simpson managed to get to the base camp on his own.

Vocabulary geographical features

4 Match these words from the story to the picture.

lake	north face	mountain	cave	summit
ridges	glacier	cliff	crevasse	

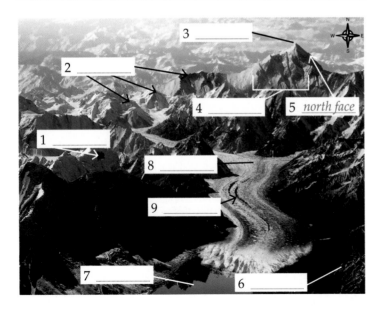

Critical thinking identifying opinion

5 Read the last paragraph again. Do the following people (1–3) think that Yates made the right decision or not?

1 some climbers
2 Simpson
3 the author of the article

6 What do you think? Did Yates make the right decision? Discuss with a partner.

Vocabulary *in*, *on*, or *at* for time expressions

7 Look at these time expressions from the story. Then complete the rules (1–4) with *in*, *on*, or *at*.

in May 1985	on Day 1
three days later	at the last second
at 4:00 in the afternoon	in 1988
in the middle of the night	

1 We use _____ with months, years, seasons, decades, centuries, and some parts of the day such as *the morning, the evening*.
2 We use _____ with days, dates, and special days such as *her birthday, New Year's Day, the weekend*.
3 We use _____ with times and special expressions such as *night, the final moment*.
4 We don't use _____, _____, or _____ with time expressions such as *yesterday, last week, two days later*.

Speaking

8 Work in pairs. Match the time expressions in Exercise 7 to these events from the story. Then tell the main parts of the story using the time expressions.

stood at the top of the mountain
cut the rope
wrote a book
heard his name
crawled back to base camp
started climbing Siula Grande

In May 1985, two climbers, Joe Simpson and Simon Yates, left their base camp by a lake and started climbing the north face of a mountain called Siula Grande in the Peruvian Andes. This climb was incredibly dangerous, but the two men were experienced climbers and physically fit. On Day 1, the weather was good and the climb began well. At night, they made a snow cave and slept on the side of the mountain.

Three days later, after some very difficult climbing and bad weather, the two men stood at the summit. Unfortunately, the weather was getting worse so they didn't stay long. As they were going down a mountain ridge, a disaster happened. Simpson fell and broke his knee. Quickly, Yates tied a rope to himself and then to his friend. He began lowering Simpson down the mountain and, for hours and hours, Yates helped Simpson get down the mountain. They were getting close to the glacier at the bottom of the mountain when Simpson suddenly slipped. This time he went over the edge of a cliff. He was hanging in mid-air. Simpson shouted up to Yates, but the wind was blowing loudly and Yates couldn't hear him.

Yates didn't know it, but Simpson was— unbelievably—still alive!

Yates didn't know what was happening below. He waited for an hour but the rope was too heavy and it was pulling him down the mountain towards the cliff. He had two choices: hold the rope and risk both their lives, or cut the rope and survive. It was an impossible decision for Yates but, at the last second, he cut the rope and saved himself. Immediately, Simpson fell 100 feet (30 m) into a crevasse.

The next day, while Yates was desperately looking for Simpson, he found the crevasse. He called for Simpson but he heard nothing. Sadly, he decided that Simpson was dead. Yates didn't know it, but Simpson was—unbelievably—still alive!

Simpson waited for hours and when he realized Yates wasn't coming, he decided to take a risk. He had some rope, so he lowered himself to the bottom of the crevasse. Then he managed to find a way out. For three days, Simpson drank water from the snow and ice and crawled back towards the base camp. At four o'clock in the afternoon on Day 7, he was very close.

In the middle of that night, as Yates was sleeping in his tent at base camp, he woke up. He was sure someone was shouting his name. Excitedly, he ran outside and looked around. Finally, after searching and searching he found Simpson lying on the ground, not moving but still breathing.

After a few days, the two men returned home and their story became famous. Unfairly, some climbers criticized Yates for cutting the rope. But in 1988, Simpson wrote a book about the events and defended Yates. He believed Yates made the right decision.

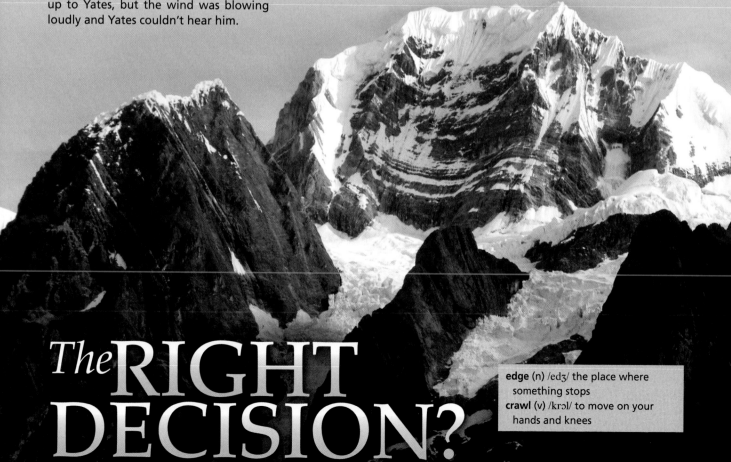

The RIGHT DECISION?

edge (n) /edʒ/ the place where something stops
crawl (v) /krɔl/ to move on your hands and knees

4d A happy ending

Real life telling a story

1 🔊 **18** Listen to the conversation and answer the questions.

1 Was the start of the weekend good or bad?
2 When did Mark and the others leave?
3 Where did the car break down? Who fixed it?
4 Why couldn't they find the campsite at first?
5 What happened after they found the campsite?
6 Where did they go instead?

2 🔊 **18** Listen again and complete the conversation.

A: Hi Mark. How was your camping trip?
B: It was great in the end but we had a terrible time at the beginning.
A: Why?
B: ¹ _____, we left the house early on Saturday morning but after only half an hour the car broke down.
A: Oh no!
B: ² _____, there was a garage nearby and the mechanic fixed the problem. But ³ _____ we arrived at the forest, it was getting dark. ⁴ _____ we drove around for about an hour, we ⁵ _____ found the campsite but it was completely dark by then. ⁶ _____, it started raining so we found a nice hotel down the road!
A: That was lucky!
B: Yes, it was a great hotel and ⁷ _____ _____ _____ we stayed there for the whole weekend.
A: ⁸ _____!

3 Match the words and expressions (1–8) in Exercise 2 with the correct section in the box.

> ▶ **TELLING A STORY**
>
> **Sequencing the story**
> At the beginning… Then… Next… While…
>
> **Introducing good and bad news**
> Luckily… But…
>
> **Reacting to good and bad news**
> Why? That was a good idea! Oh no!

4 Pronunciation intonation for responding

🔊 **19** Listen to these expressions in the conversation from Exercise 1. Notice how the listener uses intonation to show interest. Then listen again and repeat.

Why? Oh no! That was lucky!

5 Working in pairs, read the conversation in Exercise 2 aloud. Take turns being person A. Pay attention to your intonation when you are responding.

6 Practice telling another story with your partner. Student A biked to work and these events happened.

- You had a terrible journey to work.
- You were biking and it started raining.
- A car hit your bicycle.
- You weren't hurt.
- The driver was very nice. He owned a bicycle shop.
- He gave you a new bike! It's much better than your old one!

Tell your story to Student B. Student B listens and responds. Then change roles and repeat the story.

7 Think of a bad trip you had. Did it have a happy ending? Make a list of the events and tell your partner the story.

4e A story of survival

Writing a true story

1 When you read the news, is it always bad news? Are there ever any news stories with good news or happy endings?

2 Read the story and find out which of this information is included.

> the location the weather the people
> why they were there any unusual details
> how the situation ended

BOYS SURVIVE
50 DAYS LOST AT SEA

It's an amazing story and it's true! Fifty days ago, three teenage boys suddenly disappeared from the island of Atafu in a small boat. Immediately, rescue boats went to look for them but sadly there was no sign of their boat. Eventually, a fishing boat in the middle of the Pacific Ocean safely pulled them from the water. The boys were badly sunburned and dehydrated but doctors said they were in surprisingly good health. Now, they are back happily with their families.

3 Writing skill using *-ly* adverbs in stories

Look at the sentence from the story in Exercise 2. We often use *-ly* adverbs to make a story more interesting. Underline the other *-ly* adverbs in the story.

Fifty days ago, three teenage boys <u>suddenly</u> disappeared from the island of Atafu in a small boat.

4 Match the adverbs you underlined in Exercise 3 with the rules (1–3).

> ▶ **-LY ADVERBS**
>
> We often use *-ly* adverbs to:
> 1 comment on the whole clause or sentence.
> *Eventually, they saw another ship.*
> 2 describe the verb (how someone did something or how it happened).
> *He **slowly** swam toward the island. (Also He swam toward the island **slowly**.)*
> 3 describe an adjective.
> *The three survivors were **amazingly** healthy.*
>
> Many adverbs are adjectives + *-ly*: sudden – suddenly.

5 Make these sentences more interesting using the adverbs.

1 The climb was dangerous. (incredibly)
 The climb was incredibly dangerous.
2 The sun was shining. (brightly)
3 The man jumped into the car. (quickly)
4 They were nearly at the top of the mountain when one of them slipped. (suddenly)
5 It started raining. Riu had an umbrella. (fortunately)
6 The Amazon River was long and they were lost for days. (amazingly)
7 They walked back. (slowly)
8 They were lost in the forest for hours but they found the road again. (eventually)

6 You are going to write a true story (from your own life or the newspaper). Make notes on:

- where it happened
- what the weather was like
- who was there and what they were doing
- what unexpected event happened
- what happened next
- the ending (happy or sad)

7 Write your story. Use *-ly* adverbs to make it more interesting.

8 Working in pairs, exchange your stories and check:

- what information in Exercise 6 your partner includes.
- which *-ly* adverbs he / she uses effectively.

4f Alaskan ice climbing

It's hard work climbing the glacier.

Before you watch

1 Working in pairs, look at the photo and discuss the questions.

1 Where is the woman?
2 What is she doing?
3 Do you think this is a dangerous activity?
4 How do you think she is feeling?

2 What do you think these words mean? Try to match the words (1–3) with the correct meaning (a–c).

1 serac a a narrow, deep hole in ice
2 crevasse b an area with many seracs
3 ice fall c large piece of glacial ice that sticks up in the air

While you watch

3 Watch the video and check your answers from Exercise 2.

4 Put the events from the climbers' trip in order.
a It was a very special feeling for the climber when she reached the top.
b They drove to the Matanuska glacier.
c When they got to Talkeetna, the weather was bad, so they couldn't fly to Denali.
d A woman slipped, but the rope saved her.
e After a long hike they reached solid ice at the heart of the glacier.
f When they arrived at the glacier, the guides explained how to use the equipment.
g They started climbing the ice wall.

5 Watch the video again and make notes about these topics.

the weather on the trip	
the glacier	
the guides	
the equipment	
the dangers	

After you watch

6 Roleplay telling a friend about a trip

Work in pairs.

Student A: You are one of the people who went to the glacier. You are now back at home. Tell a friend about your trip. Use the ideas below to make notes.

Student B: Your friend went on a trip to a glacier in Alaska. Use the ideas below to prepare questions to ask your friend.

- the journey to the glacier
- what the glacier was like
- what the weather was like
- the equipment
- what the climb was like
- how it felt to get to the top

Act out the conversation. Then change roles and have another conversation about a different trip.

7 The narrator says Colby and Caitlin are not usually doubtful when they're in the mountains. What does this tell you about them?

8 Working in pairs, discuss these questions.
1 What kind of people like ice climbing?
2 Would you like to go ice climbing? Why?

climb (v) /klaɪm/ go up with a lot of effort
climber (n) /ˈklaɪmər/ a person who climbs
crampons (n) /ˈkræmpɑnz/ spikes that climbers have on their boots
doubtful (adj) /ˈdaʊtfəl/ not feeling certain about something
glacier (n) /ˈɡleɪʃər/ a large mass of ice
guide (n) /ɡaɪd/ a person who shows a place to visitors
heel (n) /hil/ the back part of the foot
hike (n) /haɪk/ a walk in a wild place
rope (n) /roʊp/ a thick string used for tying things
stable (adj) /ˈsteɪbəl/ not likely to fall or move in the wrong way
unsafe (adj) /ʌnˈseɪf/ dangerous

UNIT 4 REVIEW

Grammar

1 Read about two adventurers and complete the text with the simple past form of the verbs.

Steve O'Meara [1] _____ (meet) Donna in Boston in 1986. On their second date, Steve [2] _____ (take) Donna in a helicopter to Hawaii. That sounds romantic but they [3] _____ (not / fly) to a beach. They [4] _____ (go) to the Kilauea volcano. A year later, they [5] _____ (visit) the volcano again, and this time they [6] _____ (get) married on it. It [7] _____ (not / be) only for romantic reasons. Steve and Donna both [8] _____ (become) volcanologists and they [9] _____ (travel) all over the world studying volcanoes. But they really [10] _____ (want) to spend more time by Kilauea, so some years later they [11] _____ (buy) a house there. Donna explains, "This volcano can still kill you but for me to live on it is exciting every day."

2 Working in pairs, write questions about Steve and Donna using these prompts. Then take turns asking and answering them using information from the text.

Student A: When / meet?
Where / get married? What / want to do?

Student B: Where / take Donna?
What / become? What / buy?

I CAN	
talk about past events and important moments in my life	☐
ask questions about the past	☐

Vocabulary

3 Complete each sentence with the correct option (a-c).

1 My biggest _____ at school was passing my math exam. I got an A grade in the end!
 a achievement b challenge c decision
2 When you're in a traffic jam, be _____.
 a patient b reliable c experienced
3 One of the most _____ people in history was Albert Einstein. He had an amazing brain.
 a ambitious b careful c intelligent
4 Be _____ when you are ice climbing!
 a ambitious b careful c determined

I CAN	
talk about challenge and personal qualities	☐

Real life

4 Look at the pictures (1–5) and write sentences about what happened in each part of the story.

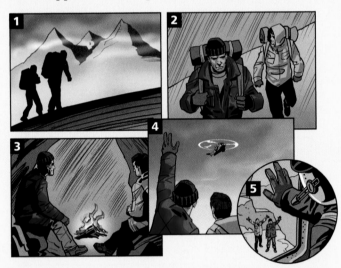

5 Working in pairs, take turns telling each other your stories from Exercise 4. The person telling the story has to include the words on the left. The person listening uses the words on the right.

then next	Why? Oh no!
while luckily	Good idea!

I CAN	
sequence the stages of a story	☐
introduce good and bad news in a story	☐
respond to a story	☐

Speaking

6 Write down five years when something important happened in your life. Show the years to your partner. Take turns guessing why each year was important.

Unit 5 The environment

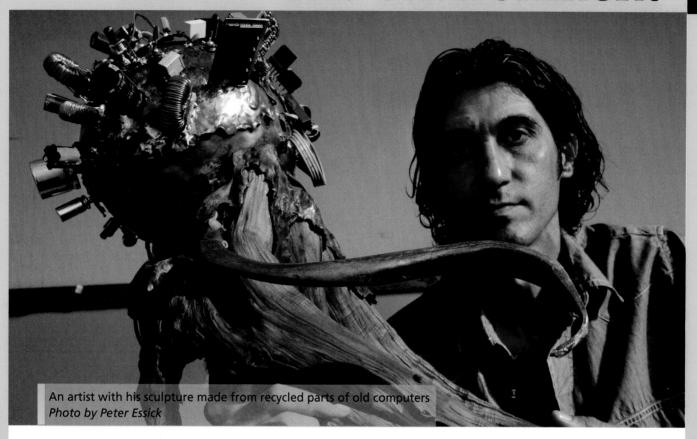

An artist with his sculpture made from recycled parts of old computers
Photo by Peter Essick

FEATURES

1 George Sabra is an artist and sculptor. Which of these materials did he use in the sculpture shown in the photo?

| cardboard | glass | leather | metal | paper | plastic | wood |

2 Answer the questions.

1 What everyday objects does Sabra use in his sculptures?
2 What do you think he does with these objects?
3 What do you think he wants us to think about?

3 Look at the highlighted expressions for talking about objects. Make sentences about these everyday objects in a similar way.

A dictionary is made of paper. You use it for looking up words.

| dictionary | cell phone | pen | scissors | tin can |

4 Working in pairs, describe what an everyday object is made of and what it's used for. Your partner has to guess the object.

5a Recycling

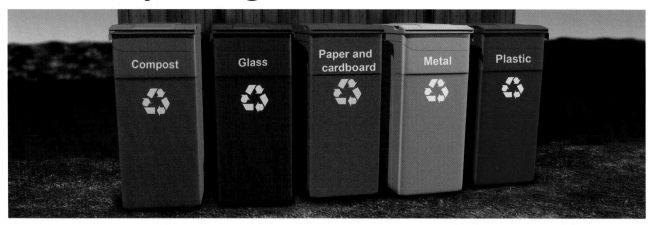

Compost Glass Paper and cardboard Metal Plastic

Vocabulary household items

1 How much do you recycle or reuse items at home or at work? How easy is it to recycle where you live?

2 Match each object with the correct recycling container above.

aluminum foil	carton	newspaper
plastic bag	coffee	eggshell
vegetable peel	jar	yogurt cup
tin can	envelope	bottle

3 Look at the grammar box. Which of the words in Exercise 2 are count (*C*) or noncount (*N*) nouns?

> ▶ **COUNT and NONCOUNT NOUNS**
>
> **Count nouns** have singular and plural forms: *a bottle, two bottles*.
> **Noncount nouns** are singular and have no plural forms. You cannot use them with numbers: *milk*.
>
> For more information and practice, see page 160.

Listening

4 🎵 **20** Listen to a radio call-in show and answer the questions.

1 Which caller (Raul or Sandra) thinks more people need to recycle?
2 Which caller doesn't think recycling helps the environment?

Grammar quantifiers

5 🎵 **20** Listen again and match the two parts of the sentences.

1	There aren't any	a	people on my street recycle.
2	There are some	b	bags.
3	They don't recycle much	c	recycling containers.
4	Not many	d	trash every week.
5	They throw away a lot of	e	minutes every day.
6	Some people recycle a little	f	recycling centers in my town.
7	You only need a few	g	stuff.

6 Find these quantifiers in the sentences in Exercise 5. Which of the quantifiers do we use to talk about small quantities?

any	a few	a little	a lot of	not many	not much	some

> ▶ **QUANTIFIERS**
>
> **Count nouns**
> We use *some*, *a lot of*, *many*, and *a few* in affirmative sentences. We use *any* or *many* in negative sentences or questions.
>
> **Noncount nouns**
> We use *some*, *a lot of*, and *a little* in affirmative sentences. We use *any* or *much* in negative sentences or questions.
>
> Note: *a lot of = lots of* (there is no difference in meaning or use)
>
> For more information and practice, see page 160.

7 Working in pairs, look at the grammar box. Then use the table to make sentences about what you recycle and throw away.

I We	(don't)	recycle throw away	a lot of many much any a few a little	metal newspapers plastic glass tin cans cardboard ink cartridges food

Reading

8 Read the article and answer the questions using quantifiers.

1 How many of us know where our e-trash goes?
2 Did Peter Essick follow the trash to lots of countries?
3 How many of the computers do sellers resell?
4 How much metal do the parts of the computers contain?
5 Why is the process of recycling these parts so dangerous?
6 How much e-trash does Peter Essick think we should export? Why?

> **WORDBUILDING**
> **hyphenated words**
> We often join words or parts of other words with a hyphen to make new words: *e-trash out-of-date, eco-friendly.*

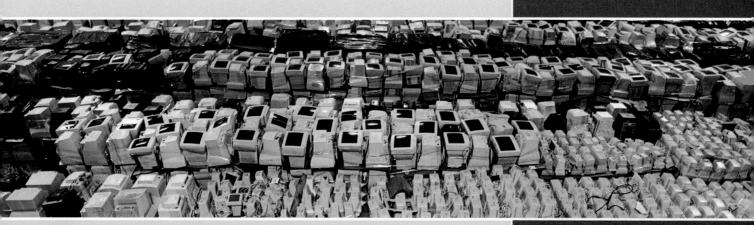

E-TRASH

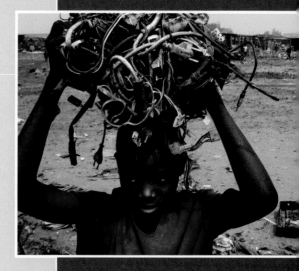

Nowadays, every household produces electronic trash (or e-trash)—an old TV or computer, a printer, or an out-of-date cell phone. But when we throw these everyday items away, not many of us know where they go. The journalist and photographer, Peter Essick, decided to follow this e-trash to several countries around the world.

In particular, Essick found that a lot of e-trash goes to Ghana. There, he saw mountains of old computers in the local markets. The sellers resell some of them, but not many work. Instead, they recycle the broken computers by melting the parts inside. These parts contain a little metal such as copper or even gold. However, this recycling process is dangerous for the workers because it produces a lot of toxic chemicals.

As a result of his journey, Peter Essick thinks it's important to stop exporting e-trash. It's bad for the environment and it's bad for people's health. Instead, he believes manufacturers need to produce more eco-friendly electronics, in other words, electronic products that you can recycle cheaply, safely, and in the country where they are made.

melt (v) /melt/ to heat an object until it turns to liquid
toxic (adj) /'tɑksɪk/ poisonous

9 Complete these sentences about the article. Then compare your sentences with the class.

I knew *a little / a lot* about this topic before reading this.

This article *is / isn't* surprising for me because …

I *agree / don't agree* with Essick because …

Speaking

10 Working in pairs, imagine you are talking on a radio call-in program.

Student A: You are the radio host. Turn to page 153 and follow the instructions.

Student B: You are a caller. Turn to page 154 and follow the instructions.

5b The Greendex

Reading and speaking

1 We describe people and their behavior as "green" when they help the environment. Are you green? Do you...

- recycle your trash?
- ever buy second-hand goods?
- turn off computers and TVs before going to bed?
- use public transportation or car pools?

Can you think of more ways to be green?

2 Working in groups, read the article and discuss the questions.

1 What is the purpose of the "Greendex"?
2 Is your country in the survey?
3 What kinds of cost do you think each of the four categories includes (housing = electricity, gas)?

3 Label the pie charts (1–5) with the correct country.

The Greendex™

The "Greendex" is a survey of 17,000 consumers in 17 countries. It finds out how these people regularly spend their money. The four categories for spending are: housing, food, transportation, and "other goods" (such as electronic items and household appliances).

LATEST RESULTS FROM THE GREENDEX:

- About ninety percent of people in Argentina eat beef nearly every day.
- Exactly half of all Russians use public transportation every day or most days.
- Just over two-thirds of people in Germany drink a bottle of water daily, and most of them also recycle the bottle.
- Consumers in the United States have the most TVs at home. Almost three-quarters have four or more.
- Nearly half of all Canadians regularly recycle electronic items.

1 _____ 2 _____ 3 _____ 4 _____ 5 _____

Vocabulary facts and figures

4 Look at these words from the article and choose the correct percentage (a–c).

1. about ninety percent
 a 89% b 90% c 99%
2. exactly half
 a 49% b 50% c 51%
3. just over two-thirds
 a 64% b 66% c 69%
4. almost three-quarters
 a 66% b 69% c 74%
5. nearly half
 a 48% b 50% c 52%

5 Divide the pie chart to show what percentage of your money you spend on each category.

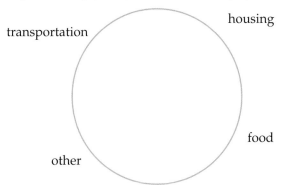

transportation

housing

other

food

6 Work in pairs. Present your pie chart using words from Exercise 4.

> *I spend about half my money on …*

> *Almost eighty percent is for …*

Grammar definite article (*the*) or no article

7 Complete the text with *the* or Ø (no article). Then check your answers in the Greendex results in Exercise 3.

- Just over two-thirds of people in ¹ _____ Germany drink a bottle of water daily, and most of them also recycle ² _____ bottle.
- ³ _____ consumers in ⁴ _____ United States have ⁵ _____ most TVs at ⁶ _____ home.

8 Look at the grammar box. Then match the rules (a–f) in the grammar box with items 1–6 in Exercise 7.

> ▶ **DEFINITE ARTICLE (*THE*) or NO ARTICLE**
>
> Use the **definite article** (*the*):
> a with something or someone you mentioned before.
> b when it is part of the name of something (*the United States*).
> c with superlative phrases (*the best*).
>
> Use **no article**:
> d with most countries.
> e to talk about people and things in a general way.
> f with certain expressions (*at night, at school*).
>
> For more information and practice, see page 160.

9 Look at these sentences from the Greendex survey. Delete *the* where it isn't necessary.

1. ~~The~~ European houses do not have air conditioning.
2. Countries such as the Brazil are using the electric cars more and more.
3. Many people around the world are trying to use less energy at the home.
4. The fish and seafood is the most common dish in the Japan.
5. The people in the United States are sharing the cars to save costs.
6. One way you can try to be green at the home is by shutting off the lights when you leave a room.

10 Pronunciation /ðə/ or /ði/

a 🔊 **21** Listen to the difference in the pronunciation of *the* before a consonant sound and a vowel sound.

/ðə/ /ði/
the TV the Internet

b 🔊 **22** Listen and write /ðə/ or /ði/. Then listen again and repeat.

1. the bottle 5. the electricity
2. the phone 6. the gas
3. the fuel 7. the insurance
4. the apple 8. the water

Writing and speaking

11 Work in groups. You are going to prepare a Greendex report about the class. Follow these steps:

1. Write eight to ten questions to find out how green everybody is.
2. Each group member meets students from the other groups and interviews them using the questions.
3. Working with your first group again, collect the information from your questions and summarize the results.
4. Present your conclusions to the class using pie charts to help your presentations.

5c A boat made of bottles

Reading

1 Look at these words from the article on page 63. What do you think it is about? Then read the article and see if your predictions were correct.

> boat plastic bottles recycle sail San Francisco
> Sydney the Pacific Ocean

2 Complete the fact file about the *Plastiki*. Write the information as figures.

The ***Plastiki*** in **facts&figures**

Number of crew: [1]

Number of bottles: [2]
Length: [3] ft
Average speed: [4] knots

Number of days at sea: [5]

Cost to build: not known

Critical thinking close reading

3 Mark sentences 1–8 as true (T), false (F), or don't know (0) because the information isn't in the text.

1 The *Plastiki* is made of the same material as other boats.
2 Nowadays, humans recycle most of their plastic bottles.
3 The boat doesn't use renewable energy.
4 The crew only ate vegetables for the whole journey.
5 Plastic in the ocean is killing animals.
6 The size of the Great Garbage Patch is growing.
7 Some people criticized De Rothschild and his journey.
8 De Rothschild wants to sail the *Plastiki* again one day.

4 Do you think the *Plastiki* made a difference to people's attitude toward trash? Will De Rothschild's journey make people change their behavior? Why?

Word focus *take*

5 Find five expressions with *take* in the article on page 63. Then match them with the correct category (1–4).

...er to
...ation
...

...ours

...bloid
...elebrity

...was a

...ney toward a correct
taints that athlete's status as a
role model

take /teɪk/
1 transportation: *take a taxi*
2 daily routines: *take a walk*
3 lengths of time: *take a few days*
4 idioms: *take time (to do something)*
takeaway /teɪkəweɪ/
1 food: *we ordered some Chinese*

6 Complete the sentences with *take* and these phrases.

> regular breaks many days care
> a plane time

1 Most people *take a plane* from San Francisco to Sydney.
2 The journey across the Great Garbage Patch
3 The journey was tiring and the crew needed to
4 For this kind of project, it's important to and plan everything before you leave.
5 The Pacific Ocean can be dangerous so everyone on the ship had to

Speaking

7 Working in pairs, prepare to interview David De Rothschild about the *Plastiki*. Write six to eight questions using the information in the article and asking him anything else you would like to know.

> *How long did the whole journey take?*

> *Do you think you made a difference?*

8 Change partners with another pair and take turns roleplaying the interview. When you play De Rothschild, use information from the article or create new answers with your own ideas and opinions.

A boat with a difference

The *Plastiki* looks similar to many other boats or yachts in Sydney harbor. It's sixty feet (18 m) long and it carries a crew of six people and has an average speed of five knots. However, once you get near the *Plastiki* you realize there's a big difference: it's made of twelve thousand five hundred reclaimed plastic bottles!

How did the *Plastiki* begin?

One day, the environmentalist David De Rothschild was reading some information about all the plastic in the oceans. He couldn't believe what he was reading. For example, humans throw away four out of every five plastic bottles they use, and plastic trash causes about eighty percent of ocean pollution. Soon afterwards, De Rothschild decided he wanted to help fight against ocean pollution. To create publicity for the problem, he started building a boat made of plastic bottles.

Designing the *Plastiki*

In addition to building the boat with recycled plastic, De Rothschild felt it was important to make the boat environmentally friendly and user-friendly. The *Plastiki* uses renewable energy sources like wind power and solar energy. The crew can make meals with vegetables from the small garden at the back of the boat. They can take a break from work and get some exercise by using a special exercise bicycle that provides power for the boat's computers. And if anyone needs to take a shower, the boat's shower uses seawater.

The journey

De Rothschild sailed the *Plastiki* across the Pacific Ocean from San Francisco to Sydney. On the way, De Rothschild took the special boat through the "Great Garbage Patch," a huge area in the Pacific with almost four million tons (3.5 billion kg) of trash. You can see every kind of human trash here: shoes, toys, bags, toothbrushes—but the worst problem is the plastic. It kills birds and sea life.

How well did the *Plastiki* survive the journey?

The journey wasn't always easy and De Rothschild and his crew had to take care during storms. They ran into giant ocean waves and incredible winds. The whole journey took one hundred and twenty-nine days. Originally, De Rothschild thought the boat could only travel once, but it survived so well that he is planning to sail it again one day.

A BOAT *made of* BOTTLES

knot (n) /nɑt/ measurement of speed at sea. 1 knot = 1.2 mi (1.8 km)/hr.
patch (n) /paetʃ/ area

5d Online shopping

Reading

1 Do you normally go shopping or do you prefer shopping online?

2 Read the website and email order. What did the customer order? What is the problem?

WWW.TECOART.COM

| HOME | MY ACCOUNT | SHOPPING CART | CHECKOUT |

Unusual clocks, Office clocks, Unique clocks, Computer clocks, Computer art, and Vintage clocks all from recycled computers!

Computer Hard Drive Clock with Circuit Board
$39.00

Apple iPod Hard Drive Clock on a Circuit Board
$35.00

Order number: 80531A

Order Date: March 20

Thank you for your order. Unfortunately, the model you ordered is currently not available. We expect delivery in seven days. We apologize for the delay. For further information, or to speak to a customer service representative, please call 800-555-0175.

Ms. Jane Powell
90 North Lane

Item Number	Description	Quantity	Price
HCV1N	Hard drive clock	1	$35

Real life calling about an order

3 🔊 **23** Jane Powell calls customer service about her order. Listen to the conversation and answer the questions.

1 What information does the customer service representative ask for and check?
2 Why does Jane want the clock quickly?
3 How much does the other clock cost?
4 What does Jane decide to do?
5 What will the customer service representative email her?

4 🔊 **23** Look at the expressions for calling about an order. Then listen to the conversation again and mark the sentences the customer service representative uses.

> ▶ **CALLING ABOUT AN ORDER**
>
> **Telephone expressions**
> Good morning. Can I help you?
> I'm calling about an order for a clock.
> Can I put you on hold for a moment?
> Is there anything else I can help you with?
>
> **Talking about an order**
> Do you have the order number?
> Would you like to order something else?
> Would you like to cancel the order?
> Would you like a refund?
> Would you like confirmation by email?
>
> **Checking and clarifying**
> Is that A as in alpha?
> Let me check.
> So that's F as in Freddie.
> That's right.

5 Pronunciation sounding friendly

a 🔊 **24** Listen to the sentences and mark if the customer service representative sounds friendly (F) or unfriendly (U).

1 Good morning. Can I help you?
2 Can I put you on hold?
3 Is that A as in alpha?
4 I'm calling about an order.
5 Is there anything else I can help you with?
6 Do you have an order number?

b 🔊 **25** Listen to the sentences again but notice that now they are all friendly. Repeat with a similar friendly intonation.

6 Working in pairs, practice two phone conversations similar to the one in Exercise 3.

Student A: Turn to page 153 and follow the instructions.

Student B: Turn to page 155 and follow the instructions.

5e Problems with an order

Writing emails

1 Put these emails (1–5) between a customer and a customer service representative in order.

> **A** Dear Mr. Cottrell,
>
> I would like to inform you that the e-book reader you ordered is now in stock. I would be delighted to deliver this item immediately. Please reply to confirm you still require this item.
>
> Charlotte Lazarro

> **B** Dear Sir or Madam:
>
> I recently ordered an e-book reader and received an email which said that it was not currently available. Please refund my credit card.
>
> Yours sincerely,
>
> Mr. M. Cottrell

> **C** Thanks, but I bought the same product at a store yesterday. Therefore, please cancel the order and, as requested, send me a refund.
>
> M. Cottrell

> **D** As requested, here is the order number: 80531A

> **E** Dear Mr. Cottrell,
>
> Thank you for your email. I apologize for the problem with your order. In order to provide you with the necessary assistance, could you please send the order number?
>
> Best regards,
> Charlotte Lazarro
> Customer Service Assistant

2 Read the emails in Exercise 1 again. Underline any phrases and expressions that request something or give instructions to do something.

3 Writing skill formal language

a The language in the emails in Exercise 1 is fairly formal. Match the formal verbs in the emails to these less formal verbs and phrases (1–9).

1 get _receive_
2 agree
3 asked for
4 give
5 give back (money)
6 help
7 say sorry
8 tell
9 want

b Working in pairs, make these sentences more formal.

1 I want my money back.
2 I'm writing to tell you that I didn't get the delivery.
3 Do you want any help?
4 Please give us your credit card details.
5 Sorry, but I can't give you your money back.

4 Working in pairs, exchange emails (1) as a customer who ordered a printer that doesn't work and is requesting a refund from the supplier, and (2) as the supplier sending a formal reply.

5 Work in pairs. Exchange emails with your partner. Write a formal reply from the supplier to your partner's email.

6 Use these questions to check the emails in Exercise 5.

- Did the writer make polite requests and give clear instructions?
- Did the writer use formal language?

5f Coastal cleanup

Video

The aim of this cleanup is to make the coastlines beautiful again.

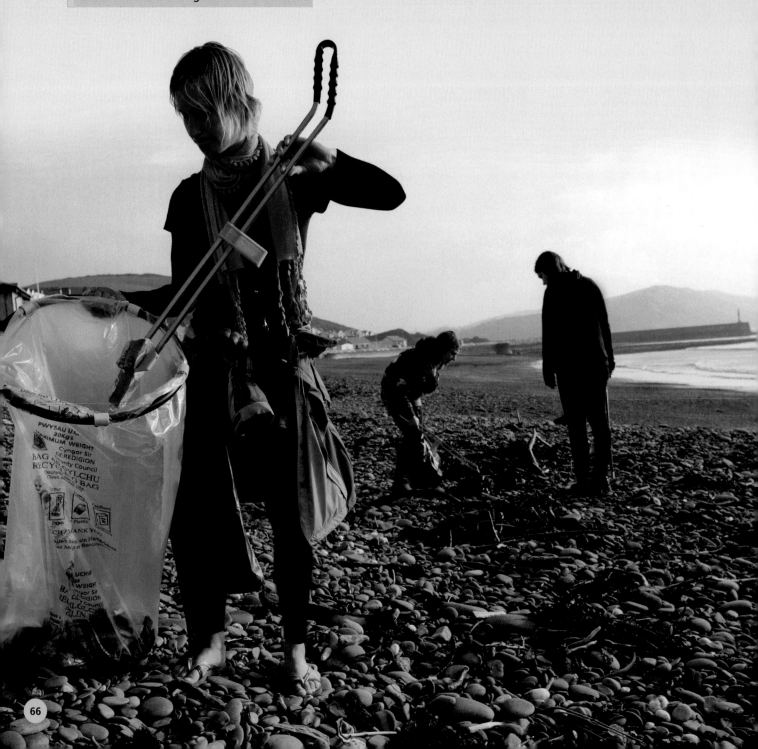

Before you watch

1 Working in groups, look at the photo and the video's title and discuss:

1 Where you think the people are.
2 What you think they are doing, and why.
3 What they might be thinking.

While you watch

2 Check your ideas from Exercise 1.

3 Number the actions in the order you see them.

a writing information on a form
b getting off a bus
c swimming underwater
d picking up tin cans
e putting bags of trash on a boat

4 Mark the sentences true (T) or false (F).

1 The government pays the people who collect the trash.
2 They collect a lot of trash along the coast.
3 The Ocean Conservancy makes a note of every piece of trash it collects.
4 Most of the trash comes from boats at sea.
5 They cleaned everything up along the river, so there isn't anything more to do there.

5 According to the video, what do these numbers and dates refer to?

1 half a million

2 almost 4,000 tons

3 35

4 1986

5 2,000 pounds

6 Complete what the people say with these words.

| amazing | disgusting | litter |
| shocked | trash | twice |

"It's ¹ _____ all this stuff that's out here. I was so ² _____ when I came out here. I thought 'Oh, you know people don't ³ _____ that much.' You see stuff on the side of the road, but when you come here it's just everywhere."

"Yeah it is pretty ⁴ _____ , actually. We can pick a lot of it up one day and the next day we come back and there's ⁵ _____ as much as the day before. So it seems like there is no end to the ⁶ _____ ."

7 According to the narrator, what are the two reasons for doing the cleanup?

After you watch

8 **Roleplay a conversation between a coastal cleanup volunteer and a member of the public**

Work in pairs.

Student A: You are a coastal cleanup volunteer and you want to get more volunteers. Make a list of reasons for helping with the coastal cleanup.

Student B: You live near the coast but you enjoy your free time and don't want to help with the coastal cleanup. Make a list of reasons why you are busy and can't volunteer.

Act out the interview. Student A must convince Student B to volunteer. Then change roles and repeat the conversation.

9 The Ocean Conservancy official says: "we are getting there." What does he mean?

10 Working in pairs, discuss these questions.

1 Are there places in your country that have a lot of trash?
2 Would you do volunteer work like this?
3 How can you stop people from littering?

amazing (adj) /ə'meɪzɪŋ/ very surprising
cigarette butt (n) /ˌsɪgə'ret ˌbʌt/ the part of the cigarette people throw away after they finish smoking it
cleanup (n) /'klin.ʌp/ the process of making something clean
coast (n) /koʊst/ the place where the ocean meets the land
collect (v) /kə'lekt/ pick up
disgusting (adj) /dɪs'gʌstɪŋ/ very unpleasant
litter (v) /'lɪtər/ leave things like paper and plastic bags in public places after you finish using them

search (v) /sɜrtʃ/ look for
shocked (adj) /ʃɑkt/ surprised in a negative way
trash (n) /træʃ/ things people throw away when they don't need them
twice (adv) /twaɪs/ two times
volunteer (n) /ˌvɑlən'tir/ a person who does something without being paid

UNIT 5 REVIEW

Grammar

1 Choose the correct options to complete the article about recycling. (Ø = no article)

Recycling around the World

New statistics give a view of recycling around the world. Here are three of the countries in the report.

Switzerland
[1] *A / The* Swiss score well at recycling. Many different types of recycling containers are available, so local people only have to throw away [2] *a little / a few* household items. For example, they recycle 80% of their plastic bottles. That's much higher than in other countries in [3] *Ø / the* Europe which have plastic recycling levels of only between 24–40%.

United States of America
Overall [4] *Ø / the* U.S. doesn't recycle as [5] *many / much* trash as a country like Switzerland, but it's introduced [6] *a lot of / any* new projects in recent years so its record is improving quickly. This year it recycled 48% of its paper, 40% of its plastic bottles, and 55% of its cans.

Senegal
Senegal only recycles [7] *a few / a little* of its industrial waste, but people don't throw away [8] *any / much* items that they can use for something else. For example, they make shoes from old plastic bags and drinking cups from tin cans. Everything has another use.

2 Working in pairs, discuss which country in the article:

1 recycles the most
2 reuses items the most
3 your country is most like

3 Ask your partner these questions after you complete them with *many, much,* or *any*.

1 How _____ of your trash do you recycle: 70% or more, between 30 and 69%, or less than 29%?
2 How _____ newspapers and magazines do you buy a week?
3 Do you ever reuse _____ of your household items for something else? For example, glass jars to put other items in, or vegetable peels for compost?

4 Name three different countries in each region.

South America	Europe	Asia	Africa
the Middle East			

I CAN	
talk and ask about quantities	
talk about countries and different regions in the world	

Vocabulary

5 Match the percentages from the article in Exercise 1 with the definitions (1–5).

1 just over half 4 two-fifths
2 four-fifths 5 nearly half
3 about a quarter

6 Working in pairs, make two sentences about your weekly life using percentages. Talk about:

- the amount of time you spend at work each week.
- how much money you spend on food.

Then say the same sentences using descriptions like "a quarter" or "over half."

I CAN	
talk about facts and figures	

Real life

7 Working in pairs, practice making a telephone call.

Student A: You want to speak to the Customer Service Manager at an online company. You bought a TV but it doesn't work and you want them to pick it up and replace it. Call the customer helpline and explain your problem.

Student B: You work at the customer helpline for the online company and your manager is not available. Take the caller's name and number and write down the details of the complaint.

I CAN	
make a telephone call	
answer a telephone call	

Speaking

8 Write three sentences about your country or another in the world. Make two of them true, and one of them false.

Example:
1 *The United States has a population of over three hundred million people.*
2 *The average person in the US works about forty hours a week.*
3 *Seventy percent of the population in the US is below the age of 30.*
(Sentence 3 is false.)

9 Working in pairs, take turns saying your three sentences and guessing which of each other's sentences is false.

Unit 6 Stages in life

The Egyptian Sphinx

FEATURES

1 The Sphinx is from ancient Greek and Egyptian mythology. The Sphinx in the photo is the most famous sphinx in the world. Where is it? What else do you know about it?

2 Read this story about the Sphinx. Do you know the answer to the Sphinx's question? Check answers with your teacher.

> In Greek mythology, the Sphinx was a giant monster with the body of a lion, the wings of a bird, and a human head. When travelers wanted to enter the city of Thebes, the Sphinx asked them a question: "What goes on four legs in the morning, on two legs at noon, and on three legs in the evening?" The Sphinx killed any traveler who didn't answer correctly.

3 Look at these different life events. Answer the questions.

> retire get engaged get married
> get a driver's license go to college or university
> learn to ride a bike leave home start a family
> start a career

1 At what age do people in your country do these things?
2 Do you think it's important to do each one at a particular age?

6a Changing your life

Vocabulary stages in life

1 Put these stages of life in the correct order (1–7) from youngest to oldest.

> adolescent child infant middle aged
> senior citizen teenager young adult

2 At what age do you think these stages begin and end? What is your current stage of life?

Reading

3 Read the article on page 71. At what stage of their life did Rich and Amanda decide to leave their jobs?

4 Underline the answers to these questions.

1 What did they intend to do on the weekend?
2 What did they realize they wanted to do?
3 Why did they buy a camper?
4 Where did they want to go by container ship?
5 How did colleagues and friends react?
6 What did Rich and Amanda start to do after they left home?

5 Who are you most like, Rich and Amanda, or their colleagues and friends? Explain your answer.

Grammar and listening verb patterns with *to* + infinitive

6 Look at the sentences (a–c) and match them to the verb patterns (1–3).

a We intend to leave our jobs.
b Let's buy a camper to travel in.
c It's difficult to understand your decision.

1 a verb followed by *to* + infinitive
2 an adjective followed by *to* + infinitive
3 a *to*-infinitive pattern to explain the purpose of the main verb

> ▶ **VERB PATTERNS WITH *TO* + INFINITIVE**
>
> **1 verb + *to* + infinitive**: *We intend/plan/want/hope/'d like to travel across Africa.*
> **2 adjective + *to* + infinitive**: *It isn't easy to learn. That's good to know.*
> **3 infinitive of purpose**: *Save your money to buy something special.* (= in order to do something)
>
> For more information and practice, see page 161.

7 🔘 26 Listen to three people talking about their plans and intentions and say what their stage in life is. Then match the two parts of the sentences.

1 One day I plan to
2 I want to take a year off to
3 I'd like to travel to
4 I intend to
5 I'll be happy to
6 These days, it's really difficult to
7 It's hard not to

a get some work experience abroad.
b do all the things I wanted to do.
c buy a house.
d go to college.
e leave my job.
f feel sad about it.
g somewhere like Chile.

CHANGING
your life

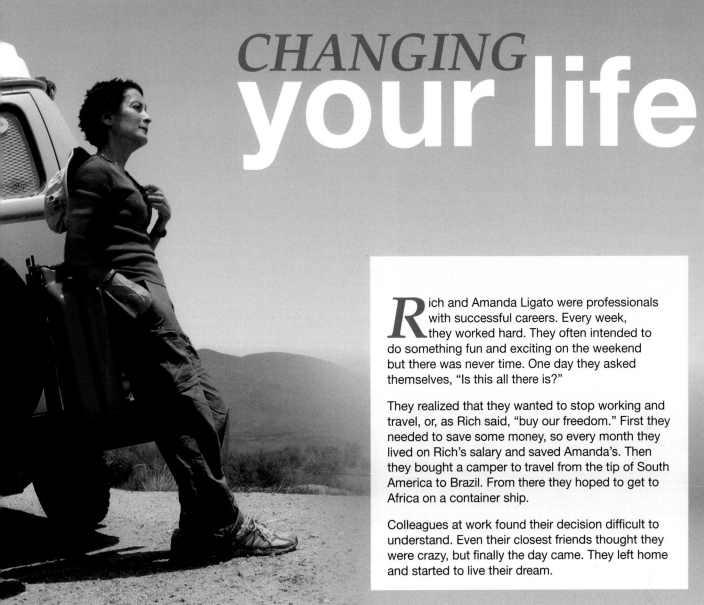

Rich and Amanda Ligato were professionals with successful careers. Every week, they worked hard. They often intended to do something fun and exciting on the weekend but there was never time. One day they asked themselves, "Is this all there is?"

They realized that they wanted to stop working and travel, or, as Rich said, "buy our freedom." First they needed to save some money, so every month they lived on Rich's salary and saved Amanda's. Then they bought a camper to travel from the tip of South America to Brazil. From there they hoped to get to Africa on a container ship.

Colleagues at work found their decision difficult to understand. Even their closest friends thought they were crazy, but finally the day came. They left home and started to live their dream.

8 Pronunciation /tə/

🔊 **27** Listen again to the sentences in Exercise 7 and notice how *to* is not stressed /tu/ but pronounced /tə/. Repeat them.

9 Write your own sentences using the sentence beginnings (1–7) in Exercise 7. Then compare your sentences with your partner's.

Speaking

10 Working in groups of three or four, imagine you are one of the people on the right. Read about your current situation and make plans for the future. What do you need to do or buy to change your life?

11 Present your plans to your group. Do they think they're good or do they find them difficult to understand?

Maria (45) and Javier (43)
They are accountants who own a small apartment in a city. They love skiing but they never have time because the mountains are so far away.

Ahmed (25)
When he was young, he wanted to be a movie star but his parents said that being an actor was difficult. He studied engineering instead and got a good job. However, he still dreams about being in movies.

Lucy (68)
She's a retired teacher and gets a good pension, but she's bored. She never traveled when she was younger but she likes watching travel shows on TV.

6b World party

WORLD PARTY

People in different countries celebrate Mardi Gras with live music, costumes, fireworks, parades, and lots of good food. These are the most famous celebrations:

New Orleans, US
Small parties for Mardi Gras began in the 1700s, and by the 1800s, they were huge events with masks, costumes, and jazz bands. Visitors can enjoy "King Cake," with its gold, purple, and green decorations.

Venice, Italy
Mardi Gras is called *Carnevale* in this beautiful city. The first celebrations were in the 11th century, and you can still enjoy the costumes, candles, and fireworks at night from a gondola in Venice's canals.

Rio de Janeiro, Brazil
The world-famous parades started in the mid-1800s with decorated floats and thousands of people dancing to samba. People eat the famous meat and bean stew called *feijoada*.

Port-of-Spain, Trinidad
The French landed here in the 18th century and brought Mardi Gras with them. From morning to midnight, everyone enjoys the parties and concerts with the famous steel drums.

Reading and vocabulary celebrations

1 What events do you celebrate in your country? Are there parties?

2 Look at the first paragraph of the article. Why is Mardi Gras called a "World Party"?

3 Read the article then match the sentences (1–6) to the place described.

1 There were no Mardi Gras celebrations here before the mid-1800s.
2 It has the oldest celebration.
3 One type of food is decorated with different colors.
4 One type of musical instrument is especially important.
5 One type of music is especially important.
6 People can travel to the party on a type of boat.

4 Find words in the article for these pictures.

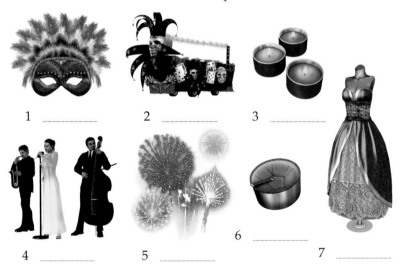

1 2 3

4 5 6 7

5 Working in groups, describe your favorite festival or celebration. Think about these things.

- History: When and why did it begin?
- Traditional food: Is there any special festival food?
- Clothes: Do people wear special costumes or masks?
- Parades: Do people walk around the streets or ride on floats? Do you have fireworks in the evenings?
- Live music: Is music important? If so, what kind?

Listening

6 ◎ **28** Listen to a news item about Mardi Gras. Where is the presenter?

7 ◎ **28** Listen again and answer the questions with *Yes* or *No*.

1 Are a lot of people going to come?
2 Is the woman riding on the float alone?
3 Is she wearing her mask at the start?
4 Does the reporter think Lorette will have a good time?

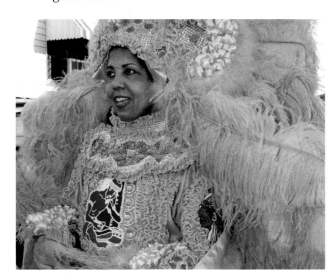

Grammar **future forms**

8 Look at the sentences (a–c) and answer the questions (1–3).

a Are you going to be in the parade today?
b I'm meeting everyone later at the float.
c A: Do you have a mask?
 B: Yes, I'll put it on.

1 Which sentence is about a plan or future intention? (It was decided before the conversation.)
2 Which sentence is a decision during a conversation?
3 Which sentence is about an arrangement with other people at a certain time in the future?

▶ FUTURE FORMS		
going to		
I'm		
he's/she's/it's	*going to* + verb	
you're/we're/they're		
'll (will)		
I/he/she/it/you/we/they	*'ll* + verb	
Present continuous for future		
She's leaving next Friday. When are they arriving?		
For more information and practice, see page 161.		

9 Choose the correct options to complete the sentences.

1 A: Did Pablo email the times for the parade?
 B: I don't know. *I'll check / I'm checking* my inbox right away.
2 *You'll go / You're going* to visit New Orleans! When did you decide that?
3 A: Hey, this costume would look great on you.
 B: Maybe. *I'm trying / I'll try* it on.
4 A: I forgot to tell you. I'm traveling back home today.
 B: Oh, so *I won't see / I'm not seeing* you later?
5 One day when I'm older, *I'm visiting / I'm going to visit* Venice.
6 A: What time *will we meet / are we meeting* everyone for the parade?
 B: At two in the main square.
7 A: *Are we going to give / Will we give* Mark the present tonight?
 B: No, because his birthday isn't until tomorrow.
8 A: What time *will you leave / are you leaving*?
 B: Right after the fireworks display.

Speaking

10 Work in groups. Next year, your town is 500 years old. Have a town meeting to plan and prepare a celebration. Discuss this list. Decide what you need and who is in charge of organizing each thing.

- type of celebration (a party, floats, parade, fireworks)
- type of food
- music
- location, indoors or out
- date and time
- items to buy and who will buy them
- who's in charge of what

We're celebrating the town's birthday next year ...

I'll buy the food!

11 Present your final plans to the whole class. Explain what you are going to do.

We're going to ...

6c Masai rite of passage

Reading

1 Discuss these questions.

 1 At what age can people legally do these things?

> drive a car get married leave home
> buy fireworks open a bank account

 2 When do you think teenagers become adults?
 3 Do you have special celebrations in your country when young people become adults?

2 Look at the photo and the title of the article on page 75. What do you think the expression "rite of passage" means? Choose the correct option (a or b), then read the article and check.

 a a long journey from one place to another
 b a traditional celebration when you move from one stage of life to the next

3 Match the number of each paragraph in the article (1–6) with the answer to each question (a–f).

 a How is hair important in Masai culture?
 b Where do the Masai live? *1*
 c What are the Masai best known for?
 d What is the "osingira"?
 e Who are the warriors?
 f How does "Eunoto" end?

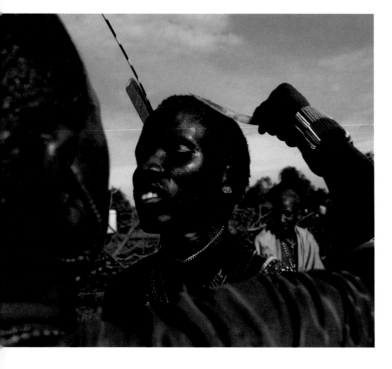

Critical thinking identifying key information

4 Write notes about "Eunoto." Use these headings and only write down the most important information from the article.

- Location
- Purpose
- Special clothing or appearance
- Special places
- Responsibilities of older men and women

5 Working in pairs, compare your notes from Exercise 4. Did you include the same information?

Word focus *get*

6 *Get* has different meanings. Underline examples of *get* in the article with these meanings.

> arrive become receive

7 Read the description of a wedding below, noticing the different ways we can use *get*. Replace the bold words with these words.

> ~~become~~ meet and socialize prepare
> receive return wakes up and gets out of bed

> Once the couple [1] **get** *become* engaged, people start to [2] **get ready** _____ for the big day! On the morning of the wedding, everyone [3] **gets up** _____ early. Family and friends sometimes have to travel long distances but it's always a great chance for everyone to [4] **get together** _____ . After the main ceremony, the couple [5] **get** _____ a lot of presents. Nowadays, many couples go abroad on their honeymoon. When they [6] **get back** _____ , they move into their new home.

Speaking

8 Working in pairs, describe one of these events to each other. Try to use the word *get* three times in your descriptions.

> a birthday a religious day or period
> New Year's Day your country's national day
> Valentine's Day another special occasion

MASAI RITE OF PASSAGE

The Masai are an African tribe of about half a million people. Most of them live in the country of Kenya, but they are also nomadic. Groups of Masai also live in other parts of east Africa, including northern Tanzania, and they move their animals (cows, sheep, and goats) to different areas of the region.

There are many other African tribes but, for many people, the Masai are the most well-known. They are famous for their bright red clothing and their ceremonies that include lots of music and dancing. One of the most colorful ceremonies is the festival of Eunoto, a rite of passage when teenaged Masai boys become men.

Eunoto lasts for many days, and Masai people travel across the region to a special place near the border between Kenya and Tanzania. The teenage boys who travel with them are called "warriors." This is a traditional name from the past when young men fought with other tribes. Nowadays, these warriors spend most of their time looking after their cattle.

When they get there, at the beginning of the ceremony, the teenagers paint their bodies. Meanwhile, their mothers build an "osingira," a sacred room in the middle of the celebrations. The older men from different tribes sit inside this place and the boys go inside to meet them. Later in the day, the boys run around the osingira going faster and faster each time. It is another important part of the ritual.

The teenagers also have to change their appearance at Eunoto. Masai boys' hair is very long before the ritual but they have to cut it off. In Masai culture, hair is an important symbol. For example, when a baby grows into a young child, the mother cuts the child's hair and gives the child a name. At a Masai wedding, the hair of the bride is cut off as she becomes a woman. And so, at Eunoto, the teenage boy's mother cuts his hair off at sunrise.

On the final day, the teenagers meet the senior elders one more time. They get this advice: "Now you are men, use your heads and knowledge." Then people start to travel back to their homelands. The teenagers are no longer warriors but adult men who will get married, have children, and buy cattle. Later in life, they will be the leaders of their communities.

tribe (n) /traɪb/ large group of families living in the same area
nomadic (adj) /noʊˈmædɪk/ never staying in one place
warrior (n) /ˈwɔriər/ soldier or someone who fights for the tribe
ritual (n) /ˈrɪtʃuəl/ formal ceremony with different stages
sunrise (n) /ˈsʌnˌraɪz/ when the sun comes up
elder (n) /ˈɛldər/ older, experienced person in a tribe or community

6d An invitation

Speaking

1 Which of these events are very formal? Which are less formal?

> an end-of-semester party
> an engagement party
> a barbecue with family and friends
> a going-away party for a colleague
> your grandfather's ninetieth birthday party
> going out to dinner with a client

Real life inviting, accepting, and declining

2 🔊 **29** Listen to two conversations and answer the questions.

Conversation 1
1 To what event does Ian invite Abdullah?
2 Why does Abdullah decline the invitation at first?
3 How does Ian convince Abdullah to come?
4 Does Abdullah need to get anything?

Conversation 2
5 When is Sally leaving?
6 What does Jasmine invite Sally to do?
7 Does Sally accept the invitation?
8 Do you think this conversation is more or less formal than conversation 1? Why?

3 🔊 **29** Look at the expressions for inviting, accepting, and declining. Then listen to the conversations again and mark the expressions the speakers use.

▶ INVITING, ACCEPTING, AND DECLINING		
	Less formal	**More formal**
Inviting	Do you want to …? How about -*ing*? Why don't you …?	Would you like to come to …? I'd like to take you to …
Accepting	It sounds great/nice. Thanks, that would be great. Yes, OK.	I'd like that very much. That would be wonderful. I'd love to.
Declining	Thanks, but … Sorry, I can't. I'm …	I'd like/love to, but I'm afraid I … It's very nice of you to ask, but I …

4 **Pronunciation** emphasizing words

a 🔊 **30** Listen to these sentences from the box in Exercise 3 and underline the word with the main stress.

1 I'd love to.
2 That would be wonderful.
3 It's very nice of you to ask.
4 I'd like to, but I'm afraid I'm busy.

b 🔊 **30** Listen again and repeat with the same sentence stress.

5 Work in pairs. Take turns to invite each other to different events. Think about how formal you need to be, and practice accepting and declining.

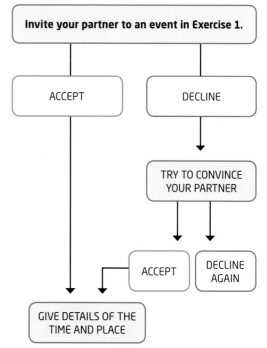

> **Invite your partner to an event in Exercise 1.**
>
> ACCEPT
>
> DECLINE
>
> TRY TO CONVINCE YOUR PARTNER
>
> ACCEPT
>
> DECLINE AGAIN
>
> GIVE DETAILS OF THE TIME AND PLACE

6e A wedding in Madagascar

Writing a description

1 On the website Glimpse, people write descriptions of their experiences abroad. Read this post. Which of the items in the box does the writer describe?

> food and meals clothes festivals and ceremonies
> nature and geographic features people
> towns, cities, and buildings transportation

glimpse YOUR STORIES FROM ABROAD

I was staying in Madagascar with a family when they invited me to their daughter's wedding. On the big day, I arrived outside an enormous tent. There was a zebu at the entrance and it looked miserable. Inside the tent, there were beautiful decorations. Over 300 excited relatives and guests were waiting for the bride and groom to arrive. The women wore colorful dresses. The older men wore gorgeous suits but the younger men were dressed less formally. I even saw jeans and T-shirts. Finally, the ceremony began with some very long and sometimes dull speeches. But the crowd listened politely and sometimes laughed and applauded. Finally, it was dinner and I suddenly realized what the zebu was for. We ate from huge plates of meat. I felt sorry for the zebu but the meat was delicious!

2 Writing skill descriptive adjectives

a Match the highlighted adjectives to these less descriptive ones (1–4).

1 big _enormous_, _____
2 unhappy _____
3 nice _beautiful_, _____, _____, _____
4 boring _____

> ▶ **WORDBUILDING synonyms**
> Some words have the same meaning as another word. These are called synonyms: *historic = old, big = huge, boring = dull.*

b Working in pairs, improve these sentences with more descriptive adjectives. You can use words from the description above or your own vocabulary.

1 Venice is a ~~nice~~ *beautiful* city with lots of ~~old~~ *historic* buildings.
2 In the US, you can buy big burgers.
3 The parade was somewhat boring after a while.
4 The crowd was happy when the nice fireworks started.
5 All the costumes were nice.
6 I was very sad to leave Paris.
7 I tried sushi for the first time and it was really good.
8 The view of the mountains was nice.

c Work in pairs. Look back at the list of subjects in Exercise 1. Think of two or three interesting adjectives to describe the items in Exercise 1. Use a dictionary to help you. Then join another pair and compare your adjectives.

Example:
food and meals – delicious, tasty, disgusting

3 Choose one of these topics and write a short description (one paragraph) for the Glimpse website.

- a day you remember from a vacation
- your favorite place in the world
- a special occasion in your life
- a festival or celebration

4 Working in pairs, read each other's descriptions. Did you use interesting adjectives?

6f Steel drums
Video

Steel band music is a popular part of life here.

78

Before you watch

1 Working in groups, look at the photo and discuss:

1 where you think these people are from.
2 what kind of musical instrument they are playing.
3 why you think this music is important to them.

While you watch

2 Check your answers from Exercise 1.

3 Put these in the order you see them.

a Beverley and Dove learning to play
b a steel band with children and adults
c a person running into the ocean
d Honey Boy tuning a drum
e a man making an oil drum into a steel drum
f people selling food in a market

4 Answer the questions.

1 What are the islands of the Caribbean famous for?

2 Is the steel drum or pan native to all the islands?

3 When did people invent this musical instrument?

4 Why did Trinidad have so many oil drums?

5 Is the music of the island old? Where did it come from?

6 Do most people play by reading music?

7 What is the name of a person who tunes the drums?

8 Who do you find in a panyard?

5 Match the people (1–4) with the comments (a–d).

1 Beverly
2 woman in market
3 Tony Poyer
4 Dove

a You got that!
b It's part of our culture.
c It's the music of my country so I should learn it.
d This is ours. We made it. We created it.

6 Complete the summary with words from the glossary.

Everywhere you go on the island of Trinidad and Tobago, you can't ¹＿＿＿＿ the sound of the steel drum. It's ²＿＿＿＿ to the island. It was the only new musical instrument of the twentieth century. Because the county produces oil, it has lots of ³＿＿＿＿ . During the Second World War, people made them into steel drums or ⁴＿＿＿＿. However, the music of the region is much older and originally it came over with the African people. Today, the drums still give pleasure to children and adults. Most people play the drums by ⁵＿＿＿＿, and every night places called ⁶＿＿＿＿ are full of people learning to play and enjoying part of their country's culture.

After you watch

7 **Roleplay a conversation with Tony Poyer**

Work in pairs.

Student A: You are Tony Poyer, the expert on steel drums in the video. A journalist is going to interview you. Look at the information below and think about what you are going to say to the journalist about the drums.

Student B: You are a journalist. You are making a documentary about steel drums in Trinidad and Tobago. Use the information below to prepare questions about the drums.

* its history
* how it's made
* how people learn to play it
* the importance of the drum in local culture

8 Working in groups, discuss these questions for each of your countries.

1 What is the most important or popular musical instrument in your country?
2 What is an important symbol of your culture? Is it a special type of music?
3 Do you think symbols are important for a country or culture? Why?

escape (v) /ɪsˈkeɪp/ run away from
be native to (v) /bi ˈneɪtɪv tu/ be from somewhere originally
oil drums (n) /ˈɔɪl ˌdrʌmz/ round metal containers for oil
play by ear (expression) /ˈpleɪ baɪ ˈɪər/ play a musical instrument by listening and not by reading music
pans (n) /pænz/ local word in Trinidad and Tobago meaning "steel drums"
panyards (npl) /ˈpænˌjɑrdz/ local word in Trinidad and Tobago meaning a place to play steel drums

UNIT 6 REVIEW

Grammar

1 Add the word *to* in six of these sentences. One sentence is correct.

1 I intend ^to^ find a new job.

2 It's difficult learn a musical instrument.

3 Save your money have a nice vacation this year.

4 We're going meet everyone later.

5 Do you want join us for lunch?

6 I'll see you at the parade.

7 Would you like come for dinner?

2 Choose the correct option (a–c) to complete the sentences.

1 We _____ visit my family this weekend but we aren't sure yet.
 a hope to
 b 're going to
 c 'll

2 A: I need someone to carry these books for me.
 B: I _____ you!
 a 'm going to help
 b 'm helping
 c 'll help

3 It isn't easy _____ the lottery.
 a win
 b to win
 c will win

4 A: When _____ bring the cake?
 B: In a few minutes.
 a are you going to
 b will you
 c are you

5 Rachel _____ a party tonight. She arranged it months ago.
 a will have
 b plans to have
 c is having

3 Work in pairs. Tell each other:

- your plans for this weekend.
- your future career intentions.

I CAN	
talk about my future plans and intentions	☐
talk about decisions and arrangements	☐

Vocabulary

4 Complete the text about the Notting Hill Carnival with these words.

costumes decorations drums floats ~~parades~~

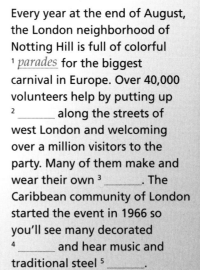

Every year at the end of August, the London neighborhood of Notting Hill is full of colorful ¹ *parades* for the biggest carnival in Europe. Over 40,000 volunteers help by putting up ² _____ along the streets of west London and welcoming over a million visitors to the party. Many of them make and wear their own ³ _____. The Caribbean community of London started the event in 1966 so you'll see many decorated ⁴ _____ and hear music and traditional steel ⁵ _____.

5 Match the verbs (1–5) with the nouns (a–e).

1 start a home
2 leave b on a float
3 take c a mask
4 wear d a break
5 ride e a family

I CAN	
talk about stages and events in life	☐
talk about parties and celebrations	☐

Real life

6 Replace the words in bold with these phrases.

I'd like you to I'd like to that sounds would you like

1 **Do you want** to go for coffee?
2 **Why don't you** come with me to the movies?
3 **It's nice of you to ask** but I'm out this evening.
4 Thanks. **That would be** great.

7 Working in groups, invite each other to do something this week. Accept or decline the invitations.

I CAN	
invite people	☐
accept and decline invitations	☐

Speaking

8 Working in groups, discuss and plan a party for your class.

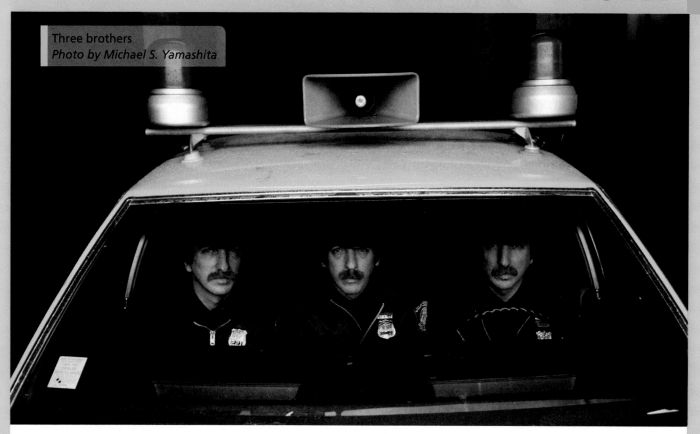

Three brothers
Photo by Michael S. Yamashita

FEATURES

1 Look at the photo. What type of job do you see?

2 Write six job titles that use two words.

| **A** | computer | electrical | fashion | ~~police~~ | security | sales |

| **B** | assistant | designer | engineer | guard | ~~officer~~ | programmer |

Example:
police + officer = police officer

▶ **WORDBUILDING suffixes**

You can make many verbs into job titles by adding a suffix:
assist – assistant, design – designer, represent – representative.

3 Do you have a job title? Where do you work? What do you deal with on the job?

7a X-ray photographer

Listening

1 Look at the photo. Where is it? How is it different from normal photos?

2 🎵 **31** Listen to a documentary about the photographer, Nick Veasey. Answer the questions.

1 What subjects does he photograph?
2 Where does he take the photos?
3 Where can you see his photos?

3 🎵 **31** Listen again and choose the correct options (a–c) to complete the sentences about Nick's job.

1 The job is _____.
 a creative b unskilled c highly qualified
2 He works in _____.
 a an office b a factory c a studio
3 His workplace is _____.
 a old-fashioned b well-equipped c spacious
4 Photography involves _____.
 a lots of meetings b traveling c writing
5 He spends a lot of the time _____.
 a on the phone b sending emails
 c on his computer

4 Work in pairs. Think about your current jobs (or jobs you'd like to have) and complete the sentences in Exercise 3 about yourselves. Use the options (a–c) or your own ideas.

Vocabulary office equipment

5 Look at the photo on page 82 again and find these items. How many of them do you have in your workplace?

bookshelf	break room	desktop lamp
filing cabinet	newspaper	bulletin board
photocopier	swivel chair	water cooler

Reading

6 Read two emails from people working in the office building in the photo. Follow the instructions and find the location of:

1 the broken photocopier
2 the drawer with the report

> **Subject: Broken photocopier**
>
> Hi,
>
> My office is on the ground floor. When your technician comes into the building, he'll find my door on the right. Tell him to go through the first office and into the next room. The broken photocopier is across from the door.
>
> Thanks,
>
> Jennie Clark
>
> Office Manager

> Sahi – I'm away this week, so go up to my office on the second floor and the report is in the filing cabinet behind my assistant's desk.

Grammar prepositions of place and movement

7 Look at the highlighted words in the sentence. Which describe the location or place of an object or person? Which describe the direction of movement?

When your technician comes into the building, tell him the elevator is on the left.

> ▶ **PREPOSITIONS OF PLACE and MOVEMENT**
>
> **Prepositions of place**
> *It's across from the door. / It's on the third floor. / It's at the top of the building. / It's next to the photocopier.*
> **Prepositions of movement**
> Prepositions of movement follow a verb of movement:
> *go down, walk into, climb up, run across.*
>
> For more information and practice, see page 162.

8 Look at the grammar box and make a list of the prepositions of place and a list of the prepositions of movement in the emails in Exercise 6.

9 Complete the emails with these prepositions.

at	down	in	into	next	on	through	up

> Let's meet ¹ _____ the break room at 11. It's the room ² _____ the top of the building. See you there.

> Can you fix my printer for me? My office is ³ _____ the third floor. The printer is ⁴ _____ to my desk.
> Jennie
> PS The elevator is out of order today so you'll have to go ⁵ _____ the reception area to the fire exit and walk ⁶ _____ the emergency stairs.

> We got ⁷ _____ the elevator on the fifth floor and now it won't go ⁸ _____ to reception. Please help!

Speaking

10 Work in pairs. Take turns to give directions to your partner from where you are now to these different parts of the building. Your partner says the place.

the elevator or stairs	your favorite café
the restroom	another classroom
the reception area	the exit

> *The stairs are at the end of the hall on the left.*

> *The exit is downstairs, opposite the elevator.*

7b The cost of new jobs

Reading

1 Work in pairs. Use these questions to tell your partner about a change in your life (like moving to a new place or changing jobs).

- Was it recent or a long time ago?
- Why did the change happen?
- Were you happy about it?

2 Read the extract from an article about the state of Pennsylvania in the US and answer the questions.

1 When did the energy companies discover natural gas there?
2 What two changes did the discovery cause?
3 Why does Donald Roessler think the discovery is good?
4 Why do Chris and Stephanie Hallowich think the discovery is bad?

Grammar present perfect

3 Look at the sentences (a–c) and answer the questions (1–3).

a In 2007, the Hallowiches built their dream house.
b Donald Roessler has lived on his farm for most of his life.
c Many people have found new jobs.

1 Which sentence describes a finished action at a definite time in the past?
2 Which sentence describes an action that happened sometime in the past but we don't know the exact time?
3 Which sentence describes an action that started in the past and is still true today?

4 Sentences b and c in Exercise 3 are in the present perfect. How do you form this tense? Underline more examples in the article.

> ▶ **PRESENT PERFECT**
>
	have	past participle
> | I/you/we/they | have (haven't) | found |
> | he/she/it | has (hasn't) | found |
>
> Have they found gas?
> Has he found a new job?
>
> For more information and practice, see page 162.

The *cost* of new jobs

The state of Pennsylvania in the northeastern United States is famous for its beautiful countryside. However, in 2004, an energy company discovered natural gas under the ground. Since then, this discovery has changed many people's lives—in good and bad ways. Many people have found new jobs but it has also changed the environment. Here are the opinions of some of the local people...

The farmer

Donald Roessler has lived on his farm for most of his life. He hasn't earned much money from farming but two years ago an energy company wanted the gas under his farm. They offered Donald a regular monthly income and he signed the contract immediately.

The teacher and the accountant

Chris and Stephanie Hallowich built their "dream house" in the middle of the Pennsylvania countryside in 2007, about the same time that gas companies moved into the area. Since then, Chris and Stephanie have found chemicals in their drinking water and pollution in the air. They want to move but they haven't sold their house yet.

5 Complete the text below using the simple past or present perfect form of the verbs.

The businessman

Paul Battista ¹ _has run_ (run) a tool supply business for thirty years. In the beginning, it ² _____ (be) very successful but around the year 2000 his sales ³ _____ (start) to decrease because of Pennsylvania's bad economy. Fortunately Paul's profits ⁴ _____ (increase) again since the new energy industries came to the region.

The driver in training

In 2009, Lee Zavistak ⁵ _____ (lose) her job at a bottle factory. At that time, there ⁶ _____ (not / be) many other jobs. However, since 2009, the new energy companies ⁷ _____ (employ) lots of people, especially truck drivers. Lee ⁸ _____ (not / find) a new job yet but she's learning to drive trucks so she's confident about the future.

6 Pronunciation **irregular past participles**

🔊 **32** Write the past participles of these irregular verbs. Then listen, check, and repeat.

1	find	_____	7	win	_____
2	sell	_____	8	teach	_____
3	buy	_____	9	grow	_____
4	fly	_____	10	run	_____
5	think	_____	11	lose	_____
6	do	_____	12	fall	_____

7 Do you think the discovery of natural gas has been a good or bad thing for the state of Pennsylvania? Why?

Listening

8 🔊 **33** A radio journalist in Pennsylvania is interviewing an engineer from one of the gas companies. Are the sentences true (T) or false (F)?

1 The engineer has always worked for the same company.
2 He's always lived in Pennsylvania.
3 He moved to Pennsylvania before they found gas.
4 Everyone has been friendly.

9 🔊 **33** Using the prompts, write the interviewer's questions in the simple past or present perfect form. Then listen to the interview again and check.

1 how long / work / for your company?
2 when / you / study / engineering?
3 have / always / live / in Pennsylvania?
4 when / you / move here?
5 how many different places / you / live in?
6 have / ever / live / abroad?
7 it / be / easy living here?
8 the local people / be / friendly?

Vocabulary *for* or *since*

10 Look at the two ways the engineer answers the question from the interview. Then complete the rules with *since* and *for*.

Interviewer: How long have you worked for your company?
Engineer: For twenty-five years. Since I left college.

We use ¹ _____ to talk about a point in time. We use ² _____ to talk about a length of time.

11 Complete the phrases with *for* or *since*.

1	_____ 2008	5	_____ I started work
2	_____ two weeks	6	_____ January 1
3	_____ six days	7	_____ 24 hours
4	_____ one o'clock	8	_____ I was ten

Speaking

12 Working in pairs, practice asking and answering questions on these topics using the present perfect and simple past.

current job/studies	where you live	travel
people you know	interests/hobbies	languages

Example:
A: Have you ever studied Chinese?
B: No, I haven't, but I study Arabic.
A: Really? How long have you studied it?
B: For about three years.

7c Twenty-first century cowboys

Vocabulary job satisfaction

1 Working in groups, decide how important these items are to job satisfaction (1 = most important).

colleagues and culture	independence	time off
job environment	promotion	training
schedule and hours	salary	

2 Look at the cowboys in the photo on page 87. What do you think is important in their job?

Reading

3 Read the article on page 87. Which of these headings (1–3) best summarizes the text?

1 How modern cowboys really live and work.
2 Cowboys and Hollywood.
3 Why people don't want to be cowboys anymore.

4 Read the article again. Choose the correct option (a–c) to complete the sentences.

1 The writer explains that life as a cowboy is _____.
 a similar to life as a Hollywood actor
 b adventurous and romantic
 c hard work
2 The cattle industry _____.
 a hasn't changed for three hundred years
 b is very different from the past
 c doesn't need cowboys anymore
3 People like Pat Criswell become cowboys for _____.
 a job security b the salary
 c job satisfaction
4 Tyrel Tucker enjoys being a cowboy because it involves _____.
 a making decisions b working in teams
 c being independent

5 Find these sentences in the article. Who or what do the bold words refer to?

1 **It** was a classic symbol of the United States. (paragraph 1)
2 People come to experience a cowboy's life (or Hollywood's version of **it**). (paragraph 2)
3 ...and cowboys still ride their horses to bring **them** home. (paragraph 3)
4 **They** all thought Pat was crazy. (paragraph 4)

Word focus *make* or *do*

6 Complete these phrases with *make* or *do*. Then find the first four verb + noun combinations in the article and check your answers. Use a dictionary for the rest, if necessary.

1 _____ business 3 _____ a job
2 _____ money 4 _____ breakfast

7 Complete these phrases with *make* or *do*. Use a dictionary to help you, if necessary.

1 _____ your homework
2 _____ a mistake
3 _____ a decision
4 _____ someone a favor
5 _____ well at work/school
6 _____ your bed
7 _____ a noise
8 _____ work

8 Work in pairs. Ask your partner three questions using verb + noun combinations with *make* and *do*.

> What kind of job do you do?

> What do you normally make for breakfast?

Critical thinking the author's opinion

9 What kind of image does the author give of twenty-first century cowboys? Choose a word from the box and underline any sentences in the article that support your choice.

hard-working	romantic	sad	unskilled

Speaking

10 Discuss as a class. Which comments are similar to your own opinions? Explain why or give a new opinion.

> I admire the modern-day cowboy because I admire people who work hard.

> I think these cowboys are strange because they don't want to be part of the modern world.

> Hollywood cowboys are better than real cowboys.

> I'm more like Pat Criswell than his colleagues: job satisfaction is much more important than money.

TWENTY-FIRST *century* COWBOYS

Cowboys have always had a romantic image. When people first watched Hollywood movies, they thought that being a cowboy wasn't a job. It was a lifestyle, full of adventure, freedom, horses. It was a classic symbol of the United States. In reality, American cowboys have lived and worked in the western and southwestern United States for over three centuries, long before Hollywood. And the cowboy lifestyle has always been about hard work and long hours.

No one knows how many cowboys are still working, maybe between ten and fifty thousand. It's also difficult to define a twenty-first century cowboy. Surely he can't be the big cattle owner who does business with the seventy-billion-dollar-a-year beef industry! Does he work on the modern ranches that use the latest technology and employ accountants? Or on one of the old traditional cattle ranches that make more money nowadays offering tours to tourists than they do raising cattle? Places where people come to experience a cowboy's life (or Hollywood's version of it)?

Maybe, but real cowboys still do the same job they have done for years. The cattle still walk across huge plains, eating grass many miles from the ranch, and cowboys still ride their horses to bring them home. Cowboys still work in the middle of nowhere, in places where cell phones don't work. And like the cowboys of the past, twenty-first century cowboys still get up early on freezing cold mornings and make breakfast over an open fire. They have no Monday to Friday work week, no weekends off, and no paid vacation.

So why do men—because it is usually men—choose this life? Pat Criswell had a good job with the government. He made good money but he didn't like the city. He wanted to do something different, so one day, he gave up his job and moved to a ranch in Texas, earning much less as a cowboy. He remembers his work colleagues in the city on the day he left. They all thought Pat was crazy, but he wanted job satisfaction more than money.

Brothers Tyrel and Blaine Tucker have lived on ranches and worked with cows since they were children. Last winter, they looked after 2,300 cows. Every day from December until April, they rode across nearly 100,000 acres of land with only the cattle, the horses, and each other for company. Eighteen-year-old Tyrel says, "It was fun. You get to be by yourself."

Blaine has a large moustache and Tyrel is growing his. They wear traditional cowboy clothes with the famous hat and boots. You could do the same job in a baseball cap and a truck, but Tyrel and Blaine prefer the traditional cowboy culture: Thinking about the whole cowboy culture, he adds, "It's a real life about you, your horse, and the open country."

symbol (n) /ˈsɪmbəl/ something that represents a society, country, or type of life
cattle (n) /ˈkæt(ə)l/ cows
ranch (n) /rænʧ/ large farm for cattle, horses, or sheep
plain (n) /pleɪn/ grassy areas of open land
good money /gʊd ˈmʌni/ expression meaning "a lot of money" or "well-paid"
acre (n) /ˈeɪkər/ measurement of land

7d A job interview

Vocabulary job listings

1 Look at the job listing. Would you apply for this kind of job? Why?

Sales Assistant required

E.I. Books is a large national bookstore. We are opening a new store so we are recruiting sales staff for full- and part-time positions (with flexible hours).

CLICK HERE for a full job description and to provide contact details.

All applicants must send a cover letter and resume.

Salary is based on previous experience.

2 Find the words in the listing that match the definitions (1–8).

1 people applying for the job
2 a letter explaining why you want the job
3 the amount of money you will make a year
4 looking for people to work for a company
5 jobs in a company
6 a summary of your qualifications and experience
7 information about the job
8 your name, number, email, and street address

Real life a job interview

3 🔘 **34** Zhang applied for the job in the listing in Exercise 1 and was invited for an interview. Listen to extracts from the interview and mark the sentences true (T) or false (F).

1 The interviewer has received her letter of application and resume.
2 Zhang has already left her last job.
3 She wants to leave Raystone's Bookshop because she doesn't like the job.
4 The interviewer is pleased Zhang has found out about E.I. Books.
5 Zhang doesn't have any questions for the interviewer.
6 They discuss something in the job description.

4 Do you think Zhang is the right person for the job? Why?

5 🔘 **34** Listen again and complete these questions from the interview. Then match them with the correct category in the box.

1 _____ long have you _____ there?
2 _____ have you _____ for this position?
3 _____ you _____ yourself as ambitious?
4 _____ are some of your main strengths?
5 _____ you _____ any questions for me?
6 _____ you _____ me more about that?

▶ **A JOB INTERVIEW**

Your current situation and job
Tell me about your current job.
Why do you want to leave your current job?

Reasons for applying
Why do you think you'd like to do this job?

Strengths, weaknesses, and personal qualities
Do you have any weaknesses?
How would other people describe you?

Questions for the interviewer
What questions do you have about the job?
Can you give me some information about (the salary, the hours, the benefits, etc.)?

6 Working in pairs, roleplay an interview for this job.

Displaying **1–12** of **84** jobs Page: **1** 2 3 4

Wanted: Office Assistant

MFR industries is hiring an assistant to help in our new sales office. You will be responsible for helping six staff members, including answering calls, filing, answering inquiries, and helping customers. Previous experience with office work is helpful but not essential. The ability to work in a team and an enthusiastic personality are more important. Some knowledge of English is also useful. Click here for a full job description and contact details. All applicants must email an application and resume. Salary is based on previous experience.

Student A: You are the interviewer. Prepare your questions.
Student B: You are the applicant. Think about answers for any questions the interviewer might ask you.

When you are both ready, begin the interview.

7 Change roles in Exercise 6 and repeat the roleplay.

7e Applying for a job

Writing a resume

1 Complete the resume with these headings.

> Address Education Home telephone Interests References
> Skills Work experience

Resume

Jack Reyes

1 _____	121 Grant St., Apt. 3A Santa Fe, NM 87508
Email	jack_reyes@aol.com
2 _____	505-555-7465
Cell	505-555-7463

3 _____

2008–2009	MA in Events Management, University of Santa Fe
2005–2008	BA in Economics, St. John's College, Taos, NM

4 _____

2011–present	Assistant manager: Managed a medium-sized hotel, supervised staff, assisted the general manager in all areas of hotel activities.
2009–2011	Hotel receptionist: Received international guests, collaborated as team member, translated hotel correspondence in Spanish.
Summer 2010	Camp counselor in summer camp: Coordinated groups of teenagers and planned events.

5 _____

Languages: English and Spanish (bilingual)
Computing: Word, Excel, website design

6 _____

Captain of local baseball team, hiking, theater

7 _____

Mr. David Keeping, Dept. of Hotel Management, 15 Duran Ave., Taos, NM
Paula Pacheco, 345 Caminito Drive, Santa Fe, NM

2 How similar is the layout to a resume in your country? Would you advise Jack to add any other information?

3 **Writing skill action verbs for resumes**

We often give a short description of our work experience in resumes using "action" verbs in the simple past without the pronoun *I*. (For example, *Managed a medium-sized hotel.*) Find eight examples of action verbs in Jack's resume in Exercise 1.

4 Look at these sentences and replace the words in italics with these action verbs to make them suitable for a resume.

> advised ~~assisted~~ designed
> represented supervised
> planned and organized

1 *I often had to help* the manager with office duties.
 Assisted the manager with office duties.
2 *As a student counselor, one of my roles was to talk to and help* students in planning future career paths.
3 *Because I'd made some websites at home, I was put in charge of making* a new website for the company.
4 *The company had lots of staff who traveled so I had to book plane tickets and hotels— anything to do with* travel arrangements.
5 *The company did lots of trade fairs so sometimes I had to be there for* the company at trade fair events.
6 *I was never officially the team leader but my job included managing* a team of four.

5 Think of a job you have done in the past and use action verbs to write sentences that summarize the main parts of the job. Use the verbs from the resume and Exercise 4 to help you.

6 Write your complete resume.

7 Working in pairs, check each other's resumes for clear headings and the effective use of action verbs.

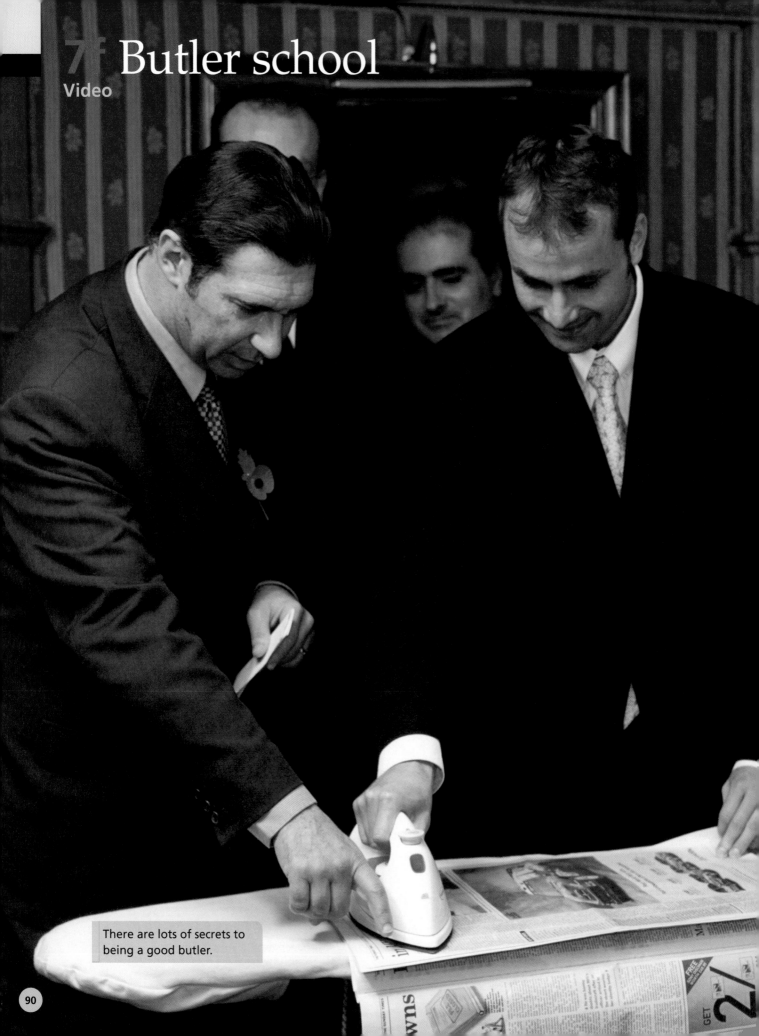

Butler school

There are lots of secrets to being a good butler.

Before you watch

1 Work in groups. Look at the photo and discuss the questions. Use as many of the words and phrases in the glossary below as you can.

1 Who are the people?
2 What are they doing? Why?
3 What do you think the caption means?

2 Mark the things and people you think you might see in the video.

glasses	hats	a London taxi	a newspaper
shoes	suits	the Queen	

While you watch

3 Watch the video and check your answers from Exercise 2.

4 Watch the first part of the video (to 02:31). Are these sentences true (T) or false (F)?

1 There are not many butlers in England today.
2 On the first day of class, the students learn how to make tea correctly.
3 There were about 200 butlers seventy years ago.
4 All the students come from England.
5 Butlers from the school sometimes work for important leaders and kings.
6 The course lasts thirteen weeks.
7 There are 86 lessons during the course.
8 The first two days are very easy for everybody.

5 Watch the second part of the video (02:31–05:01). Complete the sentences with the missing word(s).

1 Students have to _____ a lot.
2 The word "butler" comes from a French word which means "_____."
3 David Marceau starts to show some _____ .
4 David talked to his _____ last night.
5 Ivor Spencer irons a _____ .
6 Butlers may have to deal with _____ guests.

burnt (adj) /bɜrnt/ marked by fire or heat
butler (n) /ˈbʌtlər/ the head servant in a house
deal with (v) /ˈdil wɪð/ solve a problem
fetch (v) /fetʃ/ go and bring
guest (n) /ɡest/ a person who is invited to a house or party
improvement (n) /ɪmˈpruvmənt/ getting better
iron (v) /ˈaɪərn/ move a hot electrical apparatus across something to make it smooth
make it (v) /ˈmeɪk ɪt/ be successful
miss (v) /mɪs/ feel sad because you are not with a person
palace (n) /ˈpæləs/ place where a king or queen lives
servant (n) /ˈsɜrvənt/ a person who is paid to work in a house
unwelcome (adj) /ʌnˈwelkəm/ not invited and not wanted

6 Watch the final part of the video (05:01 to the end). Answer the questions.

1 What three things are mentioned as "the finer things in life"? _____ _____

2 What jobs did the people do before the course? _____ _____

7 Match the people (1–6) with what they say (a–f).

1 Ivor Spencer
2 the man in the pipe store
3 the narrator
4 David Marceau
5 the taxi driver
6 David Suter

a Long ago, England was a land of country houses, palaces, gardens, and afternoon tea.
b I haven't seen a butler for a long time.
c On every course there are about two people that don't make it past the first two days.
d Practice makes perfect, so hopefully, with a lot of practice, I'll be just as good as any other butler out there.
e I just hope I'm going to be right for the job and hope I can do it!
f It's not just a piece of wood, it's a piece of art.

After you watch

8 **Roleplay a conversation with David Marceau**

Work in pairs.

Student A: You are David Marceau. A friend calls you. Look at the ideas below. Think about what you are going to tell him or her about your experiences in the course.

Student B: You are a friend of David's. Call him and ask him about the course and his stay in England. Use the ideas below to prepare questions to ask David.

• the length of the course
• how many hours they studied every day
• how hard the course was
• what he found difficult
• what they had to do
• what job he wants to get now

9 Work in groups. Discuss these questions.

1 Would you like to be a butler? Why?
2 Would you employ a butler? Why?
3 Do you agree that you need to "practice, practice, practice" if you want to succeed?

UNIT 7 REVIEW

Grammar

1 Complete the sentences with these prepositions.

across	at	in	on	opposite
through				

1 Walk _____ the parking lot to the other side and the factory is there.
2 Can you pass me that book _____ the shelf?
3 There's lots of water _____ the water cooler so help yourself.
4 Go _____ those doors at the end and the photocopier is there.
5 The cafeteria is _____ the top of the building on the fifth floor.
6 We sit _____ each other in class.

2 Working in pairs, take turns describing the location of a classroom object and guessing what it is.

Example:
It's on the left side of the room...

3 Complete the conversation with the present perfect or simple past form of the verbs.

A: How long ¹ _____ you _____ (work) here?
B: About three years. I ² _____ (join) the newspaper when I left college.
A: So, ³ _____ you always _____ (want) to be a journalist?
B: Not particularly. But when I ⁴ _____ (be) young, I wrote stories.
A: What ⁵ _____ you _____ (study) at college?
B: Spanish.
A: ⁶ _____ you ever _____ (live) in Spain?
B: No, but I ⁷ _____ (spend) a summer in Argentina.
A: Really? ⁸ _____ you _____ (travel) around a lot?
B: Yes, I did. Especially in Patagonia.

4 Prepare three questions for your partner starting with *How long have you...?* Then ask and answer your questions using *since* or *for* in your answers.

I CAN
describe location and movement using prepositions
ask questions and talk about events and experiences in the past

Vocabulary

5 Work in pairs. Look at the photo of the balloon seller. Do you think he enjoys this job? Why?

6 Complete the text with the correct form of *make* or *do*.

Nguyen ¹ _____ two jobs. During the day he sells balloons and in the evening he ² _____ money by working in a restaurant. He helps to ³ _____ food in the kitchen. He works long days but he is saving so he can complete his studies. If he ⁴ _____ well at college he can get a good job.

I CAN
talk about different jobs and work

Real life

7 Match these questions at a job interview (1–5) with the responses (a–e).

1 Do you have any weaknesses?
2 What are your main strengths?
3 Would you say you're ambitious?
4 How well do you work with other people?
5 Do you have any questions for me?

a Yes, fairly.
b I get annoyed if other people aren't working hard.
c Quite well.
d Yes, just one…
e I'm careful and like to get things right.

8 Working in pairs, take turns asking and answering the questions in Exercise 7. Respond with your own answers.

I CAN
ask interview questions
answer questions about myself and my job

Speaking

9 Imagine your dream job. Think about these questions.

- What would you like to do? Why?
- How many hours a week would you like to work?
- How much money would you want to earn?

Work in pairs. Tell your partner about your dream job.

Unit 8 Technology

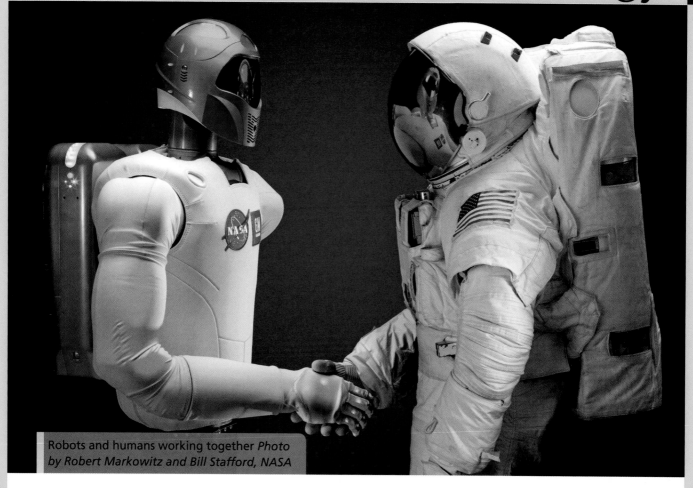

Robots and humans working together *Photo by Robert Markowitz and Bill Stafford, NASA*

FEATURES

94 Invention for the eyes

An inventor finds a solution to make the whole world see better

96 Technology for explorers

How technology is changing the world of exploration

98 Designs from nature

What we can learn from the design of animals

102 Wind power

A video about how one American school is using this energy source

1 Look at the photo and the caption. How do you think robots and humans are going to "work together"? In what ways do robots already work with humans?

2 As a class, discuss these questions.

1 What everyday jobs does technology do for humans?
2 When does technology make mistakes?
3 The robot in the photo works in the International Space Station. What do you think it does?

3 Which of these advantages are true for a robot, a human, or both?

has new ideas	finds solutions and solves problems
never gets hungry or tired	can't make a mistake
doesn't get bored	always follows instructions
makes decisions	invents things

4 Working in groups, compare humans and technology. Think of two more advantages or disadvantages for each.

8a Invention for the eyes

Speaking

1 Work in pairs. What problems did these famous inventions solve? Check your answers on page 153.

Braille	electric light bulb	
microwave oven	Post-it Note	telescope

2 Think of one more invention that solved a problem and tell the class. Compare everyone's inventions and decide which was the most important in human history.

Listening

3 🔊 **35** This Tibetan man is wearing a new type of glasses. Listen to a science program about them and answer the questions.

1 What is a problem for many people in the world?
2 How do the glasses solve this problem?
3 In which parts of the world do people now wear the glasses?

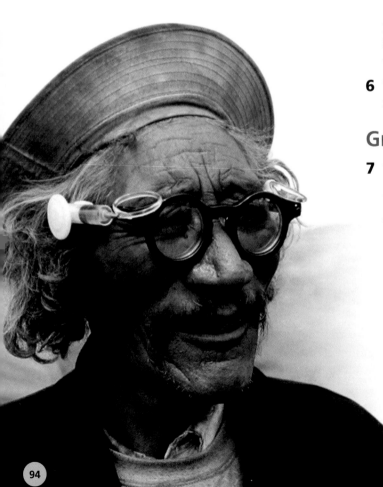

4 🔊 **36** Listen to the first half of the program again. Number the instructions in the correct order (1–4).

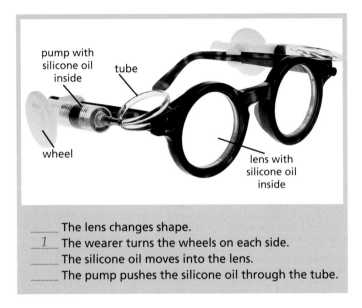

_____ The lens changes shape.
1 The wearer turns the wheels on each side.
_____ The silicone oil moves into the lens.
_____ The pump pushes the silicone oil through the tube.

5 🔊 **37** Now listen again to the second half of the program and mark the sentences true (T) or false (F).

1 Joshua had to do experiments with the glasses before they worked properly.
2 The first man who used the glasses made clothes.
3 The glasses are expensive to produce.
4 Thirty thousand people will have the glasses by 2020.

6 Does Joshua's invention solve a bigger problem than the inventions on your list in Exercise 2?

Grammar defining relative clauses

7 Look at the sentences (a–c) and answer the questions (1–2).

a They live in parts of the world where there aren't many opticians.
b There is a scientist who has found a solution to the problem.
c Joshua Silver has invented glasses which don't need to be made by an optician.

1 Which word (*where*, *who*, or *which*) do we use to talk about (a) a person, (b) a place, and (c) a thing?
2 In sentence a, the highlighted part is called the defining relative clause. It gives essential information to help people identify which person, place, or thing we are talking about. Underline the defining relative clause in sentences b and c.

► DEFINING RELATIVE CLAUSES

*The first person **who** <u>used the new glasses</u> was a man in Ghana.*

*Silver started an organization **which** <u>is called the Center for Vision in the Developing World</u>.*

*The organization has worked in many places **where** <u>over thirty thousand people now wear the glasses</u>.*

You can use *that* instead of *who* or *which* (but not *where*). It's less formal.
Tim Berners Lee is the man that invented the World Wide Web.
It's the invention that's changed the world.
This is the room ~~that~~ where he invented it.

For more information and practice, see page 163.

8 Look at the grammar box and complete the sentences with *who, which, that,* or *where*. Underline the defining relative clause.

1 Einstein was a scientist _____ changed the way we think.
2 The Hubble Telescope in space can see places _____ no one has ever been.
3 Concorde was the first commercial airplane _____ flew at supersonic speed.
4 Silicon Valley is a place _____ many technology companies are based.
5 In 1800, Alessandro Volta built a machine _____ was the first battery.
6 Hedy Lamarr was a famous actress _____ also co-invented a secret communication system.

9 In which sentences in Exercise 8 can you use *that* at the beginning of the relative clause?

10 Complete the text on the right about another invention, Lifestraw. Use these phrases and a relative pronoun (*who, which,* or *where*).

cleans the water	~~need clean water~~
there is a lake, river	can break
there is no safe	
specialize in solving problems like this	

11 Think of a famous person, a famous invention, and a famous place or city. Write a sentence to define each one. Then swap sentences with your partner. Can he/she guess what they are?

Example:
It's a thing that you put in your computer. It's small but it has a large memory. (a USB flash drive)

Lifestraw

There are still over one billion people in the world [1] *who need clean water*. They live in regions [2] _____ water supply. Now, some inventors [3] _____ have developed Lifestraw. It's an invention [4] _____ while you drink. It doesn't have any moving parts [5] _____ so it lasts a long time, and it's cheap to produce ($2 each). It's also small and easy to carry to places [6] _____ or other source of water.

Speaking

12 Work in groups. Invent a new kind of robot which helps people. Discuss these questions and draw a simple design for the robot with any important information on a large sheet of paper.

• What is the robot for (e.g., cleaning the house)?
• Who will use it (e.g., busy working people)?
• Where can you use it (e.g., around the office)?

13 Prepare and give a short presentation to the class about your new invention.

> Our new invention is a robot which …

> It's for people who …

> You can use it in places where …

8b Technology for explorers

Vocabulary the Internet

1 Use these verbs to complete the comments about how people use the Internet.

> do download log on search ~~set up~~
> subscribe upload write

1 I ___*set up*___ an account with a social networking site because it's a good way to keep in touch with old friends.
2 Does anyone buy CDs anymore? I don't. It's much easier to _____ music.
3 I _____ a weekly blog about my family.
4 A lot of my friends _____ online gaming but I find it all a little boring.
5 When I need to find information quickly, the first thing I do is to _____ the Internet.
6 I _____ to several daily podcasts.
7 My friends and family _____ and share their photos all the time.
8 Online banking is so easy. You just _____ with a password and your account details.

2 Which of the sentences in Exercise 1 are true for you? Change any sentences which are untrue or give more details.

> I write a blog but I don't write about my family. I describe what my friends and I like doing.

> ▶ **WORDBUILDING verb prefixes**
> Many prefixes can change or add new meaning to a verb. For example, the verb *load* can be **down**load, **up**load, **un**load, **over**load, **re**load.

Reading

3 Read the blog and answer the questions.

1 How does Jay Gifford use the Internet?
2 Why does he think modern technology is important for explorers?

4 Read the blog again. Which of these things does Jay write about on his social networking sites?

- where he is
- what he is doing
- his plans for later
- his recent news
- his opinions

http://blogs.ngm.com/blog_central/wild/

NATIONAL GEOGRAPHIC

NGM BlogWILD

Kamchatka Project
Posted by Jay Gifford | July 15, 2:55 PM

After traveling around the world for almost half a week and moving through three international airports and nineteen time zones, we finally step off the helicopter. We are at the beginning of the Karimskaya River in the region of Kamchatka. It's a bright sunny day and in the far distance I can see the Karimski volcano. This is probably the wildest place in Russia but if the weather is this good for the next few days, the expedition will go well.

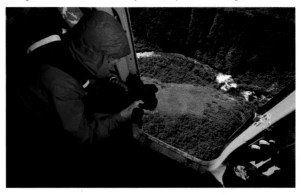

In the past, when explorers arrived in a strange place, they put up their tents or cooked a meal. But nowadays, when explorers arrive in a new place, they log on to their social networking site using a satellite phone. Explorers in the past wrote about their adventures in books which were published months or years later. Nowadays, we post a message in seconds.

Sites like Facebook and Twitter also help if we have a problem. Someone in our group touched a strange plant and suddenly his skin was red and painful. I asked for advice on Twitter: "Hand touched a strange plant. It's red and hot. Any advice?" Minutes later, someone who knew the region replied, "Probably a Pushki plant. If it is, it'll hurt but it won't kill you!" In the age of the modern explorer, communication like this really helps to make decisions, and sometimes it even saves lives.

Grammar zero and first conditional

5 Look at the sentences (a–c) and answer the questions (1–2).

a If the weather is this good for the next few days, the expedition will go well.

b Sites like Facebook and Twitter also help if we have a problem.

c When explorers arrive in a new place, they log on to their social networking site.

1 Which sentences talks about things that are generally true?

2 Which sentence talks about a possible future situation?

> **ZERO and FIRST CONDITIONAL**
>
> **zero conditional**
> *if/when* + simple present, simple present
> When we have news, we text all our friends.
> We text all our friends if we have news.
>
> **first conditional**
> *if* + simple present, *will (won't)*
> If I hear any news, I'll text you.
> I'll text you if I hear any news.
>
> For more information and practice, see page 163.

6 Look at the grammar box, then complete the conversation. Check your answers with your teacher.

A: So, what are we going to take with us?
B: Well, I don't know what the weather's going to be like. If it rains, we ¹ _____ (need) all this waterproof clothing.
A: Yes, but if we take all that, there ² _____ (not / be) space for anything else. Anyway, when I go canoeing, I ³ _____ (always/ get) wet. Why are you packing that?
B: If we don't have a map, we ⁴ _____ (probably / get) lost.
A: Don't worry. If I ⁵ _____ (bring) my GPS, we'll know exactly where we are at all times. What about food?
B: I normally take cans and packages of food when I ⁶ _____ (go) on a trip like this.
A: Good idea. If you carry the food in your canoe, I ⁷ _____ (pack) both the tents in mine.
B: Maybe that's not such a good idea. If something ⁸ _____ (happen) to one of us, then the other person either won't have any food or won't have a tent.
A: Well, that ⁹ _____ (not / happen) if we're careful.

7 Pronunciation intonation in conditional sentences

a 🔊 **38** In conditional sentences, when the *if/when* clause is first, the intonation rises and then falls. Listen and repeat.

If it rains, we'll need this.

b Working in pairs, practice reading the conversation in Exercise 6. Pay attention to the rising and falling intonation where necessary.

Vocabulary and speaking

8 Work in groups. You are going to the mountains for two days. The weather forecast is for sun on the first day and rain on the second. Because you are walking and camping, you don't want to take too many items. You have tents, backpacks, and food. Choose five others to take from the list below. Explain your reasons for taking them.

camera	gas stove	GPS	hairdryer	hat
laptop	matches	cell phone	sunblock	sunglasses
flashlight	towel	umbrella	video game player	

If we take ..., we won't need ...

We'll need ... if it rains ...

8c Designs from nature

Reading

1 Look at the photos at the top of page 99. How is the robot similar to the gecko?

2 Read the first two paragraphs of the article and answer these questions.

 1 Why are geckos amazing?
 2 What are the scientists interested in?
 3 What is the problem with the robot?
 4 Why do people study nature?

3 Inventors and designers studied the plants and animals in photos 1-4 for the inventions (A–D) on page 99. Try matching each animal or plant to an invention, then check your answers by reading the rest of the article.

Critical thinking **supporting the main argument**

4 The main argument of this article is that animal design can improve technology. Which of these sentences support or restate the argument?

 1 Scientists want to use the design of a gecko on their own robot.
 2 Animals and plants can teach humans a lot about design and engineering.
 3 Most humans have never seen a whale.
 4 Mercedes Benz is producing a new car.
 5 Engineers in Canada are studying whale flippers because they move so effectively through water.

Word focus *have*

5 Look at two uses of *have* (a–b) when it is the main, not auxiliary, verb. Then match *have* in the sentences (1–5) with the two uses.

> **have** /hæv/
> **a** possessing or owning something (including physical appearance, ideas, illnesses, etc.)
> **b** doing or experiencing something

 1 It has four feet. *a*
 2 It still has a more difficult time when it tries to walk upside down.
 3 When we have a problem, nature often has the answer.
 4 Most people have some Velcro on an item of clothing.
 5 He had a closer look.

Speaking

6 Work in groups. Read the three pieces of information about different animals. Discuss how these animals could help humans. Which products in our life could they improve?

- Spiders have a silk which is very light but very strong. It's stronger than many man-made materials, including steel.
- The abalone is a type of shellfish. Its shell is much stronger than many types of stone.
- Glow worms have a cold light which is more efficient than a light bulb.

boxfish

lotus leaf

humpback whale

bur

◻ DESIGNS FROM Nature

*When we have a problem,
nature often has the answer*

In a room at Stanford University, scientists are studying a small animal called a gecko. It's an amazing animal because it can move very quickly up and down a tree and even upside down on ceilings. The scientists are particularly interested in the gecko's feet. They want to use the same design on a metal robot that looks very similar to the gecko. It has four feet and can walk up walls made of glass or plastic, but it still has trouble walking upside down.

Animals and plants can teach humans a lot about design and engineering. As a result, many engineers, scientists, and designers spend time studying them. When they have a problem, nature often has the answer. This science is called biomimetics. *Bio* means "living things" and *mimetics* means "copying." In other words, scientists—or biomimeticists—study animals and plants in order to copy their design.

For example, engineers in Canada are studying whale flippers because they move so effectively through water. The engineers believe the shape can improve the movement of wind turbines. Similarly, engineers at Mercedes Benz in Germany are using the shape of the box fish in one of their new cars because it makes the car faster and more fuel efficient.

Velcro is probably the most famous example of biomimetics. Most people have some Velcro on an item of clothing. It was invented by the Swiss engineer George de Mestral in 1948. He was walking in the countryside when he pulled a burr off his pants. He noticed how well the burr stuck to his clothes so he studied its design. The result was Velcro, which became an affordable alternative to the traditional zipper.

In 1982, inventor Wilhelm Bartlott got a great idea studying the leaf of a lotus plant. He noticed that water always ran off the leaf. When he had a closer look, he discovered how it worked. Bartlott copied the leaf's special surface and now you can find it in specialized paint products that don't allow water and dirt to stick.

In conclusion, biomimetics not only has helped to design our world but promises many more possibilities. Unfortunately, they might take a long time to develop. This isn't really surprising: it took nature millions of years to design its animals and plants.

> **flipper** (n) /ˈflɪpər/ the flat arm or leg of a sea animal, used for swimming
> **burr** (n) /bɜr/ a seed from a plant
> **zipper** (n) /ˈzɪpər/ two rows of metal teeth-like parts which come together to close something (like a coat)

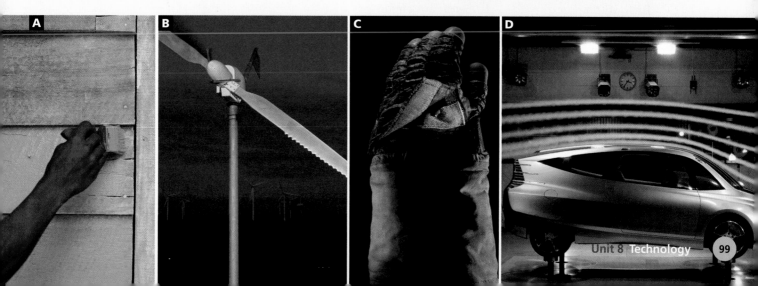

A B C D

8d Gadgets

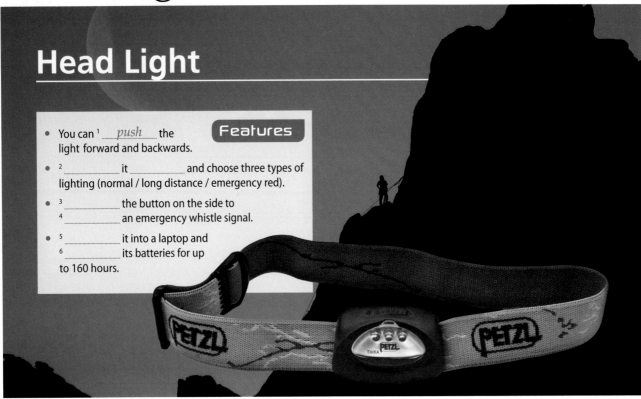

Head Light

Features

- You can [1] _push_ the light forward and backwards.
- [2] _____ it _____ and choose three types of lighting (normal / long distance / emergency red).
- [3] _____ the button on the side to [4] _____ an emergency whistle signal.
- [5] _____ it into a laptop and [6] _____ its batteries for up to 160 hours.

Vocabulary technology verbs

1 Look at the photo of the headlight in the ad above. What is it used for? Would you find it useful?

2 Complete the list of features (1–6) for the headlight with these verbs.

> plug press push recharge send turn on

3 Pronunciation linking

a 🔊 39 A word ending with a consonant sound links to the next word if it starts with a vowel sound. Listen, then practice saying these instructions.

1 Turn‿it‿on.
2 Plug‿it‿into a laptop.
3 Recharge‿it‿overnight.
4 Send‿an‿email.
5 Click‿on the link.

b Working in pairs, name more items you often use at home or at work and make sentences using the verbs in Exercises 2 and 3a. Pay attention to linking where necessary.

> I switch‿on my cell‿in the morning and recharge‿it‿overnight.

Real life asking how something works

4 🔊 40 Listen and list the features in Exercise 2 that you hear.

5 🔊 40 Listen again and mark the questions in the box that you hear.

> ▶ **ASKING HOW SOMETHING WORKS**
>
> Where do I turn it on?
> How did you do that?
> What happens if I press this button?
> What is this for?
> How long does the battery last?
> Why do you need to do that?
> How do you make it turn on / record?

6 Working in pairs, take turns asking and explaining how something works. Use these objects or gadgets in your bag or in the school.

> a cell phone a CD player
> an MP3 player a computer
> an interactive whiteboard a DVD player
> a vending machine

8e An argument for technology

Writing a paragraph

1 Read the paragraph. Where do you think it comes from? Choose the correct option (1–3).

1 an instruction manual
2 a report on energy in the workplace
3 a message to a colleague at work

LED lighting is a more effective form of modern lighting technology. **First,** LED lights last longer than normal lights. **For example,** a normal light bulb lasts about 5,000 hours. LED light bulbs last 100,000 hours. **Also,** LED light bulbs change 80 percent of electricity into light. Normal bulbs only change 20 percent. **In other words,** LED lights use less electricity to produce more light. **On the other hand,** one disadvantage is that LED lights are more expensive than normal lights. **However,** they don't have to be changed every year and they use less energy. **As a result,** they are cheaper.

2 Writing skill **connecting words**

Look back at the highlighted connecting words in the paragraph in Exercise 1. Match them with their uses (1–6).

1 to introduce a result:
2 to introduce an example:
3 to sequence ideas and sentences:*first*....
4 to say the same thing in a different way:

5 to introduce contrasting information: ,
6 to add supporting information:

3 Writing skill **supporting sentences**

The first sentence in the paragraph about LED lighting is the topic sentence. It gives a general introduction to the main idea of the paragraph. Afterwards, all the other sentences support this main idea. Which of these sentences (1–8) are topic sentences (T) and which are supporting sentences (S)?

1 The Internet has completely changed our lives.
2 Take, for example, how many books and articles you can read online.
3 For example, closed circuit television (CCTV) is on our streets and in public places.
4 Technology can provide security in many different ways.
5 In other words, all your personal information can be put onto one identity card.
6 First, Russia put the first satellite in space in 1957. Now there are thousands in space.
7 Over the last fifty years, there have been many great achievements in space travel.
8 Also, robots have now landed and traveled on Mars.

4 Read these notes about GPS technology and write a paragraph using the notes and connecting words from Exercise 2.

> Main argument:
> GPS is a good idea for anyone who travels a lot
> Supporting ideas:
> 1 GPS maps are always up-to-date and accurate
> 2 more expensive than a normal map but safer to use when driving
> 3 saves time (and money on gas)

5 Choose one of these types of technology and prepare to write a paragraph about why it is useful. Write your paragraph with three supporting ideas.

cell phones	wireless technology
email	music downloads

6 Use these questions to check your paragraph.

- Have you used a topic sentence?
- Have you used three supporting sentences?
- Have you used connecting words?

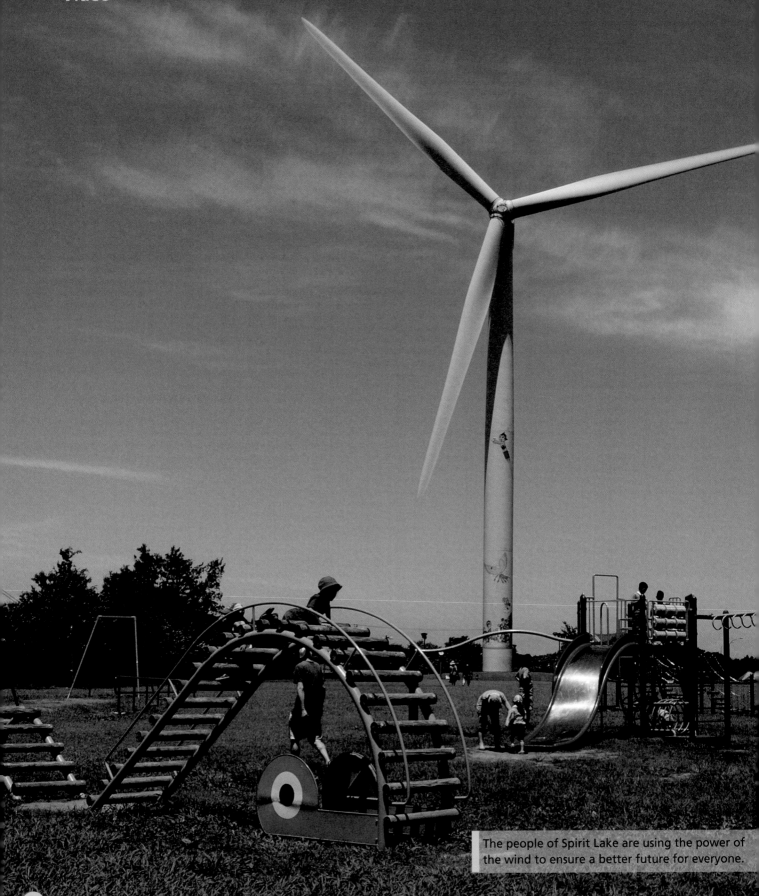

Wind power

The people of Spirit Lake are using the power of the wind to ensure a better future for everyone.

Before you watch

1 Work in groups. Look at the photo and discuss the questions.

1 Where are the children in the picture?
2 What technology can you see? What is it for?
3 How will the children benefit from this technology?

While you watch

2 Watch the video and check your answers from Exercise 1.

3 Watch the video again and answer the questions.

1 How much money could the wind turbines save the school district in energy costs?

2 How would the district spend the money?

3 Why is it very important that the turbines in Spirit Lake can withstand strong winds?

4 What does the school district do with the energy from the larger turbine?

5 Why are farmers happy when the wind blows?

6 What do teachers encourage students to do?

4 Watch the video again. Complete the phrases with the correct number.

| 6,000 | 71,000 | 81,530 | 130 | 257 | 180 | 2 |

1 The number of wind turbines in Spirit Lake:

2 The amount of money the smaller turbine has saved the district: $

3 The height of a wind turbine: _____ feet
4 The strength of winds the wind turbines can withstand: _____ mph
5 The amount of money Charles Goodman will make in a year from his wind turbines: $

6 The number of wind turbines in this piece of the Iowa countryside:

7 The number of homes in the town of Des Moines:

After you watch

5 **Roleplay a conversation between a salesperson and a principal**

Work in pairs.

Student A: You are a wind turbine salesperson. You are going to visit a school to explain the benefits of wind turbines. Write notes about three or four benefits.

Student B: You are the principal of a school. You are interested in wind turbines but are not sure whether to build one for your school. Prepare to ask the salesperson about:

• three or four disadvantages of wind turbines
• the benefits of wind turbines

Act out the conversation. Then change roles and repeat the conversation.

6 Jan Bolluyt says: "So, you know, it's not just a small thing." What is he referring to? Do you agree with him?

7 Work in pairs. Discuss these questions.

1 What types of alternative energy are used in your country?
2 What are the advantages and disadvantages of alternative energy compared to fossil fuels?
3 Where do you think we will get our energy in the future?

blade (n) /bleɪd/ the long, narrow part that makes a propeller turn when the wind hits it
blow (v) /bloʊ/ the wind does this when it moves
crop (n) /krɑp/ plants that farmers grow and harvest
encourage (v) /ɪnˈkʌrɪdʒ/ get someone to do something
ensure (v) /enˈʃʊr/ guarantee
flat (adj) /flæt/ without hills or mountains
fossil fuel (n) /ˈfɑsəl ˌfjuəl/ gas, oil, or coal
foundation (n) /faʊnˈdeɪʃən/ a solid base under the ground that a structure sits on
grid (n) /grɪd/ a system of cables for distributing electricity
impressive (adj) /ɪmˈpresɪv/ causing a feeling of admiration
pay off (v) /ˈpeɪ ˈɔf/ finish paying for something
power (n) /ˈpaʊər/ electricity, energy
power (v) /ˈpaʊər/ send electricity to
rod (n) /rɑd/ a long, round piece of metal or wood
save (v) /seɪv/ use less money
silo (n) /ˈsaɪloʊ/ a place where farmers put their crops after they harvest them
steel (n) /stil/ a type of metal
turbine (n) /ˈtɜrbən/ a type of machine that produces energy from a moving propeller
withstand (v) /wɪðˈstænd/ resist

Grammar

1 Use the words to make sentences with relative clauses.

 1 Galileo / a man / changed science
 Galileo is a man who changed science.
 2 camping / an activity / I enjoy doing
 3 The GPS / a gadget / tells you where you are
 4 my parents / the people / love me most
 5 the thing / I hate about TV / the ads
 6 the Space Shuttle / the first spacecraft / travel from and to Earth

2 Complete these sentences for you. Then tell your partner why.

 1 Someone who changed my life was…
 2 Something which improved my life was…

3 Complete the sentences with these verbs. Use *will* (*'ll*) or *won't* where necessary.

not call	not go	love	press	work

 1 When you _____ this button, the TV comes on.
 2 If you put new batteries in, it _____ again.
 3 When it's sunny, we _____ to go to the beach.
 4 If he _____, then we'll go without him.
 5 I _____ hiking without you.

> **I CAN**
>
> describe people, places, and things with extra information ☐
>
> talk about situations that are generally true and possible in the future ☐

Vocabulary

4 Match the verbs (1–5) with the nouns (a–e).

 1 make a a problem
 2 find b a decision
 3 solve c an idea
 4 make d a solution
 5 have e mistakes

5 Complete the questions with words from Exercise 4 and discuss them with your partner.

 1 What's the best _____ you've ever had?
 2 What decisions do you _____ in your daily life or at work? How important are they?
 3 What's the most common mistake you _____ in English?
 4 Do you like to solve a _____ on your own or _____ a solution with others? Why?

6 Match two words (one from each box) and complete the sentences.

click	log	plug		into		on (x2)
push	set	turn		around		up (x2)

 1 I want to _____ _____ but I've forgotten my password.
 2 How do you _____ _____ an online account?
 3 _____ it _____ the wall socket.
 4 For maximum volume, _____ the dial _____ to number 10.
 5 You usually _____ it _____ to go faster.
 6 _____ _____ the icon to open the program.

Real life

7 Put these words in the correct order to make questions for asking how something works.

 1 turn / it / where / do / I / on?
 2 you / did / that? / do / how
 3 if / I / happens / button? / press / this / what
 4 the / battery / long / how / does / last?
 5 that? / why / do / do / I / to / need
 6 record? / how / it / do / you / make

8 Match these responses (a–e) with the questions in Exercise 7. One response answers two questions.

 a So you don't lose any data.
 b Eight hours.
 c There.
 d By pressing this.
 e You turn it off.

> **I CAN**
>
> talk about using technology ☐
>
> explain and ask how something works ☐

Speaking

9 Work in pairs. Explain to your partner how to use a DVD.

Unit 9 Language and learning

Learning
Photo by Cary Wolinsky

FEATURES

1 Look at the photo. Answer the questions.

What country do you think this classroom is in?
What are the pupils learning?

2 What do you know about language? Mark the statements true (T) or false (F).

1 Homophones are words with the same sound but different meanings.
2 All languages have 26 characters.
3 Languages often borrow words from each other.

3 Read about the English language. Answer the questions. Then compare with your partner.

1 How many of the facts are true for your first language?
2 Rewrite the other facts so that they are also true.

The *English language:*

- has 26 letters.
- is an official language in 53 countries.
- borrowed words from other languages in the past, including German, French, and Latin.
- has different varieties, including American English, British English, and Australian English.
- normally uses this word order in a sentence: subject + verb + object.

9a Ways of learning

Vocabulary education

1 Match each word in the pair with its correct definition (a or b).

1 **class / subject**
 a a period of time when people learn something with a teacher
 b a topic you learn about in school (art, mathematics, geography)
2 **discipline / rules**
 a instructions that say what you must or must not do
 b the ability to makes oneself or others stick to instructions or a goal
3 **enroll / apply**
 a to join and pay for a course
 b to fill in a form to ask to join a course or to get a new job
4 **teach / instruct**
 a to tell someone to do something
 b to help people learn a new subject or skill by explaining or demonstrating it
5 **qualification / skill**
 a an ability or something you do well
 b a measurable requirement, such as degree or years of experience, that is necessary for a job

2 Pronunciation stress in two-syllable words

🔊 **41** Listen to the stressed syllables in these words, and note the difference between the nouns and verbs. Listen again and repeat.

1 lesson (n) 4 instruct (v)
2 enroll (v) 5 apply (v)
3 subject (n)

3 Work in pairs. Discuss the questions.

1 What was your favorite subject in school? Why?
2 Was there a lot of discipline in your school? Were there many rules?
3 What skills did you learn?
4 What do you think is the best way to get new knowledge or skills?

Listening

4 🔊 **42** Listen to a radio documentary about learning Kung Fu in China. Match the parts of the documentary (1–3) with the topics (a–c).

a Life at a Kung Fu school
b The history of the Shaolin Temple and Kung Fu
c Shaolin and Kung Fu in modern China

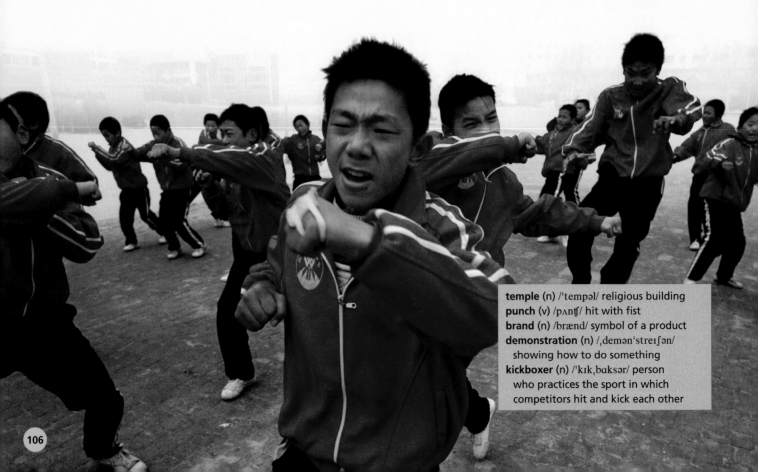

temple (n) /ˈtempəl/ religious building
punch (v) /pʌntʃ/ hit with fist
brand (n) /brænd/ symbol of a product
demonstration (n) /ˌdemənˈstreɪʃən/ showing how to do something
kickboxer (n) /ˈkɪkˌbɑksər/ person who practices the sport in which competitors hit and kick each other

5 🔘 **42** Listen to the documentary again. Choose the correct options.

1 Many people in China learn about Kung Fu for the first time *from watching movies and TV / at the Shaolin Temple.*
2 Students have learned Kung Fu at the temple since the *fifth / fifteenth* century.
3 Shaolin *only teaches Kung Fu / has different businesses.*
4 In the city of Dengfeng, there are 50,000 *schools / students* of Kung Fu.
5 *All the students / Not all the students* are at the school because they want to be there.
6 There is a lot of *discipline / free time* in the school.

6 Complete the speech bubbles with your views about learning Kung Fu in China. Then compare them with the class.

> *One thing that surprised me was …*

> *I would / wouldn't like to learn something this way because …*

> *This new interest in Kung Fu probably will / won't last a long time because …*

Grammar present passive voice: *by* + agent

7 Look at the sentences (a–b) and answer the questions (1–3).

a Teachers teach Kung Fu in many schools.
b Kung Fu is taught in many schools.

1 In sentence a, what is the object of the sentence? Who does the action?
2 In sentence b, what is the subject of the sentence? Does it say who does the action?
3 Look at the grammar box. Then underline all the verbs in the passive voice in the audioscript on page 173.

▶ **PRESENT PASSIVE VOICE: *BY* + AGENT**

	subject	verb	object

ACTIVE SENTENCE: Hundreds of tourists **visit** the temple.

	subject	verb

PASSIVE SENTENCE: The temple **is visited** by hundreds of tourists.

We form the passive with the verb *to be* + past participle:
Kung Fu is / isn't taught…
Students are / aren't enrolled in courses.

We often use the passive when who or what does the action is not important or is unknown. If necessary, we say who does the action using *by*: *by hundreds of tourists*.

For more information and practice, see page 164.

8 Complete the article about adult education with the passive voice.

Nowadays, more and more adults ¹＿＿＿＿＿ (enroll) in courses. Some of them ² ＿＿＿＿＿ (send) by their employers to acquire new skills. Others want a change of career, so new qualifications ³ ＿＿＿＿＿ (need). For many adults, learning ⁴ ＿＿＿＿＿ (not / see) as something only for school children. Studying a subject can be fun and a good way to socialize. And these days, many courses ⁵ ＿＿＿＿＿ (not / take) in a face-to-face class. Many adults are studying more by distance, or online, learning. Books ⁶ ＿＿＿＿＿ (send) to their home. Course material ⁷ ＿＿＿＿＿ (email) by their online tutor. In some courses, the lessons ⁸ ＿＿＿＿＿ (teach) by videoconference. Clearly, education doesn't have to stop when you leave school!

Adult education

9 Look at the sentences. Delete *by* + agent where you don't need it.

1 Degrees are normally taught ~~by lecturers~~ for three years.
2 Many degrees are now taught by lecturers working from home.
3 The ancient language of Latin isn't studied much by students anymore.
4 Latin isn't known by many people under the age of seventy anymore.
5 Paris is visited by twenty-seven million tourists a year.
6 In my country, English is spoken by nearly everyone under the age of thirty.

Speaking

10 Work in groups. Discuss these questions.

1 In your country, is adult education seen as normal or something new?
2 Are employees in your workplace sent to training courses? What kinds of courses do they take? How are they paid for?
3 Are you enrolled in any other courses now?
4 In your country, are many courses taught online these days? Who are these courses offered by? Have you ever studied online? How did it compare to learning in a traditional classroom?

9b The history of writing

Reading

1 Work in pairs. Think of two or three differences between speaking and writing. Then compare your ideas with the class.

Example
Writing needs extra objects; speaking doesn't.

2 Read the article and find words or phrases that describe:

1. different forms of writing (like cuneiform)
2. what people have written with (like stone or clay)
3. the reasons for writing (like counting things)

Grammar past passive voice

3 Look at the sentences (a–b) and answer the questions (1–3).

a. The symbols were made with clay.
b. The typewriter's keyboard is still used on computer keyboards today.

1. Which form do the sentences use: active voice or passive voice?
2. Which sentence is about the present and which the past?
3. How do you form the past passive voice?

> ▶ **PAST PASSIVE VOICE**
>
> We form the past passive using *was/were* + past participle:
> *The first computer **was invented** in the early twentieth century.*
> *Computers **weren't used** by many people until later in the century.*
> *When **was** the first computer **invented**? / **Were** computers **invented** then?*
>
> For more information and practice, see page 165.

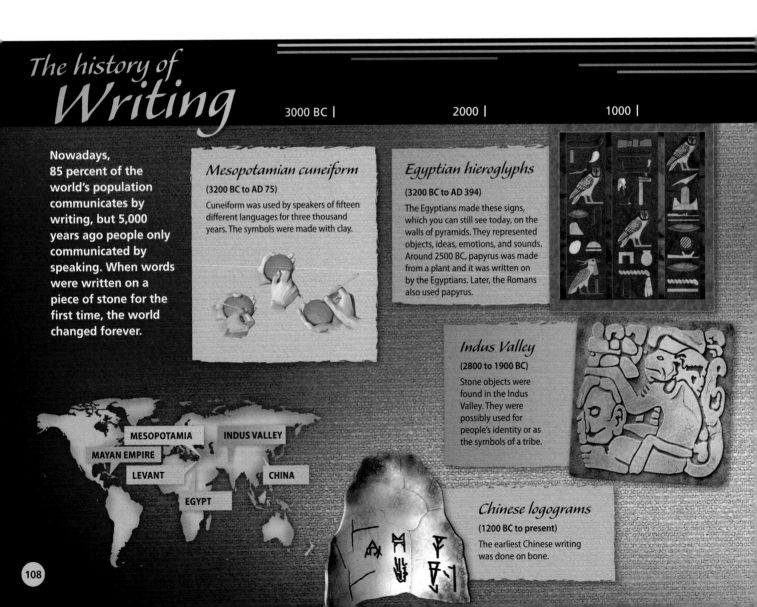

The history of Writing

3000 BC | 2000 | 1000 |

Nowadays, 85 percent of the world's population communicates by writing, but 5,000 years ago people only communicated by speaking. When words were written on a piece of stone for the first time, the world changed forever.

Mesopotamian cuneiform
(3200 BC to AD 75)
Cuneiform was used by speakers of fifteen different languages for three thousand years. The symbols were made with clay.

Egyptian hieroglyphs
(3200 BC to AD 394)
The Egyptians made these signs, which you can still see today, on the walls of pyramids. They represented objects, ideas, emotions, and sounds. Around 2500 BC, papyrus was made from a plant and it was written on by the Egyptians. Later, the Romans also used papyrus.

Indus Valley
(2800 to 1900 BC)
Stone objects were found in the Indus Valley. They were possibly used for people's identity or as the symbols of a tribe.

MESOPOTAMIA INDUS VALLEY
MAYAN EMPIRE
LEVANT CHINA
EGYPT

Chinese logograms
(1200 BC to present)
The earliest Chinese writing was done on bone.

4 Look at the grammar box on page 108, then complete the sentences with the past passive form of the verbs. (Note that some of the sentences contain false information.)

1 Papyrus _____ (make) from a type of tree.
2 Objects from the Indus Valley _____ (use) as identity cards.
3 Early Chinese writing _____ (do) on bone.
4 The first alphabet _____ (not / create) by the Phoenicians.
5 Pictures _____ (not / use) by the Maya to represent dates and times.
6 Lots of books _____ (publish) because of Gutenberg's invention.
7 The typewriter _____ (invent) in 1873.
8 eBooks _____ (not / sell) before 2010.

5 Working in pairs, decide which sentences in Exercise 4 are false.

6 Write quiz questions about the article using the past passive voice.

1 How / cuneiform symbols / make? (Answer: On clay)
How were cuneiform symbols made?
2 What / papyrus / use for / by the Egyptians and the Romans? (Answer: For writing on)
3 In the Indus Valley, why / stone objects / possibly / use? (Answer: For people's identity or as symbols of a tribe)
4 Where / the earliest Chinese writing / do? (Answer: On bone)
5 How / dates and time / represent / by the Maya? (Answer: With pictures)
6 By the end of fifteenth century, what / books / publish / with? (Answer: Gutenberg's printing press)

Writing and speaking

7 Work in groups. Prepare a history general-knowledge quiz for another group. Using the past passive voice, write five questions about historic or famous people, inventions, places, objects, and important dates.

8 As a class, take each other's quizzes and find out which group has the best general knowledge.

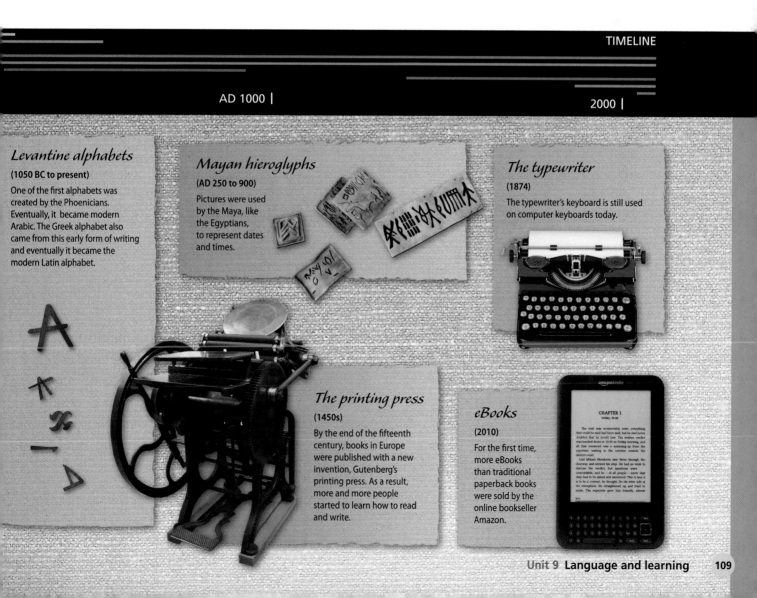

TIMELINE

AD 1000 | 2000 |

Levantine alphabets
(1050 BC to present)
One of the first alphabets was created by the Phoenicians. Eventually, it became modern Arabic. The Greek alphabet also came from this early form of writing and eventually it became the modern Latin alphabet.

Mayan hieroglyphs
(AD 250 to 900)
Pictures were used by the Maya, like the Egyptians, to represent dates and times.

The typewriter
(1874)
The typewriter's keyboard is still used on computer keyboards today.

The printing press
(1450s)
By the end of the fifteenth century, books in Europe were published with a new invention, Gutenberg's printing press. As a result, more and more people started to learn how to read and write.

eBooks
(2010)
For the first time, more eBooks than traditional paperback books were sold by the online bookseller Amazon.

9c Saving languages

Reading

1 Does your country have different languages and cultures? What are they?

2 Read the article on page 111. Answer the questions.

1 What culture is it about?
2 What has happened to their languages? Why?
3 What is the purpose of the Enduring Voices Project and the Salish school?

3 Complete the summary with words from the article.

> Five hundred years ago, Europeans arrived on the continent of ¹ _____. Eventually, they became more powerful than the Native ² _____ and moved them to reservations. Their ³ _____ and ⁴ _____ began to disappear. Nowadays, many Native Americans speak ⁵ _____ and live in ⁶ _____. But on some of the reservations, the tribes are recording the language of the older generation. They are also setting up ⁷ _____ for children to learn the language so they might save it for the future.

Vocabulary phrasal verbs

> ▶ **WORDBUILDING phrasal verbs**
>
> A phrasal verb is a verb + particle: *pick* + *up* = *pick up*, *get* + *together* = *get together*.
> When you join these two words, it creates a new meaning.

4 Find the phrasal verbs (1–8) in the article and match them to their meanings (a–h).

1	take away	a	meet and discuss something
2	give up	b	learn informally
3	get together	c	remove from someone
4	die out	d	stop doing something
5	write down	e	become less common and disappear
6	pass on	f	start something new (like a company or an organization)
7	pick up	g	record, often on paper
8	set up	h	give to someone (often children)

5 Complete the sentences with the correct form of the phrasal verbs in Exercise 4.

1 How much English do you _____ from listening to music or watching films?
2 How often do you and your friends _____ to practice speaking English?

3 Do you think traditional classrooms will _____ in this century?
4 When you hear a new word, do you have to _____ it _____ or can you remember it?
5 Is it important for older people to _____ their knowledge to younger people or is it quicker to use the Internet?

6 Work in pairs. Ask and answer the questions in Exercise 5 and give your opinion.

> *I get together with friends to practice English once a week.*

Critical thinking fact or opinion

7 An article can provide facts but also give opinions. Look at these sentences from the article and decide which three include the author's opinion.

1 Five hundred years ago, Europeans arrived on a new continent.
2 So a terrible part of history began.
3 The good news is that some of these "last speakers" are keeping their culture and language alive.
4 Many tribes now offer courses.
5 The Salish tribe is an excellent example.
6 It has 30 students aged two to twelve during the day.

8 Look at the three opinion sentences in Exercise 7. Underline the words which show the sentence is an opinion. What kinds of words are they?

Speaking

9 Work in groups. Discuss these questions.

1 Overall, how much does the author support the Native Americans and their plans to save their language and culture?
2 How strong is his opinion in the article?
3 Do you agree with him?

They brought new cultures and languages to this place which they called America. However, there were already people living here who had their own cultures and languages, so a terrible part of history began.

As more Europeans arrived, there was a fight with the Native Americans for the land and by the end of the nineteenth century, the native tribes were moved to reservations. A lot of their children were taken away to boarding schools and taught to speak English. By the end of the twentieth century, more than half of Native Americans were living in cities. They gave up speaking their old tribal language and only used English. As a result, many Native American languages disappeared, and with them, their culture.

Some Native American languages are still used today, but they are usually spoken by the older members of the tribes who still live on the reservations. In North America, there are 150–170 languages that have at least one "last speaker," and many of these languages have under a hundred speakers.

One ancient language, which is spoken by the Northern Paiute tribe, has more than two hundred speakers. When the elders of the tribe get together, they still speak it. But for most of the younger members of the tribe, the everyday language is English.

The good news is that some of these "last speakers" are keeping their culture and language alive. They are also receiving help from the National Geographic Society's Enduring Voices Project, which aims to keep languages around the world from dying out. Linguists and experts meet with these "last speakers," interview them, and record video, pictures, and audio of them. The "last speakers" tell old stories which are written down in English so people can learn more about the culture.

Recording the language and culture is only part of the project. The next stage is to pass on the language to the next generation. Some children pick it up from their parents or grandparents, but many tribes now offer courses. The Salish tribe is an excellent example. They live on Montana's Flathead Reservation and their language is spoken by about 50 people over the age of 75 and no one under 50. So the tribe has set up a school. It has 30 students aged two to twelve during the day and offers courses for adults in the evening. Schools and projects like these hopefully will save languages for the future.

SAVING LANGUAGES

Five hundred years ago, Europeans arrived on a new continent.

reservation (n) /ˌrezərˈveɪʃən/ an area of land where Native Americans live
boarding school (n) /ˈbɔrdɪŋ ˌskul/ a school where you live away from home

9d Enrolling in a course

Reading and speaking

1 Work in pairs. Read the web page and answer the questions.

1 What kind of people might be interested in each course?
2 Are the courses for people with no knowledge or experience of the subject?
3 Which course would you choose? Why?

Enroll NOW!

New evening classes for the winter term

Calligraphy
A course for anyone interested in this beautiful and ancient writing art. For beginners or those with experience.
Wednesday evenings 6:30–9:00 p.m. (10 weeks)

Preparing more effective PowerPoint presentations
Ideal for people who already give presentations for their work. The course is for people with some experience but introduces new techniques and helps participants create better, more professional-looking slides.
Mondays and Wednesdays 6:00–7:30 p.m. (5 weeks only)

Spanish for beginners
Learn Spanish for your next vacation or business trip. Useful language for restaurants, shopping, hotels, and general conversation.
Tuesdays and Thursdays 7:00–9:00 p.m. (10 weeks)

Real life describing a process

2 🔊 **43** Listen to a telephone conversation about enrolling in one of the courses and mark the sentences true (T) or false (F).

1 The PowerPoint course is full.
2 To enroll, you have to fill in a form.
3 There is an interview for the course.
4 You have to pay for the course immediately.

5 You have to put down a deposit immediately to reserve a place.
6 For this course, you have to buy a lot of books.

3 🔊 **43** Look at these expressions for describing a process, and mark the ones you hear.

> ▶ **DESCRIBING A PROCESS**
>
> First, you need to...
> The first thing you're asked to do is...
> Next, the form is sent...
> When you've completed the online enrollment form...
> Then send us payment.
> After we've received payment...
> Once you've enrolled...
> Having done that, you need to...
> At the end, click "enroll now."

4 Work in pairs. Practice a similar telephone conversation.

Student A: You are the caller. Choose one of the other courses in Exercise 1 and ask about the course and how to enroll.

Student B: You are the administrator. Answer the call and describe the process for enrolling to the caller.

Then change roles and repeat the conversation.

5 Roleplay another conversation between someone in a job recruitment agency and someone looking for a job.

Student A: Turn to page 153 and follow the instructions.

Student B: Turn to page 154 and follow the instructions.

9e Providing information

Writing filling out a form

1 Work in pairs. Answer the questions.

1 What kinds of forms do you have to fill out?
2 What kind of information do you have to provide?
3 Do you ever find them confusing or complicated?

2 Look at the forms. What is each one for?

A

Title	
First name	
Middle initial	
Last name	
Address	
Zip code	
Gender	
DOB	
No. of dependents	
Country of origin	
First language	

Current occupation
Do you smoke?
Yes ☐ No ☐
Current medications

Details of past surgery or operations

B

PLEASE USE CAPITAL LETTERS

PASSPORT NO. _____ PLACE OF ISSUE _____

NATIONALITY _____ MARITAL STATUS _____

EDUCATION (DEGREES, ETC.) _____

Have you visited this country before? (If yes, give details.)

Have you ever been refused entry or a visa on a previous occasion? (If yes, give details.)

Contact details of person to call in case of emergency (e.g., spouse, next of kin):

| For office use only: |
| Issued/Refused on by |

3 Writing skill providing the correct information

a Match the questions (1–8) with the places on the forms in Exercise 2 where you write the information.

1 Are you married, single or divorced? *marital status*
2 Do you take any types of medicine?
3 How many children do you have?
4 Where did you receive your current passport?
5 Where were you born?
6 Why weren't you allowed into this country two years ago?
7 Who do we call if you need help (your husband / wife, someone related to you)?
8 What is the first letter of your middle name?

b Look at the forms again and notice how they use certain conventions and abbreviations. Answer the questions. Then check your answers on page 153.

1 How many abbreviations can you find in the forms? What do you think they mean?
2 What do you think these abbreviations mean?
 Titles: Mr., Mrs., Ms., Dr., Prof.
 Degrees: BA, BS, MBA, PhD
3 Which form has a section you do not write in?
4 Which form does not want you to write in lower-case (small) letters?

4 Work in pairs. Design a one-page enrollment form for a language school. Make a list of all the information you need about the students. Then prepare the form.

5 Exchange your form with another pair. Use these questions to check their form. Afterwards, give them feedback on their form.

- Is the form easy to follow?
- Do you know what to write in each part?
- Is all the information they want useful and relevant?

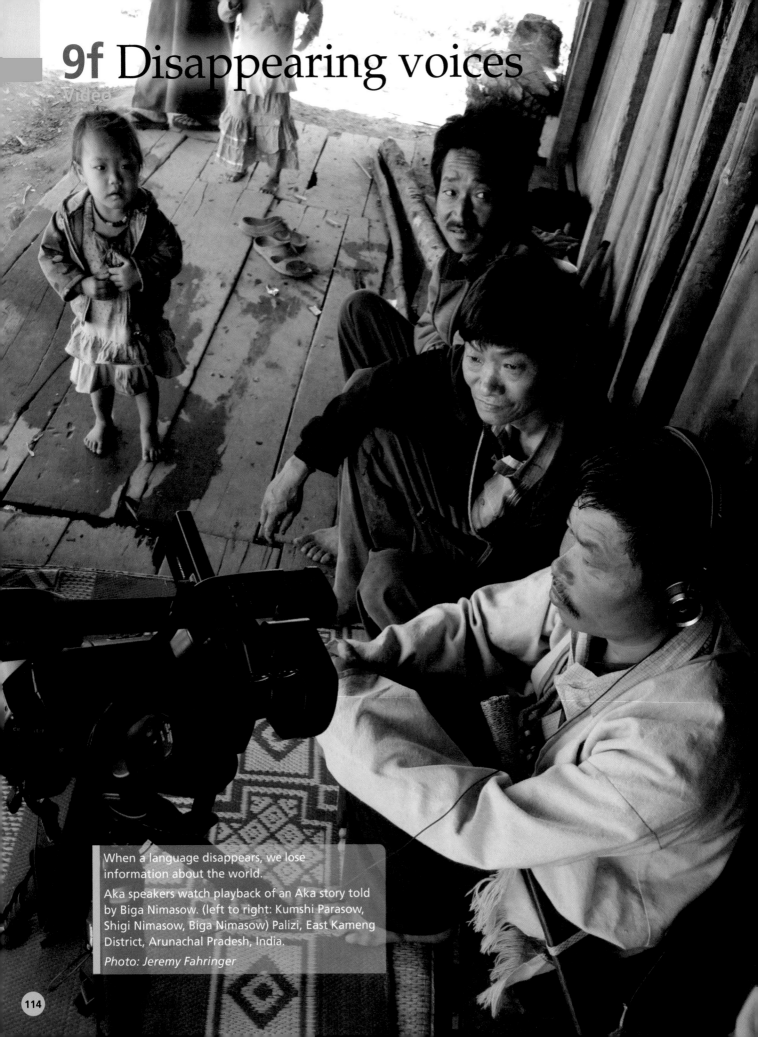

9f Disappearing voices

When a language disappears, we lose information about the world.

Aka speakers watch playback of an Aka story told by Biga Nimasow. (left to right: Kumshi Parasow, Shigi Nimasow, Biga Nimasow) Palizi, East Kameng District, Arunachal Pradesh, India.

Photo: Jeremy Fahringer

Before you watch

1 Work in groups. Look at the photo and the caption and discuss the questions.

 1 What are the people in the photo doing?
 2 What do you think the caption means? What kind of information do you think we lose?

2 Working in pairs, mark the things you think you are going to see in this video.

a camera	a classroom	a computer
a digital recorder	headphones	a map
a microphone	pen and paper	

While you watch

3 Watch the video and check your answers from Exercise 2.

4 Watch the first part of the video (to 02:17). Are the sentences true (T) or false (F)?

 1 Chris Rainier is a member of the Living Tongues Institute.
 2 Seven thousand languages are expected to disappear in the next fifty years.
 3 The three men helped to create the Enduring Voices project.
 4 After Australia, the team went to northeast India.
 5 The team never have any problems with their equipment.
 6 There is no written record of many of the local languages.

5 Answer these questions from the second part of the video (02:17 to the end).

 1 What language do most of the older people in Hong speak: Apatani, English, or Hindi?

 2 Why do the team want to meet younger people?

 3 What does a language technology kit contain and what is it for?

 4 What do the researchers hope the language technology kits will do?

6 Complete what the people say with these words. Then watch the whole video to check.

awareness	interesting	language
loss	speakers	younger

"Every two weeks around the planet a ¹ _____ disappears. Completely disappears forever and ever. So what we're doing with the Enduring Voices project is really, kind of, trying to bring ² _____ to this whole issue of language ³ _____ around the planet."

"We definitely want to find ⁴ _____ speakers because they're the ones that will be showing the shift. The older ⁵ _____ of course will have the language. So it will be ⁶ _____ to see if people who've been schooled in the modern times, if they've still kept it."

After you watch

7 Roleplay **saying what you think and giving reasons**

Work in pairs.

Student A: You are a young person from Hong. You speak a little Apatani with older people but you and your friends prefer to speak English and Hindi. You think Apatani is old-fashioned and you do not care if it disappears.

Student B: You are a researcher from the Enduring Voices project. Find out what languages the young person speaks, and why. Then try to persuade him/her that it is important to preserve Apatani. Give reasons.

Act out the conversation. Then change roles and repeat the conversation.

8 Work in pairs. Discuss these questions.

 1 Has your native language changed in your lifetime? In what ways?
 2 Do you think it is in danger from global languages? Why?
 3 Do you think the fact that English is the dominant global language is a good thing or not?

abandon (v) /ə'bændən/ stop using
awareness (n) /ə'weərnɪs/ knowledge or understanding of a subject or situation
disappear (v) /ˌdɪsə'pɪər/ stop existing
enduring (adj) /en'dʊrɪŋ/ lasting for a long time
equipment (n) /ɪ'kwɪpmənt/ instruments or tools needed for a job
extinct (adj) /ek'stɪŋkt/ not existing any more

loss (n) /lɒs/ the state of no longer having something
neglect (v) /nɪ'glekt/ forget about
remote (adj) /rɪ'moʊt/ distant and difficult to get to
researcher (n) /rɪ'sɜrtʃər/ somebody who does research (makes a detailed study of something to find out information)
school (v) /skul/ educate a child
shift (n) /ʃɪft/ a change in something

UNIT 9 REVIEW

Grammar

1 Choose the correct options to complete the article.

The language of Koro ¹ *speaks / is spoken* by about a thousand people in northeastern India. It ² *discovered / was discovered* by accident when a team of linguists ³ *began / was begun* working in the Indian state of Arunachal Pradesh. They were studying two other languages when they realized a third language ⁴ *used / was used* in conversations between local people. The team quickly ⁵ *started / was started* studying it. Koro ⁶ *doesn't write / isn't written down* anywhere so local people ⁷ *recorded / were recorded* so that the team could study their words. Not many people under the age of 20 know Koro so it's important that the language ⁸ *saves / is saved* before it dies out.

2 Work in pairs. Make questions about the article in Exercise 1 using these prompts.

1. how many people / Koro / speak / by?
2. who / Koro / discover / by?
3. Koro / write down / or / speak?
4. Koro / know / by many young people?

3 Change your partner and take turns asking and answering your questions. Do you think your partner's questions are all correct?

I CAN
use the active or passive form of the simple present and simple past tense
ask questions using the passive form of the simple present and simple past tense

Vocabulary

4 Choose the correct option (a–c) to complete the sentences.

1. What time is your history _____?
 a lesson b subject c discipline
2. I'm _____ to college but I don't know if they'll accept me.
 a studying b applying c enrolling
3. What _____ will you get when you graduate?
 a rules b degree c education
4. Mr. Smith is great at _____ us math.
 a learning b instructing c teaching

5 Complete the sentences with these particles.

away down on out up (x2)

1. I gave _____ studying French after I left school.
2. My friend finds it easy to pick _____ languages.
3. Writing letters is a skill that is dying _____.
4. It was right here! Did someone take it _____?
5. My mother was from Bulgaria and tried to pass _____ her language to me.
6. I'm going to read this message out loud and I want you to write _____ every word you hear.

I CAN
talk about language and learning

Real life

6 Replace the words in bold with these phrases.

After that The first thing you do is When

1. **First, you need to** type in the word you need and press enter.
2. **Then** read the definition of the word.
3. **Once** you've finished, remember to turn it off.

7 Work in pairs. Think of a process in your life (e.g., at work). Write down the four or five stages of a process you use (at work, for example). Then explain the process to your partner using phrases from Exercise 6.

I CAN
describe a process

Speaking

8 Working in pairs, talk about who your favorite teacher was in school, or what your favorite subject, time of day, or classroom was.

Unit 10 Travel and vacations

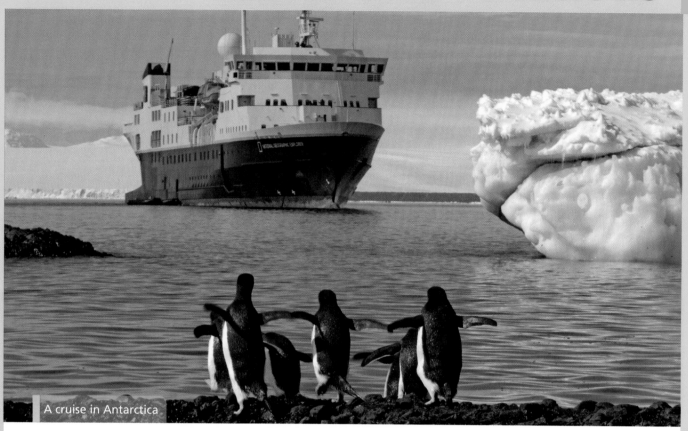

A cruise in Antarctica

FEATURES

1 This photo shows a cruise in Antarctica. Would you like to go on a cruise? Would you take a vacation someplace cold? Explain your opinion.

2 Which of these statements are true for you?
1 You go on vacation often.
2 You always take certain items when you travel.
3 You usually travel on your own.
4 You always plan where you are going to stay.
5 You think travel and vacations are about exploration and discovery.

3 Match these words to the categories (a–d). Then add one more word to each category. Compare your ideas with the class.

camera	camping	cruise	five-star hotel
package tour	self-guided	sightseeing	sunbathing
sleeping bag	suntan lotion	tent	adventure sports

a type of vacation
b accommodation
c travel items
d vacation activities

4 What kind of vacations do you prefer? What kind of vacations don't you take? Why not?

10a Vacation stories

Reading

1 Do you tip in restaurants or hotels? How much? Is there a difference between tipping in your country and other countries?

2 Read the vacation story and answer the questions.

 1 What was the description of the vacation in the brochure?
 2 What was the problem?
 3 How did she solve the problem?

3 Number the events (a–i) in the correct order 1–9.

 a gave the manager a tip
 b arrived at the hotel
 c the maintenance man didn't fix the shower
 d gave the maintenance man a tip
 e read the vacation brochure
 f turned on the shower
 g called reception
 h moved to room 405
 i waited at reception

4 Discuss the questions.

 1 What did the writer learn in this story?
 2 Should we do things differently in other countries?
 3 Have you ever learned any cultural differences by being in other countries or meeting people from them?

I was so excited after I had found the vacation in the brochure. It said: "Enjoy a week of sightseeing in one of Europe's most beautiful cities while staying at one of its most luxurious hotels." Now I wasn't so sure. I had waited fifteen minutes at reception when I arrived and now the shower in my room wasn't working. I called reception.

"Hello. This is room 308. There isn't any water in my bathroom."

"Are you sure?"

"Of course I'm sure!"

"I'll send someone immediately."

An hour later, a maintenance man came to look at the shower. He hit the pipes a few times and looked worried. "Sorry, but I cannot fix it today. Maybe, tomorrow." Then he held out his hand. I couldn't believe it! He wanted a tip for doing nothing! I was furious. But suddenly, I had a better idea. Quickly, I gave him a few coins. He hadn't fixed my shower but he had taught me something about staying in his country. Two minutes later I was at the reception desk. I explained the problem to the receptionist and he apologized: "This is a terrible situation, but what can we do?" I knew exactly what to do. I gave the hotel manager a very large tip. Fifteen minutes later I moved into room 405. It was twice the size of room 308, it had a wonderful view of the city, a comfortable bed and, most importantly, water in the bathroom.

Vacation STORIES

Grammar past perfect

5 Look at the sentence from the story and answer the questions.

I was so excited after *I had found* the vacation in the brochure.

1 Which action happened first?
2 Which verb is in the past tense?
3 How do we form the past perfect?

> ▶ **PAST PERFECT**
>
> I **had waited** fifteen minutes at reception when I arrived.
> He **hadn't fixed** my shower but he had taught me something about staying in his country.
> Note: In spoken English we often use 'd (= had)
>
> For more information and practice, see page 165.

6 Complete the sentences with the simple past or past perfect form of the verbs.

1 When we landed in London, our connecting flight to Dubai already _____ (leave).
2 When she reached Agra, her luggage _____ (not arrive).
3 They _____ (go) to lunch while their room was prepared.
4 We _____ (not eat) for hours before we finally found a restaurant.
5 I realized I _____ (lose) my passport as soon as I put my hand in my pocket.
6 By the end of the week, they _____ (have) a wonderful time in Istanbul.

Listening

7 🎧 **44** Listen to two conversations about vacations. Answer the questions.

1 What problems were there with each vacation?
2 Were the problems solved?
3 What happened in the end?

Grammar subject and object questions

8 Look at the question and answer pairs (a–b), then answer the questions (1–3).

a **Who** took your bag?
A man outside the hotel took it.
b **When** did it happen?
It happened after we'd arrived.

1 Which question asks about the subject (subject question)?
2 Which question asks about the object (object question)?
3 Does the subject question or the object question need the auxiliary verb *did*?

> ▶ **SUBJECT and OBJECT QUESTIONS**
>
> **Subject questions**
>
subject	verb	object
> | **Who** | booked | the vacation? |
> | **My friend** | booked | the vacation. |
>
> **Object questions**
> **How much** did she pay?
> She paid **one hundred dollars**.
>
> For more information and practice, see page 165.

9 Look at the grammar box. Then underline all the questions in the audioscript on page 173. Which are subject and which are object questions?

10 Work in pairs. Write subject or object questions about the vacation story in Exercise 2.

1 Where / find the vacation? (In a brochure.)
Where did she find the vacation?
2 Who / call? (The person at reception.)
3 Who / look at the shower? (The maintenance man.)
4 What / the maintenance man do? (Nothing.)
5 What / happen / next? (She went to reception.)
6 What / give the hotel manager? (A large tip.)
7 Where / move to? (Room 405.)

Speaking

11 Make notes about a vacation or trip of yours under these headings:

- the type of accommodation and/or transportation you used
- other people who went with you and local people you met
- one day or thing you remember in particular (What happened? Did anything go wrong?)

12 Work in pairs. Take turns asking questions about each other's vacation or trip.

Where did you ...?

What happened next?

Who ...?

10b Adventure vacations

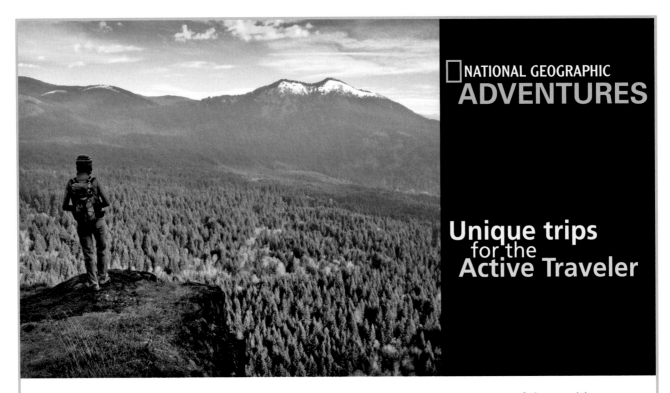

NATIONAL GEOGRAPHIC
ADVENTURES

Unique trips
for the
Active Traveler

Get ready for the trip of a lifetime with National Geographic! Walk through some of the world's most stunning mountain ranges. Kayak down legendary rivers like the Amazon. Let our expert guides take you to the birthplaces of ancient civilizations and introduce you to the fascinating people who live there now: from the Hadza tribesmen of Tanzania to Bhutanese villagers. This is your opportunity for a unique adventure with active itineraries that combine spectacular places, cultural interaction, and physical challenge: the perfect mix for an unforgettable adventure.

Vocabulary vacation adjectives

1 Look at the website. What sort of person do you think would choose this kind of vacation?

2 Match the highlighted adjectives in the website with these synonyms and definitions.

1 important or memorable _____
2 very old _____
3 very interesting _____
4 impressive or dramatic _____,

5 very famous _____
6 one of a kind _____

3 Work in pairs. Imagine your partner wants to go on an adventure vacation. Try to convince him/her to visit your country or a country you know. Talk about the country's:

• geographic regions and wildlife
• important cities and famous places
• history and culture

Listening

4 🎧 45 Listen to part of a radio interview and answer the questions.

1 What kind of new job does Madelaine have?
2 What are some of her responsibilities?

5 🎧 45 Listen again and mark the sentences true (T) or false (F).

1 Madelaine's job is sometimes boring.
2 National Geographic vacations are quite traditional.
3 Madelaine is going to the Galápagos Archipelago for the first time.
4 Some people on the tour come on their own.
5 Everyone has to do the same activities as a group.
6 You have to be in good shape to take this kind of trip.

6 Does Madelaine's job sound exciting to you? Which parts of the world would you like to work in?

Grammar -ed/-ing adjectives

7 Look at the adjectives in the two sentences and answer the questions.

You're very excited *about this job.*

This tour is very exciting *because it's unique.*

1 Which adjective describes a feeling?
2 Which adjective describes a place, person, or thing?

> ▶ **-ED / -ING ADJECTIVES**
>
> We use **-ed** adjectives to describe feelings:
> *He feels bored/excited/worried/annoyed, etc.*
> We use **-ing** adjectives to describe:
> • places: *Venice is fascinating.*
> • people: *Her brother is so boring.*
> • things: *This movie is exciting.*
>
> For more information and practice, see page 166.

8 Look at the grammar box. Then choose the correct adjectives to complete the conversation.

A: So, how was your vacation?
B: I had an ¹ *amazed / amazing* time. I'm so ² *bored / boring* being back at work.
A: I'm sure. Where did you go exactly?
B: We went hiking in Patagonia! It's a ³ *fascinated / fascinating* place.
A: Yes, I watched an ⁴ *interested / interesting* TV show about it once. The mountains there looked ⁵ *frightened / frightening*!
B: Well, we had a fantastic guide so I wasn't ⁶ *worried / worrying*.
A: What were the rest of the people in the group like?
B: Really nice except for one man who was really ⁷ *annoyed / annoying*. He kept complaining about all the walking. He said he was ⁸ *tired / tiring* all the time.
A: Sounds like he booked the wrong trip!

9 Pronunciation number of syllables

🔊 **46** Listen to the sixteen adjectives in Exercise 8 and write the number of syllables you hear in each word. Then listen again and repeat.

Example:
1 amazed (2), amazing (3)

10 Work in pairs. Talk about these topics using the *-ing* or *-ed* form of these adjectives.

amaze	annoy	bore	excite
fascinate	interest	tire	worry

1 a place you visited recently
2 the last book you read
3 a person you met recently for the first time
4 a TV show you saw last week
5 a present you received recently

> *I recently visited Hong Kong. I was excited because...*

> ▶ **WORDBUILDING dependent prepositions**
>
> We often use a preposition with **-ed** adjectives: *fascinated by, worried about.*

Speaking

11 Work in groups of three or four. Imagine you have each won $1,000 from a travel magazine to spend on "the vacation of a lifetime." You can choose any vacation lasting seven days but you must all travel as a group. Follow these steps:

1 Think about the kind of vacation you are interested in and make notes about it.
2 Take turns telling each other about the kind of vacation you want.
3 As a group, try to agree and plan a vacation which everyone will enjoy. You will need to discuss:
 • the destination
 • the type of accommodation
 • the type of activities (daytime and evening)
 • the type of itinerary (flexible or fixed?)
4 Present your vacation to the rest of the class.

10c A tour under Paris

Reading

1 What is Paris famous for? Why do millions of tourists visit it every year?

2 Look at the photo and the title on page 123 and predict the answers to these questions.

1 Where is this man?
2 Why do you think he is there?
3 What do you think he might find there?

3 Read the article. Check your predictions in Exercise 2 and underline any words or sentences which explain:

1 what is under Paris.
2 why people go there.

4 Read the article again and choose the correct answers (a–c). There is more than one answer for some questions.

1 What does the author describe?
 a what he sees
 b what he hears
 c what he smells
2 In paragraph 1, what time of day is it?
 a early in the morning
 b noon
 c late at night
3 Why were the tunnels built?
 a no one knows
 b for many different reasons
 c He doesn't say.
4 Are tourists allowed to go underground?
 a Yes, nowadays they can go everywhere.
 b It depends where they want to go.
 c No, never.
5 Why does the writer say it's dangerous in the tunnels?
 a There are criminals down there.
 b The tunnels might fall down on you.
 c You might get lost.
6 Why is Dominique and Yopie's room difficult to find?
 a It isn't on a map.
 b It's at the end of a two-hour walk through many tunnels.
 c They never show people where it is.

Critical thinking reading between the lines

5 Which of the statements (1–5) do you think are probably true? What parts of the article make you think this?

1 The author travels a lot and often visits Paris.
2 The tunnels below Paris have a long history.
3 Many young people go underground because they don't enjoy life above ground.
4 The author broke the law to write the article.
5 Dominique and Yopie are employed by a tour company.

Vocabulary places in a city

6 Find these places in the article. Do you think the places are above ground, underground, or both?

avenue	canal	catacombs	cellar
cemetery	district	tunnel	

7 Match the places in Exercise 6 with the definitions (1–7).

1 long underground passage
2 official area of a town
3 wide straight road through a city, often with trees on both sides
4 man-made river
5 area of land where dead people are buried
6 underground rooms where dead people are buried
7 underground room for storing food or wine

8 Think of a famous city in your country. Which parts are popular with tourists? Has it got many of the places in Exercise 6?

Speaking and writing

9 Imagine Paris decides to open more of the tunnels to tourists. You are a tour company and want to offer a new tour called "Paris Underground." Working in pairs, use the information from the article to discuss the type of tourist you will attract and which parts of the tunnels they will be interested in.

10 Write a short paragraph about the tour for your company's website.

A TOUR
under Paris

The streets are quiet, the stores are closed. There's the smell of fresh bread from a bakery somewhere. It would be hard to say which time of the day in Paris I prefer, but this is probably it. Soon the streets will be full of people and traffic, and the real Paris will appear as the city wakes up.

There is, however, another part of Paris which is silent and free from people 24 hours a day. Under the city are hundreds of miles of tunnels. There are sewers and old subways, but there are also canals and catacombs, and wine cellars that have been made into nightclubs and galleries. During the 19th century, Parisians needed stone to build the city, so they dug tunnels beneath it. After that, farmers grew mushrooms in them. During World War II, the French Resistance fighters also used them. Since the 1970s, groups of young people have spent days and nights in these tunnels. Parties, theater performances, art galleries—anything goes here!

myth (n) /mɪθ/ a fictional story
illegal (adj) /ɪˈliɡəl/ against the law
collapse (v) /kəˈlæps/ fall down

Everywhere you go under Paris, there is history and legend. Historians and novelists often refer to the tunnels in their books. Victor Hugo mentions them in his famous novel *Les Misérables*, and the story and musical *The Phantom of the Opera* features a pond beneath the old opera house. Most people think it's a myth, but in fact there is an underground pond there—with fish! Tourists can visit parts of the Paris underground like the catacombs beneath the Montparnasse district. Here you can see the bones and skeletons of about six million Parisians. The bodies came from cemeteries above the ground two centuries ago, when the city needed more space.

However, it's illegal to enter other parts of the underground, and police often search the area. It's also very dangerous because some of the tunnels might collapse. Nevertheless, there are people who will take you to visit them. I have found two unofficial tour guides—Dominique and Yopie (not their real names). They take me through many tunnels, and after a couple of hours we arrive at a room which isn't on any map. Yopie and some of his friends built it. It's comfortable and clean, with a table, chairs, and a bed. Yopie tells me there are many other places like this. "Many people come down here to party, some people to paint… We do what we want here."

10d At tourist information

Reading and listening

1 Work in pairs. Look at the ad on the right and answer the questions.

1 Would you go on this tour? Why?
2 What kind of information is missing?
3 What questions would you ask at a tourist information office to get it?

Example:
When is it open? / Is it open today?

Real life **direct and indirect questions**

2 🔊 **47** Listen to a conversation at a tourist information office about visiting the Catacombs of Paris. Complete the ad in Exercise 1 with the missing information.

3 🔊 **47** The man asks five questions using direct and indirect questions. Listen again and complete the questions (1–5).

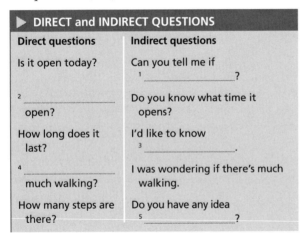

▶ DIRECT and INDIRECT QUESTIONS	
Direct questions	**Indirect questions**
Is it open today?	Can you tell me if ¹ _____ ?
² _____ open?	Do you know what time it opens?
How long does it last?	I'd like to know ³ _____ .
⁴ _____ much walking?	I was wondering if there's much walking.
How many steps are there?	Do you have any idea ⁵ _____ ?

4 Look at the direct and indirect questions in Exercise 3. Answer the questions (1–3).

1 Which questions are more polite?
2 Which questions use the same word order as an affirmative sentence?
3 Do you use *if* in indirect questions with *wh-/how* questions or *yes/no* questions?

5 Pronunciation /dʒə/

🔊 **48** Listen to these two indirect questions. How does the speaker pronounce the first two words? Listen again and repeat.

1 Do you know if there's a taxi stand near here?
2 Do you have any idea how much it costs?

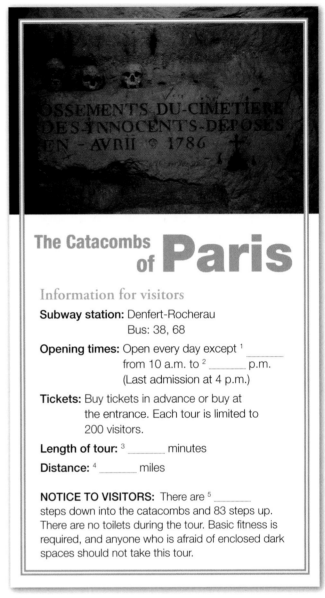

The Catacombs of **Paris**

Information for visitors

Subway station: Denfert-Rocherau
 Bus: 38, 68

Opening times: Open every day except ¹ _____
 from 10 a.m. to ² _____ p.m.
 (Last admission at 4 p.m.)

Tickets: Buy tickets in advance or buy at the entrance. Each tour is limited to 200 visitors.

Length of tour: ³ _____ minutes

Distance: ⁴ _____ miles

NOTICE TO VISITORS: There are ⁵ _____ steps down into the catacombs and 83 steps up. There are no toilets during the tour. Basic fitness is required, and anyone who is afraid of enclosed dark spaces should not take this tour.

6 Make these direct questions into indirect questions using the words in italics.

1 Which bus do I take?
 Can you tell me…?
2 Is there a post office near here?
 Do you know if…?
3 What time does the gallery open?
 I'd like to know…
4 Are there any good restaurants nearby?
 I was wondering if…
5 How much does it cost?
 Do you have any idea…?

7 Work in pairs. Practice two conversations between a tourist and a person at tourist information.

Student A: Turn to page 154.
Student B: Turn to page 155.

10e Requesting information

Writing a formal letter

1 When you want to go on vacation, how do you get information: online, from a travel agent, by mail?

2 Read the letter and answer the questions.

 1 What is the writer's purpose?
 2 What information does the writer want from the travel company?

3 **Writing skill** formal expressions

The phrases (1–10) are less formal. Find similar, but more formal, phrases in the letter in Exercise 2.

Starting
1 Hi…
2 I'm writing about…
Asking for more information
3 Can you send me more information about…?
4 What level of fitness do I need?
5 Can you tell me what "average" means?
6 Please tell me when you will know the tour dates.
7 Will this also happen when we stay in hotels…?
Ending
8 Thanks for any help or information.
9 Hope to hear from you soon.
10 All the best,…

4 Look at the vacation ad for a cruise. Write to the tour company and request:

- details about the exact length of the cruise (in weeks)
- the exact starting location in South America
- the cost of meals (or whether they're included)
- the prices of cabins with ocean views

5 Work in pairs. Exchange letters and check whether they use:

- a formal style of writing
- indirect phrases and expressions

Dear Sir or Madam,

I am writing with regard to the "Explorer's Vacations" on your website. I would like to request further details about your next expedition to Alaska.

First of all, I was wondering what level of fitness is required for this trip. The website says participants should have an average level of fitness. I'd be grateful if you could define "average" for me.

Second, the website says that you will confirm the exact dates for next year "in the near future." I'd like to know when the tour dates will be available.

My last question is about accommodation. I understand that for the parts of the journey when we'll be camping, we will share a tent with someone else in the group. Can you tell me whether this is also the case for staying in the hotels and cabins, or will we have our own private rooms?

Thank you in advance for providing any further details about the tour. I look forward to hearing from you.

Best regards,
Dr. Luis Mejia

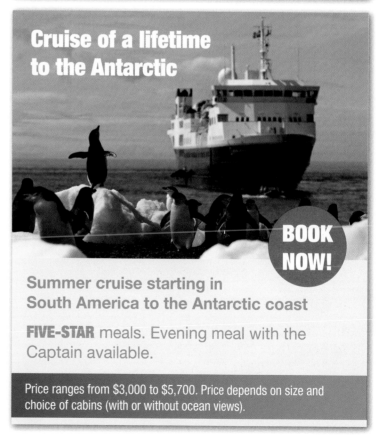

Cruise of a lifetime to the Antarctic

BOOK NOW!

Summer cruise starting in South America to the Antarctic coast

FIVE-STAR meals. Evening meal with the Captain available.

Price ranges from $3,000 to $5,700. Price depends on size and choice of cabins (with or without ocean views).

10f Living in Venice

Video

This is the part of Venice that most visitors never see.

Before you watch

1 The photo shows people living and working in Venice. Read the sentences and choose the option you think is correct.

1 *Late afternoon / Early morning* is the best time for shopping in the outdoor markets.
2 Residents say it's a very *clean / dirty* city to live in.
3 The population of Venice is getting *younger / older*.
4 Property *is / isn't* very expensive.
5 Getting home from work is often very *easy / difficult*.
6 Venice is *less expensive than / as expensive as* many other cities.

While you watch

2 Watch the video and check your answers from Exercise 1.

3 Number the things in the order you first see them.

a a trader peeling vegetables
b early morning in the Piazza San Marco
c sunset in Venice
d musicians playing violins
e a gondolier
f a fish market
g a man jogging

4 Make notes about the advantages and disadvantages of living in Venice, then compare them with a partner.

Advantages	
Disadvantages	

5 Match the people (1–3) with what they say (a–g).

1 Giovanni dal Missier
2 the narrator
3 Gino Penzo

a In a few hours, thousands of people will come to this square.
b We have many, many kinds of fish.
c My son, he doesn't… live in Venice. I am very sorry.
d The tourists come to experience a city that feels like it's still in the fifteenth century.
e Anyone who comes to Venice will fall in love.
f I know that it's a… gift to live in a city (like) Venice.
g For those who stay, it can be a wonderful experience.

After you watch

6 Roleplay a conversation between a tourist and a tour guide

Work in pairs.

Student A: You are a tour guide showing a visitor your town or city. Use the information below to make notes.

Student B: You are a tourist visiting the town or city. Find out what it's like to live there by asking the tour guide about:

• the best places to see
• the advantages of living there
• the disadvantages of living there

Act out the conversation, then change roles and act it out again.

7 Giovanni dal Missier says: "I get bored with the people, with the tourists." Do you sympathize with him? Why?

8 Working in pairs, discuss these questions.

1 Which is the most visited tourist city in your country? Why do visitors go there?
2 Would you like to live in a city with lots of tourists? Why?
3 What benefits does tourism bring? What are the disadvantages?

earn a living (v) /ˈɜrn ə ˈlɪvɪŋ/ make enough money to live
gift (n) /gɪft/ a present

property (n) /ˈprɑpərti/ houses
trader (n) /ˈtreɪdər/ a person who buys and sells things

UNIT 10 REVIEW

Grammar

1 Complete the conversation with the simple past or past perfect form of the verbs.

A: How was your vacation?
B: It was fine, in the end.
A: Why? What ¹ _____ (happen)?
B: Well, we arrived at the hotel but they ² _____ (not / receive) our reservation. So we ³ _____ (not / have) a room and they were full.
A: Oh no! ⁴ _____ you _____ (book) the hotel?
B: Yes, I had. Anyway, they ⁵ _____ (call) another hotel and fortunately it ⁶ _____ (have) rooms. Unfortunately, it was in another town.
A: So what ⁷ _____ you _____ (do)?
B: Well, I was really angry after everything that ⁸ _____ (happen), but the manager ⁹ _____ (pay) for a taxi to the other hotel, and it was funny because we ¹⁰ _____ (see) our new hotel in the brochure months ago but it ¹¹ _____ (be) more expensive so we ¹² _____ (book) the other one!

I CAN
tell stories and describe what happened to me
ask questions about the past

2 Complete the adjectives with *-ing* or *-ed*.

1 Do you feel bor____?
2 This book is very interest____.
3 We had an amaz____ time in Peru.
4 Stop being annoy____ and leave me alone!
5 This is so excit____!
6 I'm really frighten____!

3 Work in pairs. Look at the photo. How do they feel? How would you describe the activity they are doing?

I CAN
describe how people feel
describe places, people, and things

Vocabulary

4 Delete the incorrect word in each group and say why.

1 old, historical, ~~unforgettable~~, ancient
 the others are synonyms of "old"
2 suntan lotion, camping, package tour, cruise
3 stunning, huge, beautiful, spectacular
4 sleeping bag, tent, camera, adventure sports
5 camping, sunbathing, self-guided, cruise
6 cellars, tunnels, bridges, catacombs

5 What's your dream vacation? Make notes about the location, accommodation, and activities.

6 Work in pairs. Tell your partner about your dream vacations.

I CAN
talk about tourist locations and vacations

Real life

7 Imagine you are a tourist in your town or city. Complete these indirect questions to ask for information.

1 Can you tell me _____?
2 I'd like to know _____.
3 Do you know _____?
4 I was wondering _____.

8 Rewrite your questions in Exercise 7 as direct questions.

I CAN
ask for tourist information using direct and indirect questions

Speaking

9 Work in pairs. Comment on these different aspects of vacations and travel using the phrases and your own words.

adventure vacations
waiting at airports
hot beaches
visiting new countries
looking at other people's vacation photos
waiting in line to visit tourist sites
new exotic food
flying

We both like / dislike… are interested in…
get bored with… get excited / worried / angry
about…

Unit 11 History

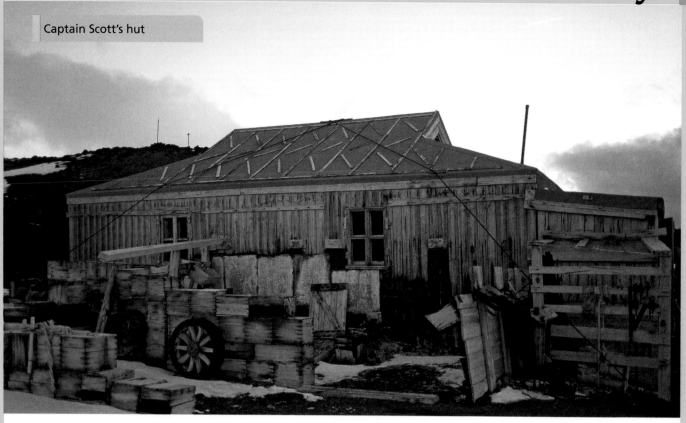

Captain Scott's hut

FEATURES

1 Captain Scott was a famous polar explorer. Read the text and answer the questions.

Just over one hundred years ago, the British explorer Captain Robert Falcon Scott died with his team of men in the snow and ice of Antarctica. This hut was the base for his expedition. Because of the freezing temperatures in this part of the world, the hut has become a time capsule—a place where nothing has changed. So for example, inside the hut there is butter and other items of food which are one hundred years old. The ice has preserved them all. When you go inside, it's almost as if Scott has only just left the hut.

1 What objects would you expect to see inside the hut?
2 Historians call the hut "a time capsule." What do you think that means?

2 Sometimes we put objects in a time capsule and bury it so that future generations can learn more about us. Working in groups, imagine you are going to make a time capsule with only five items. Discuss which five objects you will include. Use these examples or your own ideas.

a clock	money (coins and bills)	a popular novel
a restaurant menu	drawings and diaries	a can of food
a CD of popular music	a DVD showing a movie about daily life	
a copy of today's newspaper		

11a An ancient civilization

Speaking

1 Do you live in or near a town or city with historical places? Which of these does it have? What do you know about the history of each place?

> ancient roads and bridges castles
> city walls museums pyramids
> old religious buildings a palace
> statues of historical people

2 Which of these are the reasons why your town or city looks after some of the places you described in Exercise 1?

1 The place is unique.
2 Someone famous lived there.
3 The architecture is important.
4 There are important objects inside.

Vocabulary archaeology

3 Read the text and match the highlighted words with the definitions (1–6).

1 to dig out an area of land to reveal buildings and objects from the past
2 the action of finding something you didn't know was there
3 people who study societies from the past by looking at their buildings, tools, and other objects
4 to kill an animal (or human) for your god(s)
5 a human society from the past
6 metal or stone images of someone or something

> ▶ **WORDBUILDING word roots**
>
> Parts of many English words come from the ancient languages of Greek and Latin. For example, the first part of the word *archae*ology comes from a Greek word meaning *ancient, old, from the beginning*. The *ex-* in the word *ex*cavation is a Latin prefix meaning *out of*. Sometimes you can guess the meaning of a new word if you know some of these word roots.

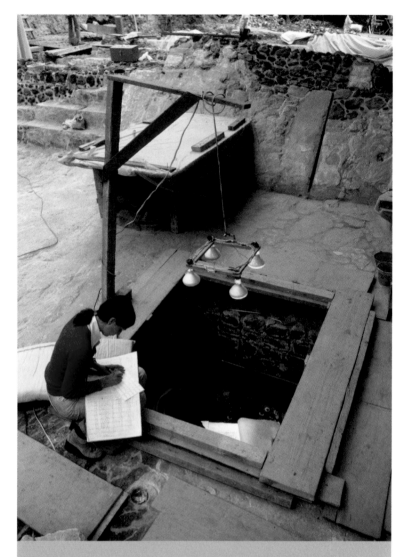

In 1978, archaeologists made an important discovery right in the middle of modern Mexico City. It was a fourteenth-century pyramid from an ancient civilization: the Aztecs. They started to excavate different rooms inside. In some rooms they found objects like plates and cooking pots. In others, there were small religious statues or knives which the people used to make a sacrifice to their gods.

Listening

4 🎧 **49** Listen to an interview with an archaeologist and list what she has found in the pyramid. Why is it important?

5 🎧 **49** Listen again and match the objects (1–5) from the excavation with their purpose (a–e).

1	pots and plates	a	doing business
2	gold and jade	b	cooking
3	statues	c	sacrificing
4	knives	d	hunting
5	(the skeleton of) a dog	e	religious importance

Grammar *used to*

6 Look at the sentences (a–d) and answer the questions (1–4).

a Archaeologists discovered this pyramid in 1978.
b The Aztecs used to sacrifice animals.
c Did the Aztecs use to keep dogs as pets?
d No, they didn't use to have pets.

1 Which sentence, a or b, describes a single action at a specific time in the past?
2 Which sentence, a or b, describes a past situation or habit which doesn't happen now?
3 What form of the verb follows *used to*?
4 How does the negative and question form of *used to* change?

> ▶ **USED TO**
>
> I/you/he/she/it/we/they **used to live** in this house.
> I/you/he/she/it/we/they **didn't use to live** in this house.
> Did I/you/he/she/it/we/they **use to live** in this house?
> Yes, I did. / No, I didn't.
>
> For a particular time in the past, we use the simple past:
> I *used to live* in this house in 1989. ✗
> I *lived* in this house in 1989. ✓
>
> For more information and practice, see page 166.

7 Look at the grammar box. Then complete the text with the correct form of *used to*. Use the simple past where *used to* is not possible.

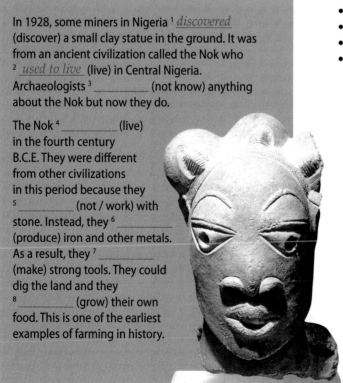

In 1928, some miners in Nigeria ¹ *discovered* (discover) a small clay statue in the ground. It was from an ancient civilization called the Nok who ² *used to live* (live) in Central Nigeria. Archaeologists ³ _____ (not know) anything about the Nok but now they do.

The Nok ⁴ _____ (live) in the fourth century B.C.E. They were different from other civilizations in this period because they ⁵ _____ (not / work) with stone. Instead, they ⁶ _____ (produce) iron and other metals. As a result, they ⁷ _____ (make) strong tools. They could dig the land and they ⁸ _____ (grow) their own food. This is one of the earliest examples of farming in history.

8 Pronunciation /s/ or /z/

🔊 **50** Listen to the change in pronunciation of the words *use* or *used* and practice saying the sentences. What is the rule for the /s/ or the /z/?

The Nok **used** *to live in Africa but they didn't* **use** *to live in Europe. They* **used** *iron but they didn't* **use** *any stone.*

9 Working in pairs, test each other's knowledge of other ancient civilizations. Use the prompts to ask questions with *used to*. In some cases, both answers are correct, only one is correct, or neither is correct. Check your answers with your teacher.

1 Ancient Egyptians: build pyramids / castles
2 Ancient Greeks: watch theater / sports
3 The Celts: live in South America / in Asia
4 Native Americans: grow corn / potatoes

> *Did the ancient Egyptians use to build pyramids and castles?*

> *They used to build pyramids but they didn't use to build castles.*

Speaking

10 Working in pairs, discuss what people used to do in recent history and what they do now for each topic.

- fashion
- information (like news)
- communication
- music and entertainment
- transportation

> *How did people use to listen to music?*

> *What kind of clothes did people use to wear?*

> *Did people use to travel by...?*

> *Do people still...today?*

11b Modern history

Speaking

1 What is the most important moment of world history in your lifetime? Why?

2 Work in groups. Think of one historic moment for each of these topics.

> world politics
> famous individuals
> space exploration
> culture and the arts
> countries and cities
> technology

3 Compare your ideas from Exercise 2 with the rest of the class. Then choose the three most important moments in history.

Reading

4 Read the article and number the paragraphs (A–E) in the correct order.

5 Answer the questions with the correct times and dates.

1 On what date did the Space Age begin?
2 How many years later did an American walk on the moon?
3 When did the US lead the space race?
4 How many years later did they agree on plans for the ISS?
5 When did the ISS start orbiting the Earth?
6 When did space tourism begin?
7 What period of history does the speaker talk about at the end?

6 Work in pairs. Discuss the questions.

1 What is an important date in your country's history?
2 Which is your favorite decade in history?
3 Which century in your country's history is the most interesting?
4 What were you doing at the turn of the last century?
5 How do you think life will change in the next half century?

MOMENTS IN SPACE *history*

A

Eight years later, an American finally walked on the moon, and during the early 70s, the US led the Soviet Union in the space race. However, space travel was expensive and they needed to cooperate more. As a result, in 1975 astronauts from both countries flew two spacecraft and met in space. Afterwards, one astronaut said that the mission showed that the Soviet Union and America could work together.

B

At the beginning of the twenty-first century, businessman Dennis Tito paid twenty million dollars and told the world he loved space as he spent eight days on the ISS. Since then, space tourism has developed with plans for regular tours and floating hotels.

C *1*

On October 4, 1957, the Soviet Union sent Sputnik 1 into space and a new age in history began: the Space Age. The Soviets launched more Sputnik satellites in the 50s, and by 1961 they had put the first man into space.

D

And what about the next half a century? In 2009, a Russian space chief said Russia was planning a nuclear spaceship for travel to Mars. In 2010, US president Barack Obama told an audience that by the mid-2030s, the US would send humans to Mars. The race for Mars has already started.

E

Nearly two decades later, leaders from both countries said they had agreed on plans for a new International Space Station (ISS), and by the turn of the century, the ISS had started orbiting the Earth. Nowadays, the ISS is used by scientists from all over the world.

Grammar reported speech

7 Look at the example of reported speech and its direct speech equivalent. Which words change in reported speech?

Reported speech: One astronaut said that the mission showed that the Soviet Union and America could work together.

Direct speech: One astronaut said, "The mission shows that the Soviet Union and America can work together."

8 Look at the examples of direct speech. Then look back at the article in Exercise 4 and find their equivalents in reported speech. How do the pronouns and tenses change?

1 Tito said, "I love space."
2 The leaders of both countries said, "We have agreed on plans for a new International Space Station."
3 A Russian space chief said, "Russia is planning a nuclear spaceship for travel to Mars."
4 Barack Obama told an audience that, "By the mid-2030s the US will send humans to Mars."

> **▶ REPORTED SPEECH**
>
Direct speech	→	Reported speech
> | Simple present | | Simple past |
> | Present continuous | | Past continuous |
> | Simple past | | Past perfect |
> | Present perfect | | Past perfect |
> | *will* | | *would* |
>
> For more information and practice, see page 167.

9 Look at the grammar box. Then complete the direct and reported speeches.

1 The boy said, "One day I want to be an astronaut."
The boy said that one day _____ to be an astronaut.
2 Last year the president said he had plans for a new mission to the moon.
Last year the president said, "_____ for a new mission to the moon."
3 In 2010, astronomers said, "The Hubble Telescope has found a new planet."
In 2010, astronomers said that the Hubble Telescope _____ a new planet.
4 Scientists said a robot had discovered water on Mars.
Scientists said, "A robot _____ water on Mars."
5 The radio announcer said, "The rocket is landing."
The radio announcer said the rocket _____ .
6 The government said they were discussing the problem.
The government said, "We _____ the problem."
7 China said, "We will visit the moon in the next few years."
China said it _____ the moon in the next few years.
8 They said they couldn't afford the ticket into space.
They said, "We _____ the ticket into space."

Vocabulary *say or tell*

10 Look back at the article in Exercise 4 and underline examples of *say (said)* or *tell (told)*. Then complete this rule with *say* or *tell*.

¹ _____ always needs an object such as *me, him, her, you, us, them, everyone*. Do not follow ² _____ with an object.

11 Choose the correct options to complete the conversation.

A: Did I ¹ *say / tell* you there was a great TV show on last night about space travel in the next century? They ² *said / told* humans would soon land on Mars.
B: Really? When did they ³ *say / tell* it would happen?
A: The presenter didn't ⁴ *say / tell* us exactly, but I think before the year 2050.
B: I read another article and it ⁵ *said / told* there would be a hotel on the moon soon.
A: Yes, but someone ⁶ *said / told* me a few years ago that space hotels would be orbiting the Earth soon, but nothing's happened yet.

Speaking

12 Work in pairs. Interview each other with these questions and write down your partner's answers.

1 What's one thing you want to do in your lifetime (like jump out of an airplane or travel into space)?
2 Which was your favorite subject in school (history, geography)?
3 What famous historical places have you visited (Machu Picchu or the Great Wall of China)?
4 Do you think you will travel to space in your lifetime? Where will you go (Mars, the moon)?

13 Work with a new partner and report your original partner's answers. Use *say* or *tell* and reported speech.

> He said he wanted...

> She told me it had been...

11c Jane Goodall

Reading

1 Do you ever read biographies? What kind of people do you like to read about (people from history, celebrities)?

2 Read the biography about the life of Jane Goodall on page 135. Which paragraphs are about her life during these different times?

1 the sixties
2 the seventies
3 the eighties
4 the nineties up to the present day

3 Read the biography again and answer the questions. Underline the information in the article that gives you the answer. Then compare your answers and the information you underlined with your partner.

1 Who was Jane traveling with when she first arrived in Gombe?
2 How soon after Jane arrived in Gombe did she try to find her first chimpanzee?
3 How qualified was she for this kind of work?
4 What did she discover about chimpanzees?
5 When did scientists and academics start reading her work?
6 Why did Gombe become a dangerous place?
7 Did all the foreigners, including Jane, leave the region?
8 Why were there only about a hundred chimpanzees living in Gombe by the end of the eighties?
9 Has Jane retired?
10 What does Jane do now?

Critical thinking **relevance**

4 These statements (a–d) could be included as useful background information at the end of four of the paragraphs in the article. Match them with the correct paragraph.

a This was new and surprising scientific information at that time.
b Even ordinary people around the world were starting to recognize her name.
c This was the start of a lifetime of studying the behavior of the chimps in Africa.
d This work continues to the present day.

Writing and speaking

5 Work in pairs. Imagine you are biographers and you are going to write a biography of Jane Goodall. Prepare seven or eight interview questions for her based on the information in the article.

Example:
Do you remember your first day in Gombe?
What did you have with you?
Why did you go to the forest?

6 Work with a new partner and roleplay an interview between the biographer and Jane Goodall. Take turns being the interviewer and Jane.

On the morning of July 14, 1960,

Jane Goodall arrived on the east shore of Lake Tanganyika in the Gombe National Park. She had brought a tent, a cup without a handle, a pair of binoculars, and her mother. A group of local men met the strange pair of women and helped carry their camping gear. Then, around 5 p.m., somebody reported that they had seen a chimpanzee. Immediately, Jane went into the forest to find her first chimpanzee.

As a young woman, Jane Goodall had no scientific qualifications, but this didn't stop her from following her childhood dream of studying chimpanzees in Africa to find out how they really lived. After many months of difficult work she made three important discoveries: chimpanzees ate meat, they used tools to get food, and they also made tools.

Every evening, Jane wrote her findings in a journal. She began to publish articles in magazines like National Geographic. After a while, scientists and academics started reading her studies and Jane was offered admission to a university. In 1966, after more years of research, she got her doctorate degree. Her work was also making her famous. There was a film documentary, *Miss Goodall and the Wild Chimpanzees* (1963), and then *My Friends the Wild Chimpanzees* (1969), the first of many books.

rebel (n) /ˈrebəl/ soldier who fights against government soldiers
fled (to flee) (v) /fled/ left quickly because of a dangerous situation
deforestation (n) /diˌfɔrɪ'steɪʃən/ when trees and forests disappear
sanctuary (n) /ˈsæŋktʃuˌeri/ a safe place
trade (n) /treɪd/ buying and selling

During the seventies, Gombe became a dangerous place to work. It is on the border of four different countries and there was fighting between soldiers and rebels. Many foreigners fled the region, but Jane stayed—with a military escort—to continue her work. In one of her journals from this period she noted that chimpanzees could also be violent: "I thought the chimps were nicer than we are," she wrote. "But time has revealed that they... can be just as awful."

A different problem developed in Gombe in the 1980s. The increasing human population in the region was causing deforestation. As a result, there were only about a hundred chimpanzees living in Gombe by the end of the decade. Jane realized that something had to be done so chimpanzees and humans could live together, so she organized an initiative with the local community to grow more trees in the region.

After 1989, Jane left her career in Gombe and started traveling and giving lectures. She protested about cruelty to chimpanzees in medical research laboratories. She also set up sanctuaries for chimps which had been captured or were orphans because of the trade in chimpanzee meat. Nowadays, she spends about 300 days a year giving interviews, talks, and lectures, meeting with government officials, and raising money for the Jane Goodall Institute, which continues her research. She has very little spare time but still spends part of every year in the forest in Gombe, watching her chimpanzees.

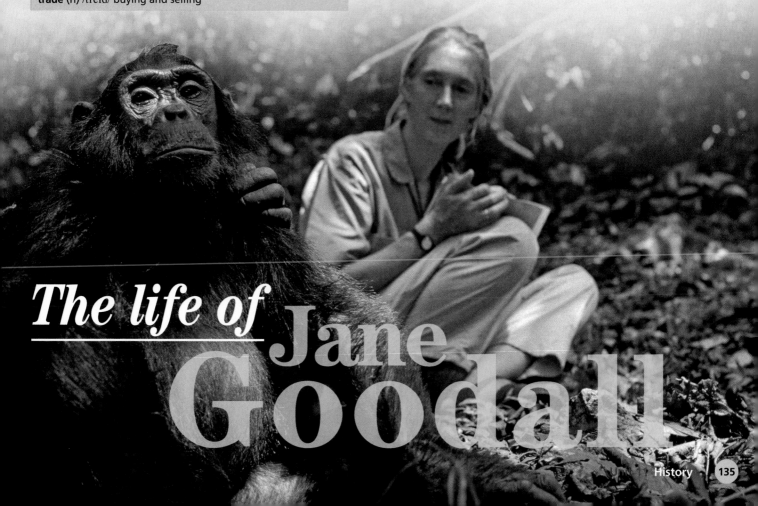

The life of Jane Goodall

11d A journey to Machu Picchu

Real life giving a short presentation

1 Do you ever give talks or presentations in your own language (or in English)? What are they about? Why would people give talks or presentations in these situations?

- at work
- in class
- at the meeting of a local club or town council

2 🎵 **51** Listen to parts of a presentation and mark which of the topics (1–6) the presenter talks about.

1 the people in Peru and their customs
2 the history of Machu Picchu
3 the history of the Incas
4 the capital city of Peru
5 his own journey
6 the food in Peru

3 🎵 **51** Listen again and complete these expressions for giving a short presentations.

▶ GIVING A SHORT PRESENTATION

Good morning and ¹ _____ _____ all for coming.
Today I would like to ² _____ about…
Let me ³ _____ by telling you about…
So, that's everything I wanted to ⁴ _____ about…
Now, let's ⁵ _____ on to…
The ⁶ _____ part of my presentation is about…
I'd like to ⁷ _____ you some of my photos.
That's the ⁸ _____ of my talk. In summary,…
Are there any ⁹ _____?

4 Pronunciation pausing

a 🎵 **52** Presenters often pause at the end of a sentence, the end of a phrase, or before and after important words they want to emphasize. Listen to the presentation again and notice the first five pauses (/) and write in the missing pauses (/) from the next few comments.

Good morning / and thank you all for coming. / Today / I'd like to talk about / my vacation in Peru / and in particular, about my journey to Machu Picchu, also called "The Lost City of the Incas." Let me begin by telling you about the history of Machu Picchu.

b In pairs, practice reading the same part of the presentation.

5 Prepare a short presentation for your partner about a historical place you have visited. Talk about:

- Where it is.
- Why it's important.
- Who lived there in the past.

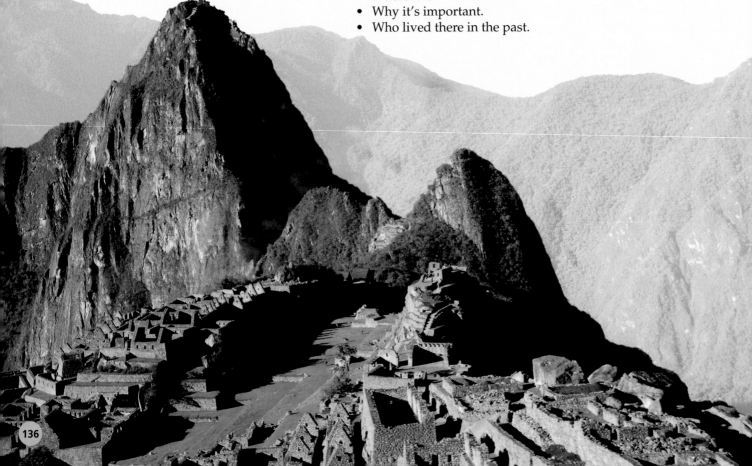

11e The greatest mountaineer

Writing a biography

1 Think of three pieces of information you would expect to find in a biography. Compare your ideas with your partner.

2 Read the biography of Reinhold Messner. Does it include your ideas from Exercise 1? Which paragraph (1–4) has information about the topics (a–f)? Two paragraphs each contain two topics.

 a When and where the person was born
 b Childhood and early life
 c Why the person became well-known
 d Something famous the person said
 e What other people think or have said about the person
 f When the person died or what the person is doing now

3 Writing skill **punctuation in direct speech**

a The second paragraph in the biography includes direct speech. Underline another example in the text.

b Answer these questions about punctuation rules for direct speech.

 1 Where do you put the two quotation marks?
 2 Do you always put a period at the end of the quotation or only if it ends the sentence?
 3 Where do you put the comma? What does it separate?

c Write in the missing punctuation.

 1 My grandfather always told me you should follow your dreams
 2 Yes we can said Barack Obama when he campaigned to become president
 3 Education is the most powerful weapon said Nelson Mandela

4 Write a short biography (100–120 words) about someone famous or someone you admire. Try to include all the topics in Exercise 2 and remember to use the correct punctuation with quotations or direct speech.

The world's greatest mountaineer

1 Reinhold Messner has been described as the greatest mountaineer in history. He's famous for being the first man to climb Mount Everest without oxygen in 1980. But he was also the first man to climb all fourteen of the world's mountains over 26,000 feet.

2 Messner was born in 1944 in a small village in the mountains of northern Italy. When he talks about the area he still says, "it's the most beautiful place in the world." His father was a climber and took his son up a mountain when he was only five. As a teenager, Messner climbed with his younger brother Günther.

3 In their twenties, the brothers started climbing in the Himalayas, but Günther died in an accident and Reinhold lost six toes. Nevertheless, Messner continued climbing and became a legend among other mountaineers. The climber Hans Kammerlander believes Reinhold changed climbing. "Reinhold had so many new ideas," says Kammerlander, "new ways, new techniques."

4 Nowadays, Messner spends time at home with his family. He has written over sixty books. In 2006, he opened the Messner Mountain Museum where people can find out more about the world he loves.

5 Exchange your biography with a partner. Use these questions to check your partner's biography.

 • Which topics in Exercise 2 has he/she included?
 • Is the punctuation correct?

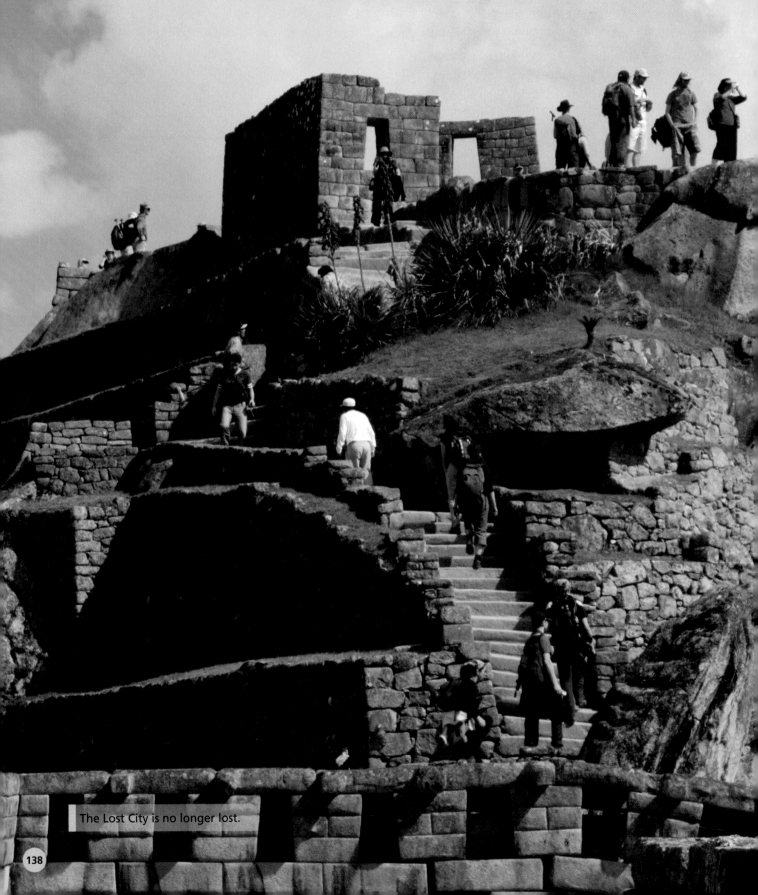

The lost city of Machu Picchu

The Lost City is no longer lost.

Before you watch

1 Work in groups. Look at the photo and discuss the questions.

1 Who are the people in the photo?
2 Where are they?
3 What are they doing?
4 What do you think the caption means?

2 Mark the things you think you are going to see in the video.

bicycles	buses	cameras	children	dogs
mountains	a river	ruins	a train	umbrellas

While you watch

3 Check your answers from Exercise 2.

4 Choose the correct option to complete the summary.

Machu Picchu is an ancient city ¹ *8,000 / 18,000* feet up in the ² *Andes / Pyrenees*. It is over ³ *1,000 / 500* years old. It is sometimes called the Lost City of the ⁴ *Inca / Aztec*. When their civilization ended, few people knew Machu Picchu existed, but in ⁵ *1911 / 2001* an explorer, Hiram ⁶ *Bingham / Birmingham*, found it again.

5 Are these sentences true (T) or false (F)? Watch the video again to check your answers.

1 It is always sunny at Machu Picchu.
2 The lost city is not very popular with tourists.
3 You can't walk around the ruins.
4 Machu Picchu is now a very noisy place.
5 Local people would like more tourists to visit Machu Picchu.
6 Conservationists say that tourism is good for the environment.
7 Many parts of Peru are very poor.
8 Aguas Calientes is a very large city.

6 Match the people (1–3) with what they say (a–f).

1 Julio (tour guide)
2 José (hotel owner)
3 The narrator

a It is a magic attraction.
b Why not be like the rest of the world?
c Why keep it to the few?
d Machu Picchu is one of the magnetic centers of the ancient world.
e This beautiful, quiet place is covered in sunshine.
f Even in the rain and fog, it's wonderful to walk through the ruins.

After you watch

7 Roleplay **discussing the future of Machu Picchu**

Work in pairs.

Student A: You are a conservationist. Read the information below and make notes, then argue your point of view with your partner.

• You want to limit the number of tourists who visit the ancient city.
• Give reasons (for example, too many people are destroying the ruins, people leave a lot of trash).

Student B: You work in the tourist industry. Read the information below and make notes, then argue your point of view with your partner.

• You want to increase access to Machu Picchu.
• Give reasons (for example, more tourists mean more money for the local economy, hotel owners will benefit).

Act out the discussion, then change roles and repeat the discussion.

8 According to the narrator, time may be running out for the Lost City of the Inca. What do you think that means?

9 Work in pairs. Discuss these questions.

1 Are there any ancient sites or ruins in your country? Who built them? Are they tourist attractions?
2 Does tourism have a positive or negative impact on these places? Why?
3 How can ancient monuments best be preserved for future generations?

conservationist (n) /kɑnsərˈveɪʃənɪst/ a person who works to preserve a natural or ancient place
fog (n) /fɔg/ low cloud that makes it difficult to see
ruins (n) /ˈruɪnz/ destroyed buildings
run out (v) /rʌn ˈaʊt/ come to the end, finish
stall (n) /stɔl/ a temporary shop without walls
step (n) /stɛp/ the place where you put your foot when you go up stairs

UNIT 11 REVIEW

Grammar

1 Complete the sentences with the correct form of *used to*.

1 We _____ live in Lima but now we live in Quito.
2 I _____ read but now I watch TV.
3 They _____ like vegetables, but now they love them!
4 There _____ be trees all around my house but now there are other houses.
5 The town _____ have cafés and restaurants, but now it has lots.

2 Work in pairs. Comment on these aspects of your appearance in the past and now.

- length and/or color of hair
- height
- use of glasses
- colors and style of clothes

> *I used to have long hair and now I don't.*

3 Rewrite the direct speech as reported speech.

1 "I want to fly in space."
 He said he _____ .
2 "I'm driving home."
 She said she _____ .
3 "We visited the pyramid in Giza."
 They said they _____ .
4 "He's gone to the museum."
 You said he _____ .
5 "One day I'll go on vacation to Rome."
 Luis said one day he _____ .

4 Complete the sentences with *say* or *tell*.

1 _____ him to hurry up!
2 Did she _____ what time she was coming?
3 Don't _____ me the answer.
4 Did the archeologist _____ who built this ruin?

5 Work in pairs. Tell your partner something:

- a reporter said on the TV or radio this morning.
- your English teacher told you today.

I CAN	
talk about past situations and habits	☐
report what people said or told me	☐

Vocabulary

6 What does the photo show? What do you think it was for?

7 Complete the text with these words and check your ideas in Exercise 6. There is one extra word.

archaeologists	civilization	excavations
pyramids	sacrifices	statue

The Inca ¹ _____ was the largest in South America in the thirteenth and fourteenth centuries. ² _____ are still finding objects from their past. For example, the ³ _____ in the photo is a llama. It was found in ⁴ _____ at a site that they used for animal and human ⁵ _____ .

I CAN	
talk about history and archaeology	☐

Real life

8 Put these sentences from different parts of a presentation in order (1–7).

 ☐ Today I'd like to talk about my visit to Guatemala.
 1 Good morning everyone and thank you for coming.
 ☐ So that's everything about Tikal and its pyramid.
 ☐ But before I finish, are there any questions?
 ☐ Let me begin by telling you a bit about Tikal.
 ☐ In summary, Guatemala is full of wonders.
 ☐ Now let's move onto my next stop, which was the nearby city of Flores.

I CAN	
give a short presentation	☐

Speaking

9 Discuss as a class. What's your favorite historical period? Why? What do you like about it (the clothes, the architecture, the art)?

Unit 12 Nature

Animal disguises
Photo by Christian Ziegler

FEATURES

1 Look at the photo. Describe what you can see.

2 Match these words to the correct category (1–7) in the diagram. Then think of one more word for each category.

| butterfly | eagle | horse | shark | snake | toad | tree |

NATURE

1 PLANT ANIMAL

2 INSECT 3 AMPHIBIAN 4 MAMMAL 5 REPTILE 6 BIRD 7 FISH

3 Work in pairs. Complete these sentences with the name of an animal (or animals) and give reasons.

I've never seen...

I'd love to have a(n)... as a pet.

I'm really scared of...

12a Nature in one cubic foot

Listening

1 Working in pairs, discuss whether you enjoy taking photos of nature, and why.

2 Match the photos (A–D) with the locations (1–4).

1 forest 3 ocean
2 mountain 4 river

3 🔊 **53** Listen to a documentary about David Liittschwager, the photographer. Why does he take photos of the green metal frame?

> **cube** (n) /kjub/ a shape that has six equally square sides (cubic = adj)
> **ecosystem** (n) /ˈikoʊˌsɪstəm/ all the plants and animals that live in a particular area

4 🔊 **53** Listen to the documentary again. Are the sentences true (T) or false (F)?

1 The narrator thinks most people look at the natural world and see everything.
2 David Liittschwager thinks there is natural beauty everywhere.
3 He put his green cubic foot in different ecosystems.
4 He spent three weeks taking photos around the world.
5 He photographed living things that were smaller than one millimeter in size.
6 In total, he photographed over a thousand organisms in each cubic foot.

5 Work in pairs. Describe the view from a window in your house. Use these questions to help you.

- Can you see any natural locations such as mountains or rivers, or do you see buildings and roads?
- How important is it for you to look at nature?

Grammar *any-, every-, no-, some-* and *-thing, -where, -one, -body*

6 Look at the highlighted words. Does the yellow part of the word talk about a place, a person or an object?

1 Everyone looks at nature differently.
2 Maybe you're somebody who has no interest in nature.
3 If you go anywhere green, you don't notice anything.
4 Nowhere in the world is without natural beauty.

7 Look at the green part of the highlighted words in Exercise 6. Complete the sentences with *any-, every-, some-,* or *no-*.

1 _____one loves taking photos. It's very popular.
2 _____body likes that photo. We all look terrible in it.
3 _____one can take a photo. It's easy.
4 _____one took my photo. It's in today's newspaper.

> ▶ **ANY-, EVERY-, NO-, SOME-** and **-THING, -WHERE, -ONE, -BODY**
>
> **Affirmative** (*any-, every-, some-*)
> *Anybody/Anyone can take a photo.*
> *Everybody/Everyone likes nature.*
> *Let's go anywhere/everywhere/somewhere.*
>
> **Negative** (*any-, no-*)
> *People don't notice anybody/anything there.*
> *Nobody/No one uses the park in my city.*
>
> For more information and practice, see page 168.

8 Look at the grammar box and complete the words in the article on the right. Sometimes more than one answer is possible.

Speaking

9 Look at these slogans from different ads. What are they advertising?

10 Work in groups. Imagine you work for a local tourist company which wants to attract more visitors to the region. Write four slogans to use on your advertisements.

11 When you are ready, present your best slogan to the class. Which is the best slogan of all?

FOUR DIFFERENT ECOSYSTEMS

FOREST
Central Park New York

¹ Any_____ who visits New York visits Central Park but it isn't ² some_____ famous for its natural life. However, the forest is full of plants and animals.

CORAL REEF
Moorea French Polynesia

³ _____where is as beautiful as a coral reef. There's always ⁴ _____thing to look at, from the multicolored coral to the orange, green, and yellow sea life.

MOUNTAINS
Table Mountain South Africa

Possibly, there isn't ⁵ _____ where else in the world with an ecosystem as rich as this one. ⁶ Every_____ you look, there are different types of plants.

FRESH WATER
Duck River Tennessee

⁷ _____body in Tennessee who likes fishing knows about the Duck River. It's one of the most biodiverse rivers in the US.

Everywhere you look, you'll find nature's beauty.

Enjoy the peace and quiet but sshh! Don't tell anyone!

Everybody is looking for a natural paradise…
We know where it is.

12b The power of nature

Vocabulary and reading **extreme weather**

1 Match these weather words with the pictures (A–F).

flood	hurricane	lightning
snowstorm	thunderstorm	tornado

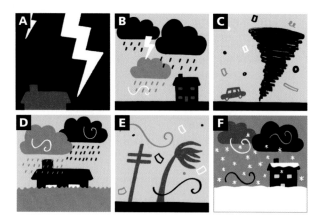

2 Discuss the questions.

1 Which parts of the world often have the extreme weather in Exercise 1?
2 Which types of extreme weather do you have in your country?
3 What time of year is typical for this kind of weather?

3 Read the article below. What type of extreme weather is it about?

4 Read the article again. Complete the diagram with the phrases (1–5).

1 sees a tornado
2 drives away from the tornado
3 drives towards the tornado
4 is lucky
5 is very unlucky

Rex Geyer All Tim Samaras

1

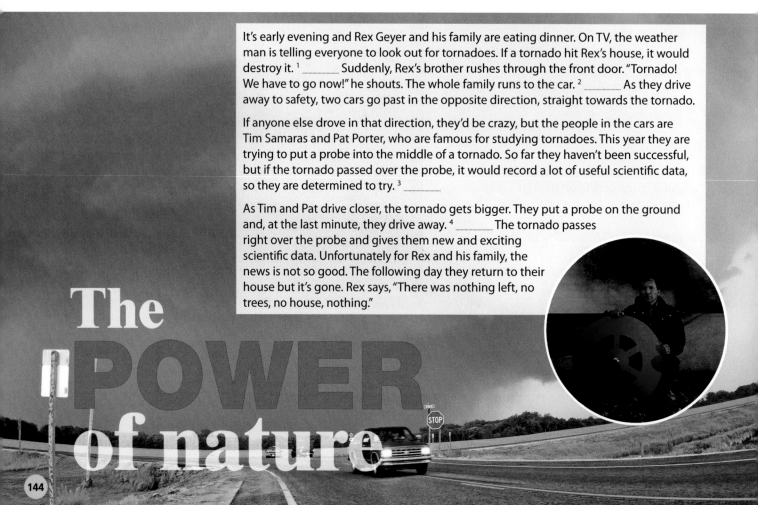

It's early evening and Rex Geyer and his family are eating dinner. On TV, the weather man is telling everyone to look out for tornadoes. If a tornado hit Rex's house, it would destroy it. [1] _____ Suddenly, Rex's brother rushes through the front door. "Tornado! We have to go now!" he shouts. The whole family runs to the car. [2] _____ As they drive away to safety, two cars go past in the opposite direction, straight towards the tornado.

If anyone else drove in that direction, they'd be crazy, but the people in the cars are Tim Samaras and Pat Porter, who are famous for studying tornadoes. This year they are trying to put a probe into the middle of a tornado. So far they haven't been successful, but if the tornado passed over the probe, it would record a lot of useful scientific data, so they are determined to try. [3] _____

As Tim and Pat drive closer, the tornado gets bigger. They put a probe on the ground and, at the last minute, they drive away. [4] _____ The tornado passes right over the probe and gives them new and exciting scientific data. Unfortunately for Rex and his family, the news is not so good. The following day they return to their house but it's gone. Rex says, "There was nothing left, no trees, no house, nothing."

The POWER of nature

5 Complete the gaps in the article (1–4) with the sentences (a–d).

 a Maybe they'll be lucky this time.
 b Tornadoes travel at over two hundred miles an hour and the biggest are over half a mile wide.
 c This time it works!
 d They leave everything except for a cell phone.

6 Work in pairs. Complete the comments with your own words.

 1 I feel sorry for Rex because…
 2 I think people like Tim and Pat are a little crazy because…
 3 Rex and his family were unlucky, but they were also lucky because…

Grammar second conditional

7 Look at the sentences (a–b) and answer the questions (1–2).

 a Tornadoes travel at over two hundred miles an hour and the biggest are over half a mile wide.
 b If a tornado hit Rex's house, it would destroy it.

 1 Which sentence describes something real or a fact?
 2 Which describes something imagined?

8 Match the two parts of this grammar explanation.

In second conditional sentences:
1 we use *if + simple past* in the *if-clause* to
2 we use *would/wouldn't* + infinitive in the main clause to

a describe the situation.
b describe the imagined result of the situation.

▶ **SECOND CONDITIONAL**

*If a tornado **came**, **I'd leave** immediately!*
*I **wouldn't wait** to look at a tornado **if** it **came** towards me.*
*What **would you do if** a tornado **came** towards your house?*

For more information and practice, see page 168.

9 Complete the text about the Gulf Stream in the Atlantic Ocean with the correct form of the verbs. Add *would/wouldn't* where necessary.

If the
climate
changed...

The Gulf Stream is a current of warm water which begins in Florida and travels across the Atlantic Ocean. As a result, countries on the west coast of Europe have warmer climates. If there ¹ _____ (be) no Gulf Stream, life in Europe ² _____ (change) forever and countries like Great Britain ³ _____ (become) much colder, especially in the winter. If the ocean was colder, spring and summer ⁴ _____ (not / last) as long. Farmers ⁵ _____ (not / produce) certain types of food and heating costs ⁶ _____ (go up). If the Gulf Stream never ⁷ _____ (return), eventually Europe ⁸ _____ (have) another ice age. As the world's climate changes, some scientists believe this might actually happen.

10 In pairs, answer these questions.

 1 Would you live in another country if you could? Where would you move to?
 2 Would you like to meet someone famous? Who? What would you ask him or her?
 3 Would you go into space if you had the opportunity? Which planet would you like to visit?

> *Would you live in another country?*

> *No, I wouldn't. If I moved, I would miss my family too much.*

Speaking

11 Work in groups. Imagine you work for a special department in the government that must plan for any future possibility. Discuss what action you would take for each of the following situations. Afterwards, present your ideas to the class.

What would happen if:

- the weather became much colder?
- sea levels and rivers rose?
- there wasn't enough oil?

> *If the weather became much colder, we'd need more heating.*

12c Changing Greenland

Reading

1 Work in groups of four. What do you know about Greenland? Brainstorm as much information as possible.

2 Work in your groups again. The article on page 147 has four paragraphs. Each student reads one paragraph out loud. Then answer the questions.

1 What recent changes are there in Greenland?
2 What are the problems and dilemmas for Greenlanders?

3 Take turns reporting your answers back to the rest of the group. Write notes about the other paragraphs.

4 Now read the whole article and check all the answers.

Critical thinking close reading

5 Mark the sentences T, F, or 0.

T = The sentence is true based on the text.
F = The sentence is false based on the text.
0 = The information isn't in the text.

1 Greenland has the smallest population in the world.
2 25 percent of the population live in the cities.
3 Sea levels around Greenland are rising.
4 There are plans to drill for oil around the coast.
5 The country has a difficult choice about the oil.
6 Farmers have longer periods to grow their crops.
7 The author thinks the winters might be shorter in a hundred years' time.

Vocabulary society and economics

6 Match these adjectives with their corresponding nouns.

Adjective	Noun
1 economic	resources
2 social	season
3 traditional	economy
4 modern	difficulties
5 strong	development
6 natural	problems
7 growing	industry

> ▶ **WORDBUILDING adjective + noun collocations**
>
> Pairs of words with this combination are common in English.
> *The country has had **economic difficulties**.*
> *Its **traditional industry** is fishing.*

7 Pronunciation word stress

🔊 **54** Listen to the answers in Exercise 6 and underline the stressed syllable in each word. Then repeat.

eco<u>no</u>mic <u>di</u>fficulties

Grammar will / might

8 Look at the highlighted verbs in these sentences. Both make predictions about the future, but which verb is more certain? Which verb is less certain?

1 Oil production will begin in the next few years.
2 Drier summers might create new problems.

> ▶ **WILL and MIGHT**
>
	modal	+ main verb
> | I/you/he/she/ it/we/they | will might | change in the future. |

Speaking

9 What do you think will or might change in your country over the next ten years? Make predictions about its:

- population and cities
- economic situation and taxes
- social problems and difficulties
- technological developments and traditional industries

Talk about any other issues affecting it.

10 Working in groups, compare your predictions. How similar or different are they?

> *There might be less countryside because ...*

> *More people will move to the cities because ...*

> *If more people have modern technology, there will / might ...*

Changing Greenland

Greenland, the largest island in the world, has a small population of 56,000. Many Greenlanders live close to the coastline because a large part of the country is covered with ice and glaciers. More than a quarter of all the people live in the capital, Nuuk. Since the 1960s, the country has had economic difficulties and social problems. Its traditional industry—and its biggest—is fishing, but the country still imports much more than it exports. Now, however, life is about to change dramatically for many Greenlanders—and all because of the weather.

Most scientists agree that the world's climate is getting warmer, and you can already see the difference in Greenland. Small icebergs the size of city buses float near the coast. They have broken off from much larger areas of ice farther out in the ocean because of warming temperatures, and the huge sheet of ice which covers Greenland is shrinking by about 18 cubic miles a year. If all of Greenland's ice melted, sea levels across the world would rise 25 feet.

One industry that is benefiting from the melting ice is the oil industry. Nowadays, the sea around the west coast of Greenland has no ice for six months of the year. This means oil companies can explore this area and drill for oil in the next few years. Greenlanders have mixed feelings about this modern development. The country's prime minister, Kuupik Kleist, explains the dilemma: "The Arctic people are the ones most exposed to climate change, but we need a strong economy and we have to use the opportunities that oil could bring us… We don't have any other natural resources for the time being that hold as much potential as oil."

Farming will also change. The growing season is longer, with spring arriving earlier and summer ending later. On the one hand, if the country produced more of its own food, it wouldn't need to import so much. On the other hand, some farmers worry the drier summers might create new problems. Last year it was so dry, farmers produced half the normal amount of food. I spent my last night in the town of Qaqortoq with farming families at their annual celebration before the summer begins. After dinner, everyone started singing a traditional song about the importance of summer in a place where, in the past, the winters were long. As nature and the weather change in Greenland, I wondered if they would still be singing this song in a hundred years' time. They might not.

Summer, summer, how wonderful
How incredibly good.
The frost is gone,
The frost is gone …

dilemma (n) /dɪ'lemə/ problem or difficult choice
iceberg (n) /'aɪs,bɜrg/ large piece of ice in the ocean with a small part of it above the water

12d Saving the zoo

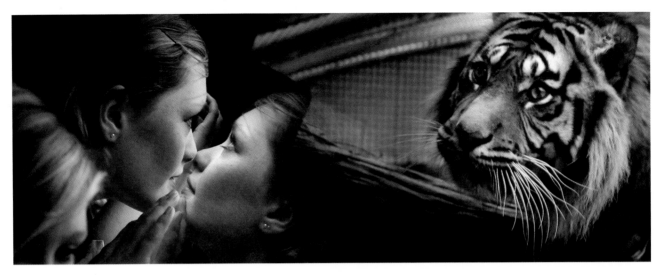

Speaking and reading

1 Do you ever visit zoos? Why?

2 Look at the photo and read the text below. Answer the questions.

 1 Is it certain that the zoo will close?
 2 What problem does the council need to solve?
 3 What would happen to the animals if it closed?

Council: Animals Will Have Nowhere to Go if Zoo Closes

The city's zoo might close in six months if the city council cannot solve the problem of low visitor numbers and lack of money. The zoo's manager is also worried about the animals at the zoo. "If the zoo closed, they couldn't go back into the wild. We'd have to find them a new home."

Real life finding a solution

3 🔊 **55** Listen and mark the sentences true (T) or false (F).

 1 If the zoo doesn't receive more money, it will close.
 2 Lots of people visit the zoo.
 3 The zoo manager thinks the zoo helps to save animals from extinction.
 4 The zoo manager likes the suggestion about advertising.
 5 The zoo manager likes the suggestion about sponsorship.

4 🔊 **55** Complete the sentences with these phrases. Then listen again and check.

But if we don't	I'm sorry but	that's not	we can't
What about	What if you	why don't you	You might

 1 _____ giving us more money?
 2 _____ the council doesn't have any more money for the zoo.
 3 _____ find a solution soon, then we'll have to close it.
 4 _____ advertised the zoo more?
 5 But if we don't have any money, _____ advertise.
 6 Well, _____ try sponsorship?
 7 Actually, _____ a bad idea.
 8 _____ be right!

5 Match the sentences in Exercise 4 with the correct section in the box.

> **▶ FINDING A SOLUTION**
>
Stating and explaining the problem	**Responding positively**
> | The problem is that… | That's a good idea. |
> | **Making suggestions** | **Responding negatively** |
> | We could also… | Yes, but… |
> | | No, that won't work. |

6 Work in groups of four. Imagine you all work for the zoo and want to save it. Roleplay a conversation and discuss your suggestions.

Student A: You are the zoo manager and will lead the meeting. At the end of the discussion, choose the three best suggestions. Turn to page 154.
Student B: Turn to page 155.
Student C: Turn to page 154.
Student D: Turn to page 155.

12e Good news

Writing a press release

1 The manager of a zoo has sent this press release to the local and national newspapers. Read it and answer the questions.

1 Why is the new tiger important?
2 How will the zoo use the new sponsorship money?
3 What special events are they planning?

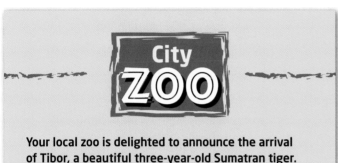

City ZOO

Your local zoo is delighted to announce the arrival of Tibor, a beautiful three-year-old Sumatran tiger. Sumatran tigers are the smallest species of tiger and there are only about 400 of them left in the world. Tibor's mother was killed in the wild, so the zoo is proud to offer the young tiger a home as part of its excellent animal conservation program.

This wonderful news also comes as the zoo is pleased to announce a new sponsorship deal with a local food manufacturing company. The sponsorship agreement means the zoo can:

• advertise nationally.
• give a home to more animals like Tibor.
• have longer opening hours in the summer.

During the summer, the zoo is also excited about its special events:

• live music every Thursday evening
• "animal adventure days" for children

More events are also planned. We look forward to seeing everyone this summer!

2 Work in pairs. Discuss the questions.

1 What is the purpose of a press release?
2 Does it include general news, a special event, or both?

3 Press releases usually contain a lot of positive words or phrases for giving good news. Read the press release again and underline examples of these kinds of words or phrases.

Example:
…is delighted to announce…

4 **Writing skill** **using bullet points**

a Look at the bullet points in the press release and mark (✓) the correct information below.

> We use bullet points with:
> • the main information we want the reader to know. ☐
> • short, simple phrases or sentences. ☐
> • paragraphs. ☐
> • extra or less important information. ☐

b Rewrite this press release using bullet points.

> The council is delighted to announce a new sponsorship deal with a sports manufacturer to build a stadium which can be used by the soccer team and local schools. It also plans to use the stadium for a series of free outdoor summer concerts and other cultural events. The stadium will also include restaurant facilities for use at sporting and cultural events, and for private and corporate events.

5 Work in pairs. Write another press release using this information and one more item of news about the zoo.

> The zoo has raised $5,000 from visitors and local companies to open a new area for two baby elephants. It is also opening a new café with a store selling zoo souvenirs (for example, T-shirts and hats).

6 Exchange your press release with another pair. Read their press release and use these questions to check it.

• Does it include words and expressions for giving good news?
• Does it use bullet points effectively?

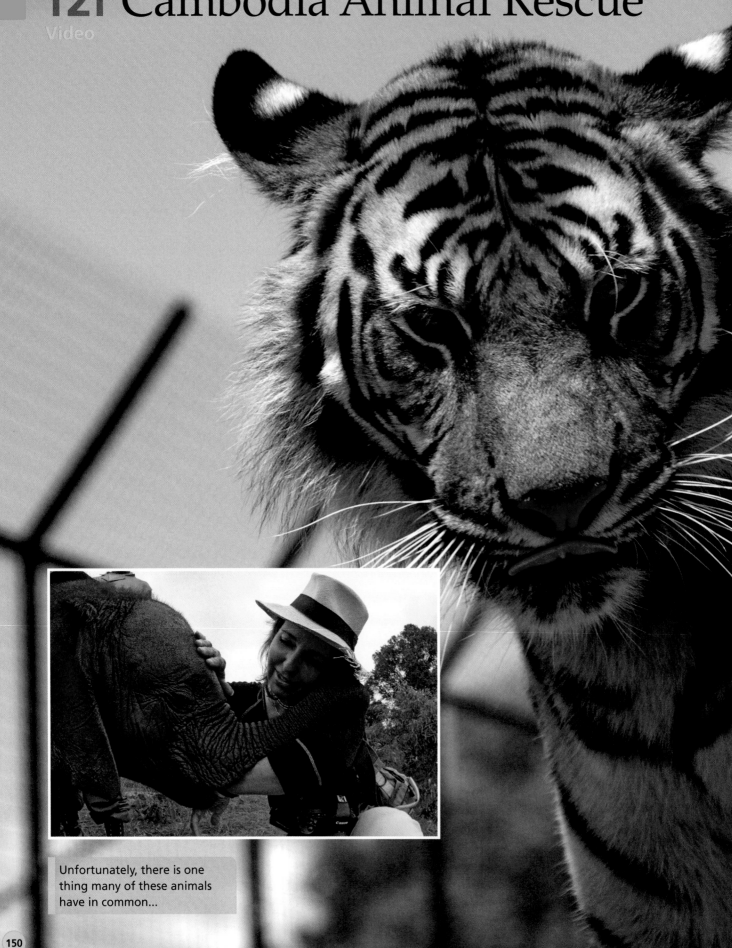

12f Cambodia Animal Rescue

Unfortunately, there is one thing many of these animals have in common...

Before you watch

1 You are going to watch a video about an animal rescue center in Cambodia. Work in pairs. Look at the photos and discuss the questions.

1 What animals are in the photos?
2 What do you think they "have in common"?
3 How do you think the rescue center helps them?

While you watch

2 Watch the video and check your answers from Exercise 1.

3 Put the animals in the order you first see them on the video.

a	scorpions	e	a bear
b	a tiger	f	crocodiles
c	an elephant	g	monkeys
d	crested eagles	h	a gibbon

4 Watch the first part of the video (to 02:09) and answer the questions.

1 What do the letters MU stand for?

2 What does the MU do?

3 Does the government of Cambodia support the work of the MU?

4 What does the American group Wild Aid do?

5 Where did the little gibbon live before the rescue center?

6 Which organization sponsors Mimi?

7 Why did the family take Mimi to the rescue center?

5 Complete the paragraph using words from the box below to help you. Then watch the second part of the video (02:09 to the end) and check your answers.

¹ _____ can make a lot of money by selling a tiger's body parts ² _____ . In some Asian countries, certain parts of the tiger are ground into ³ _____ and sold as an expensive traditional medicine. People think that taking the product will ⁴ _____ their health.

After you watch

6 Roleplay **talking about a plan**

Work in pairs.

Student A: You want to go and work at the Animal Rescue Center in Cambodia. Look at the information below and make notes.

- You plan to go for a year.
- You want to find out more about poaching in Cambodia.
- You want to help the animals at the rescue center because you love animals.
- You have a particular interest in tigers.

Student B: A friend of yours wants to go and work at the Animal Rescue Center in Cambodia. Ask why and what he/she plans to do there.

Act out the conversation, then change roles. For the second conversation, Student B should choose a different animal and reasons.

7 According to the narrator, what is "the bigger problem"? Why is it still a problem?

8 Working in pairs, discuss these questions.

1 How do you feel when you see the animals in the video?
2 Does animal poaching exist in your country? What animals do poachers catch? Why?
3 What can we do to protect animals from poaching?

grind (past tense: ground) (v) /graɪnd/ break something into smaller and smaller pieces, usually in a machine
handle (v) /ˈhænd(ə)l/ look after or control something or somebody
illegally (adv) /ɪˈliɡəli/ in a way not allowed by the law
poacher (n) /ˈpoʊʧər/ a person who catches or kills animals illegally
poaching (n) /ˈpoʊʧɪŋ/ the activity of catching or killing animals illegally
powder (n) /ˈpaʊdər/ a very fine, dry substance

release (v) /rɪˈlis/ set free
rescue (v) /ˈreskju/ take someone or something out of a dangerous situation
sponsor (v) /ˈspɑnsər/ support an organization by giving it money and help (such as training) often in return for publicity
support (v) /səˈpɔrt/ help
victim (n) /ˈvɪktəm/ a person or thing that has been affected by a dangerous event
the wild (n) /ðə ˈwaɪld/ the natural environment

UNIT 12 REVIEW

Grammar

1 Complete the sentences with these pairs of words.

anyone + anywhere everyone + anything
nobody + everybody nowhere + everywhere
someone + somewhere something + nothing

1 _____ is as beautiful as this part of the country. _____ you look there are trees and plants.
2 _____ told me there's a snake _____ in the grass so be careful.
3 Has _____ seen Miguel? I can't find him _____.
4 _____ is hungry. Is there _____ in the fridge?
5 I left a message but _____ called me back. Is _____ on vacation?
6 I'd like _____ special to eat but _____ on the menu looks very interesting.

2 Complete the second conditional sentences with the correct form of the verbs.

1 If it was hotter, we _____ (go) to the beach.
2 The grass would be much greener if it _____ (rain).
3 You would see more hurricanes if you _____ (live) in the south.
4 We _____ (not / need) air conditioning if we moved north to a colder climate.
5 They wouldn't eat my cooking if they _____ (not / like) it!

3 Complete these sentences about yourself. Then compare them with a partner.

1 If I had a million dollars, I'd…
2 If I could visit anywhere in the world, I'd go to…
3 If I lived in another country, I'd live in…

> **I CAN**
> talk about unreal and imagined situations ☐

Vocabulary

4 Match these words with the correct groups.

in the sky mammals plants reptiles
types of storms

1 _____: tree, grass, flower
2 _____: cow, horse, human
3 _____: dust, ice, snow
4 _____: snake, turtle, crocodile
5 _____: lightning, rain, sun

5 Work in pairs. Look at the photo. What does it show? How do you think the photographer took it?

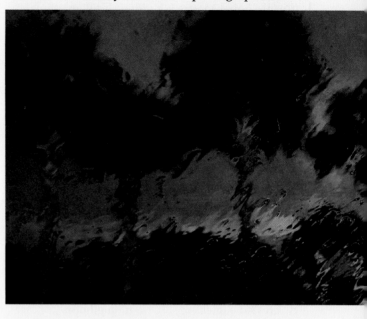

> **I CAN**
> talk about animals and nature ☐

Real life

6 Match the two halves of the sentences.

1 What about
2 Why don't we
3 We won't get any visitors if we
4 The problem is that
5 If we don't advertise, we

a we don't advertise.
b advertising the zoo?
c advertise the zoo?
d don't advertise.
e won't get any visitors.

7 Work in pairs. Discuss these problems and make suggestions to solve the problems.

- unemployment in your country
- too much traffic on the roads
- cities are growing so there is less countryside for animals and nature

> **I CAN**
> discuss problems and suggest solutions ☐

Speaking

8 Imagine you are the leader of your country. Write down three changes you would make. Make a short speech to your class about your plans for change.

If I was the leader of my country, I'd…

UNIT 5a, Exercise 10, page 59

Student A

Ask the caller about his/her views on recycling and what we need to do about the problem. It's your job to ask questions and argue with the caller about his/her views. Before you begin, prepare some questions for the caller. Use some of the questions and ideas from the audioscript on page 171.

UNIT 5d, Exercise 6, page 64

Student A

Conversation 1

You ordered some clothes online and received an email from the company saying that the clothes are not in stock. Call the customer service helpline.

- Say why you are calling.
- Give your order number: EI3304A.
- Spell your last name.
- Find out how long you have to wait for the clothes.
- Ask for a refund. The price was $149.50.

Conversation 2

You are a customer service representative for a book supplier. Answer the telephone.

- Ask for the customer's order number and the title of the book.
- Tell the customer that the book isn't in stock and you don't know when it will arrive.
- Offer the caller a used copy of the same book for $3.50.

UNIT 9d, Exercise 5, page 112

Student A

You work for a job recruitment agency which helps people find a new job. Describe the process to someone who is looking for a new job.

- fill in an application form
- attend an interview with the recruitment agency
- match your skills with different jobs
- choose possible jobs
- contact employers
- start new job!

UNIT 9e, Exercise 3b, page 113

1 DOB = date of birth
 No. = number
 e.g. = for example
 etc. = et cetera
2 Mr. = used before the name of any man
 Mrs. = used before the name of a married woman
 Ms. = used before the name of a woman when we don't know if she is married or single
 Dr. = Doctor
 Prof. = Professor
 BA = Bachelor of Arts
 BS = Bachelor of Science
 MBA = Master of Business Administration
 PhD = Doctor of Philosophy (a qualification given when you become a doctor in your subject, not necessarily philosophy)
3 Form B: It says "For office use only" at the bottom.
4 Form B: It says "Please use capital letters" at the top.

UNIT 8a, Exercise 1, page 94

Braille
A way for blind people to read by touching a series of dots on paper (invented in 1825 by Louis Braille).

Electric light bulb
Invented by Thomas Edison in the nineteenth century to provide bright light for long periods of time using electricity.

Microwave oven
An oven which cooks food much faster than traditional ovens by using microwave radiation.

Post-it Note
A piece of paper which can be stuck anywhere and reused. It solved the problem of losing your notes!

Telescope
It solved the problem of looking at objects a long distance away, for example, objects in space.

UNIT 5a, Exercise 10, page 59

Student B

Before you begin, prepare some comments and opinions. Use some of the expressions and ideas from the audioscript on page 171. Speak to the radio host. Explain your views about recycling and what we need to do about the problem in the future.

UNIT 9d, Exercise 5, page 112

Student B

You are looking for a job through a recruitment agency. Ask about the process of finding a job.

Examples:

How do I start looking for a job?
Do I need to fill in a form / attend an interview?
Then what happens?

UNIT 10d, Exercise 7, page 124

Student A

1 You are a tourist. You want to ask about the missing information (1–3) and check some information (4) in this tour. Prepare indirect questions using these words.

1 I'd like to know how old…
2 I was wondering how often…
3 Do you know when…
4 Can you tell me if…

History

The Caves of Lascaux are in the Dordogne region of France. The paintings on the cave walls are over (1) _____ years old.

Tour information

Bus: The tour bus leaves your hotel (2) _____.
Departure time: (3) _____ a.m. to 5 p.m.
Tour price: 100 euros (includes all entrance fees and lunch). Each tour is limited to 30 visitors.

On some tours, there is also a visit to a beautiful local town. Check with your tour guide for details (4).

2 Now ask your questions about the tour of the Caves of Lascaux and complete the missing information.

3 You are the person at tourist information. Answer the tourist's questions about this tour.

Information for visitors

Subway: Metro A line
Bus: 714, 118
Parking is available 1 kilometer from the entrance.
Hours: 9 a.m. to 1 p.m. and 2 to 5 p.m. every day except Wednesday
Tickets: Adults: 8 euros Children: 5 euros
Time: 40 minutes

Note to visitors

This tour involves a lot of walking. Basic fitness and good shoes are required.

UNIT 12d, Exercise 6, page 148

Student A

You are the zoo manager and will lead the meeting. Here are two possible suggestions. You can also make more suggestions.

- Ask companies to sponsor different animals and put their name near the animal.
- Hold an open day where everyone in the city can visit the zoo for free to learn more about their zoo.

When you are ready to begin the meeting, state and explain the problem and then discuss each suggestion. Start your meeting by saying: *Hello, everyone and thank you for coming. Today we are going to discuss the zoo. The problem is that…*

At the end of the discussion, choose the three best suggestions.

UNIT 12d, Exercise 6, page 148

Student C

Here are two possible suggestions. You can also make more suggestions.

- Start a souvenir shop which sells zoo T-shirts, posters, hats, etc.
- Invite newspaper and TV reporters to a special event featuring the zoo's role in conservation work.

UNIT 5d, Exercise 6, page 64

Student B

Conversation 1
You are a customer service representative for a clothing company supplier. Answer the telephone.

- Ask for the customer's order number and last name.
- Tell the customer that the clothes aren't in stock but they will be in two weeks.
- Offer some different clothes at the same price.

Conversation 2
You ordered a book online and received an email from the company saying that the book is not in stock. Call the customer service helpline.

- Say why you are calling.
- Give your order number: AZE880.
- Find out how long you have to wait for the book.
- Ask for the price of the used copy.
- Buy the used book.

UNIT 10d, Exercise 7, page 124

Student B

1 You are the tourist. You want to ask about the missing information (1–3) and check some information (4) in this tour. Prepare indirect questions using these words.

1 I'd like to know which…
2 I was wondering which day…
3 Do you know how much…
4 Can you tell me if…

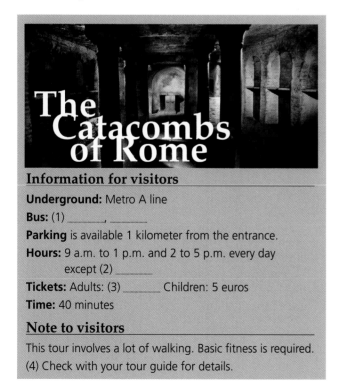

The Catacombs of Rome

Information for visitors
Underground: Metro A line
Bus: (1) _____, _____
Parking is available 1 kilometer from the entrance.
Hours: 9 a.m. to 1 p.m. and 2 to 5 p.m. every day except (2) _____
Tickets: Adults: (3) _____ Children: 5 euros
Time: 40 minutes

Note to visitors
This tour involves a lot of walking. Basic fitness is required. (4) Check with your tour guide for details.

2 You are the person at tourist information. Answer your partner's questions about this tour.

The Caves of Lascaux

History
The Caves of Lascaux are in the Dordogne region of France. The paintings on the cave walls are over 17,000 years old.

Tour information
Bus: The tour bus leaves your hotel every day.
Departure time: 9 a.m. to 5 p.m.
Tour price: 100 euros (includes all entrance fees and lunch). Each tour is limited to 30 visitors.

Tuesdays and Fridays there is also a visit to a beautiful local town.

3 Now you are the tourist. Ask your questions about the Catacombs of Rome in Exercise 1 and complete the missing information.

UNIT 12d, Exercise 6, page 148

Student B
Here are two possible suggestions. You can also make more suggestions.

- Offer special tickets with discounts such as a family ticket or a children's fare.
- Ask the public to sponsor an animal that lives at the zoo.

UNIT 12d, Exercise 6, page 148

Student D
Here are two possible suggestions. You can also make more suggestions.

- Contact other zoos and exchange animals so people will come back to look at new animals.
- Have a parade with costumes and food and some of the animals.

UNIT 1

Simple present and adverbs of frequency

Form

Affirmative	Negative	Question
I/you/we/they **work**	I/you/we/they **don't work**	**Do** I/you/we/they **work?**
he/she/it **works**	he/she/it **doesn't work**	**Does** he/she/it **work?**

Use

We use the simple present to talk about:
- habits and routines. *I **eat** an apple every day.*
- things that are always true. *Lions **eat** meat.*

We often use adverbs of frequency (*always, usually, often, sometimes, rarely, never*) and expressions of frequency (*once a week, on Fridays, on the weekend in the summer, every Saturday*) with the simple present to talk about how often we do something.

Adverbs of frequency usually go before the main verb or after the verb *to be*.
*I **sometimes** watch sports.* *I'm **always** happy.*

Expressions of frequency usually go at the beginning or end of a sentence.
***On the weekend,** they travel.*
*They travel **on the weekend.***

Practice

1 Complete the sentences with the simple present form of the verbs and the adverbs/expressions of frequency.

1 I ___*walk*___ (walk) into town every Saturday.
2 Emily _____ (ride/often) her bike to work.
3 When _____ he _____ (be/usually) at home?
4 I _____ (not be/often) in the office on Mondays.
5 He _____ (do/never) exercise on the weekend.
6 _____ the doctor _____ (work/every weekend)?

Present continuous

Form

We form the present continuous with the simple present of the verb *to be* plus the *-ing* form of the verb.

Affirmative	Negative	Question
I **am** / you **are** / he **is** / she **is** / it **is** / we **are** / they **are washing**	I **am not** / you **are not** / he **is not** / she **is not** / it **is not** / we **are not** / they **are not washing**	**Am** I / **are** you / **is** he / **is** she / **is** it / **are** we / **are** they **washing?**

Use

We use the present continuous to talk about:
- things happening now. *He's **watching** TV right now.*
- things happening around now, but not necessarily right now. *Vicky's **traveling** this year.*
- current trends and changing situations. *Fewer people **are buying** cars this year.*

We don't usually use stative verbs (*be, have, like, love, hate, want*) in the present continuous.

Notes

Notice the spelling rules for the *-ing* form:
- for most verbs, add *-ing* (*walk → walking, play → playing, read → reading*).
- for verbs ending in a consonant + vowel + consonant, double the last letter of the verb and add *-ing* (*sit → sitting, run → running*).
- for verbs ending in *-e*, delete the final *e* and add *-ing* (*make → making, write → writing*).

Practice

2 Complete the sentences. Use the present continuous or simple present form of the verbs.

~~cook~~	not bike	do	go	play	prepare

1 Carl usually ___*cooks*___ on Wednesday.
2 The boys often _____ hiking.
3 _____ David _____ tennis right now?
4 She _____ to work today. It's raining.
5 Please wait. The pharmacist _____ the medicine.
6 We always _____ gardening on the weekend.

UNIT 2

Verb + *-ing* forms

Form

We add *-ing* to the main verb. The spelling rules are the same as for the present continuous.

verb	*-ing* form
walk	walking
swim	swimming
give	giving

Use

We use the verb + *-ing* form:
- as the subject of the sentence. The *-ing* form is often a noun. ***Eating** a lot of fruit is important.*
- after verbs such as *like, love, enjoy, prefer, don't like, hate, can't stand, (not) mind* as an object. *I love **walking** in the mountains.*
- after a preposition. *I'm very good at **playing** tennis.*

Practice

1 Complete the sentences with the -ing form of these verbs.

| bike | eat | go | shop | sit | visit | watch |
| write |

1 I'm listening to a radio program about _biking_.
2 Do you enjoy _____ sports on TV?
3 _____ at home all day is boring!
4 We don't like _____ this soccer stadium.
5 Jenny is very good at _____ sports reports.
6 _____ for a new bike is fun.
7 He hates _____ to games when it rains.
8 _____ a lot before a game is bad for you.

like + -ing / 'd like to

Form

like + -ing

Affirmative	Negative	Question
I/you/we/they **like watching** old movies.	I/you/we/they **don't like watching** old movies.	**Do** I/you/we/they **like watching** old movies?
He/she/it **likes playing** in the park.	He/she/it **doesn't like playing** in the park.	**Does** he/she/it **like playing** in the park?

'd like to (= would like to)

Affirmative	Negative	Interrogative
I**'d**/you**'d**/he**'d**/she**'d**/it**'d**/we**'d**/they**'d like to** go there tomorrow.	I/you/he/she/it/we/they **wouldn't like to** go there tomorrow.	**Would** I/you/he/she/it/we/they **like to** go there tomorrow?

Use

like + -ing

We use *like + -ing* to talk about a general feeling which is true now.
Richard likes skiing a lot.
Ella doesn't like listening to rap music.

'd like to (= would like to)

We use *'d like to* to talk about a future ambition.
I'd like to visit Kenya next year.
She wouldn't like to compete in the Ironman.

Practice

2 Complete the sentences with *like + -ing* or *'d like to* and the verbs.

1 Andy _likes playing_ (like/play) baseball every Saturday.
2 The boys _____ (like/learn) how to swim next year.
3 _____ Mike _____ (like/drive) his new car?

4 I _____ (not like/compete) all day!
5 _____ you _____ (like/sit) here?
6 Jo _____ (not like/travel) round the world next year.
7 My father _____ (like/cook) lunch for the family every Sunday.
8 She _____ (like/watch) the game with us next week.

Modal verbs for rules

Form

I/you/he/she/it/we/they **must** wear goggles.	I/you/he/she/it/we/they **can** play here.	I/you/he/she/it/we/they **have to** hit the ball.
	I/you/he/she/it/we/they **can't** (= cannot) play here.	I/you/he/she/it/we/they **don't have to** hit the ball.

Notes

There are two important differences between *must* and *can* and regular verbs in the simple present:

* There is no third person -s with modal verbs.
 *She **must** go. I **can** stay.*
* There is no auxiliary *do* with modal verbs.
 *I **must win**. He **can't** play.*

Have to is a regular verb. *I **have to** go. He **has to** help.*
*I **don't have to** play. She **doesn't have to** compete.*

Use

We use different modal verbs to talk about rules.

* When something is necessary and an obligation, we use *must* and *have to*. *You **must** be home at eleven o'clock. You **have to** finish your homework tonight.*
* When something is allowed according to the rules, we use *can*. *Yes, you **can** go to the movies on Friday.*
* When something is not necessary (but allowed), we use *don't have to*. *You **don't have to** compete.*
* When something is not allowed, we use *can't*. *He **can't** play soccer tomorrow.*

Practice

3 Put the words in the correct order.

1 get up he must tomorrow early
 He must get up early tomorrow.
2 competition finish at must ten o'clock the

3 send my have today application I to

4 tomorrow to don't they have to go work

5 argue referee team with the the can't

6 noon to game have doesn't finish at the

7 to wear Tim can clothes casual the game

8 sports equipment they forget their can't

UNIT 3
Comparatives and superlatives
Form

Adjective	Comparative	Superlative
▶ REGULAR		
new	newer	newest
hot	hotter	hottest
nice	nicer	nicest
easy	easier	easiest
interesting	more interesting	most interesting
▶ IRREGULAR		
good	better	best
bad	worse	worst

We add -er to regular short adjectives to form the comparative, and we add -est to regular short adjectives to form the superlative:
new → newer → newest

We add *more* and *most* to form the comparative and superlative forms with longer adjectives:
interesting → more interesting → most interesting

Notice the spelling rules for comparative and superlative adjectives:
- for regular short adjectives, add -er / -est:
 long → longer → longest
- for adjectives ending in -e, add -r / -st:
 large → larger → largest
- for adjectives ending in -y (after a consonant), change the -y to -i: *happy → happier → happiest*
- for adjectives ending in consonant–vowel–consonant, double the final consonant:
 big → bigger → biggest; hot → hotter → hottest

We use *than* after a comparative adjective.
My bicycle is newer than yours.

We usually use *the* before a superlative adjective.
It's the quickest way to get to the station.

We use *much* to add emphasis to a comparative adjective.
Gas cars are much more expensive than electric cars.

Use
We use comparative adjectives to compare two things.
Cars are faster than buses.

We use superlative adjectives to compare three or more things.
Blues whales are the biggest animals in the world.

Practice
1 Write sentences. Use the comparative (C) and superlative (S) forms.

1 India / Norway / hot (C)
 India is hotter than Norway.
2 cars / bikes / dangerous (C)

3 James / friendly / person / in our class (S)

4 Helena / good athlete / in the country (S)

5 cheetahs / tigers / fast (C)

6 Naomi / happy / person / in the office (S)

7 skiing / exciting sport / in the world (S)

8 sports cars / family cars / difficult to drive (C)

as...as
Form

Affirmative	Negative	Question
An elephant is **as heavy as** a car.	A bus **isn't** (is not) **as comfortable as** a car.	Is a horse **as strong as** an elephant?

Use
We use *as* + adjective + *as* to compare two things and say they are the same or equal.
Ying is as tall as his brother.

We use *not as* + adjective + *as* to compare two things and say they are different or not equal.
Gustavo is not as clever as Anna.

Practice
2 Write comparative sentences and questions using *as ... as* (+) and (*not*) *as ... as* (–).

1 Rosa / old / Maria (+)
 Rosa is as old as Maria.
2 Alaska / cold / Canada (+)

3 cars / cheap / bicycles (–)

4 horse riding / healthy / running (?)

5 buses / quiet / trams (–)

6 books / exciting / movies (?)

7 our car / clean / an electric car (+)

8 China / hot / Brazil (?)

UNIT 4
Simple past
Form

Affirmative	Negative	Question
▶ **REGULAR**		
I/you/he/she/it/we/they **walked** all day.	I/you/he/she/it/we/they **didn't walk** all day.	**Did** I/you/he/she/it/we/they **walk** all day?
▶ **IRREGULAR**		
I/you/he/she/it/we/they **said**	I/you/he/she/it/we/they **didn't say**	**Did** I/you/he/she/it/we/they **say**?
		Short answers
		Yes, I/you/he/she/it/we/they **did**.
		No, I/you/he/she/it/we/they **didn't**.

We add -*ed* to regular verbs to form the simple past: *work → worked, walk → walked, play → played*.

Notice the spelling rules for other regular verbs:
- for verbs ending in -*e*, we add -*d*: *die → died*
- for verbs ending in -*y*, we change the -*y* to *i* and add -*ed*: *try → tried, cry → cried, study → studied*
- for verbs ending in vowel + consonant (not -*w*, -*x* or -*y*), we double the consonant: *stop → stopped*

Some verbs have irregular past forms:
be → was / were, do → did, go → went, drive → drove, know → knew, take → took

We use the auxiliary verb *did / didn't* to form negatives and questions.
*Kirsten **didn't** go on the adventure.*
***Did** you live in Peru?*

We also use *did / didn't* to form short answers.
*Did you live in Peru? Yes, I **did**.*
*Did Kirsten go on the adventure? No, she **didn't**.*

Use

We use the simple past to talk about completed actions and events in the past. We often use a time phrase (*yesterday, last week, ten years ago*) with the simple past.
*I visited Paris **in January**.*
*They didn't see his new movie **last night**.*

Practice

1 Write questions and answers using the simple past.

1 Where / he / go? go / Mexico
 Where did he go? He went to Mexico.

2 Where / she / live? live / Beijing

3 What / they / do? drive / Panama

4 When / you / find / it? find / it / today

5 How / Ana / do ? do / well

Past continuous
Form

We form the past continuous with the simple past of the verb *to be* plus the -*ing* form of the verb.

Affirmative	Negative	Question
I/he/she/it **was working** last week.	I/he/she/it **wasn't working** last week.	**Was** I/he/she/it **working** last week?
You/we/they **were working** last week.	You/we/they **weren't working** last week.	**Were** you/we/they **working** last week?

Use

We use the past continuous to:
- describe actions and situations in progress at a particular time in the past. *Gaby **was watching** TV.*
- talk about the background to a story. *The sun **was shining** and the birds **were singing**.*

We often use the past continuous with the simple past to talk about two actions that happened at the same time in the past. We can join the tenses with the words *when* or *while*.
*Tania was waiting at the station **when** the rest of the climbing team arrived. **While** the team was getting off the the train, she ran to meet them.*
Remember, we don't usually use stative verbs (*be, like, believe, understand*) in the continuous form.

Practice

2 Complete the sentences with the simple past or the past continuous form of the verbs.

1 Jo ___*was driving*___ (drive) and Katya ___*was reading*___ (read) the map.
2 She _____ (sleep) when a noise _____ (wake) her up.
3 The team leader _____ (shout) and the wind _____ (blow).
4 While the boys _____ (make) a fire, it _____ (start) to rain.
5 Liz _____ (cook) supper and the others _____ (talk) about the expedition.
6 As they _____ (walk) in the mountains, the weather _____ (get) worse.
7 The rescue team _____ (arrive) while we _____ (decide) where to go.
8 While I _____ (swim), I _____ (see) a group of dolphins.

UNIT 5
Count and noncount nouns
Form and use

Some nouns are **count** nouns that you can count and that have both a singular and a plural form. We use them with an indefinite article (*a/an*) and numbers.

*There is **a bag** on the table.*
*There are **two bags** on the table.*

Some nouns are **noncount** nouns that you cannot count and that have no plural form. We use them with the definite article or no article. You cannot use them with *a/an* or numbers: *water (~~two waters~~), trash (~~two trash~~).*

*We drink **water** every day.*
***The water** is in the jug.*

Quantifiers
Form

Affirmative	Negative	Question
▶ **COUNT NOUNS**		
I've got **some** books.	I haven't got **any** books.	Are there **any** books?
There are **a lot of / many** books.	There aren't **many** books.	How **many** books have you got?
She's got **a few** books.		
▶ **NONCOUNT NOUNS**		
I've got **some** water.	I haven't got **any** water.	Have you got **any** water?
There is **a lot of** water.	There isn't **much** water.	How **much** water have you got?
They've got **a little** water.		

Use

We use quantifiers with count and noncount nouns to talk about quantity.

Count nouns

We use *some, a lot of, many,* and *a few* in affirmative sentences.

*I have **some** newspapers. He has **many** friends.*
*We have got **a lot of** bottles. There are **a few** cans.*

We use *any* or *many* in negative sentences or questions.

*I don't have **any** books. Do you have **any** bags?*
*There aren't **many** boxes. How **many** photos did you take?*

Noncount nouns

We use *some, a lot of,* and *a little* in affirmative sentences.

*I have **some** water. There is **a little** milk.*
*They have **a lot of** food.*

We use *any* or *much* in negative sentences or questions.

*I don't have **any** information. Do you have **any** trash?*
*There isn't **much** bread. How **much** water is there?*

Note: *a lot of = lots of* (there is no difference in meaning or use)

Practice

1 Choose the correct option.

1 There's *any /* (*some*) pollution in the river.
2 There isn't *much / many* food on the table.
3 Are there *much / any* plastic bags in the park?
4 I have *a lot of / a few* drinking water.
5 How *any / many* recycling containers are there here?
6 Do you throw away *many / much* plastic?
7 He recycles *much / a little* trash.
8 How *much / many* air pollution is there?

Definite article (*the*) or no article
Form and use

We use the definite article (*the*):
- with something or someone you mentioned before. *Have they done a survey? Yes, They finished **the** survey last week.*
- when it is part of the name of something. ***The** US introduced "car pool" lanes.*
- with superlative phrases. *Consumers spend **the** most money on electronic equipment.*

We use no article:
- with most countries. *He lives in Canada and I live in Spain.*
- to talk about people and things in a general way. *People are trying to recycle more trash.*
- with certain expressions. *I don't work **at night**.*

Practice

2 Choose the correct option. Choose Ø for no article.

1 There's a black dog in my garden. It's (*the*) / Ø dog from next door!
2 He's visited recycling plants in *the* / Ø Peru?
3 He's *the* / Ø greenest person I know.
4 There was *the* / Ø trash everywhere.
5 What time do you go to *the* / Ø work?
6 I'm going to a meeting about the environment in *the* / Ø Netherlands.
7 He is staying in Taipei on *the* / Ø business.
8 How much did *the* / Ø computer cost?

UNIT 6

Verb patterns with *to* + infinitive

Form

We use *to* + infinitive after several structures. The form of the verb is always the same.

They intend/plan	**to go** to South America.
It's difficult	**to learn** Chinese.
She worked hard	**to buy** a new car.

Use

1 verb + *to* + infinitive

After certain verbs we use the *to* + infinitive form of another verb. This is often to talk about hopes, intentions, and decisions.

*He decided **to stop** work.*

*She agreed **to travel** with him.*

Common verbs which are followed by the *to* + infinitive form are: *intend, plan, want, hope, 'd like, decide, agree, refuse, promise.*

We don't use *to* + infinitive after modal verbs.

*She can't **play** tennis. We will **stay** here.*

2 adjective + *to* + infinitive

We use *to* + infinitive after certain adjectives, often to express a feeling about something.

*It's **fun to play** a musical instrument.*

*It's **difficult to live** on $50 a day.*

3 infinitive of purpose

We can use *to* + infinitive to explain the purpose of the main verb or an action (= in order to do something).

*Marco moved to New York **to go** to college.*

*They visited Greece **to learn** about ancient Greece.*

Practice

1 Put the words in the correct order.

1 planning summer go diving to this we're
 We're planning to go diving this summer.

2 would like Argentina Alma and Leo visit to

3 medicine get job she to studied good a

4 have savings account to it's important a

5 wants his my brother leave job to

6 isn't to your save it easy money

7 promised email Brenda every to week

8 fun vacation a it's plan to

Future forms: *going to, will,* and present continuous

Form

1 *going to*

Affirmative	Negative	Question
I'm/you're/he's/she's/it's/we're/they're going to come to the party.	I'm not / you aren't / he isn't / she isn't / it isn't / we aren't / they aren't going to come to the party.	Am I / are you / is he / is she / is it / are we / are they going to come to the party?

2 *will*

Affirmative	Negative	Question
I/you/he/she/it/we/they 'll (will) go home later.	I/you/he/she/it/we/they won't (will not) go home later.	Will I/you/he/she/it/we/they go home later?

3 Present continuous

For the present continuous form see page 156.

Use

1 *going to*

We use *going to* + infinitive to talk about a plan or a future intention.

I'm going to make a costume. She isn't going to eat.

2 *will* ('ll)

We use *will* to talk about a decision which is made during the conversation.

Vikram: *Oh no! There isn't any sugar left.*

Sue: *Don't worry. I'll buy some when I go to the store.*

3 Present continuous for future

We use the present continuous to talk about an arrangement with other people at a certain time in the future.

I'm leaving for the party at five o'clock.

We're moving next month.

We usually use the present continuous, not *going to*, with the verbs *go* and *come*.

I'm going to the parade later. He's coming to the party.

Practice

2 Choose the correct option (a–c).

1 We ____ to Costa Rica on vacation next year.
 (a) are going b are going to go c will go

2 I've decided to take an evening class. I ____ Italian.
 a am studying b am going to study
 c will study

3 Alex: I left my money at home.
 Thomas: Never mind. I ____ the tickets.
 a am buying b am going to buy c 'll buy

4 What ____ next weekend?
 a are you doing b are you going to do
 c will you do

5 I'm so excited! We ____ for Athens in a week!
 a are leaving b are going to leave
 c will leave

6 Sam _____ in Beijing next year.
 a 's working b 's going to work
 c 'll work
7 I don't know when it starts. I _____ out now.
 a am finding b am going to find
 c 'll find
8 _____ to stay with you?
 a Is he coming b Is he going to come
 c Will he come

UNIT 7
Prepositions of place and movement
Form
Prepositions of place
*The printer is **on** the desk.*
*The office is **next to** the bank.*
*The meeting is **at** the conference center.*

Common prepositions of place are:

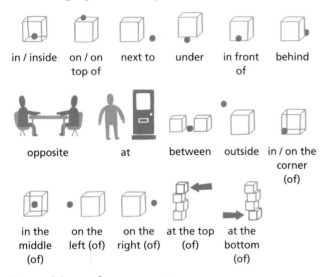

in / inside on / on top of next to under in front of behind

opposite at between outside in / on the corner (of)

in the middle (of) on the left (of) on the right (of) at the top (of) at the bottom (of)

Prepositions of movement
*He walked **up** the stairs.*
*Claire went **through** the door.*
*The man got **into** the taxi.*

Common prepositions of movement are: *up, down, to, in, into, on, onto, over, under, across, along, around, through.*

Use
We use prepositions of place to describe where people and things are.
The pen is in my hand. Alex is at the door.

We use prepositions of movement to talk about the direction in which someone or something moves. Prepositions of movement follow a verb of movement.
*Jack drove **down** the road. We flew **around** the storm.*
Common verbs of movement are: *go, climb, come, run,* and *walk.*

Practice
1 Complete the text with these prepositions.

down	at	in	front	next	on
across from		through		up	

When you arrive [1] *at* the office, go
[2] _____ the front door. Reception will be in
[3] _____ of you. All the meeting rooms are
[4] _____ the second floor. There's no elevator,
so go [5] _____ the stairs. Your meeting is
[6] _____ room 306. Coffee will be on the
table [7] _____ to the window. If you need the
bathroom, walk [8] _____ the corridor—it's
[9] _____ the photocopier.

Present perfect
Form
We form the present perfect with the simple present of the verb *to have* plus a past participle.

Affirmative	Negative	Question
I/you/we/they **have found** the report.	I/you/we/they **haven't found** the report.	**Have** I/you/we/they **found** the report?
He/she/it **has found** the report.	He/she/it **hasn't found** the report.	**Has** he/she/it **found** the report?
		Short answers
		Yes, I/you/we/they **have.**
		Yes, he/she/it **has.**
		No, I/you/we/they **haven't.**
		No, he/she/it **hasn't.**

We add *-ed* to regular verbs to form the past participle:
*work → work**ed**, walk → walk**ed**, play → play**ed**.*

The spelling rules for other regular verbs are the same as for the simple past tense (see page 159).

Many verbs have irregular past participles:
buy → bought, do → done, find → found, see → seen, take → taken, teach → taught

The verb *go* has two past participles: *been* and *gone*
*I've **been** to Santo Domingo.* (And now I'm back.)
*He's **gone** to Santo Domingo today.* (He isn't back yet.)

We use the auxiliary verb *have/has* and *haven't/hasn't* to form negatives and questions.
*I **haven't** bought a farm.*
***Has** she seen her colleague this week?*

We also use *have/has* and *haven't/hasn't* to form short answers.
*Have you lived in Canada? Yes, I **have**.*

Use

We use the present perfect to talk about:

- an action that happened sometime in the past but we don't know the exact time. *I've worked for several banks in London.*
- an action that started in the past and is still true today. *Amy has lived in Paris since Christmas.* (She still lives in Paris.) *Mark hasn't found the watch he lost.* (The watch is still lost.)

When we use the present perfect we often do not say when the action happened:
I've been to Rome.

But because we use the simple past to describe a finished action at a definite time in the past, we often do say when the action happened.
I went to Rome last year.

We often use the present perfect with *for* and *since*. We use *for* to talk about the duration of a present situation, for example, *for 30 minutes, for two months.*
My sister has lived in Shengzen for six months.
We use *since* to show the starting point of a present situation, for example, *since 2.00 p.m., since Friday, since 2011.*
My sister has lived in Shengzen since September.

Practice

2 Complete the sentences with the present perfect form of the verbs.

1 John ___has known___ (know) his boss for about four months.
2 My sister _____ (work) for lots of different businesses.
3 We _____ (see) this training movie three times before.
4 _____ your father _____ (visit) the factory in Mumbai yet?
5 She _____ (not eat) Indian food before.
6 They _____ (not be) in the office since eight o'clock.
7 _____ you _____ (copy) the report?
8 Bob and Louise _____ (buy) a new car.

3 Complete the text with the present perfect or the simple past form of the verbs.

I [1] ___have been___ (be) a photographer for over 20 years. I [2] _____ (change) jobs ten times and I [3] _____ (work) in about fifteen different countries, so I [4] _____ (often / live) abroad. My first job [5] _____ (be) as an assistant photographer for a magazine. I [6] _____ (take) pictures and [7] _____ (develop) them. Then I [8] _____ (start) working on a project about polar bears. The team [9] _____ (spend) many months on the Arctic sea ice, and we [10] _____ (search) for the bears' homes. Eventually we [11] _____ (find) where the

bears lived. Some bears [12] _____ (approach) me without fear. I [13] _____ (take) hundreds of photos. It was incredible and exciting, but I [14] _____ (never / be) so scared!

UNIT 8
Defining relative clauses
Form

He is the man **who (that)** *invented the World Wide Web.*
This is the system **which (that)** *I told you about.*
That is the place **where** *we buy our computers.*

Use

We use *who* (for people), *which* (for things), and *where* (for places) to introduce defining relative clauses. These clauses give us essential information about the person, place, or thing we are talking about.
*The person **who** discovered the solution was from China.*
*The factory **which** makes the machine employs 200 people.*
*The organization **where** he works is called Novotech.*

We can use *that* for people or things instead of *who* or *which*. This is less formal.
*The person **that** discovered the solution was from China.*
*The factory **that** makes the machine employs 200 people.*

Practice

1 Join the two sentences with the correct relative pronoun (*who, which, where*).

1 He's the man. He invented a new bike.
 He's the man who invented a new bike.
2 That's the farm. They are experimenting with new crops at the farm.
3 There is the woman. She works for my father.
4 These are the machines. They use less energy.
5 That is the nuclear power station. They had problems at the power station last year.
6 This is the documentary. I saw it last week.
7 She's the doctor. She saved my father's life.
8 That's the factory. They developed the new lamps at the factory.

Zero and first conditional
Form
Zero conditional

If-clause (*If / When* + simple present), main clause (simple present)
*If / When you **drive** too fast, it **is** more difficult to stop.*

First conditional

If-clause (*If* / *When* + simple present), main clause (*will* /*won't*)
If you drive too fast, it will be more difficult to stop.

We can use *if* in two positions:
- If-clause first: *If you study, you learn faster.*
- Main clause first: *You learn faster if you study.*

When the *if*-clause is at the beginning of the sentence, we use a comma to separate it from the main clause.

Use

Zero conditional

We use the zero conditional to talk about facts or things that are generally true.
If you want to travel in the US, you need a visa.
When you cool water below 32 degrees, it freezes.

When you talk about things that are generally true, you can use *if* or *when*. There's no difference.

First conditional

We use the first conditional to talk about a possible future situation.
If it rains tomorrow, we won't go to the mountains.

When you talk about situations in the future, there is a difference between *if* and *when*. We use *when* + simple present to talk about a certain future action.
When Jack arrives, I'll ask him to help us.

Practice

2 Complete the sentences with the correct form of the verbs.

1 When a mosquito lands on your skin, it
 ____tries____ (try) to suck your blood.
2 If a dog wags its tail, it _____ (mean) that it is happy.
3 If the weather is good, we _____ (explore) the forest on Saturday.
4 If they find a cure for cancer, many people _____ (live) much longer.
5 When he comes home from an expedition, he _____ (be) usually very tired.
6 When Oliver gets here tomorrow, I _____ (not tell) him about my problems.
7 That fish _____ (die) if you don't feed it.
8 People _____ (become) dehydrated when they don't drink enough water.

UNIT 9
Present passive voice: *by* + agent
Form

We form the present passive with the simple present of the verb *to be* (*am* / *is* / *are*) + past participle.

Affirmative and negative

Chinese	is/isn't	offered at the school.
Students	are/aren't	taught in big classes.

Question

Is	Chinese	offered at the school?
Are	students	taught in big classes?

Use

We use the present passive voice to focus on an action or the object of the action, rather than on the person who is doing the action. The object of the active sentence becomes the subject of the passive sentence.

Active: Students take the exam in the summer.
subject ... object

Passive: The exam is taken by students in the summer.
subject ... object

by + agent

In an active sentence, you know who does the action.
Teachers teach Kung Fu in many countries.

In a passive sentence, we can say who does the action (the agent) using *by*.
Kung Fu is taught by teachers in many countries.

We use *by* + agent when it is important to know who does the action.
Kung Fu is taught in many countries by specially trained teachers.

It isn't always necessary to use *by* + agent. We don't usually use the agent when it is obvious who has done the action, when we don't know the name of the agent or when it isn't important or relevant.
Lunch is served ~~by someone~~ every day at 1:00.

Practice

1 Rewrite the sentences in the present passive voice using *by* + agent where appropriate.

1 They teach French at that school.
 French is taught at that school.
2 She does her homework on a computer.

3 Tutors usually provide lecture notes on the Internet.

4 They keep old books in that part of the library.

5 Do you use laptops at your school?

6 The students print out class material during the course.

7 My employers don't pay for English classes.

8 Students often complete coursework online.

Past passive voice
Form

We form the past passive with the simple past of the verb *to be* (*was / were*) + past participle.

Affirmative and negative		
Black ink	**was/wasn't**	**invented** by the Egyptians.
Spices	**were/weren't**	**discovered** in Asia.

Question		
Was	black ink	**invented** by the Egyptians?
Were	spices	**discovered** in Asia?

Use

We use the past passive voice to focus on a past action or the object of the past action, rather than on the person who did the action. The object of the active sentence becomes the subject of the passive sentence.

Active: subject object
Active: Scribes wrote letters for the Pharoahs.
Passive: subject object
Passive: Letters were written by scribes for the Pharoahs.

Practice

2 Complete the text with the past passive form of the verbs.

> carve discover ~~find~~ leave make paint
> record use worship

There are cave paintings and cave art all over Europe. Famous examples ¹ *were found* in Lascaux, France, and Altamira, Spain, many years ago. In 2003, new paintings ² _____ by researchers in Nottinghamshire, northern England. The question is, why ³ _____ they _____ ? There are many theories, but many experts agree that early hunters and priests or shamen gathered before a hunt to pray for good luck. Animal gods or spirits ⁴ _____ in the hope that the hunt would be successful. After the hunt, the events ⁵ _____ in drawings or paintings. Natural dyes and colors ⁶ _____ and paints ⁷ _____ from substances such as blood, plants, and earth. Often, animals ⁸ _____ from wood or stone and sometimes these objects ⁹ _____ next to the paintings.

UNIT 10
Past perfect
Form

We form the past perfect with the simple past of the verb *have* (*had*) + past participle.

Affirmative	Negative	Question
I/you/he/she/ it/we/they **had worked** hard.	I/you/he/she/it/ we/they **hadn't** (had not) **worked** hard.	**Had** I/you/he/she/it/we/ they **worked** hard?

Short answers
Yes, I/you/he/she/it/we/ they **had.**
No, I/you/he/she/it/we/ they **hadn't.**

Note: In spoken English we often use *'d* (*= had*). Don't confuse the contracted forms of *had* and *would*.
I'd worked in the hotel for five years. (= I had worked)
I'd like to work in that hotel. (= I would like to work)

Use

We use the past perfect to talk about an action in the past that happened before another action or before a certain time in the past.
I had visited Rome twice before I went to Venice.
We often use the past perfect and the simple past together.
I had learned Mandarin before I went to Beijing.

We often use the following time expressions with the past perfect simple: *already, just, before, previously, recently,* and *earlier.*
I had just bought my ticket when the train arrived.

Practice

1 Complete the sentences with the simple past or past perfect form of the verbs.

1 Mei ___*went*___ (go) to Laos after she ___*had visited*___ (visit) Vietnam.
2 We _____ (be) in Mexico for two weeks before Mark _____ (arrive).
3 They _____ (cancel) the flights two days after they _____ (book) them!
4 I _____ (not meet) any other travelers until I _____ (get) to the mountains.
5 _____ they _____ (travel) abroad before they _____ (visit) Cambodia?
6 When I _____ (arrive) at the hostel, I realized I _____ (forget) my sleeping bag.
7 I _____ (not explore) the jungle before I _____ (get) to Costa Rica.
8 They _____ (check) into the same hotel that they _____ (stay) in previously.

Subject and object questions
Form

▶ SUBJECT QUESTIONS		
subject	verb	object
Who	canceled	the flight?
What	happened	to Tim?

We do not use an auxiliary verb (*do, does, did*) with subject questions.

question word	auxiliary	subject	main verb
What	does	he	like?
Who	did	she	visit?

Object questions use an auxiliary verb (*do, does, did*).

Use

In **subject questions,** the question word (*who, what, which, whose, how much/many*) is the subject. The word order is the same as in the affirmative sentence.
Who canceled the flight? Ming canceled the flight.

In **object questions,** the question word is not the subject and the word order is not the same as in the affirmative sentence.
Who did she visit? She visited her parents.

We cannot form subject questions with the following question words: *where, when, why, how.*
Where did they go? (not *Where they went?*)
How does she travel? (not *How she travels?*)

Practice

2 Write subject questions (S) and object questions (O).

1 Who / work / here (S)
 Who works here?

2 What / be / that (S)

3 Where / you / live (O)

4 How much / the vacation / cost (O)

5 Which / resort / be / this (S)

6 Where / they / go / last year (O)

7 When / you / want / to catch / the train (O)

8 What / country / be / this (S)

-ed/-ing adjectives and dependent prepositions

Form

-ed adjectives
*I'm **bored**.*
*He's **interested** in rock climbing.*

-ing adjectives
*This book is very **boring**.*
*He's an **interesting** person.*

Use

We use *-ed* adjectives to describe feelings.
*They were **amazed** by it. He was **excited** to see her.*

We use *-ing* adjectives to describe a place, person, or thing.
*L.A. is an **exciting** city. Digital cameras are **amazing**.*

Dependent prepositions often follow *-ed* adjectives—
*amazed **by**, annoyed **with**, bored **with**, excited **about**, fascinated **by**, interested **in**, tired **of**, worried **about**.*

Dependent prepositions are followed by nouns or gerunds.
*They were worried about **the flight/flying**.*

Practice

3 Complete the sentences with the *-ed* or *-ing* form of the adjectives.

annoy	bore	excite	fascinate	interest
please	tire	worry		

1 The new movie was really ___*boring*___ .
2 The flight was very _____ so we went to bed when we arrived.
3 India is a _____ country to travel in. There are so many amazing things to see.
4 We weren't very _____ with the hotel. It was dirty and rundown.
5 They weren't _____ in going to the museum because the lines were too long.
6 Emily was _____ with the tour guide because he didn't know anything!
7 There's an _____ trip to the coast this weekend. I've never been diving before!
8 We were _____ about the big storms.

UNIT 11
used to
Form

Affirmative	Negative	Question
I/you/he/she/ it/we/they **used to** play hockey in college.	I/you/he/she/ it/we/they **didn't use to** play hockey in college.	**Did** I/you/he/she/it/we/ they **use to** play hockey in college?
		Short answers
		Yes, I/you/he/she/it/we/they **did**.
		No, I/you/he/she/it/we/they **didn't**.

We use an infinitive without *to* after *used to*.
*The gallery **used to open** at 9:00 a.m.*

Note that the negative and interrogative forms do not have a final -d in *use to*.
Ana **didn't use to like** him. **Did** Ana **use to** like him?

Use

We use *used to* to talk about a situation, a state, or a habit in the past that is no longer true.

- State: *I used to have long hair when I was young.*
 I used to have long hair, but now it's short.

- Habit: *I used to play tennis three times a week.*
 I used to play tennis three times a week, but now I am too busy.

We don't use *used to* with a particular time in the past. We use the simple past instead.
I used to go to college ~~in 2005~~.
I went to college in 2005.

We can only use *used to* to talk about the past. We cannot use it to talk about the present.
*I **used to** visit museums every week.* (past)
*I **usually visit** museums every week.* (present)

Practice

1 Complete the sentences with *used to* and the verbs.

1 Victorian children *used to play* (play) with lots of dolls.
2 In ancient Rome, captured warriors _____ (work) as slaves.
3 _____ the Vikings _____ (wear) make-up?
4 Before the electric light, people _____ (go) to bed early.
5 The Celts _____ (not sleep) in beds.
6 In 1914, 48 percent of people _____ (drive) a Ford car.

Reported speech

Form

When we report what someone said, we often move the tense "backwards."

▶ DIRECT SPEECH	▶ REPORTED SPEECH
Simple present	**Simple past**
Vikram: I **live** in Delhi.	Vikram said that he **lived** in Delhi.
Present continuous	**Past continuous**
Li: I **am working** very hard.	Li said that she **was working** very hard.
Simple past	**Past perfect**
Paco: I **wanted** to be an astronaut.	Paco said that he **had wanted** to be an astronaut.
Present perfect	**Past perfect**
Devi: I **have read** the travel guide.	Devi said that she **had read** the travel guide.
will	*would*
Jack: I **will meet** you at the café.	Jack said that he **would meet** me at the café.

We often need to make other changes when we report what someone said:

- Pronouns: *I → he / she; we → they; my → his / her; our → their; you (object) → me*
- Time expressions: *now → then; today → that day; tomorrow → the next day; yesterday → the previous day; last night → the night before*

Use

We use reported speech to say what someone said to us or to report someone's words from the past.
Direct speech: "*I **am getting** married **tomorrow**.*"
Reported speech: *She said that she **was getting** married **the next day**.*

The use of the conjunction *that* is not required.
Direct speech: "*I think they will win.*"
Reported speech: *Paul said **that** he thought they would win. = Paul said he thought they would win.*

We often use the verb *say* to report someone's words but we don't follow it with an object.
"*I think they will win.*" → *Paul **said** (that) he thought they would win.*

We can use *tell* to report someone's words and to say who someone is talking to. *Tell* always needs an object such as *me, him, her, you, us them, everyone*.
"*I think they will win.*" → *Paul **told me** (that) he thought they would win.*

Practice

2 Change the direct speech into reported speech.

1 The famous model: I like diamonds.
 The famous model said that she liked diamonds.
2 The politician: I don't want to talk to them.

3 The writer: I don't have any new ideas.

4 The businessman: I'm going to Russia on Friday.

5 The organizer: We won't be able to build the Olympic stadium on time.

6 The government: We've cut taxes for the poor.

7 The scientist: Did you understand the experiment?

8 The famous actor: I didn't see the first James Bond movie.

UNIT 12

any-, *every-*, *no-*, *some-* and *-thing*, *-where*, *-one*, *-body*

Form

	-thing (object / action)	*-where* (place)	*-one* (person)	*-body* (person)
any-	anything	anywhere	anyone	anybody
every-	everything	everywhere	everyone	everybody
no-	nothing	nowhere	no one	nobody
some-	something	somewhere	someone	somebody

When we use these pronouns as subjects, the verb is in the singular form.
*Everyone **likes** taking photos. There **isn't** anyone here.*

Use

We use indefinite pronouns to talk in general about things, people, or places. We use *every-*, *any-*, and *some-* in the affirmative.
***Everything** is fascinating on this trip.*
*I'm looking for **something** to eat.*

We use *no-* and *any-* in negative sentences.
*There **isn't anywhere** to sit. There is **nowhere** to sit.*

We use *any-* in questions.
*Have you visited **anywhere** interesting today?*

There is no difference between *no one* and *nobody*.
*There is **no one** here = There is **nobody** here.*

We can use these pronouns before adjectives to give more detail.
*Lucy discovered **somewhere beautiful** on the island.*

Practice

1 Complete the sentences with the words.

something	anyone	everything	anything
somewhere	anywhere	somebody	everybody

1 I'm going to see ___*something*___ exciting today.
2 We are driving _____ beautiful tomorrow.
3 Are you meeting _____ you know there?
4 He didn't buy me _____ for my birthday!
5 I just saw _____ running into our garden.
6 Did you go _____ interesting?
7 _____ wanted to hear the latest news.
8 Please leave _____ where it is and don't move a thing.

Second conditional

Form

If-clause (*If* / *When* + simple past), main clause (*would* / *wouldn't* + infinitive)
*If there **was** a hurricane, it **would destroy** the town.*

Main clause (*would* / *wouldn't* + infinitive) *if*-clause (*if* + simple past)
*People **would move** out if sea levels **rose**.*

Use

We use the second conditional to talk about unreal or imagined situations. We use *if* + simple past in the *if*-clause to describe the situation. We use *would* / *wouldn't* + infinitive in the main clause to describe the imagined result of, or reaction to, the situation.
*If I **had** a lot of money, I **would donate** it to charity.*
*What **would** you **say** if you **met** a famous explorer?*

When we give advice, we often use *If I were you* rather than *If I was you*:
If I were you, I would go on vacation.

Practice

2 Choose the correct options.

1 If I *was* / *would be* rich, I *went* / *would go* on safari in Africa.
2 If it *rained* / *would rain* more, the crops *were* / *would grow* better.
3 If Ali *moved* / *would move* to Cairo, he *found* / *would find* a good job.
4 What *did you do* / *would you do* if there *was* / *would be* a snowstorm?
5 If there *was* / *would be* a tsunami, it *destroyed* / *would destroy* the town.
6 I *didn't tell* / *wouldn't tell* her if she *asked* / *would ask* me.
7 He *drove* / *wouldn't drive* to work if there *was* / *would be* ice on the road.
8 *Did you take* / *Would you take* me to the mountains if the weather *was* / *would be* nice?

Unit 1

1

This quiz is a good way for people to find out how they sleep. It shows them what kind of person they are. People with mostly A answers usually sleep very well. They have regular routines and they are hardly ever tired. People with B answers sleep fairly well. Most adults wake up once or twice a night and that's normal. But these people probably have busy working lives or families so they always want extra hours in bed. Try to go to bed earlier and sleep for an extra hour on the weekend. People with mostly C answers have the biggest problems. These people don't relax before bedtime. They regularly work in the evening or do exercise. Don't misunderstand me. Sports are good for your health, but not late at night.

2

1 feels
2 needs
3 watches
4 sleeps
5 goes
6 dances

3

P: No one knows exactly why some people live longer than others. Why are they so healthy? Is it their diet? Do they go to the gym more than others? Well, one man is trying to answer these questions and that man is explorer and journalist David McLain. He's currently traveling to places and regions with large numbers of centenarians and asking the questions: Why are they so healthy? What are they doing that the rest of us aren't? Right now he's working on the island of Sardinia in Italy, but he's speaking to us right now on the phone. David, thank you for joining us today.

D: Hi. Thank you for having me.

P: So, first of all, tell us why you decided to visit Sardinia.

D: Well, Sardinia is an interesting place because men live the same amount of time as women. That isn't normal for most countries. Men normally die younger.

P: And does anyone know the reason why people live longer in Sardinia?

D: There are different ideas about this but possibly one explanation is that the family is so important here. Every Sunday the whole family meets and they eat a huge meal together. Research shows that in countries where people live longer, the family is important. But also on Sardinia, the older mother or grandmother often has authority in the family. As men get older, they have less responsibility in Sardinian culture, so perhaps the older men have less stress, which means they're living longer.

P: I see. So, do you think people live longer in traditional societies?

D: That's an interesting question. It's true that even on Sardinia the younger generation are eating more food like French fries and burgers. Also young people are moving to the city, so they are doing less exercise because of their lifestyle. It'll be interesting to come back to Sardinia in twenty years and see if people are still living longer…

4

1 head	bed
2 throat	note
3 cough	off
4 ache	wake
5 ear	here

5

Conversation 1

C = Customer, P = Pharmacist

C: Hello. I have a sore throat and a runny nose. I feel terrible.
P: Do you have a fever, too?
C: No, it's normal.
P: Well, you should take this medicine twice a day. It's good for a sore throat.
C: Thanks.
P: And try drinking hot water with honey and lemon. That helps.
C: OK. I will.
P: Oh, and you need a box of tissues. If you still feel sick in a few days, see a doctor.

Conversation 2

P = Patient, D = Doctor

P: I have an earache in this ear. I couldn't sleep last night because it was so painful.
D: Let me have a look. Ah, yes, it's very red in there. What about the other one?
P: It feels fine.
D: Hmm. It's a bit red too. Do you feel sick at all?
P: No, not really.
D: Let me check your temperature… Yes, it's higher than normal. I'll give you something for it. You need to take one of these pills twice a day for seven days. Drink lots of water and come back if you don't feel better.

Unit 2

6

1 watching
2 language
3 waiting
4 thinks
5 cycling
6 losing
7 winning
8 English
9 competing
10 thanks

7

M = Maria, P = Paulo, K = Kali

M: I love getting up early every morning and going to the pool. It's really quiet at this time and there are only one or two other people. I'm not very good at swimming but I've got problems with my back so it helps with that.

P: I prefer watching sports to doing them, especially running. We have to do sports at school on Tuesdays and Fridays with our teacher Mr. Sykes. He tells us to run around the school field. Running is really boring exercise and I'm always last. I hate losing.

K: I like playing tennis so much that I'm working with a tennis coach to improve my game. I have my first competition in a month. I'm very excited about competing because one day I'd like to become a professional player, and this is an opportunity to see how good I really am against other players.

8

Well, here we are in a place called Banner Elk. Yes, I've never heard of it either. Anyway, it's in the mountains of North Carolina in the US, and it is cold! But that doesn't stop hundreds of competitors from coming here every October for the town's annual Woolly Worm Race. The rules for the competition are easy. Anyone of any age can enter but you must have a woolly worm. You can bring your own or you can buy one before the race. Each race has twenty people and twenty woolly worms. You have to put your worm on a piece of string at the start. Then they're off! The only rule is that you can't touch your worm during the race. During the day, there are lots of races, and if your woolly worm beats the others in the race, you take part in the grand finale in the afternoon. And the prize money is one thousand dollars! Well worth it, I'd say!

9

1 people
2 should
3 friends
4 evenings
5 something
6 what

Unit 3

10

A: One day I'd like to buy an electric car. They're much cleaner than gas cars, but I'm not sure if I'll see many on the road in the near future.

B: But you can already buy them.

A: Really?

B: Sure, and they have the most efficient type of engine. Unfortunately, they're much more expensive than gas cars. When they're cheaper, more people will buy them.

A: I'm not sure if that's better or worse! With more people on the road, we'll have more traffic jams.

B: Especially at eight in the morning. It's the worst time of the day.

A: Yes. I try to avoid rush hour now. I leave home before seven.

B: Well, I'd like to leave the car at home but every other type of transportation is slower. This town needs better public transportation. The buses don't go to the right places and they're always late. Last week I waited for a number twenty-nine for over an hour!

 11

Electric cars are much cleaner than gas cars.

Electric cars are much more expensive than gas cars.

 12

Documentary 1

On a beautiful summer morning in Thailand, guests are arriving for a wedding. Some are arriving in cars but the most special guests are riding, in traditional style, on the backs of elephants. Elephants are as heavy as cars but they aren't as fast, and most people also think elephants aren't as comfortable as cars. However, in Thailand these animals are very important. The Asian elephant became a domestic animal 5,000 years ago. In the past, they transported soldiers to wars and worked in the forests pulling up trees and carrying wood. Nowadays, it's more common to see them transporting tourists and people on special occasions, but they are as important as ever in Thai society.

Documentary 2

Lester Courtney and his wife spend a lot of time with their horses, not for leisure but for work. They are tree loggers who cut trees in traditional ways. They also transport the trees traditionally: with horses. Once the trees are down, Dan and Maddy pull them away. They're Lester's two horses. Lester has always used horses. They aren't the fastest form of transportation but Lester doesn't believe modern machines are as good. It's true that horses aren't as strong as trucks, or as fast, but Lester prefers working with animals. For one thing, a horse isn't as heavy as modern machinery so it doesn't damage the old forests. Lester also prefers horses because they aren't as noisy.

13

1 Trucks are heavier than horses.
2 Elephants are as heavy as trucks.
3 They aren't as fast as cars.
4 Horses are the fastest.

14

1 J = Javier, D = Driver

J: Hello? Are you the next taxi?
D: Yes, that's right.
J: I'd like to go to the station, please.
D: Bus or train?
J: Oh, sorry. The train station.
D: OK. Get in.

2 D = Driver, J = Javier

D: There's road work up by the entrance.
J: You can drop me off here. It's fine. How much is it?
D: Sixteen dollars and thirty cents.
J: Sorry, I only have a fifty-dollar bill. Do you have change?
D: Sure. That's thirty-three dollars and seventy cents. Do you want a receipt?
J: No thanks. Bye.

3 S = Suri, D = Driver

S: Hi. Do you stop at the airport?
D: Yeah, I do. Which terminal, north or south?
S: Umm, I need to get to the … north terminal.
D: OK. One-way or round-trip?
S: One-way, please.
D: That's two dollars.

4 J = Javier, T = Ticket seller

J: A round-trip ticket to the airport, please.

T: OK. The next train leaves in five minutes.
J: Good. That one, please.
T: First or second class?
J: Second.
T: OK. That's thirty dollars and fifty cents.
J: Wow! Can I pay by check?
T: Sorry. Cash or credit card.
J: Oh no… Oh, wait a minute! Maybe I have enough left.
T: OK. Here you are.
J: Which platform is it?
T: Umm, platform six.

5 A = Attendant, S = Suri, J = Javier

A: Hello. May I see your passport?
S: Here you are. I don't have a ticket because I booked online.
A: That's OK. How many bags are you checking?
S: None. I only have this carry-on.
A: OK. Window or aisle?
S: Umm, I don't mind but can I have a seat next to my friend?
A: Has he already checked in?
S: No, I'm waiting for him.
A: Well, I can't…
J: Suri!
S: Where have you been?
J: It's a long story.

 15

1 One-way or round-trip?
2 Window or aisle?
3 Cash or credit?
4 Bus or train?
5 North or south?
6 First or second?

Unit 4

16

1 lived
2 finished
3 wanted
4 studied
5 waited
6 looked
7 decided
8 climbed

17

I = Interviewer, W = Sandy Weisz

I: Normally we only hear bad news so it's good to have some good news from time to time. For example, did you hear in the news about Maria Garza? She was sitting on an airplane in Denver airport with her one-year-old child when she saw a fire from the window. It was coming from one of the engines. Did you read that? No? It was amazing. While the other passengers were running to the exits, Maria climbed out of the window and onto the wing of the plane. She saved her daughter's life and she was pregnant at the time! So, in fact she saved three lives.

In today's program we're talking about why some people are survivors. We want to know what makes these people so special. For example, what are their personal qualities? Here to help us answer that question is Doctor Sandy Weisz. Sandy is a doctor of psychology and an expert in survival skills. So Sandy, what kind of person is a survivor?

W: Well, the story of Maria Garza is a good one because she showed a personal quality that all survivors have.
I: Which is?
W: They are always decisive. They always think and move very quickly and so she saved three lives. It's an important quality in a difficult situation. Another important

quality they need is determination. For example, did you read about thirteen-year-old Bethany Hamilton? She showed real determination. One day when she was surfing a shark attacked her and she lost an arm. It was an incredible story. With one arm, she swam back to the beach.
I: Incredible, and there was another recent similar story… Umm, that couple … the Carlsons.
W: Sorry, what were they doing?
I: They were sailing their boat when a wave hit them. The boat sank and they were at sea for thirty-one days.
W: Oh yes, I remember that story. But they were experienced with boats, so skill and knowledge probably saved them more than anything else.
I: But what if I don't have special personal qualities or skills? Is there anything I can do?
W: Yes, there is. Most survivors don't normally take risks.
I: What do you mean?
W: Well, on an airplane, the survivors usually wear seat belts. At sea, you take extra food and water. On a mountain, a climber always wears warm clothes…
I: I see. I suppose we normally think survivors are risk-takers but in fact most of them are quite careful.
W: Exactly. We all take risks—even when we walk across the road—but most survivors don't take unnecessary risks.

 18

A: Hi Mark. How was your camping trip?
B: It was great in the end but we had a terrible time at the beginning.
A: Why?
B: First, we left the house early on Saturday morning but after only half an hour the car broke down.
A: Oh no!
B: Fortunately, there was a garage nearby and the mechanic fixed the problem. But when we arrived at the forest, it was getting dark. After we drove around for about an hour, we finally found the campsite but it was completely dark by then. Unfortunately, it started raining so we found a nice hotel down the road!
A: That was lucky!
B: Yes, it was a great hotel and in the end we stayed there for the whole weekend.
A: Sounds great!

 19

Why? Oh no! That was lucky!

Unit 5

20

P = Presenter, R = Raul, S = Sandra

P: OK. So, this week on Radio Talk, we're talking about recycling. We want to know: How much do you recycle? And do you think it's important? The phone lines are open … and our first caller this morning is Raul from San Miguel. Raul, you're on Radio Talk. Go ahead. Raul? Are you there?
R: Hello? Can you hear me?
P: Yes, Raul, I can hear you and so can about half a million other people. What did you want to say, Raul?
R: Well. A lot of people talk about recycling these days and they say it's good for the environment, but I'm not so sure. Take where I live, for example. There aren't any recycling centers in my town.

P: Really, Raul? But what about your local supermarket? Are there any recycling containers there?

R: OK, yes, there are some recycling containers, I admit, and a lot of people take their trash there. But listen to this: a truck comes every single week to take it all away. I ask you! How is that good for the environment? Think about all the fuel it uses. No, I'm not convinced. And another thing…

P: Actually, Raul, I'm going to stop you there because on line two I have another caller. Line two? Are you there?

S: Hello, yes I'm here.

P: And what's your name?

S: Sandra.

P: OK, Sandra. You're live on Radio Talk.

S: Well, I'm really angry with the man who was just on.

P: You mean Raul?

S: Yes. He's just like all the people who live around me. They don't recycle much stuff either.

P: What? None of them?

S: Well, not many people on my street recycle. I don't know about other parts of town. Every week I see them. They throw away a lot of bags. I suppose some people recycle a little trash every week, but most don't think they have time for recycling.

P: And do you ever say anything to them?

S: Yes, I do! I tell them you only need a few minutes every day to separate your glass, plastic and paper. And there are a lot of places where you can take recycling. There's no excuse at all.

P: That's an interesting opinion, Sandra, and so what I want to do is bring back Raul, who's waiting on line one. Raul?

R: Hello?

P: Raul, I'd like you to reply to Sandra because she says it's easy to recycle. What do you say to that?

R: Well, she might be right but where I live you can't…

💿 21
the TV the Internet

💿 22
1 the bottle 5 the electricity
2 the phone 6 the gas
3 the fuel 7 the insurance
4 the apple 8 the water

💿 23
V = Recorded voice, C = Customer service representative, J = Jane

V: Thank you for calling Teco Art dot com. Your call is important to us. For information about our latest products, press one. For orders, press two. For problems with your order, press three… All our customer service representatives are currently busy. We apologize for the delay. Your call is important to us. One of our customer service representatives will be with you as soon as possible.

C: Good morning. Can I help you?

J: Hi, I'm calling about an order for a hard drive clock from your website. I received an email saying I have to wait seven more days.

C: One moment… Do you have the order number?

J: Yes, it's 8-0-5-3-1-A.

C: Is that A as in alpha?

J: That's right.

C: Is this Ms. Jane Powell of 90 North Lane?

J: Yes, it is.

C: Hmm. Can I put you on hold for a moment?

J: Sure.

C: Hello?

J: Yes, hello.

C: I'm very sorry but this product isn't in stock at the moment. We'll have it in seven days.

J: I already know that, but it's my husband's birthday tomorrow.

C: I see. Well, would you like to order a similar clock? We have an Apple iPod one for thirty-five dollars.

J: Hmm. I really liked the one I ordered.

C: Oh, I'm sorry about that. Would you like to cancel the order?

J: Yes, I think so. How does it work?

C: Well, we'll refund the amount of thirty-nine dollars to your credit card.

J: OK. Thanks.

C: Would you like confirmation by email?

J: Yes, please.

C: Let me check. Your email is Jpowell at gmail dot com.

J: That's right.

C: Is there anything else I can help you with?

J: No, thanks. That's all.

C: OK. Goodbye.

J: Bye.

💿 24 & 25
1 Good morning. Can I help you?
2 Can I put you on hold?
3 Is that A as in alpha?
4 I'm calling about an order.
5 Is there anything else I can help you with?
6 Do you have an order number?

Unit 6

💿 26
Speaker 1 One day I plan to go to college but first I want to take a year off to get some work experience abroad. I'm working at a local supermarket and I'm going to save all my money. Then I'd like to travel to somewhere like Chile if I can afford it.

Speaker 2 People seem to think this stage in life means looking after grandchildren and playing golf. Forget about it! I intend to do all the things I wanted to but never had the time. And as for work? Well, I'll be happy to leave my job.

Speaker 3 We hope to get a place of our own, but these days it's really difficult to buy a house. House prices are so high that we're still living with my husband's parents. It's hard not to feel sad about it.

💿 27
1 One day I plan to go to college.
2 I want to take a year off to get some work experience abroad.
3 I'd like to travel to somewhere like Chile.
4 I intend to do all the things I wanted to do.
5 I'll be happy to leave my job.
6 These days, it's really difficult to buy a house.
7 It's hard not to feel sad about it.

💿 28
R = Reporter, L = Lorette

R: It's about six o'clock in the morning here in New Orleans and the streets are very quiet. But in about six hours, the city is going to have the biggest party in the world and thousands of visitors from all over are going to fill the streets. However, Mardi Gras is really about the local communities in the city, so I've come to the traditional Tremé neighborhood of New Orleans where some people are already preparing for the big day. I'll try to speak to some of them… Hello? Hello?

L: Hi.

R: Hello. What's your name?

L: Lorette.

R: Hi, Lorette. You're wearing a fantastic costume. Are you going to be in the parade this afternoon?

L: That's right. I'm meeting everyone at the float in a few minutes and then we're riding through the city.

R: Your dress is really amazing. Did you make it?

L: Yes, we all make our own costumes for Mardi Gras.

R: And do you have a mask?

L: Sure. Here it is. I'll put it on.

R: Wow! That's perfect! So tell me, how important is Mardi Gras for the people in Tremé?

L: It's the most important part of the year. It brings people together.

R: Well, good luck this afternoon. You're going to have a great time, I'm sure!

💿 29
1 I = Ian, A = Abdullah

I: Hi, Abdullah. How's it going?

A: Good. I finished all my classes today so I can relax.

I: Great. Maybe you'll have time for some traveling and sightseeing now.

A: Maybe, but I think I'll take it easy this weekend.

I: Oh! Well, why don't you come to my house? My family is coming over. We're having a barbecue in the backyard. It'll be fun.

A: Thanks, but I have a few things to do at home and it's with your family so you probably don't want other people there…

I: No, really. Don't worry because I'm inviting a few people from our class as well so you'll know people. I'd really like you to come.

A: OK. Thanks, that would be great. Is it a special occasion?

I: Well, my oldest sister has a new baby girl so it's somewhat a celebration for that.

A: Oh! I should bring something.

I: No, please don't. It isn't like that. There's no need.

2 J = Jasmine, S = Sally

J: Hello, Sally. How are you?

S: Fine, thanks. It's been a busy week.

J: Yes, I imagine. When do you finish?

S: Tomorrow.

J: Oh, really? I didn't realize it was so soon.

S: Well actually, my flight home is on Saturday.

J: But you're staying for another week?

S: No.

J: Oh. Well, what are doing tonight?

S: Nothing right now. I'll be at my hotel.

J: Would you like to go out for dinner? Let's go somewhere this evening.

S: Really? I'd love to.

J: Of course. I'd like to take you to my favorite restaurant.

S: That would be wonderful. I'd like that very much.

J: Great! Let's go right after work. I'll meet you downstairs at reception.

S: OK. What time?

J: I finish at six. Is that OK for you?

S: Sure. I'll see you then. Bye.

💿 30
1 I'd **love** to.
2 That would be **wonderful**.
3 It's very **nice** of you to ask.
4 I'd **like** to, but I'm afraid I'm busy.

🔊 31

Nick Veasey takes photographs of ordinary people, places, and objects, but no one could describe the final photographs as ordinary. In fact, they are very creative. Nick uses X-ray photography so you see *inside* the object. The final images are often beautiful, strange, or surprising. Working with X-rays can be dangerous because of the radiation, so safety always comes first for Nick. His well-equipped studio is a large black building. It has thick concrete walls to contain the radiation. Inside he has different X-ray machines for different sizes and types of images. But not everything he photographs will fit in the studio, so sometimes he has to travel to his subjects. For example, he has photographed an airplane, a bus, and an office building with people working inside. These kinds of projects take many days and many different X-rays. Then, he takes the best image back to his studio and spends a lot of his working day improving it on his computer until it is ready for an exhibition. You can see his photos in galleries all over the world, and many companies use his images in their advertisements.

🔊 32

1	found	7	won
2	sold	8	taught
3	bought	9	grown
4	flown	10	run
5	thought	11	lost
6	done	12	fallen

🔊 33

I = Interviewer, E = Engineer

I: How long have you worked for your company?
E: For twenty-five years. Since I left college.
I: So, when did you study engineering?
E: I started college when I was nineteen and I got my engineering degree about four years later.
I: And have you always lived in Pennsylvania?
E: No. I've lived in lots of different places. In the energy business, you live where the work is.
I: So when did you move here?
E: In 2007, just after they found gas here.
I: How many different places have you lived in, do you think?
E: I'd say about fifteen, maybe sixteen places.
I: Have you ever lived abroad?
E: Yes, but only for about three months.
I: And how does Pennsylvania compare with other places? Has it been easy living here?
E: Yes, it has, overall.
I: Have the local people been friendly?
E: Yes, they have. Well, most people anyway.
I: Ah, but not everyone?
E: Some people didn't want us here in the beginning because they were worried about the environment. But the changes have been good for this region. The gas industry has brought jobs back to Pennsylvania, so I think most people have understood how important this is.

🔊 34

I = Interviewer, C = Candidate (female)

I: Right. Have a seat, Zhang.
C: Thanks.
I: So, I've received your resume and your letter of application and I see your current job is as a sales assistant at Raystone's Bookshop. How long have you worked there?
C: I've been there for about eighteen months.
I: Oh, yes, so I see. In that case, why have you applied for this position?

C: Well, I've really enjoyed my work at Raystone's. I've always been interested in books and usually the customers are really nice. And I like trying to find books for them, especially rare books.
I: So, why do you want to leave them?
C: Because it's quite a small independent bookstore, whereas E.I. Books is a much bigger company. I read on your website you have over fifty branches now and you're still growing. And I see you also have a website where people can order books. So, I think there are probably lots of opportunities for me in the future.
I: Well, it's true that we've grown quickly in recent years. And it's nice to see you've found out about the company. So would you describe yourself as ambitious?
C: Umm, I don't know. Not especially, but I'd like to have a successful career.
I: And what are some of your main strengths?
C: Uh, I work hard and I enjoy working with other people. And, uh, I can solve problems.
I: So, I can ask you to do something and you can do it on your own?
C: Yes, I think so.
I: Well, I've asked you a lot of questions. Do you have any questions for me?
C: Yes, I do. I've applied for the position of sales assistant here, but earlier I said I was interested in developing a career. Are there often opportunities in the company for promotion?
I: Yes, we're growing all the time and if you are prepared to move, there are jobs at other branches.
C: OK. Great. And in the job description, it says you offer flexible hours. Can you tell me more about that?
I: Sure. Because we open our bookstores in the evenings as well as during the day, we ask the staff when they prefer to work. We have one member of staff who likes to work a few hours in the morning and then a few hours in the evening.
C: I see.

🔊 35

More than one billion people in the world don't have glasses but need them. They live in parts of the world where there aren't many opticians. For example, in parts of Africa there is only one optician per million people. But now, scientist Joshua Silver has invented a solution to the problem: glasses which don't need to be made by an optician.

They look like a pair of normal glasses but there is a pump on each side with silicone oil. First, you turn a wheel which controls the pump. The pump pushes the silicone oil through a tube and it moves into the lens. The shape of the lens changes and you turn the wheel until you can see correctly.

Silver had the idea a few years ago, and he did many experiments before he got it right. The first person who used the new glasses was a man in Ghana. The man made clothes but he had bad eyesight and found it hard to work. But when the man put on the glasses he could start working again. Silver says, "I will not forget that moment."

As a result, Silver started an organization called the Center for Vision in the Developing World. The glasses are cheap to produce and so far the organization has worked in Africa, Asia, and Eastern Europe, where over thirty thousand people now wear them. Silver hopes a billion people around the world will have them by 2020.

🔊 36

More than one billion people in the world don't have glasses but need them. They live in parts of the world where there aren't many opticians. For example, in parts of Africa there is only one optician per million people. But now, scientist Joshua Silver has invented a solution to the problem: glasses that don't need to be made by an optician.

They look like a pair of normal glasses but there is a pump on each side with silicone oil. First, you turn a wheel which controls the pump. The pump pushes the silicone oil through the pipe and it moves into the lenses. The shape of the lenses changes and you turn the wheel until you can see correctly.

🔊 37

Silver had the idea a few years ago, and he did many experiments before he got it right. The first person who used the new glasses was a man in Ghana. The man made clothes but he had bad eyesight and found it hard to work. But when the man put on the glasses he could start working again. Silver says, "I will not forget that moment."

As a result, Silver started an organization called the Center for Vision in the Developing World. The glasses are cheap to produce and so far the organization has worked in Africa, Asia, and Eastern Europe, where over thirty thousand people now wear them. Silver hopes a billion people around the world will have them by 2020.

🔊 38

If it rains, we'll need this.

🔊 39

1 Turn it on.
2 Plug it into a laptop.
3 Recharge it overnight.
4 Send an email.
5 Click on the link.

🔊 40

A: OK. All packed?
B: Almost. I've got the tent. I've got my walking boots.
A: Have you got a good coat? They say it's going to rain.
B: Uh, I only have this one.
A: Yeah, it'll be OK. Hey, what's that?
B: Oh yeah, my brother gave it to me.
A: Wow! That is cool! Where do I turn it on?
B: Here. But you press this if you want different types of light.
A: What do you mean?
B: Press here if you want normal lighting, but press here for long distances.
A: Wow! That's amazing!
B: It can light objects two hundred feet away. And press it again and you get a flashing red light for emergencies.
A: Aaah, I want one!
B: And listen to this.
A: How did you do that?
B: I pressed this button. It's a sound for emergencies. You know, if you get lost during the day and you need help.
A: Fabulous! What is this for?
B: Plugging it into your laptop.
A: Why do you need to do that?
B: To recharge the battery.
A: But what if you don't have your laptop?
B: Well, the battery lasts for a hundred and sixty hours so you shouldn't need it.
A: Fantastic! Where can I get one?

Unit 9

🔊 41

1 lesson
2 enroll
3 subject
4 instruct
5 apply

🔊 42

1

Every day, the ancient Shaolin temple is visited by hundreds of tourists. They come from all over China and from every background. There are soldiers, business people, retired people, and young couples. In particular, there are parents with excited children who are punching and kicking. Most people have learned about Kung Fu from movies and TV, so they all come to the Shaolin Temple to see the place where Kung Fu began. According to history, people started learning Kung Fu at the Shaolin Temple in the fifth century. Since then, Kung Fu teachers have taught generations of students.

2

Nowadays, the name Shaolin is known across the Kung Fu world. It is a brand and a multimillion dollar business. Shaolin products are sold from the website. There are movie and TV projects, and Kung Fu demonstrations are given by groups of Shaolin performers. As a result, the Shaolin Temple has started a new interest in Kung Fu, and it is taught in hundreds of new schools in China. In the city of Dengfeng, for example, six miles from the Shaolin Temple, more than 50,000 students are enrolled at one of the sixty martial arts schools.

3

For six days a week, eleven months a year, the school schedule starts early and finishes late. Male and female students as young as five get up early for their first class. They always wear red uniforms and stand in rows, practicing Kung Fu. Many of these students have seen Kung Fu at the movies, and they dream of becoming a Kung Fu movie star or a famous kickboxer. Others want to learn the skills they will need for a good job in the military or on the police force. Some students are sent by their parents because the schools are well-known for their hard work and discipline. At night, the students sleep in unheated rooms. They train outside even when the weather is below freezing. They hit trees to make their hands stronger and the movements are repeated again and again for hours on end.

🔊 43

H = College helpdesk, C = Caller

H: Hello, Corfield College. This is Melanie speaking.
C: Oh, hi. I'm calling about one of your evening classes starting this term. I want to know if there are any places left.
H: Uh, one moment. Let me take a look. I know one of them is full…
C: It's called *Preparing more effective PowerPoint presentations.*
H: Oh, yes. That is a popular course… there is one slot, but I suggest you enroll soon.
C: Well, can I do it today?
H: Yes, it's all online, so you need to go to the website. When you click on the ENROLL NOW button, the first thing you're asked to do is to fill in an enrollment form.
C: OK.
H: Have you seen the website?

C: Yes, but I didn't know if I had to fill in the form for a short course. There isn't an interview, is there?
H: No, no. Nothing like that. But when you've completed the online enrollment form, a copy is sent to us here at the office and also to the course instructor.
C: And do I pay when I send you the form?
H: It's up to you. Payment is accepted either when you enroll or no later than six weeks before the course starts. But you must put down a deposit so a place is reserved for you.
C: Well, I can pay it all right away because my employer is paying.
H: Fine. After we've received payment, a receipt is emailed to your employer.
C: And then what happens?
H: Before the course starts, you mean?
C: Yes.
H: Once you've enrolled, you're sent a list of books to buy or any course materials. But actually… for your course… I don't think… no, all the materials are provided by the instructor. He'll provide them on the first day.
C: OK. Well, I'll enroll now in that case. Thanks for your help.
H: You're welcome.

Unit 10

🔊 44

Story 1

A: So where did you go exactly?
B: On the River Nile from Aswan to Luxor.
A: Wow! How long did it take?
B: Well, the cruise took about four days in the end, but we stopped in lots of places. But on the first day, just after we'd left Aswan, the boat's engine stopped working.
A: Oh no! What happened next?
B: Well, eventually they fixed the problem but we spent an extra day on the ship, which was fine. It was relaxing watching day-to-day life on the river.

Story 2

A: Where did you stay?
B: In a hotel near the train station. But it was a mistake. My bag was stolen from the reception desk!
A: Oh no! When did it happen?
B: Just after we'd arrived.
A: Who took it?
B: A man outside the hotel. He'd followed us into the hotel. Fortunately, the hotel receptionist ran after him and got it back. After that it was fine. We went sightseeing, visited a couple of museums—you know, all the usual things. But then, on the very last night, there was no electricity in the hotel.
A: So, what did you all do?
B: Well, first I went to look for the manager but she'd already left. The person at the front desk had some candles, and all the guests sat together in the bar area and sang songs. Actually, it was a lot of fun in the end. That was probably the best part of the vacation…

🔊 45

I = Interviewer, M = Madelaine

I: So, Madelaine. We've talked about some of your photography and your travel writing with *National Geographic* magazine, but I know that you're also very excited about your new job.
M: That's right. Recently, I've also started working as a tour guide with National Geographic Adventures.

I: Is that strange for you? I mean, you're someone who is fascinated by travel and experiencing new places, so what is it like taking groups of people around on tour buses and showing them famous cities? It sounds a little boring for someone like you.
M: Actually, it's fascinating because it isn't anything like what you've just described. These are National Geographic Adventure vacations, so they're for people who love adventure and, on my tours, are especially interested in photography.
I: So, this isn't your traditional package-tour vacation by the beach with some sightseeing.
M: No, not at all. It's for people who are bored with that kind of experience. This is something quite different. For example, my next job is in the famous Galápagos Archipelago.
I: Wow!
M: Exactly. This tour is very exciting because I've never been there before and it's such a legendary part of the world.
I: So give us a basic idea of the type of people who go on the tour. How big is the group, for example?
M: Well, it's a small group of us, about nine or ten usually. Sometimes it's couples, but often they're independent travelers and they make new friends.
I: But don't independent travelers get annoyed with other people in a group? I mean, after all, they normally travel on their own.
M: Well, of course, everyone has the same interests so quite a few people come on their own and then make friends with everyone in the group. But if someone wants to go and walk up the side of a volcano on their own or spend the day in a canoe out on the ocean, that's fine. The itinerary is very flexible. But there are also scheduled events. For example, I give some talks about taking photographs, and in the evenings, we usually cook our meals together on a barbecue. It's a lot of fun.
I: One last question: Some of our listeners are probably thinking it all sounds amazing but they're worried about the physical requirements for this kind of vacation. How physically fit do you have to be?
M: You don't have to be an athlete or anything, but you should be an active person. We tell people that before they come. This is an adventure vacation, after all. But there's also plenty of time for relaxing by the beach in the evenings. And you never get tired of the views. It must be the best job in the world!

🔊 46

1 amazed, amazing
2 bored, boring
3 fascinated, fascinating
4 interested, interesting
5 frightened, frightening
6 worried, worrying
7 annoyed, annoying
8 tired, tiring

47

TI = Tourist information, T = Tourist (male)

TI: Bonjour, Monsieur.

T: Ah, bonjour. Sorry, do you speak English?

TI: Yes, I do. How can I help you?

T: I'm interested in the catacombs museum. Can you tell me if it's open today?

TI: Uh, let me check. I don't think so. A lot of places are closed on Mondays in Paris. No. Every day except Monday.

T: Oh well. That's OK. What time does it open?

TI: At ten, and it closes at five. Would you like to book a ticket for tomorrow? I can do it for you here. There's usually a long line for the catacombs, but if you book it here, you don't need to wait in line.

T: OK. That sounds like a good idea. But uh … I'd like to know how long it lasts.

TI: The tour through the tunnels is forty-five minutes long and you might have to wait a few minutes at the beginning. So, about an hour in total.

T: Fine. Is there much walking? I can't walk very far you see.

TI: Well, the tour is about a mile and a quarter long. And there are some steps down under the ground at the beginning and then at the end.

T: Do you have any idea how many steps there are? Is it far?

TI: Over a hundred, I think. Yes, a hundred and thirty.

T: Oh dear. Perhaps I'd better choose something else.

TI: Have you been on the sightseeing bus? It takes you all round Paris.

48

1 Do you know if there's a taxi stand near here?

2 Do you have any idea how much it costs?

Unit 11

49

R = Reporter, A = Archaeologist

R: I believe archaeologists discovered this pyramid in 1978.

A: That's right. But we haven't excavated everything yet. There's still a lot to do.

R: Where are we standing now?

A: We're near the north wall of the pyramid.

R: And why have you brought me here?

A: Well, recently we discovered this box in the ground which tells us a lot about the Aztecs.

R: Yes, I can see that it's full of objects. What are they?

A: Some of them are pots or plates. They used them for cooking.

R: I see. And what else is in there?

A: There were some small pieces of gold and a precious blue stone called jade, but we've taken them out now. The Aztecs used to do a lot of business so these types of stones were important. We also found some small statues which had religious importance. And also there were knives. The Aztecs used to sacrifice animals—and even other humans—to their gods, so the knives are probably for sacrifices.

R: Did you find any bodies?

A: Actually, yes. The skeleton of a dog, but it wasn't a sacrifice. It wore a beautiful collar so it was obviously an important animal.

R: Did the Aztecs use to keep dogs as pets?

A: No, they didn't use to have pets. Well, we don't think they did. But obviously this dog was important in some way. Maybe the owner used him for hunting.

50

The Nok used to live in Africa but they didn't use to live in Europe. They used iron but they didn't use any stone.

51

Good morning and thank you all for coming. Today I would like to talk about my vacation in Peru and, in particular, about my journey to Machu Picchu, also called "The Lost City of the Incas." Let me begin / by telling you about the history of Machu Picchu. It was discovered by the explorer Hiram Bingham / in 1911…

So, that's everything I wanted to say about Hiram Bingham. Now, let's move on to the history of the Incas and why they built Machu Picchu. The first Incas lived in the region of Peru around the thirteenth century…

OK. Now, the next part of my presentation is about my own journey through Peru and up to Machu Picchu. For this, I'd like to show you some of my photos. The first one is a picture of me in the town of Aguas Calientes. You have to catch the bus from here to Machu Picchu…

OK. That's the end of my talk. In summary, Peru, and especially Machu Picchu is a magical place and anyone who is interested in history should go there. Are there any questions?

52

Good morning and thank you all for coming. Today I would like to talk about my vacation in Peru and in particular, about my journey to Machu Picchu, also called "The Lost City of the Incas." Let me begin by telling you about the history of Machu Picchu.

Unit 12

53

Everyone looks at nature differently. Maybe you're somebody who has no interest in nature, and if you go anywhere green, you don't notice anything. Or maybe you can name a few different plants and animals in your local park. But for people like David Liittschwager, nowhere in the world is without natural beauty. He sees plants and animals everywhere he looks. David is a photographer for *National Geographic* magazine and he wanted to show how much nature there is around us all the time. So, he took a green metal frame measuring one cubic foot to different locations around the world, for example, to the middle of a forest, on the side of a mountain, in the ocean, and in a river. Nowhere was too far away or too difficult for David. Then, he spent three weeks in each place and he photographed everything alive inside the green metal frame. This included photographing living things as small as one millimeter in size. The result was a series of photos showing over a thousand individual organisms in each cubic foot, and a new view of our world and its ecosystem.

54

1 economic difficulties
2 social problems
3 traditional industry
4 modern development
5 strong economy
6 natural resources
7 growing season

55

Z = Zoo manager, C = City Council

Z: What about giving us more money?

C: I'm sorry, but the council doesn't have any more money for the zoo.

Z: But if we don't find a solution soon, we'll have to close it, and the zoo is part of the city. It's a tourist attraction.

C: Yes, but that's the point. It simply isn't attracting enough tourists. You're going to have to find the money somewhere else.

Z: But it's also an important place for animal conservation. Some of these animals are close to extinction. If we didn't have zoos, they wouldn't survive.

C: I understand that, but we need to find a different solution. What if you advertised the zoo more? In the newspaper or on the radio, for example.

Z: But if we don't have any money, we can't advertise.

C: Well, why don't you try sponsorship? You know, ask a company to support the zoo.

Z: Actually, that's not a bad idea. You might be right!

C: I have the names of some company bosses you could contact.